AMAZING
INSECTS

In Memory

of

Verne Speak

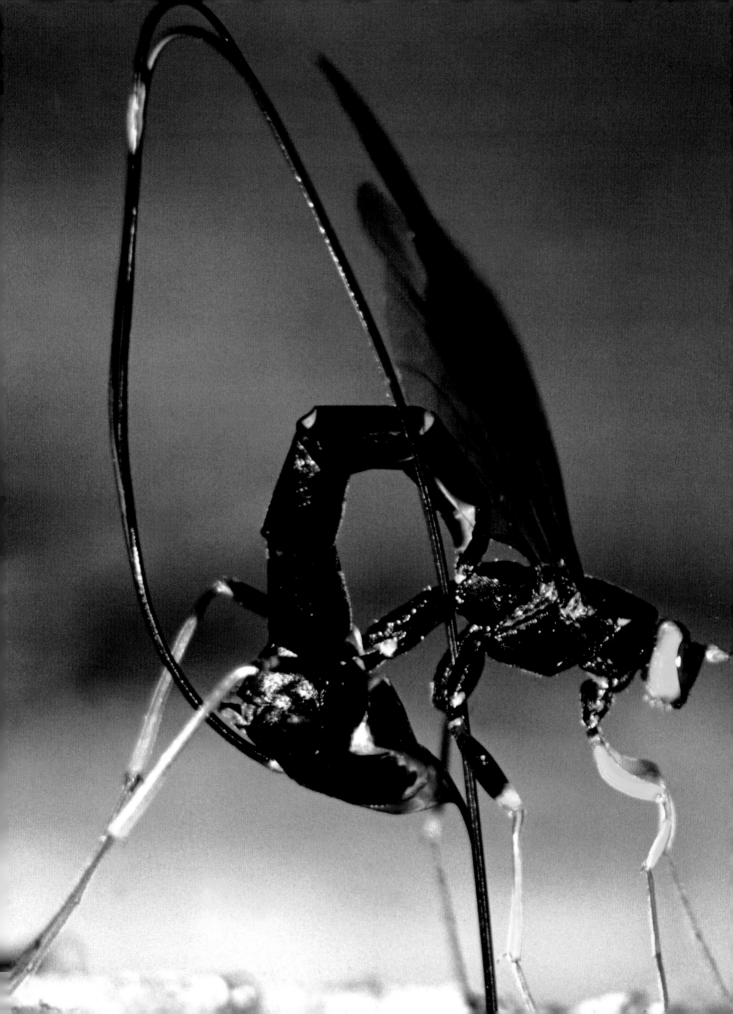

AMAZING INSECTS

IMAGES OF FASCINATING CREATURES

MICHAEL CHINERY

FOREWORD BY
DAVID BELLAMY OBE

FIREFLY BOOKS

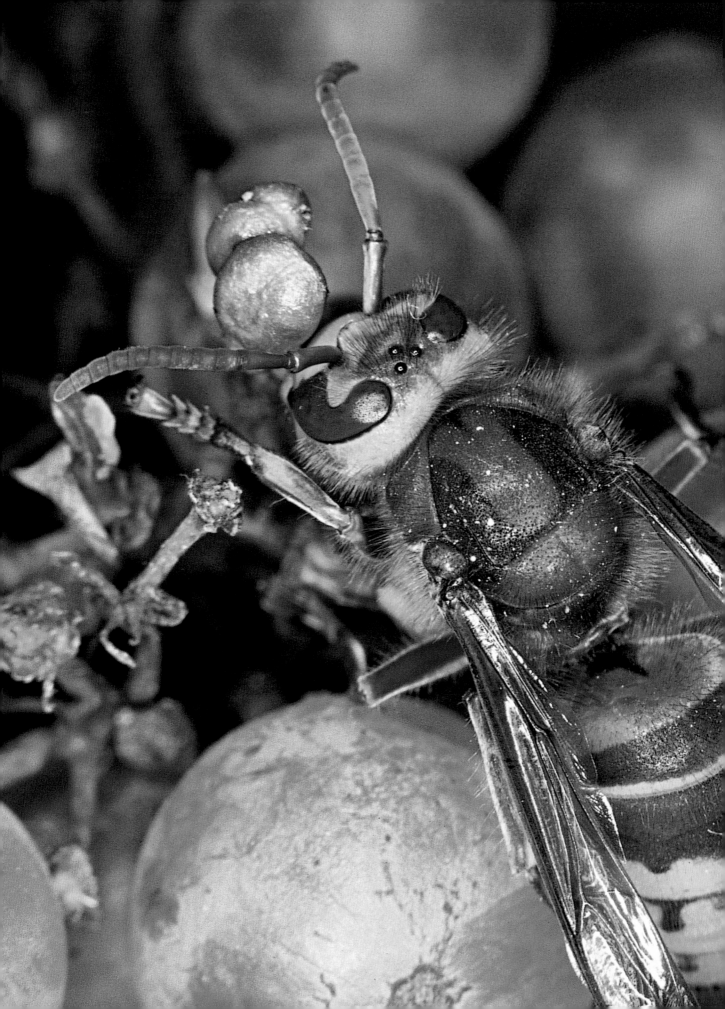

CONTENTS

FOREWORD

Calling all insectophobes! Console yourselves with the fact that there is a safe haven from your six legged armour plated tormentors and it covers five sevenths of this lonely planet. Earth's own inner space is full of salty water, an enormous habitat which is almost terra incognita for both the staggering diversity and abundance of the tribe of insects. To coin a phrase, they don't seem to like "salt up 'em."

So from your insect proofed houses – unless you live in the ocean – you can open up this superb book and begin to understand just how fascinating and important insects are to life on earth, which happens to include you.

This weighty tome will enthral, entertain and educate you about the world's most diverse and abundant creepy crawlies. The superb pictures will let you into the many secrets of Mother Nature's own binmen who reduce, reuse and recycle the products of every living thing. Exterminate them and the world would be in a real mess. There is much to learn about these creatures and this book showcases the object of this research for everyone.

Take the case of the bumbling bees. Without them, what would pollinate the trees in our orchards and all the nectar-producing flowers that play crucially important roles in many food chains? Ants are great diggers and stirrers maintaining the stucture and fertility of our all important soils. Their deep excavations have even led to the discovery of new diamond fields.

Insects are the only group of invertebrates that can fly. Their wings are made of chitin the same stuff that makes their body armour, to which their muscles are attached from the outside in. Some have complex life cycles requiring several different habitats and even food sources. Insects communicate with each other with sound, light, touch and chemicals called pheromones and sometimes just a few molecules of these nove substances are needed to guide them to their mates.

Their defence mechanisms are just as clever, as Charles Darwin found when collecting insects – if both hands were fully occupied, his next specimen would be held in his mouth only for him to discover its horrible taste. Of course be wary of them, but if you do eve get bitten by a female mosquito, or any of the other tiresome bloodsuckers, rest assured that your sacrifice will allow her to reproduce more of these chitin-encased flying machines ready to feed off their predators. That's what makes the living world go round

What a great book and if you find that you still hate insects then you can always use it to squash them, but please recycle the book to your local school or library so that it can

INTRODUCTION

A small boy was once heard to ask his mother who made the flies that were crawling on the window of a bus on which they were travelling. On being told that God made them, he remarked that it must be a fiddly job to make a fly! Although it is doubtful if he knew anything about a fly's anatomy, it was a perceptive observation. A fly, even the smallest of species, is an incredibly complex creature. It has legs and wings with which to get about, a digestive system to deal with its food, muscles and nerves – including a brain – to control everything, and, of course, a reproductive system to ensure that more flies of the same kind appear in due course: a fiddly job indeed, but the wizardry of the double helix that is DNA guarantees that a house-fly's eggs, for example, develop into more house-flies and not into bluebottles. DNA is the essence of the genes that are contained within each cell of the body and ensure that each and every feature, however miniscule or intricate, develops in the correct way for each species.

Although each species has own brand of DNA, ensuring that the organisms have the right numbers of bits and behave in the right way, this does not mean that each individual of a species has exactly the same genetic make-up. Offspring receive a set of genes from each parent, and these genes can combine in different ways to produce slight differences in the offspring. Among the insects these differences might involve eye-colour or wing length, increased cold-hardiness, better camouflage, or an improved ability to attract a mate. The changes from one generation to the next are usually extremely small, but if they are of even the slightest benefit to those individuals exhibiting them they have a good chance of being passed on to future generations. Over millions of years and

millions of generations these tiny changes can add up to big differences, and this is the basis of evolution that has led to the amazing variety of plant and animal life that we see around us today.

Insect life is particularly varied, for there are well over a million known species – and probably even more still unknown – and they occupy just about every possible habitat on the planet, although very few insects have managed to invade the open sea. Virtually every kind of plant or animal matter is eaten by some insect or other, and the insects have evolved an equally wide range of feeding methods and equipment. Insects have also adopted many different ways of getting about and escaping from their enemies. Many build elaborate homes, and the majority exhibit almost magical transformations during their life cycles.

The photographs in this book, some of them taken at very high magnifications, illustrate something of the incredible complexity of insect anatomy, and also reveal much of the insects' fascinating behaviour, which is just as much a part of a species' make-up as its physical appearance and has contributed just as much to the success of the insects.

Michael Chinery

INTRODUCING THE INSECTS

Insects belong to the major group of invertebrate animals known as the arthropods. These all have jointed limbs and their bodies are composed of a number of rings or segments, although the segments are not always obvious. Spiders, scorpions, centipedes, shrimps, and woodlice are also arthropods, but most adult insects can be distinguished from these other groups because they have three major parts to the body – the head, the thorax, and the abdomen. They also have a pair of antennae or feelers attached to the head and three pairs of legs attached to the thorax. Most adult insects have one or two pairs of wings attached to the thorax. No other group of invertebrates ever has wings.

There are well over a million known kinds or species of insect in the world and entomologists have arranged them in about 30 major groups called orders. Classification is not an exact science, however, and different entomologists have different opinions on how to split up the insects. A 'lumper' may decide that two insect groups are not sufficiently different to be placed in separate orders, whereas a 'splitter' may feel that the two groups are sufficiently different. One entomologist may thus recognise more orders than another. New biochemical techniques allowing biologists to study the insects' DNA may help to resolve such problems.

The following paragraphs briefly describe and illustrate all the generally accepted orders, with the exception of two very small and little-known groups – the *Zoraptera* and the *Grylloblattodea*.

Silverfish and Firebrats: Order *Thysanura*

These little insects, never more than 2 cm/0.8 in. long and usually much smaller, are completely wingless and have three slender 'tails' at the rear end. These 'tails' are clothed with stiff bristles and the insects are collectively known as bristletails. Their bodies are clothed with shiny scales which, as anyone who has tried to pick up a silverfish will know, are easily detached. Silverfish, firebrats, and several other bristletails live in houses and other buildings throughout the world, feeding on starchy materials and commonly damaging books and papers, but most of the 600 or so known species live as scavengers on the forest floor or on the seashore. A few species live in ants' nests. The bristletail's life cycle is very simple, with no metamorphosis: youngsters are just miniature versions of the adults apart from having no scales in the early stages. Surprisingly for such small creatures, the insects can live for four or five years.

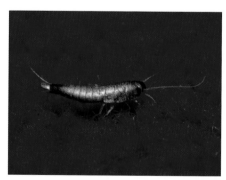

Silverfish and Firebrats: Order *Thysanura*

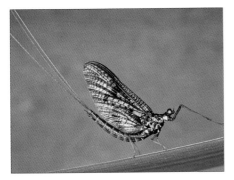

Mayfly: Order *Ephemeroptera*

Mayflies: Order *Ephemeroptera*

Mayflies are delicate insects with one or two pairs of flimsy wings and two or three long, slender 'tails'. The hind wings, if present, are much smaller than the front ones and the insects almost always rest with the wings held together above the body. The antennae are minute and not easily seen. Mayflies spend their early lives in water, with some species taking up to three years to reach maturity, but the weak-flying adults rarely live for more than a day or two. They do not feed and do not even have functional mouths, and they rarely move far from the ponds and streams in which they grow up. There are about 2000 known species.

Dragonflies: Order *Odonata*

These slender-bodied, predatory insects all have four rather stiff wings, huge eyes that may contain thousands of tiny lenses, and minuscule bristle-like antennae. The larger species usually snatch smaller insects in mid-air as they swoop to and fro at high speed. These larger dragonflies rest with their wings spread out on each side of the body, but the smaller ones, generally known as damselflies, usually rest with their wings held together over the body. Damselflies generally fly more slowly than their larger relatives and are more likely to snatch prey from the vegetation. The early stages of dragonflies and damselflies are all aquatic, usually growing up in still or slow-moving water. Adult damselflies rarely move far from the water, but the larger species fly strongly and can be found almost anywhere. There are about 5000 known species.

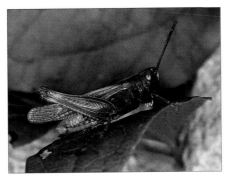

Dragonfly: Order *Odonata*

Stoneflies: Order *Plecoptera*

These insects are mostly black or brown, although some species are yellow. At rest, their four flimsy wings are folded flat over the body or else rolled around it and the insects are seldom noticed. They are weak fliers and rarely found far from the water in which they grow up. Most of the 3000 or so known species breed in clean, fast-running water. The adults, up to about 5 cm/2 in. long, may nibble pollen or scrape algae from waterside rocks and vegetation, but many do not feed at all.

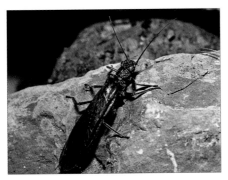

Stonefly: Order *Plecoptera*

Grasshoppers and Crickets: Order *Orthoptera*

This order contains about 20,000 species, in most of which the back legs are large and adapted for jumping. There are normally two pairs of wings, the front ones being tough and leathery and the hind ones membranous, although many species lack hind wings and some lack wings altogether. The wings are folded back along the body at rest. Grasshoppers have short, stout antennae, while the antennae of crickets are filamentous and generally much longer than the body. Grasshoppers, which include the destructive locusts, are all vegetarians, whereas crickets tend to be omnivorous or carnivorous. The males of most species attract their mates and repel rivals with 'songs', produced by rubbing one part of the body against another. Each species has its characteristic sound.

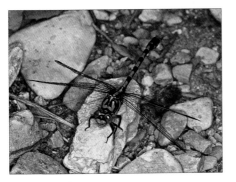

Grasshopper: Order *Orthoptera*

Stick Insects and Leaf Insects: Order *Phasmida*

Named for the extraordinary resemblance of most species to twigs or leaves, these insects are found mainly in tropical regions. All of the 2500 or so species are vegetarians and the largest ones are more than 30 cm/12 in. long. Many species are completely wingless; others may have well-developed flimsy hindwings, but the forewings, if present, are rarely more than small horny flaps. Virgin birth or parthenogenesis is common: males being very rare or unknown in some species.

Earwigs: Order *Dermaptera*

These are mostly brown or black insects, no more than about 5 cm/2 in. long, and easily recognised by the pincers at the rear end. Most of the 1200 or so known species have short, horny front wings covering elaborately folded, membranous hindwings, although many species lack hindwings and some have no wings at all. The majority of earwigs are scavenging insects, living in a wide range of habitats. Youngsters resemble the adults except that they lack wings and their pincers are straight and slender.

Termites: Order *Isoptera*

The termites are all social insects, living in colonies ranging from a few hundred to several million individuals, although they are far removed from the other social insects – the bees, wasps, and ants in the *Hymenoptera* (see p. 17). Most of the 2250 or so species live in the tropical regions, where many of them build huge and elaborate nests (see p. 264). Many termites feed on grass and seeds, but wood is the commonest food material and the insects cause immense damage to buildings. They have soft bodies and, as in the other social insects, they exist in three or more different castes. Most are under 20 mm/0.8 in. long, although the long-lived queens, whose bodies are packed with eggs, may reach about 15 cm/6 in. Unlike those of the social *Hymenoptera*, termite colonies have a workforce made up of more or less equal numbers of males and females, and they each have a king who mates frequently with the queen. As well as the workers, who build the nests, collect the food, and do all the household chores, the workforce includes a number of soldiers, whose function is to defend the colony with their large jaws. Only those termites destined to become new kings and queens have wings – and then only for a short time: they break off their flimsy wings after their mating flights and then settle down to start new colonies.

Cockroaches and Mantids: Order *Dictyoptera*

The cockroaches and mantids and are often placed in two separate orders – the *Blattodea* and the *Mantodea*. Cockroaches are flattened, long-legged scavengers, usually with leathery front wings and membranous hindwings although many species are completely wingless. Most of the 3500 or so known cockroach species live out of doors in the warmer parts of the world, but several species have become cosmopolitan pests in heated buildings. The largest species are about 6 cm/2.4 in. long. Mantids are predatory insects with a long neck and spiky front legs resembling gin-traps, but their bodies and wings otherwise resemble those of the cockroaches. They range up to about 15 cm/6 in. in length. There are about 1800 known species.

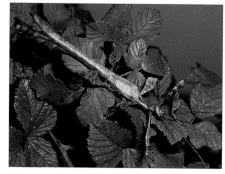

Stick Insect: Order *Phasmida*

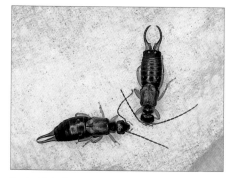

Earwigs: Order *Dermaptera*

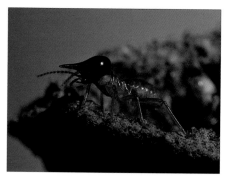

Termite: Order *Isoptera*

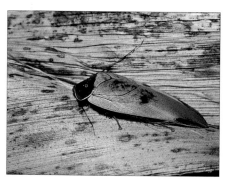

Cockroach: Order *Dictyoptera*

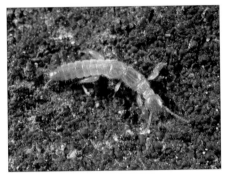

Booklice and Barklice: Order *Psocoptera*

Booklice and Barklice: Order *Psocoptera*

These soft-bodied insects, also known as psocids, are rarely more than 5 mm/0.2 in. long. Most of the 1800 or so known species have four flimsy wings, but many are completely wingless. All have relatively large heads and long antennae, and biting jaws. Some of the wingless species live indoors, where they feed mainly on tiny moulds growing on rarely-moved books and papers – hence the name of booklice. Out of doors, psocids feed on moulds, fungal spores, and pollen, and also scrape algae from tree trunks – hence the name of barklice.

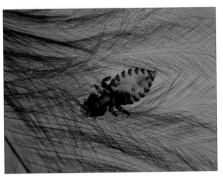

Web-Spinner: Order *Embioptera*

Web-Spinners: Order *Embioptera*

These little-known insects live in silken tunnels in the soil or on tree trunks. The silk comes from glands on their swollen front legs. There are less than 200 known species, all living in the warmer parts of the world. Their cylindrical bodies are no more than about 12 mm/0.5 in. long and they can scuttle backwards and forwards in their tunnels with equal ease. Some males have two pairs of flimsy, hairy wings: females are always wingless. Web-spinners often live in loose colonies but, although the females may tend their eggs and young, the insects do not co-operate with each other and they are not social insects. They feed mainly on decaying vegetation.

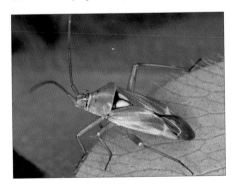

Lice: Orders *Mallophaga* and *Anoplura*

Lice: Orders *Mallophaga* and *Anoplura*

These tiny, flattened wingless insects rarely more than 5 mm/0.2 in. long, all live as ectoparasites on birds and mammals. Strong claws enable them to cling tightly to their hosts. Being wingless, there is little difference between youngsters and adults apart from the size. The two groups are sometimes grouped together as the *Phthiraptera*, but significant anatomical differences suggest that they are not closely related. The *Mallophaga* are the biting lice and most of the 3000 or so known species live on birds. The head is quite large and nearly as wide as the body, and the insects feed mainly on scraps of skin and feathers. The *Anoplura* are the sucking lice, found only on the bodies of mammals, including humans. The head is very narrow and equipped with piercing mouth-parts with which they obtain blood from their hosts. There are about 500 known species.

Bugs: Order *Hemiptera*

This huge order contains a very diverse assemblage of winged and wingless insects and the only feature that they have in common is a needle-like beak with which they suck the juices of plants or other animals. About 80,000 species are known and they include many serious crop pests. They range from less than 1 mm/0.04 in. to about 13 cm/5 in. in length and some of the cicadas have wings spanning as much as 20 cm/8 in. There are two very distinct sub-orders – the *Heteroptera* and the *Homoptera* – and many entomologists regard them as two separate orders. Among the *Heteroptera*, the

Bug: Order *Hemiptera*

forewings, when present, are largely horny or leathery, but they always have a membranous tip. These wings are usually laid flat over the body, overlapping in the middle and completely concealing the membranous hindwings. This sub-order contains both plant-feeding and predatory species and includes all the aquatic bugs. Among the *Homoptera*, the forewings, when present, are either tough or membranous, but always with a uniform texture. The wings are held tent-like over the body. All members of this sub-order are plant-feeders and they include the cicadas as well as the aphids and scale insects which cause so much damage to crops.

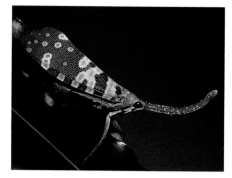
Bug: Order *Homoptera*

Thrips: Order *Thysanoptera*

Thrips are very small, dark insects whose more or less cylindrical bodies are rarely more than about 3 mm/0.1 in. long, although a few tropical species reach lengths of 14 mm/0.5 in. The four wings are heavily fringed with hairs and often look like minute feathers, although many thrips are wingless. Most of the 5000 or so known species are vegetarians, plunging their beaks into leaves and petals to get at the sap. Many are serious crop pests. The insects are often known as thunderbugs or thunderflies because they take flight in humid, thundery weather and drift through the air in enormous numbers. Large numbers may hibernate in houses, often getting under loose wallpaper and even into picture frames.

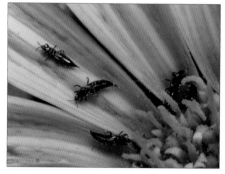
Thrips: Order *Thysanoptera*

Lacewings and Ant-Lions: Order *Neuroptera*

These soft-bodied insects, mostly brown or green, are named for the lace-like network of veins exhibited by most of the 5500 or so known species. They range up to about 7.5 cm/3 in. in length and 17 cm/7 in. in wingspan, and usually rest with their wings held roofwise over the body. Adults and young all feed mainly on other insects, with aphids forming a major food source for most lacewings. Adult ant-lions also feed largely by plucking small insects from the vegetation, but the insects get their name from the fiercely predatory habits of their youngsters (see p. 135). The fast-flying ascalaphids catch their food on the wing like dragonflies. Several lacewing species grow up in fresh water.

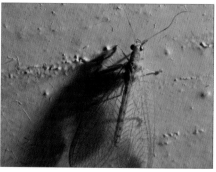
Lacewing: Order *Neuroptera*

Snake Flies: Order *Raphidioptera*

These insects get their name for the long 'neck' that carries the head well above the rest of the body. There are about 100 known species, rarely more than about 2 cm/0.8 in. long, and they are carnivorous at all stages of their lives. These insects were once included in the *Neuroptera*, but most entomologists now give them an order to themselves.

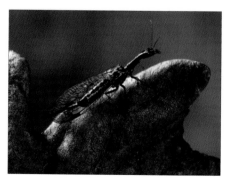
Snake Fly: Order *Raphidioptera*

Alder Flies and Dobson Flies: Order Megaloptera

These insects closely resemble the lacewings, and were once grouped with them in the *Neuroptera*, but they tend to have fewer veins and, unlike those of the lacewings, the veins rarely fork at the ends. Dobson flies may reach 10 cm/4 in. in length and have wings spanning 15 cm/6 in., but the alder flies are a good deal smaller. The insects are rather weak fliers. Despite the large jaws of some of the dobson flies, the insects do no more than nibble pollen and algae: many adults do not feed at all. There are about 300 known species and they all grow up in water, where the young stages feed on a variety of other aquatic creatures .

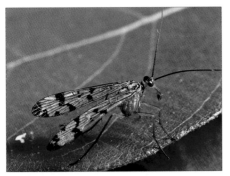

Alder Fly: Order *Megaloptera*

Scorpion Flies: Order *Mecoptera*

Scorpion flies are named for the way in which the swollen rear end of most males turns up like that of a scorpion, although the insects are quite harmless. The female abdomen tapers to a point. All scorpion flies have a stout beak, often orange, with jaws right at the tip. The two pairs of wings are quite similar, generally long and slender and usually spotted with brown. The majority of the insects are scavengers, with a definite liking for dead insects (see p. 134). Most of the 400 or so known species live in the cooler parts of the Northern Hemisphere.

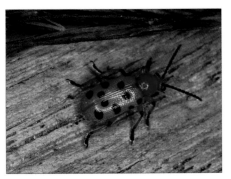

Scorpion Fly: Order *Mecoptera*

Beetles: Order *Coleoptera*

Beetles are easily recognised because most of them have tough front wings, known as elytra, that generally cover the abdomen and meet in a straight line down the middle – unlike the overlapping wings of the *heteropteran* bugs (see p. 14). The delicate hindwings are usually completely hidden under the elytra, although many species lack hind wings and a few beetles, such as the female glow-worm, are completely wingless. Beetles all have biting jaws and few natural materials escape the attention of at least some of these insects. There are about 370,000 known species, making them by far the largest of all the insect orders. Their sizes range up to about 20 cm/8 in. in length and their shapes are amazingly varied. The fist-sized Goliath beetle, weighing in at about 100 g/3.5 oz, is the heaviest of all insects, but at the other end of the scale there are beetles less than 0.5mm/0.02 in. long – candidates for the title of the world's smallest insect.

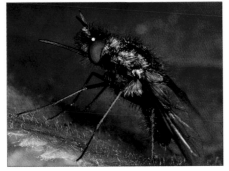

Beetle: Order *Coleoptera*

Flies: Order *Diptera*

The insects in this order are often called true flies to distinguish them from all the other insects with the word fly in their name. There is just a single pair of membranous wings, held flat or tent-like over the body a rest. A few flies, mainly parasitic species, are wingless. There are nearly 100,000 known species, ranging from minute midges only 0.5 mm/0.02 in. long to gangly crane-flies, sturdy bluebottles, and colourful hover-flies. The largest species are about 5 cm/2 in. long, with wings spanning up to 8 cm/3 in. Flies all feed on liquids of some kind or other. Many, including the notorious mosquitoes and tsetse-flies, are blood suckers and are equipped with piercing mouth-parts that often resemble tiny hypodermic syringes.

Fly: Order *Diptera*

15

Fleas: Order *Siphonaptera*

Fleas are wingless, blood-sucking parasites of birds and mammals. They are much more active than lice (see p. 13) and, being flattened from side to side, they are able to scuttle easily through the fur or plumage of their hosts. Strong claws and combs of backward-pointing spines enable them to cling on tightly when required, while long and powerful back legs enable them to leap on to fresh hosts. About 2,000 species are known, the largest being about 1 cm/0.4 in. in length.

Flea: Order *Siphonaptera*

Caddis Flies: Order *Trichoptera*

Caddis flies are mostly brownish, moth-like insects but, instead of having scales (see below), their four flimsy wings are clothed with hairs. The wings are held tent-like above the body and the long antennae are held out in front. Flight is usually weak and the insects are active mainly at night. There are about 5,000 known species, with lengths ranging from about 1.5 mm/0.06 in. to 3.5 cm/1.4 in. Mouth-parts are weak and the insects do no more than lap nectar from waterside flowers: many do not feed at all. With very few exceptions, the caddis flies all grow up in water, where many of the youngsters, known as caddis worms, make portable homes or cases with plant debris or sand.

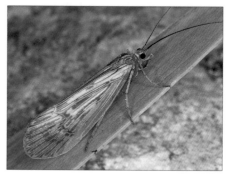
Caddis Fly: Order *Trichoptera*

Butterflies and Moths: Order *Lepidoptera*

This order contains some of the most spectacular and familiar of the insects. There are normally four membranous wings, whose colours are provided by a covering of minute scales that overlap like tiles on a roof (see p. 57). Some of the giant silk moths and birdwing butterflies have wingspans of about 30 cm/12 in. – larger than that of any other insect, although their bodies are relatively small. At the other end of the scale, there are moths with wings no more than 3 mm/0.1 in. across. There are getting on for 200,000 known species, of which under 2000 are butterflies. Butterflies are mostly day-flying insects, while most moths fly at night. Butterfly antennae end in small clubs, whereas most moth antennae are feathery or hair-like. Butterflies rest with their wings held together over the body, with only the lower surfaces visible, but most moths rest with their wings flat or folded tent-like over the body with the upper surfaces showing. But there are many exceptions to these 'rules' and the division of the order into butterflies and moths is entirely artificial, with no single difference between all the butterflies on the one hand and all the moths on the other. Most butterflies and moths are nectar feeders, with mouth-parts in the form of a long, tubular proboscis or tongue. Some of the smaller ones chew pollen, but many moths do not feed in the adult state. The young stages, known as caterpillars, have chewing mouth-parts and almost all of them feed on or inside plants.

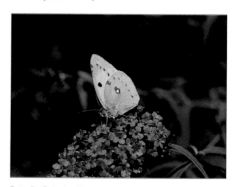
Butterfly: Order *Lepidoptera*

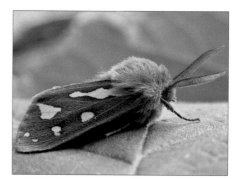
Moth: Order *Lepidoptera*

16

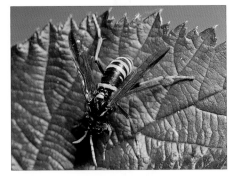
Bee: Order *Hymenoptera*

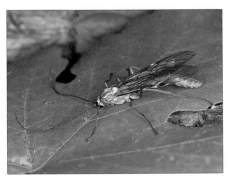
Sawfly: Order *Hymenoptera*

Ichneumon: Order *Hymenoptera*

Bees, Wasps, Ants, and their Kin: Order *Hymenoptera*

This huge order, with over 120,000 known species, is one of the most diverse in the insect world. Its members range from minute fairy flies, no more than 0.2 mm/0.01 in. long, that grow up inside the eggs of other insects, to scary-looking wasps and sawflies over 5 cm/2 in. long. Their habits are equally varied, with herbivores, carnivores, parasites, and gall-causers all represented. The order also contains a wide array of social insects, including all the ants and numerous bees and wasps. There usually are four membranous wings, although worker ants are always wingless, but the hind wings are very small and often hard to see. Relatively few veins mean that the cells are quite large. Apart from the sawflies, the insects all possess a narrow 'waist' in the middle of the body. They have biting jaws, often used for nest-building as well as for feeding, although bees also have tubular 'tongues' for sucking up nectar. Many bees, wasps, and ants have stings for defence or for paralysing their prey (see p. 54).

17

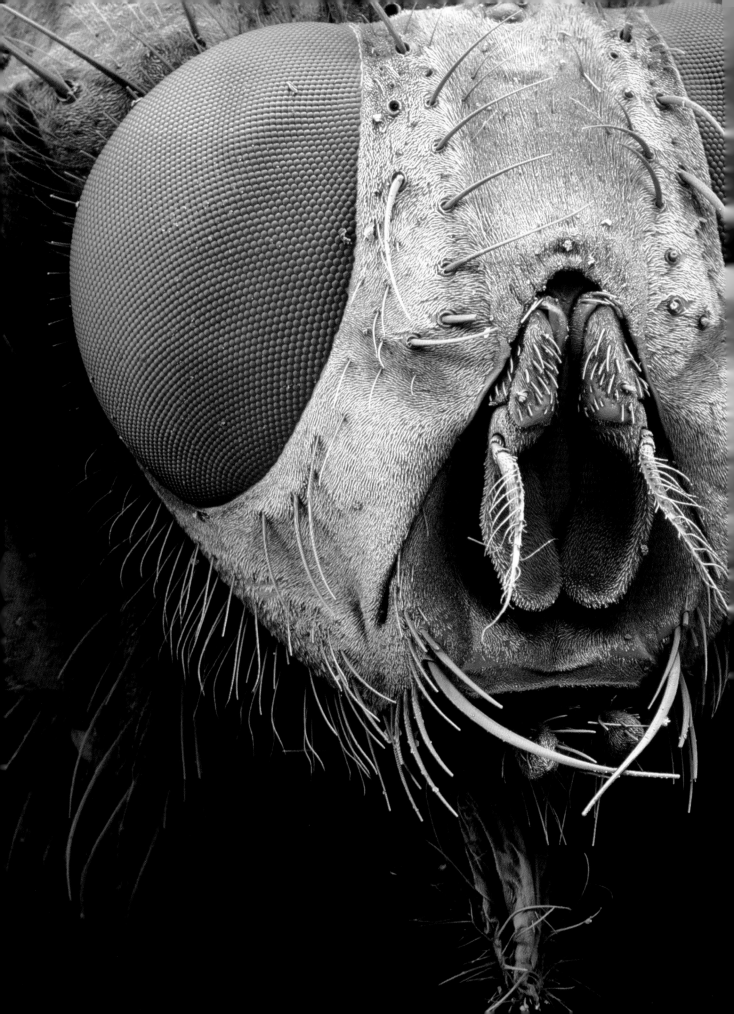

Up Close and Personal

Looking at even the plainest of insects through a microscope can open up a whole new world of fascinating patterns and structures. A butterfly's wing, for example, looks quite flat to the naked eye, but when viewed through even a low-power microscope it reveals an intricate and often very colourful pattern of overlapping scales. At higher magnifications, the individual scales can be seen to have elaborately sculptured surfaces. Every part of the insect body has secrets to reveal, and some real surprises as well. Many things that we assume were invented by the human race were, in fact, being used by insects long before we came on the scene. Various resting moths and sawflies, for example, hold their wings in place with Velcro-like pads, and many other insects use miniature suction pads to enable them to grip smooth leaves and other shiny surfaces — including our window panes.

Many of the pictures on the following pages have been taken with a scanning electron microscope (SEM), which uses electrons instead of beams of light to look at an object. These microscopes can produce magnifications of more than x 200,000 and can show us the most amazing details of insect anatomy.

An electron gun produces a stream of electrons which are then condensed into a narrow beam by a series of magnetic 'lenses'. The beam then scans the sample, and as it moves across the surface some of the electrons bounce off. Other electrons are 'knocked' from the surface, and both sets are collected and counted electronically, the final image being built up from the number of electrons coming from each tiny section of the sample. Because the SEM works with a much greater depth of field than a light microscope, we end up with an incredibly detailed and realistic three − dimensional image of the surface of the sample.

Electrons are incredibly small particles and are readily knocked off course by molecules of air, so the scanning operations all have to take place in a vacuum. This means that living insects cannot be examined with the SEM. Careful drying of the specimens is essential to ensure that they do not shrivel and provide false information to the electron beam. The images initially produced by the SEM are monochrome, but any colour can be added later by computer.

We don't know the function of all of the elaborate structures revealed by high-power microscopes, but we can't help marvelling at the intricacy of the insect body − and that is just from the outside. Internally, there is undoubtedly even greater complexity.

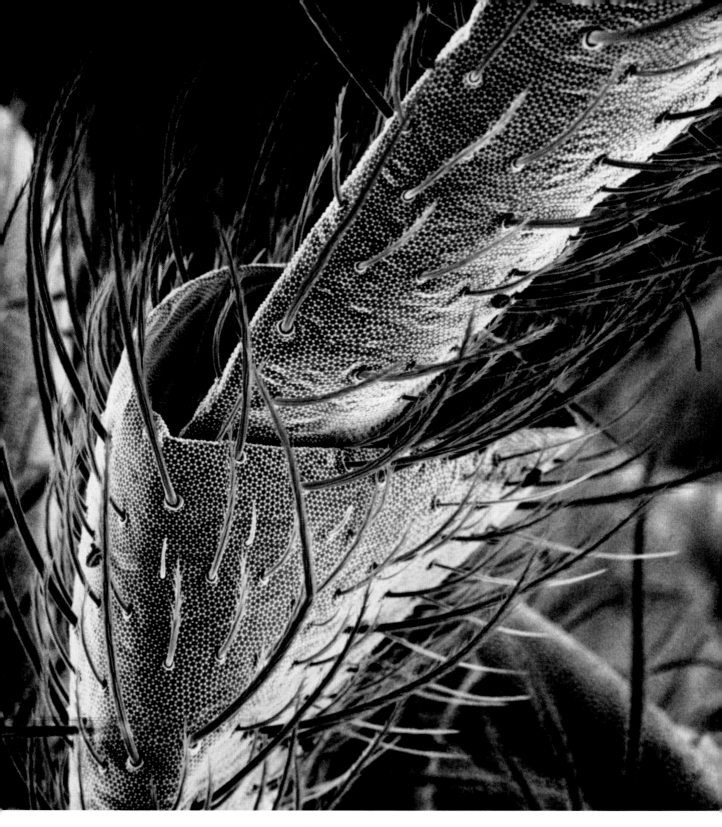

Astonishing Detail

THE ANTENNA OF A SPRINGTAIL, photographed with the scanning electron microscope at a magnification of about x 2000, clearly shows the tiny hairs around one of the joints. These hairs pick up a variety of chemical and tactile signals. The photograph also reveals an astonishingly detailed surface texture, the function of which can still only be guessed at. Springtails are wingless creatures, once considered to be primitive insects although most entomologists now regard them as a separate group of arthropods.

Three-Dimensional Image

THE FRONT END OF A YOUNG SILKWORM *(Bombyx mori)*, seen from below at a magnification of about x 50, shows the amazing three-dimensional imagery produced by the scanning electron microscope. The dark structures in the middle of the head are the jaws, and outside them are the tiny antennae, each nestling in a little pit. On each side of the head there is a cluster of simple eyes known as stemmata. Two pairs of legs can be seen just below the head. The bristles clothing the head and body are sensitive to touch and, among other things, they inform the caterpillar of the relative positions of its limbs and body segments.

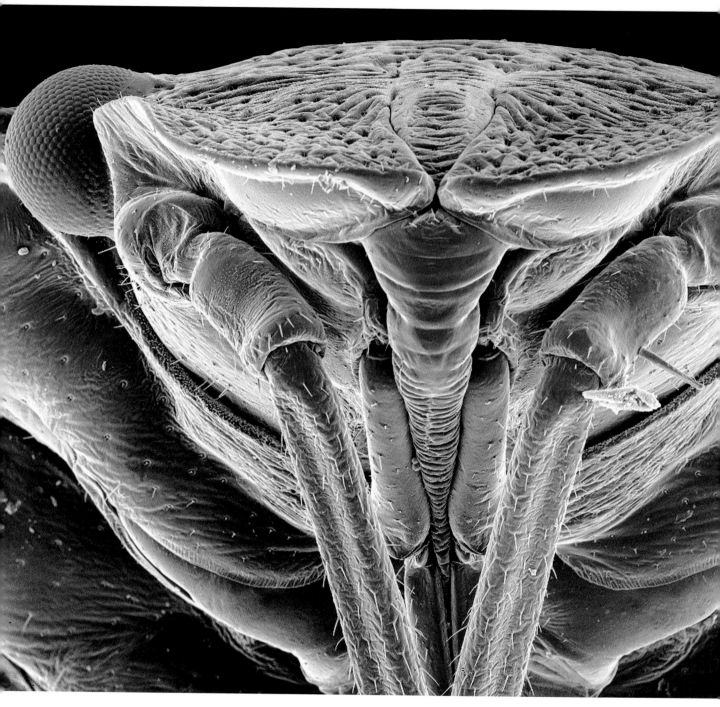

Sap Sucker

THE HEAD OF A GREEN SHIELD BUG *(Palomena prasina)*, magnified about 200 times, shows the large compound eyes, made up of hundreds of tiny lenses. Right in the centre of the picture is the piercing beak in its resting position, folded back under the head. When about to feed, the beak swings forward and the sheath is drawn back to expose the sharp 'hypodermic needle', which is then plunged into various plants to withdraw the sap. Shield bugs are also called stink bugs because they discharge foul-smelling fluids when disturbed.

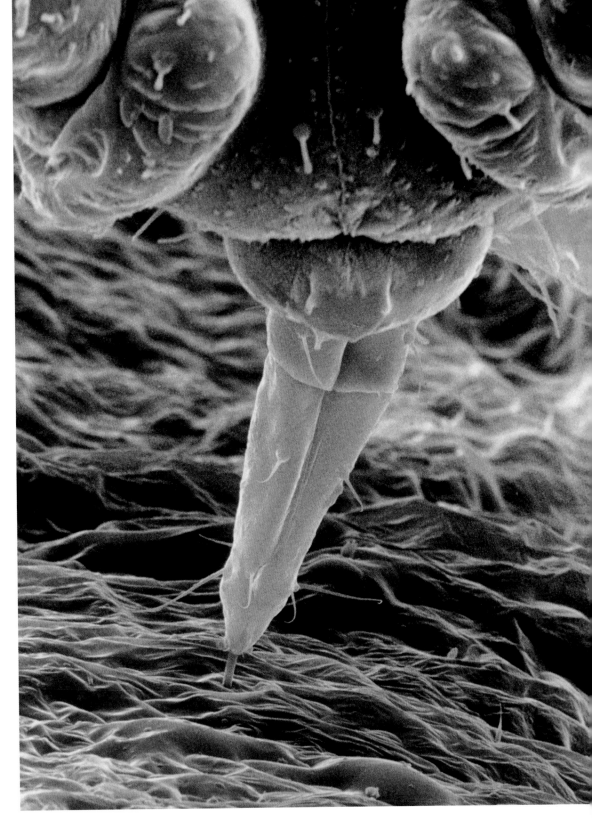

Aphid Attack

AN APHID PLUNGES ITS TINY, NEEDLE-LIKE BEAK into a leaf. In this very highly magnified picture the 'needle' can just be seen protruding from the lower end of its sheath. Each aphid takes only a small amount of sap and small numbers of aphids may not harm the plants, but while sucking the sugar-rich sap from the cells they may pass on viruses which can cause severe damage.

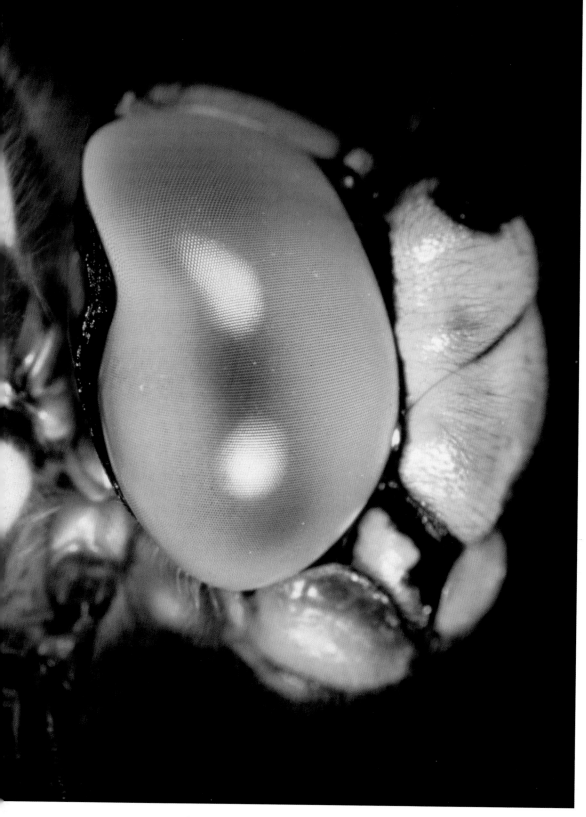

Big-Eyed Hunter...

DRAGONFLIES HUNT ON THE WING and need terrific eyesight to detect and home in on mosquitoes and other small prey. They also use their eyes to find mates. Their eyes take up nearly all of the head, giving the insects all-round vision. Each eye may consist of as many as 30,000 tiny lenses. Each lens forms its own image and sends it to the brain, so the insect actually sees a mosaic of thousands of tiny images. Dragonflies rely almost entirely on sight and their antennae are no more than tiny bristles sticking out in front of the eyes.

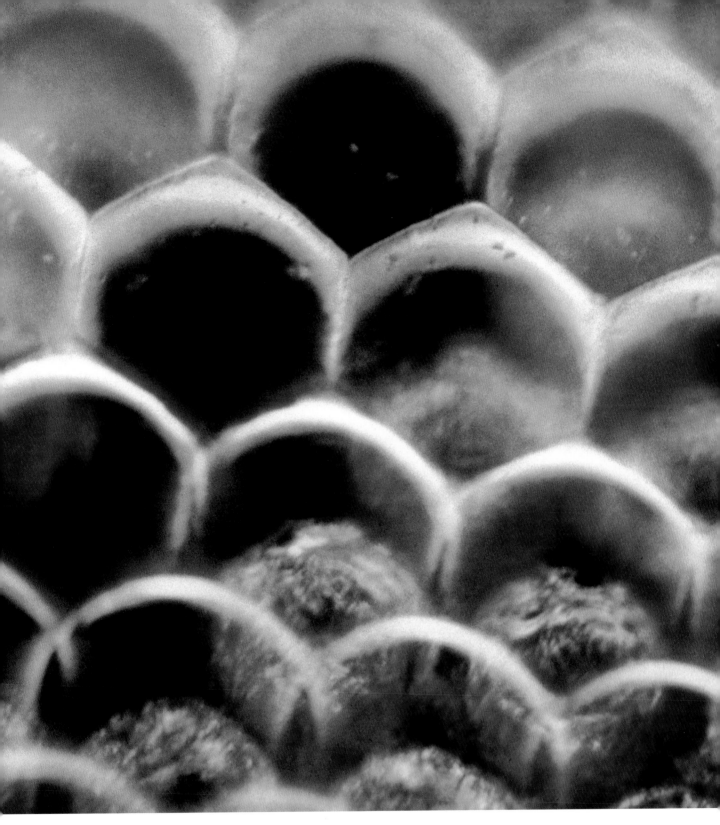

...has Thousands of Lenses

THIS HIGHLY MAGNIFIED VIEW OF PART OF A DRAGONFLY'S EYE shows just a few of its thousands of tiny lenses, each capable of forming its own tiny image. This system does not produce a very clear picture but it is very good at picking up movement – because an object, such as a fly, moving across the field of vision affects a lot of different lenses in quick succession.

Four Eyes are better than Two (Right)

THE WHIRLIGIG BEETLE (Gyrinus natator) spends much of its life skimming round and round on the surface of still or slow-moving water, propelled by its paddle-like legs. It feeds both on and under the surface and its eyes are uniquely adapted for this dual role: each eye is split into two halves, one looking across the surface and the other peering down into the water. Mosquito larvae, spotted with the submerged lenses, are the most common prey, but whirligigs also catch small insects that fall on to the surface. Victims are grabbed by the relatively long front legs and chopped up by the jaws, which can be seen in the centre of the photograph.

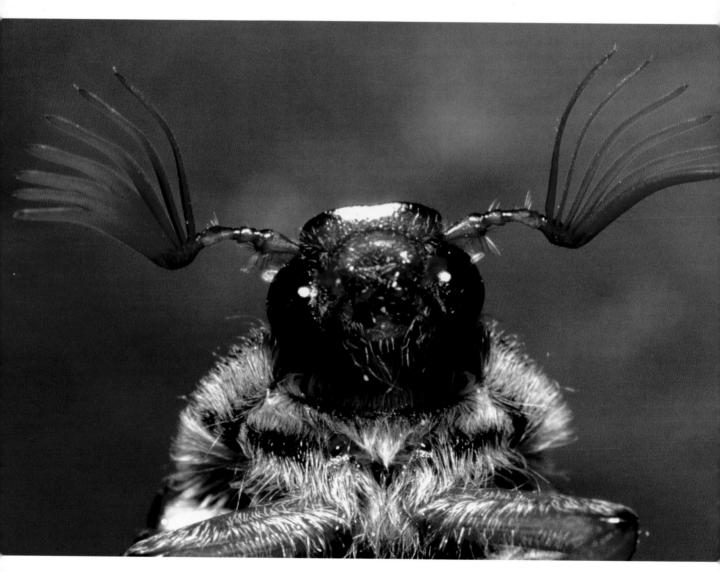

Message Received

THE MALE COCKCHAFER (Melolontha melolontha) has enormous antennae, each consisting of seven flaps that can be opened out like a fan. Each flap is densely clothed with sensory cells that are receptive to the scent of the female beetles, and by opening the flaps the male exposes the maximum surface to the air and increases its chances of picking up the scent. When the beetle is not searching for a mate, the antennal flaps are closed up and then look like a club. Female beetles have smaller antennae with only six flaps.

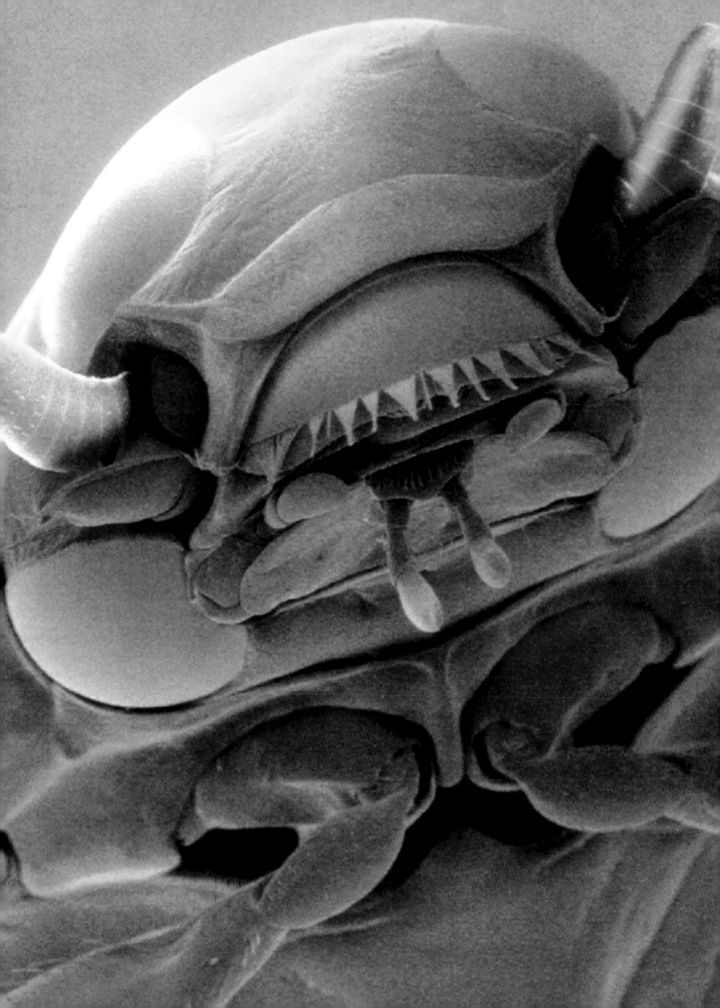

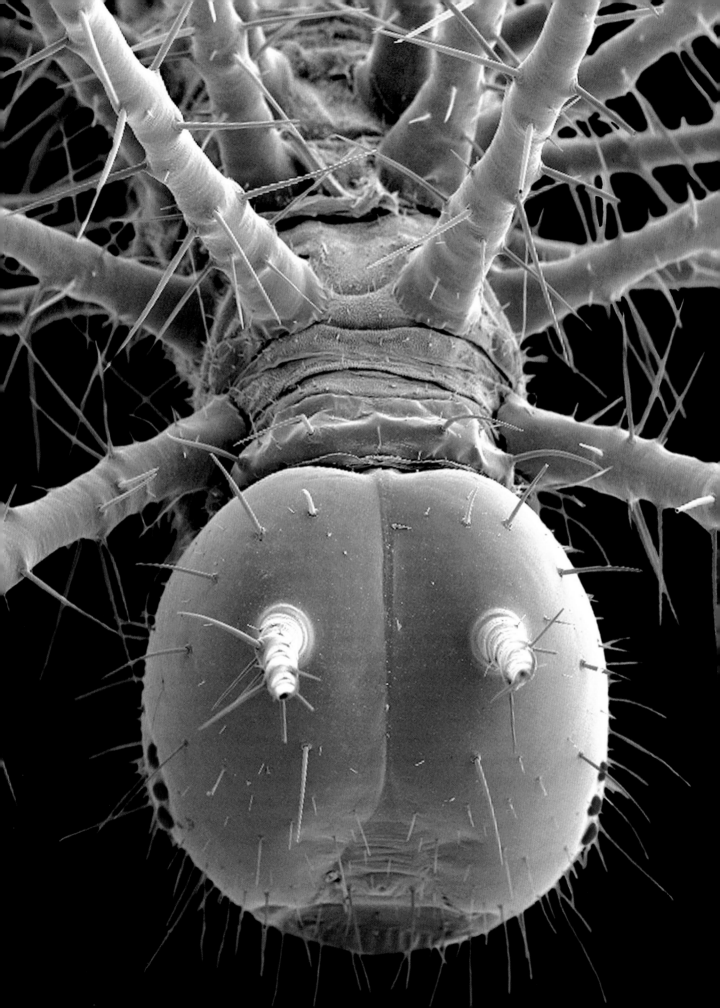

More Bristle than Body (Left)

THIS NEWLY-HATCHED CATERPILLAR appears to be all spines and bristles, but not without good reason: ichneumons and other parasites are always eager to lay their eggs in young caterpillars (see p. 137) (see p. 137) and a spiny coat is a good defence against them because it prevents them from reaching the soft body. The caterpillar's tiny antennae are clearly seen on the front of the head.

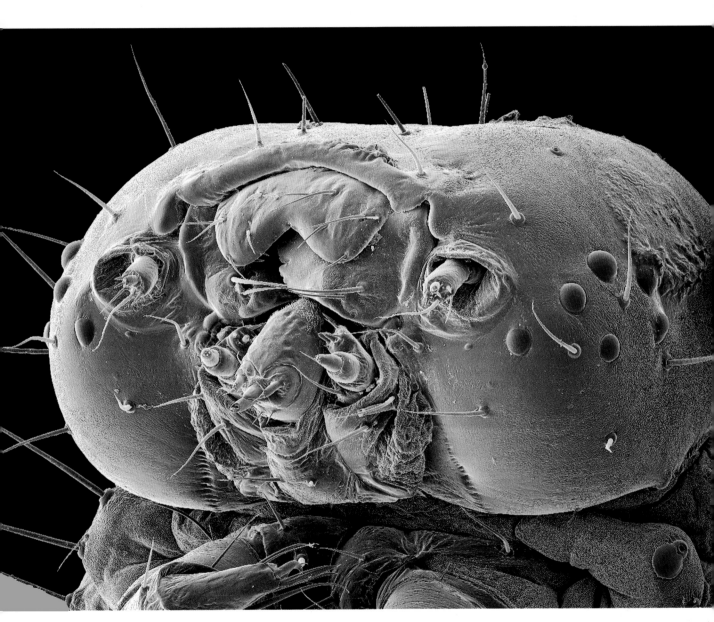

Simple Eyes

CATERPILLARS DO NOT HAVE COMPOUND EYES made up of numerous lenses like those of adult insects. They have an arc or a ring of simple eyes on each side of the head. Coloured pink in this highly magnified photograph, they are called stemmata and they probably do no more than detect light and darkness. In the centre of the head, just below the mouth, are the sensory palps, which help the caterpillar to find the right food.

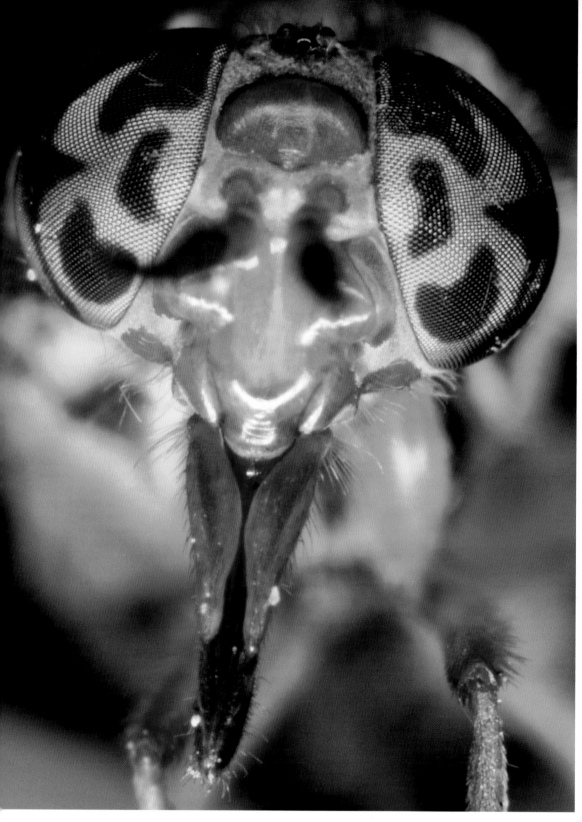

Colourful Eyes

BEAUTIFULLY COLOURED EYES ARE A FEATURE OF MANY HORSE-FLIES. Some species have coloured stripes and some, including this *Chrysops vittatus*, have coloured spots, but the patterns always disappear when the insect dies. As well as the colourful eyes, this photograph shows the triangle of simple eyes, called ocelli, on the top of the head, and the fearsome beak typical of female horse-flies. The females feed on blood, including human blood when they have the chance, using their blade-like beaks to cut the skin and then lapping up the blood oozing from the wound. Male horse-flies prefer nectar.

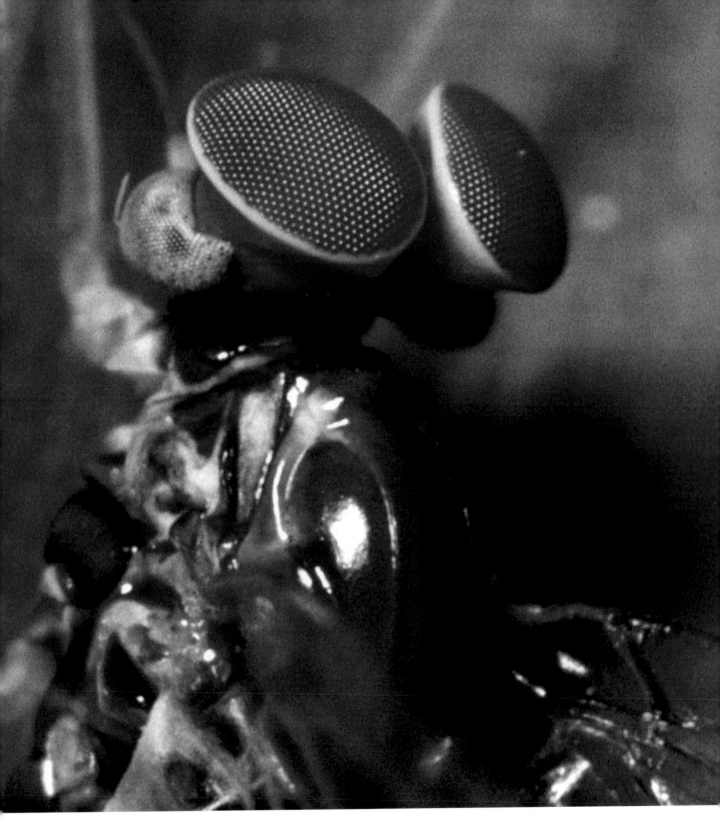

All the Better to See You With

THE EYES OF MALE MAYFLIES are larger than those of the females, and in some species, including *Centroptilum luteolum* pictured here, each eye is divided into two parts, with the upper part raised on a conspicuous turret. The lenses in this raised area are larger than the rest and they look upwards, enabling the male to home in accurately on a female flying above him. He always approaches her from below and grabs her with his long front legs.

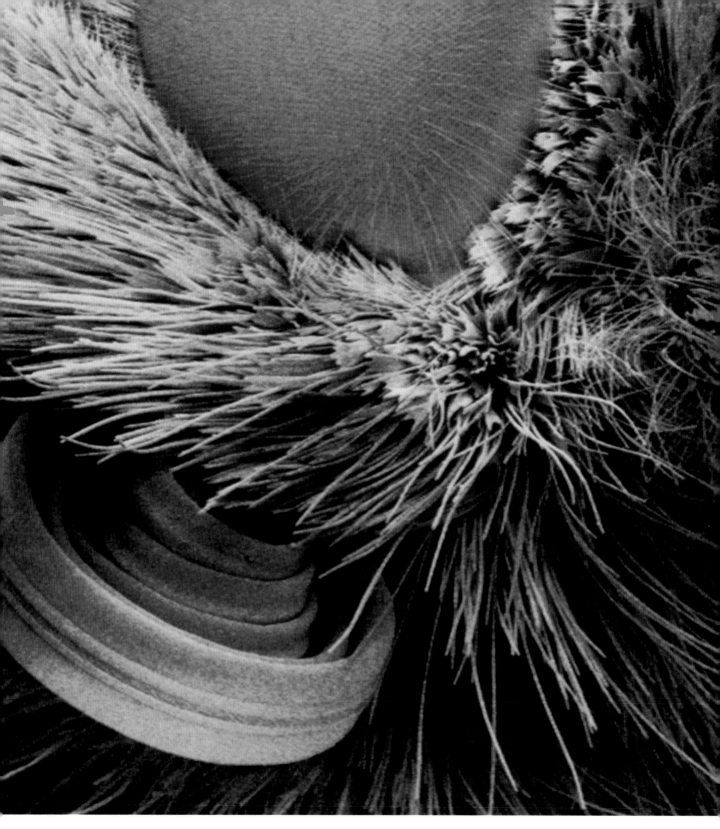

Rolling the Tongue

THE TONGUES OF BUTTERFLIES AND MOTHS are tightly coiled under the head and more or less hidden between the hairy palps when not in use. When the insect is about to feed, the hollow tongue, technically known as the proboscis, is extended mainly by a combination of muscular action and blood pressure. Nectar is the usual food and it is pumped through the proboscis by muscles inside the mouth. After use, the proboscis is rolled up by muscular action and its own elasticity (see page 127).

33

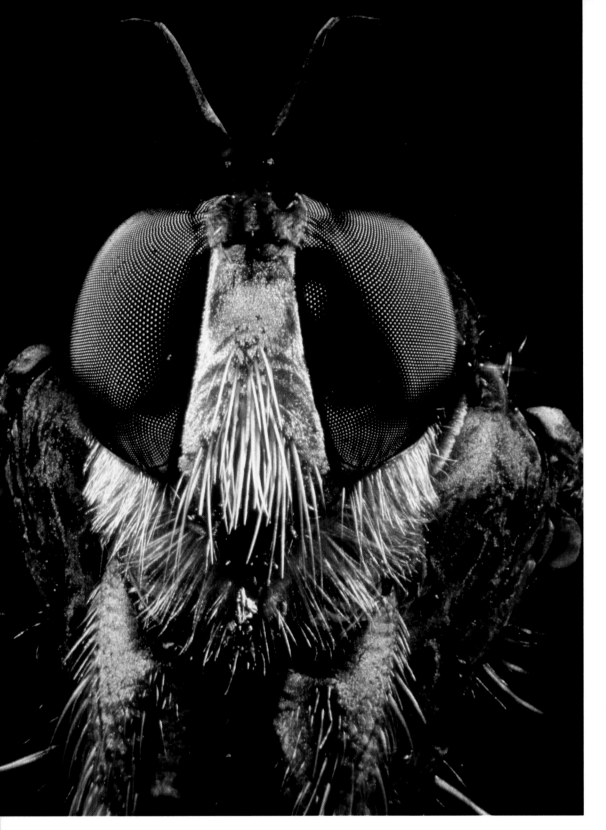

Protective Beards

ROBBER-FLIES OF THE FAMILY *ASILIDAE* feed on other insects, most of which are caught in mid-air. The stout beak then pierces the prey and sucks it dry. Good eye-sight is obviously essential for spotting and catching the prey and the robber-fly must protect its huge eyes from the struggling victim impaled on its beak. This is the function of the forest of bristly hairs covering much of its face.

Only for Drinking

THE HOUSE-FLY *(MUSCA DOMESTICA)* CANNOT TAKE IN SOLID FOOD. It has no jaws and its mouth-parts are in the form of a sponge, seen on the left of the photograph, that can only soak up liquids. But the fly can deal with solid food by dribbling saliva on it. The saliva dissolves various foods and the fly then sucks up the solution (see page 115).

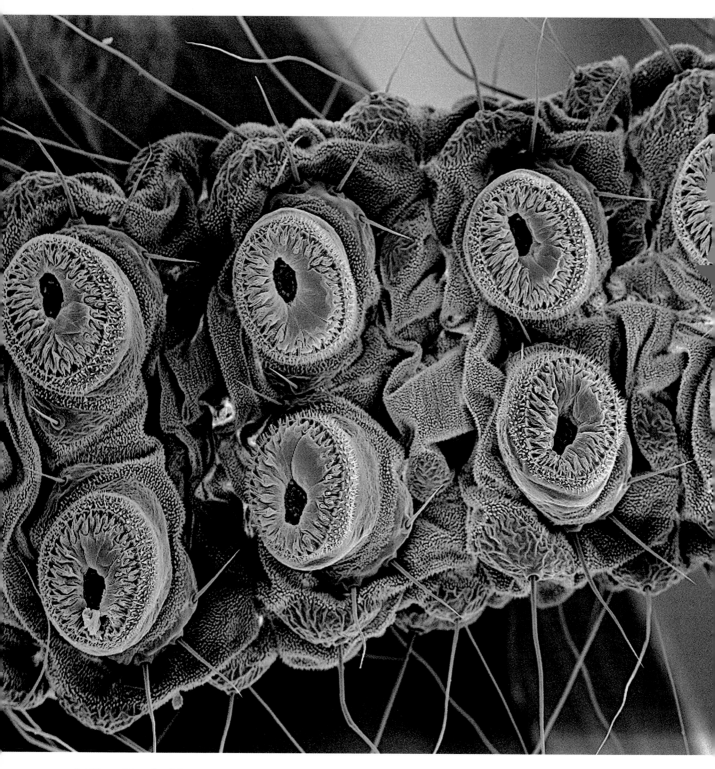

A Firm Foothold

CATERPILLARS GENERALLY HAVE UP TO FIVE PAIRS OF FLESHY LEGS AT THE REAR in addition to three pairs of slender legs at the front. The fleshy legs are properly known as prolegs and they do most of the walking (see p. 69) as well as holding firmly on to the twigs or leaves. They do this by means of thousands of tiny hooks on the 'soles' of the feet, seen here at a high magnification.

Muscle Power

THE HOOKS ON A CATERPILLAR'S FOOT are worked by powerful muscles inside the leg. When the muscles tighten, the hooks, technically known as crochets, dig into the twigs or leaves and it is then very difficult to pull the caterpillar off without damaging it.

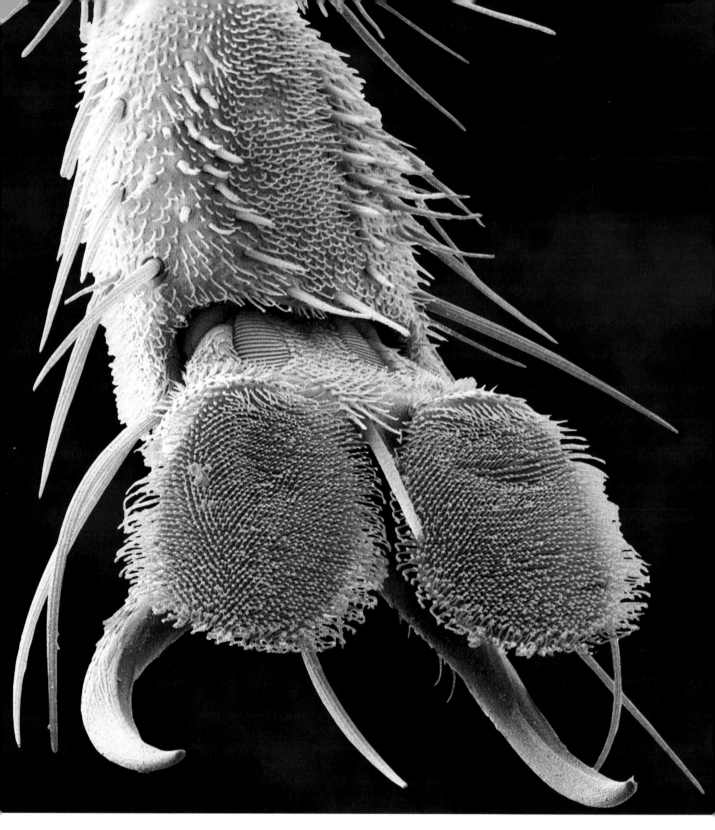

Walking on Windows

FLIES CAN WALK UP AND DOWN WINDOW PANES and other smooth surfaces with the aid of little pads called pulvilli, of which there are two or three on each foot. The undersides of these pads are clothed with thousands of minute tubular hairs (seen here at high magnification) that together provide sufficient adhesion to hold the fly on a vertical window pane. The claws surrounding the pads are used when walking on rough surfaces.

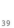

Adhesion Power

THE THOUSANDS OF MINUTE TUBES on a fly's foot were once thought to provide grip through suction, but it is now known that they work by adhesion. The tubes have very smooth, flat ends that can be pressed firmly against glass and other smooth surfaces. Tiny drops of oily fluid oozing from the tubes bond them to the glass by molecular attraction, and with perhaps 50,000 tubes on one pad the adhesive forces are more than enough to hold the fly on to the glass. By altering the angles of its foot pads, the fly can break the seal and move its feet up the window pane.

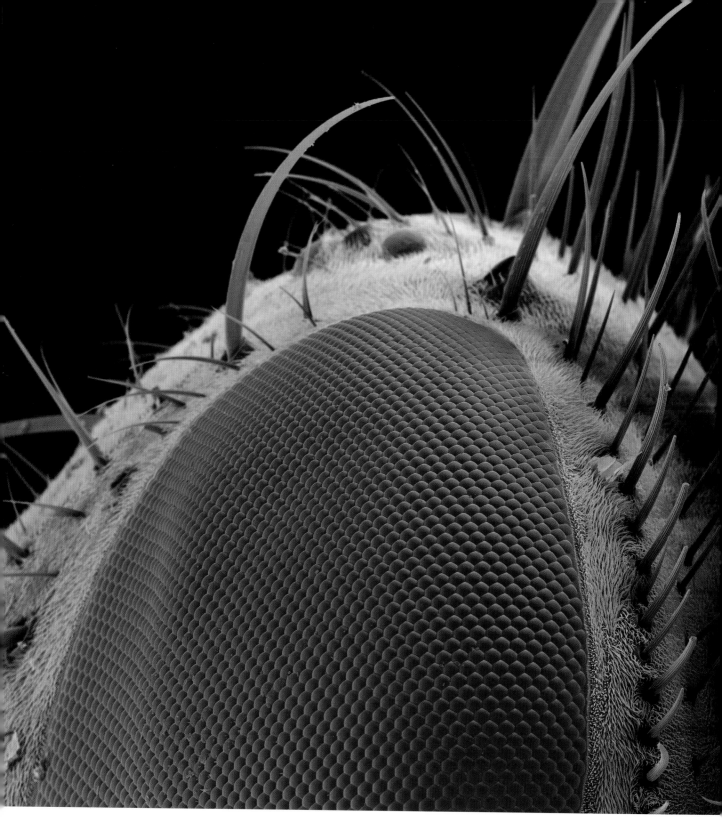

Ever Aware

A HOUSE-FLY'S EYE is not as large as that of a dragonfly, but it still contains several thousand tiny lenses. These can see in nearly all directions, so the fly is always aware of approaching danger. The bristles clothing its head and body also warn the fly when anything large approaches it because they are sensitive to any disturbance in the air – which is why it is so difficult to swat a fly!

Measuring Up

STALK-EYED-FLIES of the genus *Diopsis* live mainly on tropical areas, where they feed on decaying vegetation. Each fly adopts a small feeding patch and if another fly tries to take it over the two insects square up to each other and compare eye-spans. The one with the smaller span usually gives way. The eye-stalks are not visible in the pupal stage, but gradually unroll after the fly leaves the pupal case and before its skin hardens.

Golden-Eye (Right)

THE HEAD OF A GREEN LACEWING *(Chrysoperla carnea)* shows its bulging compound eyes, artificially coloured orange here although in life they often have a golden or brassy sheen. Green lacewings, of which there are numerous species, are often called golden-eyes. The insects feed largely on aphids and are welcome in the garden.

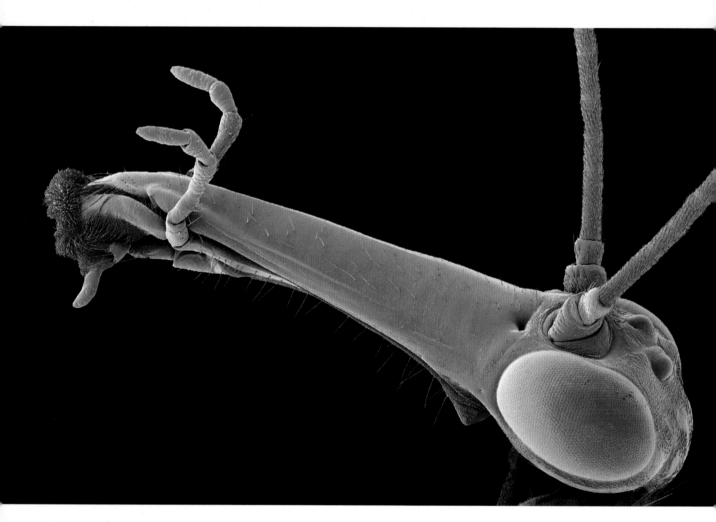

A Beaky Scavenger

SCORPION FLIES, BELONGING TO THE ORDER *MECOPTERA*, all have a long snout or beak with the jaws right at the end. This feature may be linked to the insects' diet: it certainly keeps the eyes and antennae away from the carrion and rotting fruit that forms a large proportion of the scorpion flies' food (see p. 134). The curved structures close to the tip of the snout are the palps, which play a major role in tasting food and assessing its palatability.

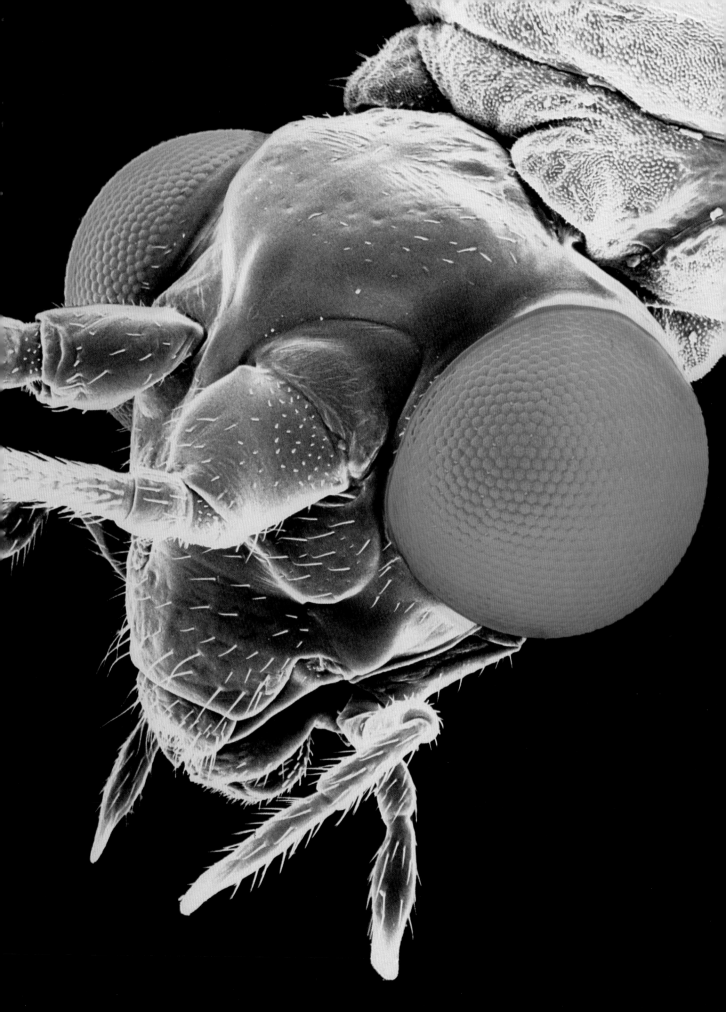

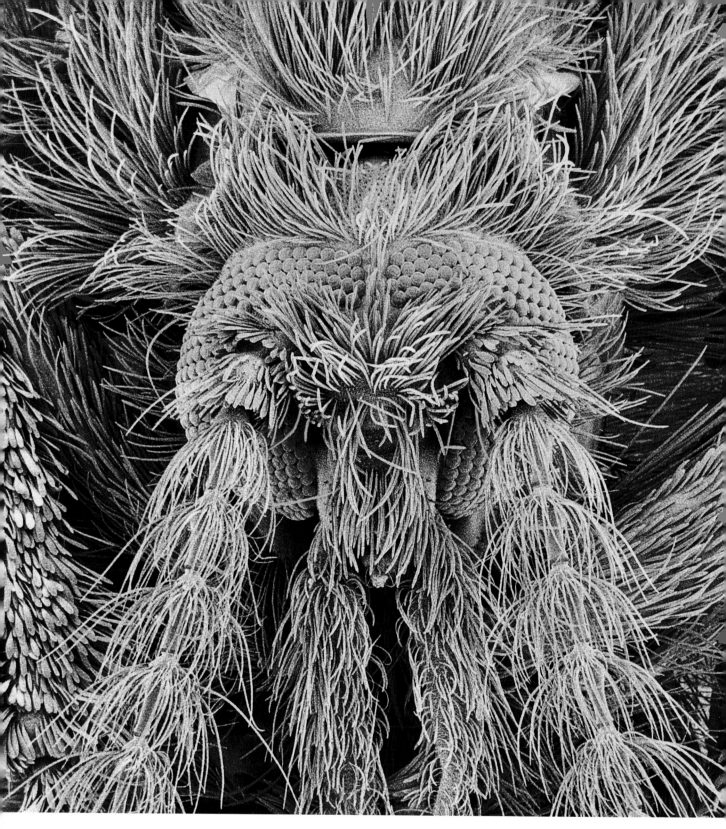

Hairy Midget

THE HEAD OF A MOTH-FLY *(Psychoda species)*, like the rest of its body, is densely clothed with hair. Even its wings are hairy. The small eyes have relatively few lenses and the insect relies more on scent than on sight. Its antennae, springing from near the centre of each eye, carry whorls of sensitive hairs than pick up scents and vibrations. Also known as owl midges, moth-flies breed in decaying matter, usually in water, and are extremely common around sewage works.

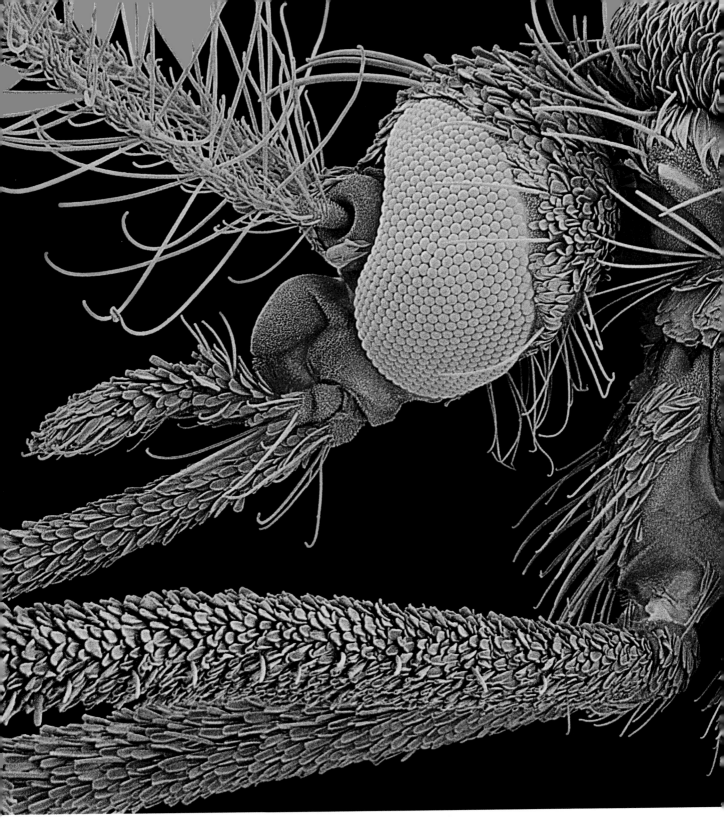

Scaley Suckers

MOSQUITOES ARE CLOTHED WITH SCALES, clearly seen here behind the eyes, on the legs at the bottom of the picture, and on the proboscis sheath emerging from the bottom of the head. This is a female mosquito and her antennae, at the top of the picture, are much less hairy than those of the male (see p. 46). Only female mosquitoes are blood-suckers.

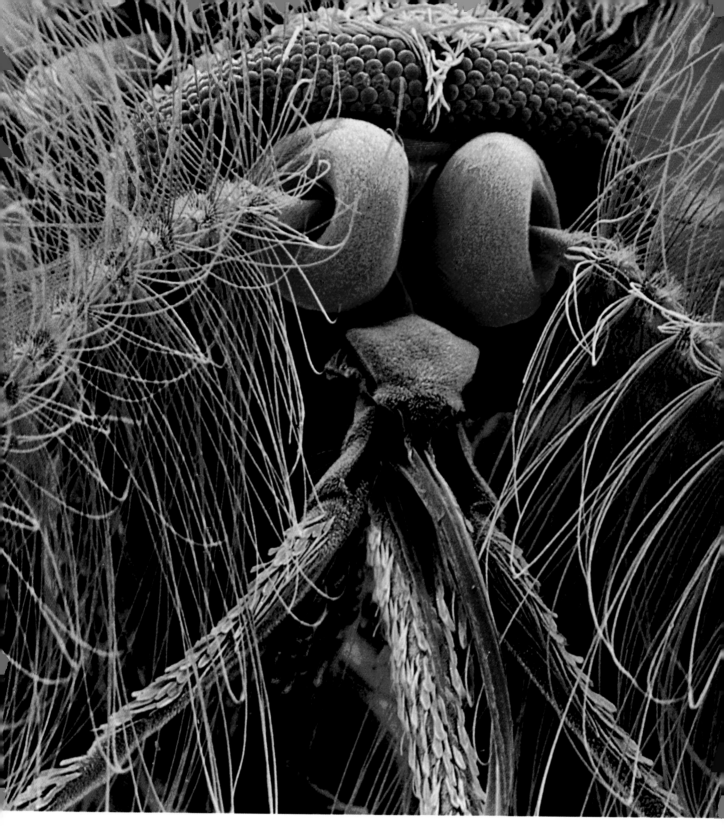

Hairy Aerials

THIS HEAD-ON VIEW OF A MALE MOSQUITO shows the antennae emerging from their cup-like bases just below the eyes. The antennae bear dense whorls of hair that are sensitive to vibrations in the air and they detect the sounds made by the wing-beats of the females. The pink tube running down the centre is the proboscis, partly out of its sheath and flanked by the palps. Male mosquitoes feed mainly on nectar and do not suck blood.

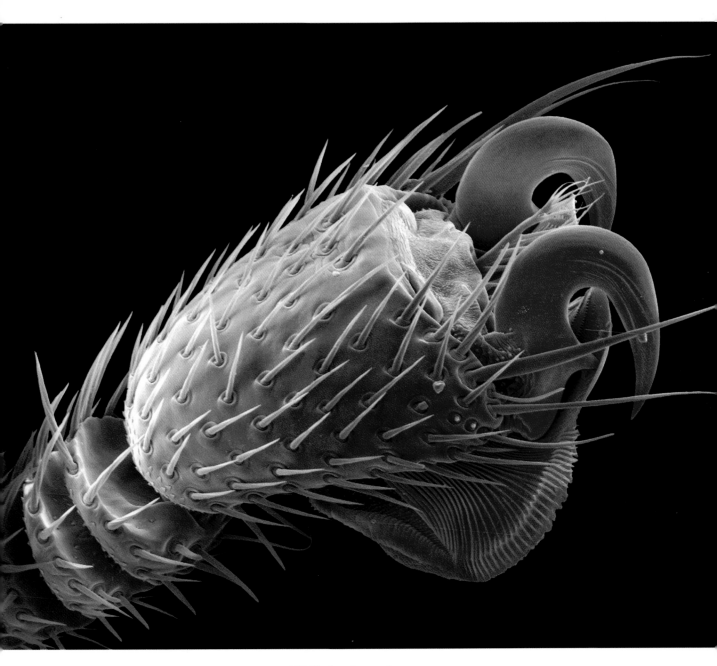

Well Anchored

THE FOOT OF A BAT-FLY, belonging to the family *Streblidae*, shows the strong claws typical of external parasites. Bat-flies occur mainly in the tropics, living in the fur of bats and feeding entirely on their blood. The insects need to cling on tightly and the claws of many such parasites are exactly the right size and shape to anchor themselves to their hosts' hair.

47

Hooked Up

AMONG THE BEES AND WASPS and other members of the *Hymenoptera*, the hindwings are often so small and delicate that the insects look as though they have only one pair of wings. Each hindwing is linked to the forewing by a row of minute hooks called hamuli. They sit near the middle of the front edge of the hindwing and loop over the trailing edge of the forewing. This photograph was taken with a scanning electron microscope and is highly magnified, but you can see the hooks quite easily in bumble bees and other large species with the aid of a good lens.

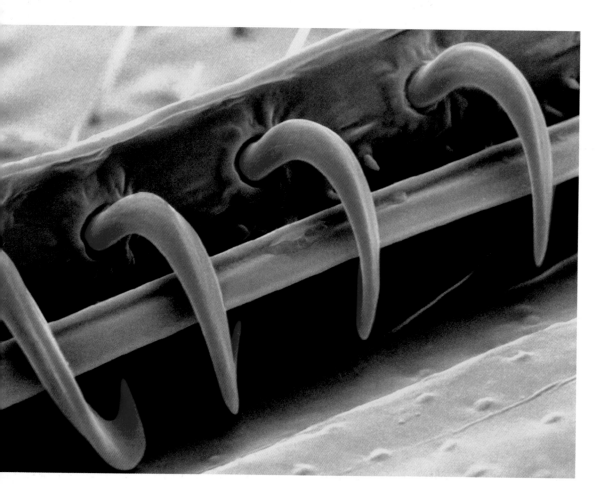

48

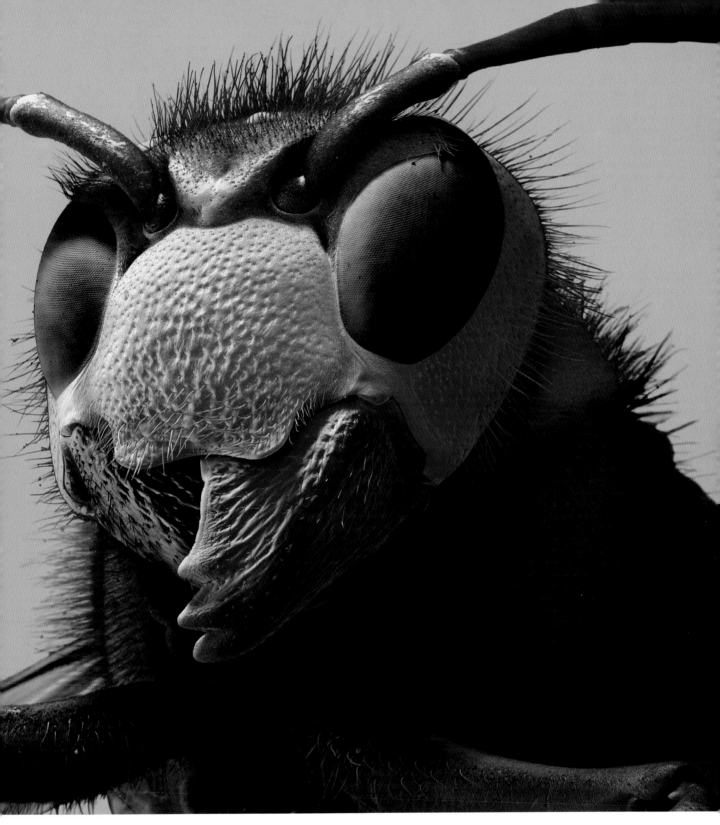

Horny Jaws

THE HIGHLY-MAGNIFIED HEAD OF A HORNET *(Vespa crabro)* shows its powerful jaws which, like the rest of the insect's outer coat, are made of a tough, horny material called chitin. The toothy jaws, technically known as mandibles, chew up prey and are also used to gather and chew the wood needed for making the nest (see p. 270).

(see p. 270)

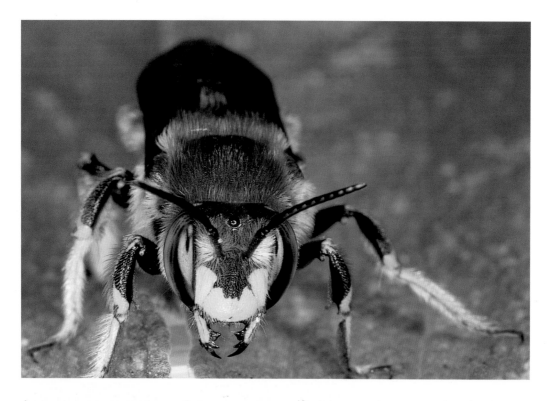

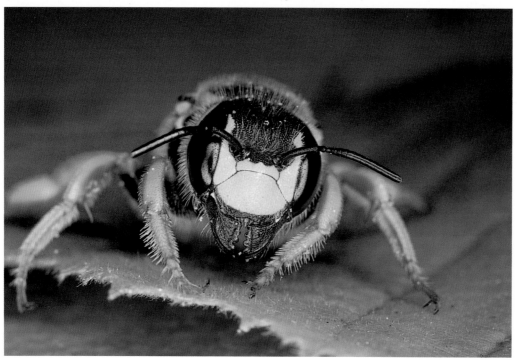

Multi-purpose Mouth-parts

BEES HAVE COMPLICATED MOUTH-PARTS because, as well as having nectar-sucking tongues, they have retained their biting jaws for manipulating pollen and building materials. The detailed shape of the jaws varies according to the materials that it uses. The European wool-carder bee *(Anthidium manicatum)* (top) uses its toothy jaws to mow soft fibres from leaves and then comb them into sheets to line the cells of the nest. *Anthidium interruptum* (bottom) lines its nest with resin, collected from pine trees and moulded into shape with relatively blunt teeth.

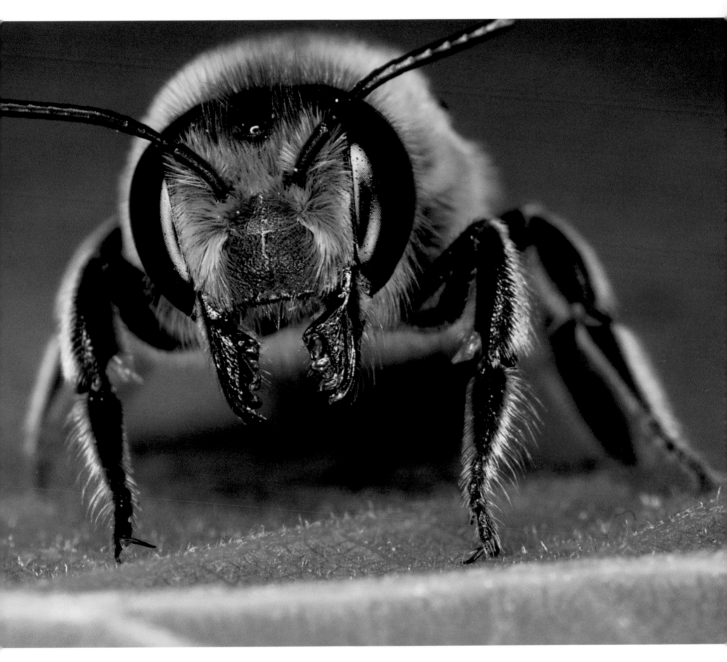

Carving Leaves

THE JAWS OF THE LEAF CUTTER BEE *(Megachile centuncularis)* work like a pair of scissors to cut
sections from leaves. The sections are used to line the bee's nest (see p. 261).

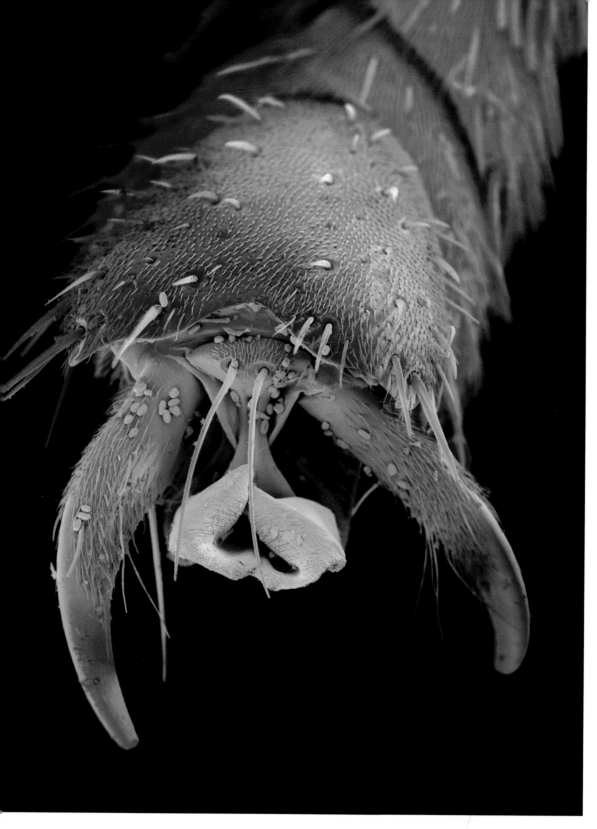

Jointed Feet

THE FOOT OF A HORNET *(Vespa crabro)*, like that of any other insect, is made up of several segments, reflecting the fact that they all belong to the large group of animals called arthropods, meaning 'jointed feet'. The three terminal segments are visible here, with the final one bearing two claws and the soft pads that help the insect to grip smooth surfaces. The green dots are pollen grains picked up from a flower.

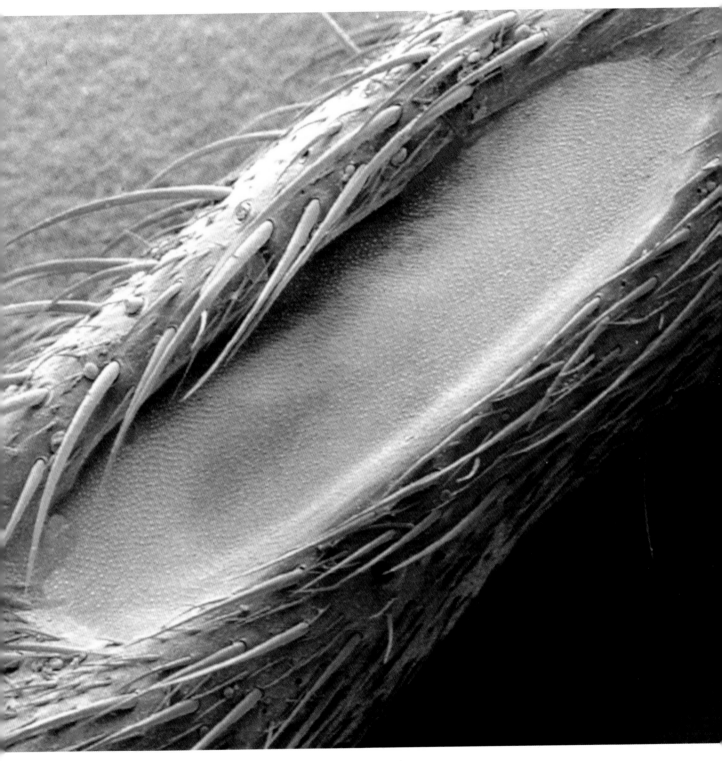

Unusual Ears

THE EAR OF THE HOUSE CRICKET *(Acheta domesticus)* is a patch of bare skin on its front leg! All crickets have their ears on their front legs and there is usually an ear-drum or tympanum on each side on the leg, just below the 'knee'. The eardrums vibrate when they pick up the sounds of the chirping males. Each species has its own 'song' and the females respond only to males of their own species. By turning their legs they can work out where the sound is coming from, and then move towards the singing males. When a male cricket picks up the song of another male it normally moves away.

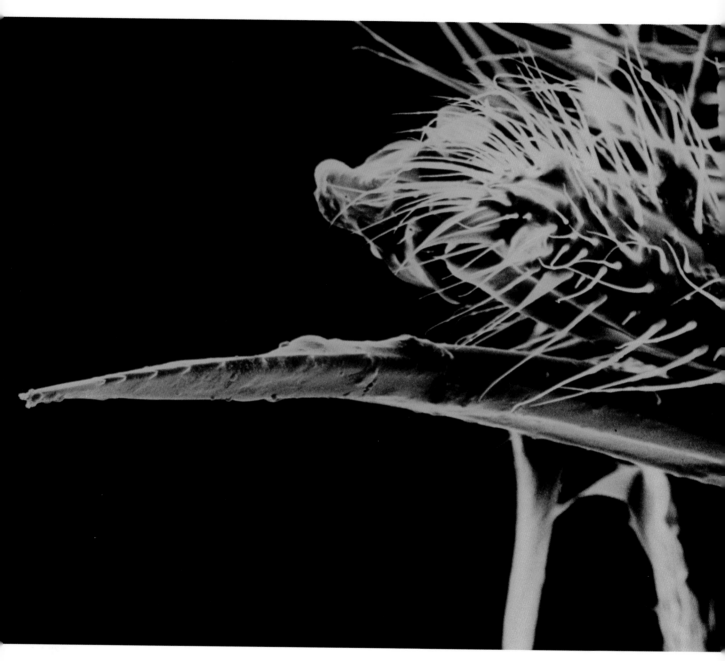

A Sting in the Tail

THE STING OF THE COMMON WASP *(Vespula vulgaris)*, as with all the social wasps, is used to defend the colony. The wasps stream out from their nests at the slightest disturbance and often attack anything in the flight-line near the nest. The sting, in the rear of the abdomen, consists of a reservoir of venom and three needles – two barbed lancets and a stylet – linked together to form a hollow tube. The stylet makes the initial wound, and the lancets, which slide on two 'rails' on the stylet, then move forward alternately to penetrate deeper. Muscles around the venom sac pump venom into the wound. The sting is derived from egg-laying apparatus, so only females – the queens and workers – have stings.

INSECTS

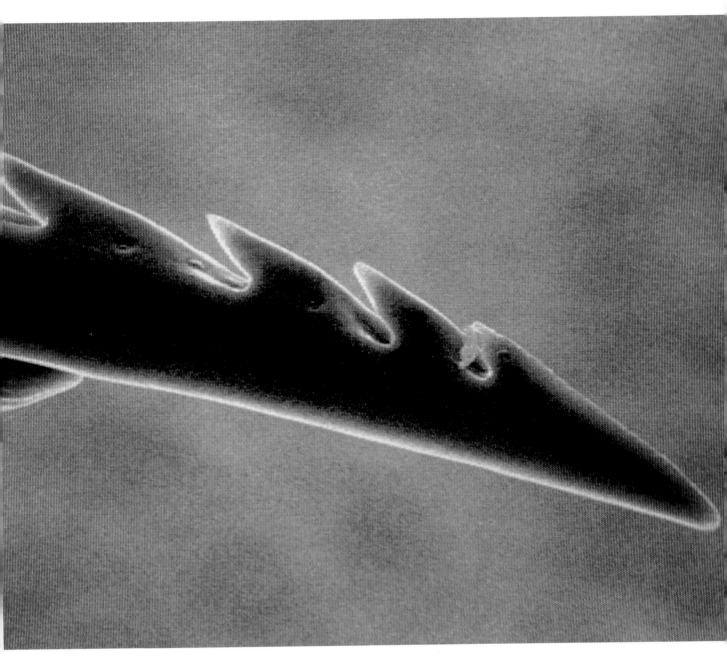

Suicide Stinger

THE STING OF THE WORKER HONEY BEE *(Apis mellifera)* resembles that of the common wasp but has much larger barbs and cannot be withdrawn from mammalian flesh. The bee can only escape after stinging someone by ripping herself away and leaving the sting behind. This kills the bee, but the sacrifice of a few individuals is not a high price to pay for the security of the colony as a whole. Muscles around the venom sac continue to pump venom into the wound even after the bee has gone, and the isolated sting continues to release alarm substances causing more workers to join the attack. The queen honey bee uses her sting only to kill rival queens in the hive.

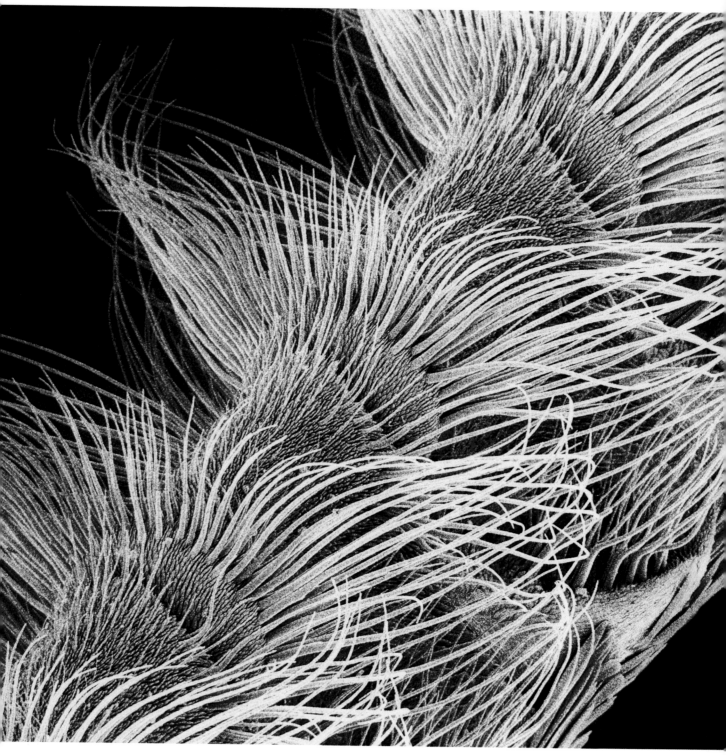

Hairy Feelers

MOTHS NAVIGATE LARGELY BY SIGHT, but most of them use their antennae for exploring their immediate surroundings. Hairy antennae, such as the one pictured here at high magnification, are particularly good at picking up scent because the hairs are covered with minute sense organs, each tuned to a particular scent, such as that of the female. The hairiest antennae usually belong to males. Antennae also pick up vibrations, and can be used to taste things and to assess textures – and for this reason they are commonly called feelers.

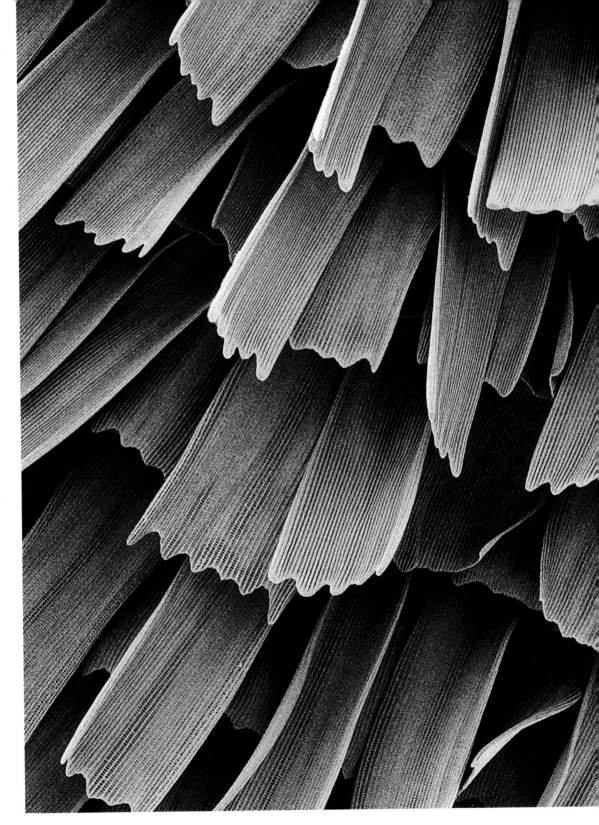

Colourful Scales

BUTTERFLY WINGS ARE CLOTHED WITH MINUTE SCALES, which are actually much-modified hairs. They overlap like tiles on a roof and give the insects much of their colour. They also help butterflies to raise their temperatures by absorbing the sun's warmth when they bask with their wings open. Many butterflies need a body temperature of about 30°C before they can take off. Dark colours absorb heat more efficiently than pale ones, hence mountain butterflies are usually darker than lowland ones. Moths also have scales and they belong with the butterflies in the order *Lepidoptera*, meaning 'scale-wings', although the scales occur all over the insects' bodies, not just the wings.

Colour from Pigments (Right)

REDS, BROWNS, BLACKS, AND YELLOWS are usually produced by pigments within the scales of the butterfly or moth wing. White wings or patches are usually produced by the scattering of light waves by the internal surface of non-pigmented scales.

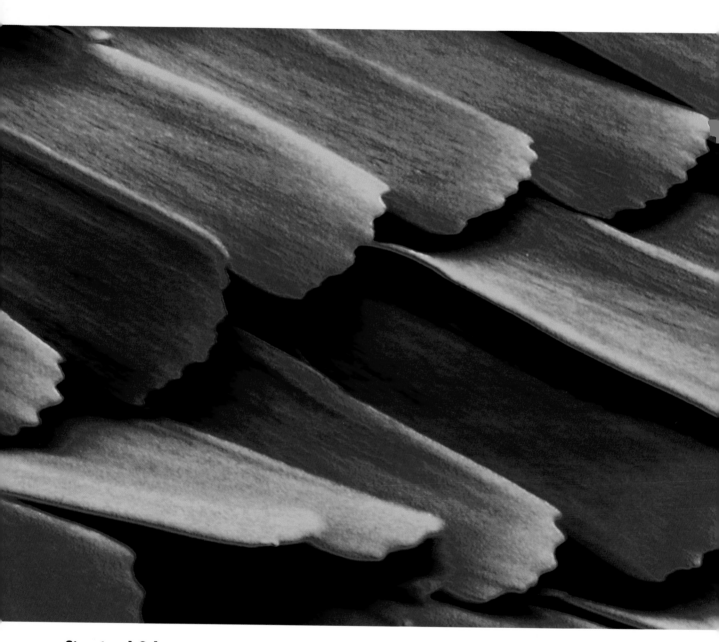

Structural Colours

SCALES FROM THE WING OF A MALE MORPHO BUTTERFLY show something of the brilliant iridescent colours exhibited by these tropical butterflies. These colours are due not to pigments, but to the existence of tightly packed ridges and grooves inside the scales or on the surface. Visible only with the electron microscope (see p. 19), the ridges all reflect light but, because they are so close to each other, the reflections interfere with each other and blot out some wavelengths, usually leaving just blue or purple to reach our eyes. The colours of many other blues and metallic-looking butterflies are produced in the same way.

58

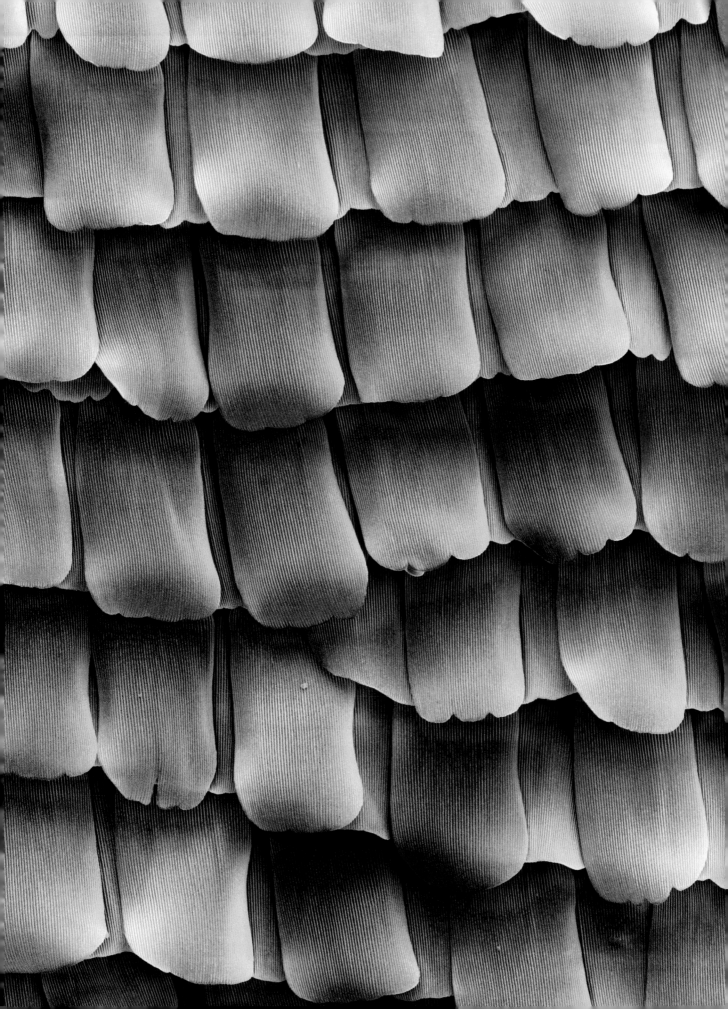

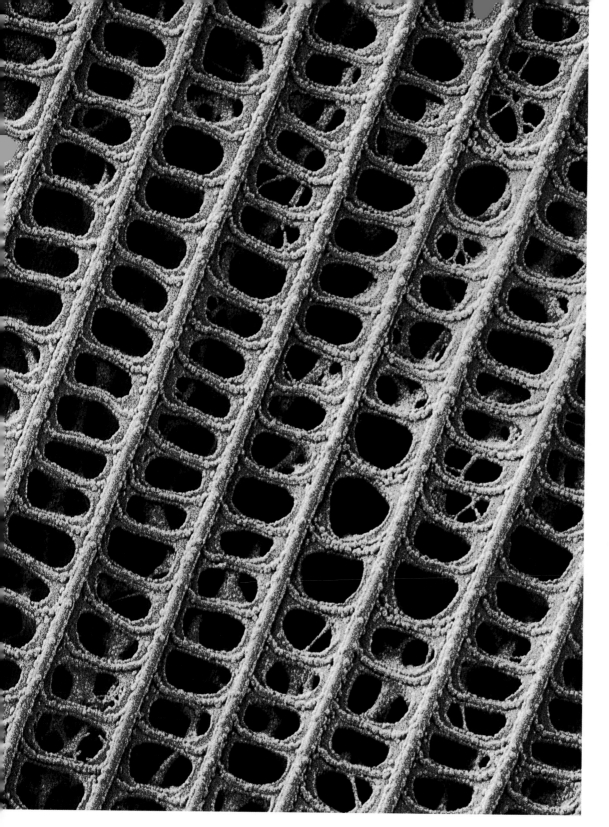

A Complex Surface

THIS VERY HIGHLY MAGNIFIED PICTURE OF A BUTTERFLY'S SCALE shows the complex arrangement of ridges, grooves, and other structures responsible for the iridescent colours, also known as interference colours (see p. 58). Because this picture was taken with the scanning electron microscope, there was no light to produce the colours.

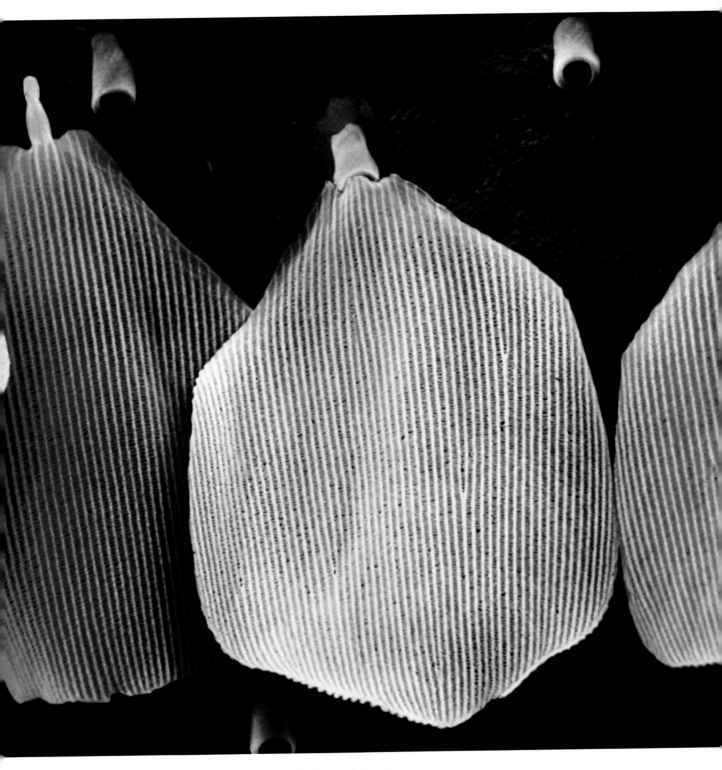

Coloured Dust

THE SCALES OF A BUTTERFLY OR MOTH WING each have a minute stalk that fits into a socket in the wing membrane. Many butterflies, especially the males, have special scales, called androconia, that disseminate mate-attracting scents. But the scales are not firmly anchored and, as anyone who has handled the insects will know, they are easily rubbed off, leaving a dusty deposit on one's fingers. Butterflies nearing the end of their lives often look very worn through the loss of scales.

61

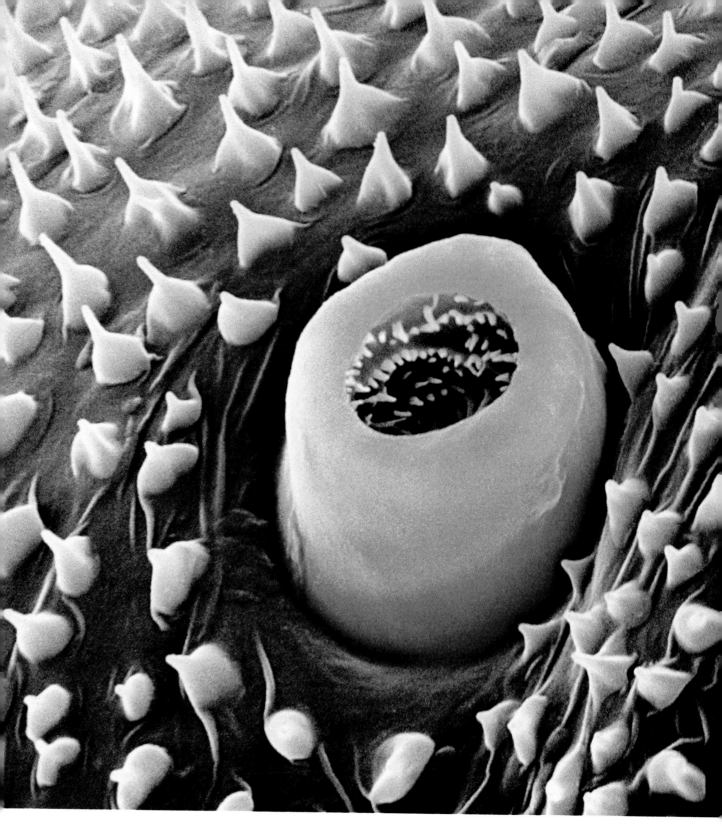

Breathe In ...

INSECTS DO NOT HAVE LUNGS: they breathe through tiny pores called spiracles, each of which is connected to a network of tubes called tracheae that carry air to all parts of the body. Most body segments carry a pair of spiracles. The spiracle shown here is that of a young tiger moth caterpillar *(Arctia caja)*. The orange tube is the outer wall or lip, and inside this there is a web of hair-fringed 'fingers' that prevent the entry of dust, water, and other unwanted materials.

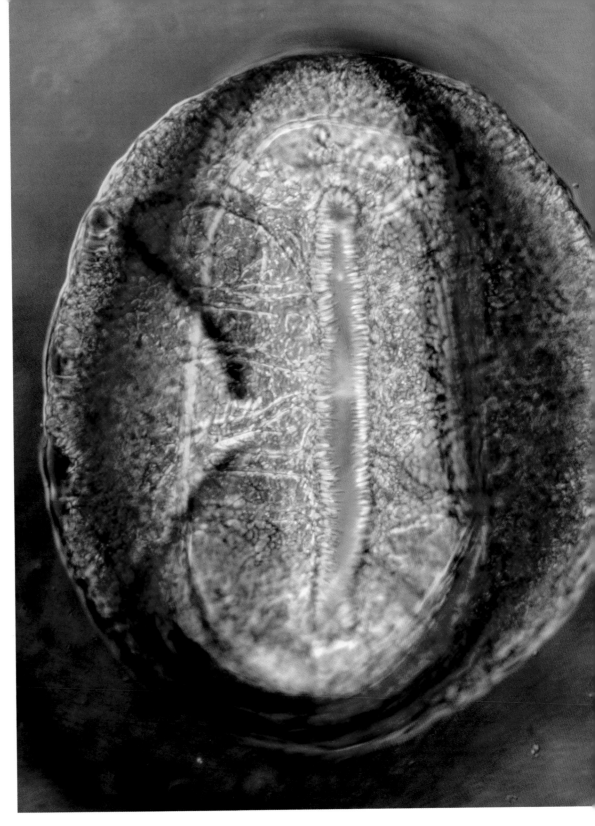

...and Out

SPIRACLES ARE MOST EASILY SEEN on the sides of large, non-hairy caterpillars. They are often ringed with colours that contrast with the rest of the body. The one pictured here belongs to a silkworm *(Bombyx mori)*. The air-filtering hairs are clearly visible in the central region. Very active insects, including hover-flies and wasps, use their body muscles to force air out of the spiracles and then relax them so that fresh air flows in.

63

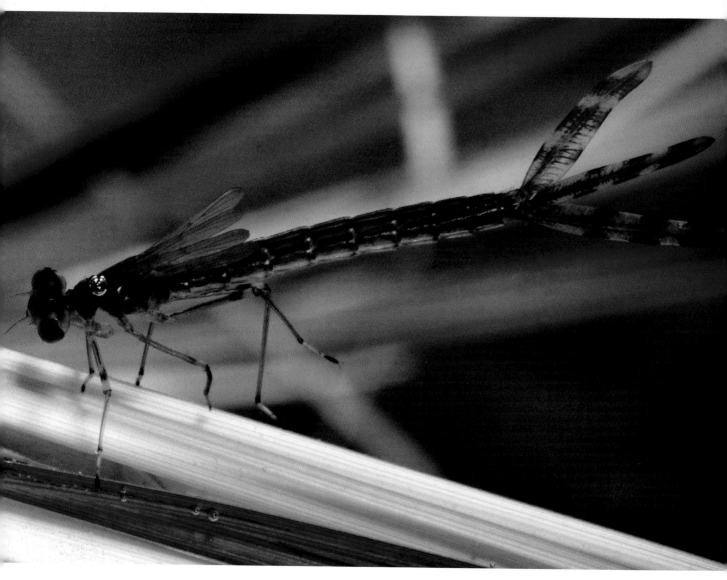

Breathing through the Tail

THE REAR END OF A DAMSELFLY NYMPH bears three delicate tail-like flaps that are actually its gills. They are very thin-skinned and well supplied with tracheae (see p. 62). Oxygen dissolved in the surrounding water passes through the skin and into the tracheae, through which it is then carried to all parts of the body. The nymphs of larger dragonflies have their gills inside the abdomen, and they breathe by pumping water in and out of the back passage. By pumping it out rapidly they can even propel themselves forward.

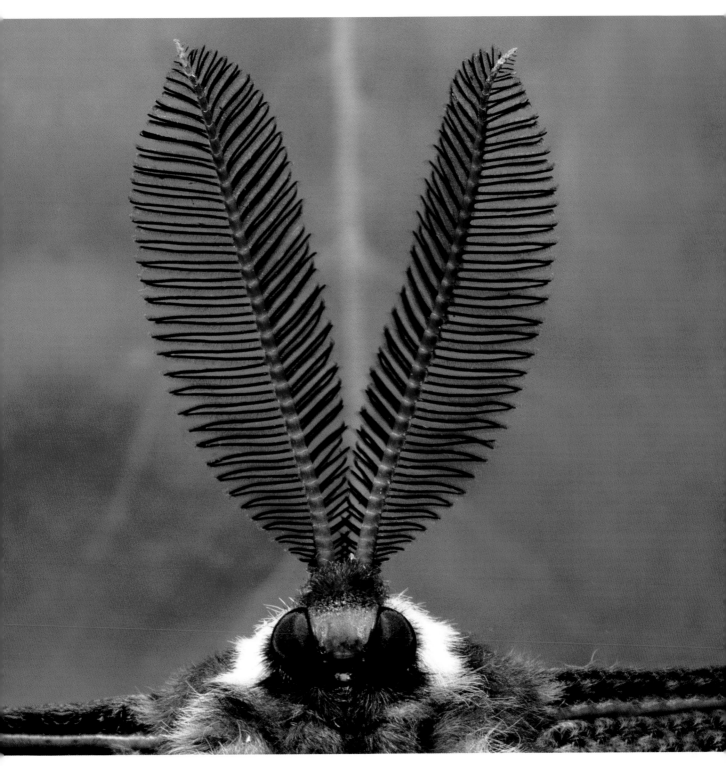

Long-distance Signalling

THE MALE CEANOTHUS MOTH *(Hyalophora euryalus)* has incredibly sensitive antennae, each with feathery branches carrying hundreds of thousands of scent receptors. Their large surface area gives them the best possible chance of intercepting the scent particles emitted by the females (see p. 228). They can detect just a few molecules of the scent drifting through the air, and when they pick it up the moth immediately begins to fly upwind to find its source. The males can detect 'calling' females from at least 2 km/1.2 miles away.

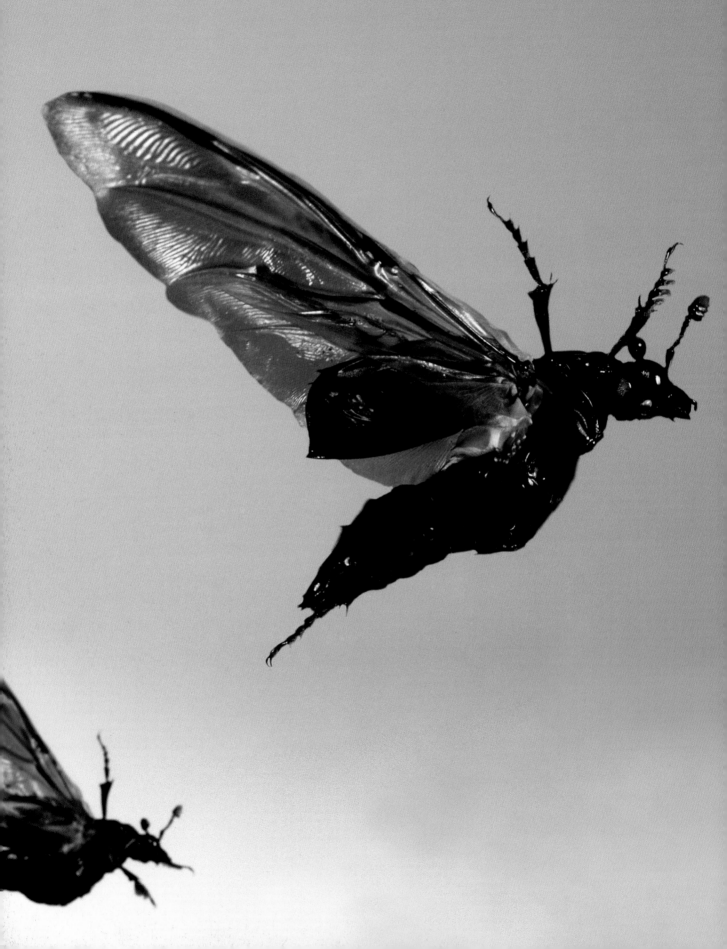

On the Move

Insects are the only invertebrate animals with wings, and flying is the most obvious way in which the majority of them get around. The wings are always attached to the thorax and most insects have two pairs. All four wings may be fairly soft and membranous, as in lacewings, bees, and butterflies, but beetles and many bugs have tough, horny front wings. These cover much of the body at rest, so the insects don't appear to have wings at all.

It is difficult to measure the speed of insects with much accuracy because they rarely fly in straight lines for more than a few metres. Various wasps and hawkmoths and some larger dragonflies have speeds of about 70 kph/45 mph, but most insects fly much more slowly. The top speed for most butterflies is no more than about 15 kph/9 mph. Butterflies flap their wings relatively slowly, commonly at a rate of about ten flaps per second in medium-sized species such as the cabbage whites, although smaller species, such as the skippers, generally have a more rapid wing-beat. Some of the larger species, including many swallowtails, often punctuate flapping flight with long, elegant glides. At the other end of the scale, there are tiny midges whose wings beat up and down as much as 1000 times in a second. But the frequency of wing-beat is not necessarily related to the speed of flight: the midges drift quite slowly through the air, while the hawkmoths achieve their high speeds with no more than 100 beats per second and dragonflies can generate equally high speeds with as few as 20 or 30 beats per second.

The majority of insects are home-lovers, with even fully-winged species rarely moving more than a few hundred metres from the places in which they grew up. But there are some exceptions and none more spectacular than the mass movements of locusts in response to food shortages. Millions of these insects may take to the air together, and they can darken the sky as they fly to new feeding grounds. The monarch butterflies of North America also go in for mass migration, flying south in their thousands in the autumn to spend the winter months in California, Florida, and Mexico. Some of these butterflies travel over two thousand miles to their winter quarters and, unlike locusts, they embark on a return journey in the spring. Many dragonflies also go in for mass migration.

Insects obviously do not spend their whole lives in the air: immature insects have no functional wings and many species do not fly even in the adult state. Running, crawling, jumping, burrowing, swimming, and even skating are all used as alternatives to or in addition to flying, and the insects' legs are superbly modified to manage these various activities. A look at its legs will often provide a good clue to an insect's life style: burrowing species tend to have enlarged front legs, while jumping species usually have long back legs and hair-fringed legs suggest a life in the water. Insects with long, slender legs are generally fast runners. But there are exceptions: the mantids, for example, have long legs, but they are fairly sedentary creatures and, except when shooting out their spiky front legs to impale their prey, they move very slowly.

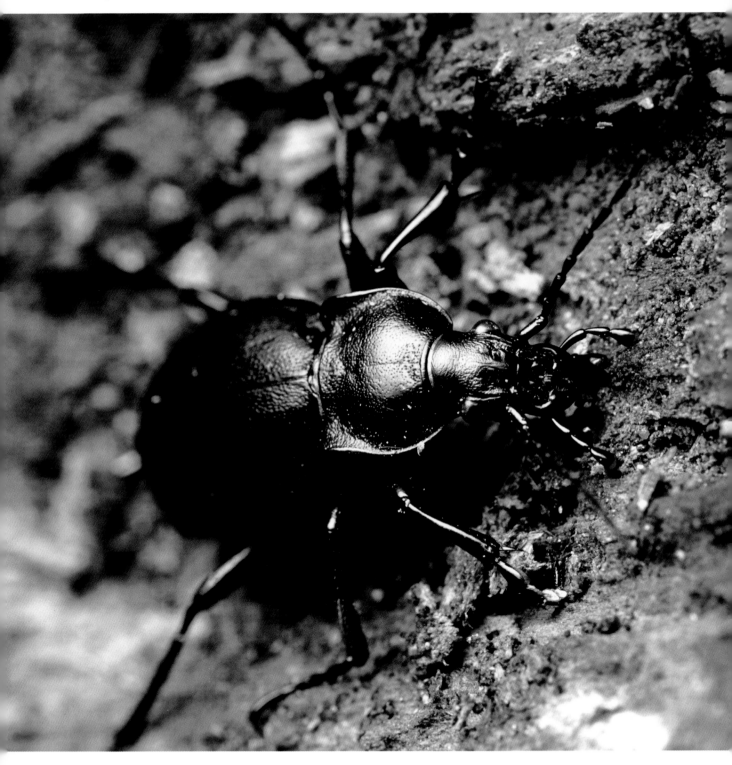

Tripod Stability

THE VIOLET GROUND BEETLE *(Carabus violaceus)* is a fast-running, flightless predator of slugs, worms, and many other small creatures. In common with most other running insects, it moves only three legs at a time and always has the other three – two on one side and one on the other – in contact with the ground at any one time, just like a tripod.

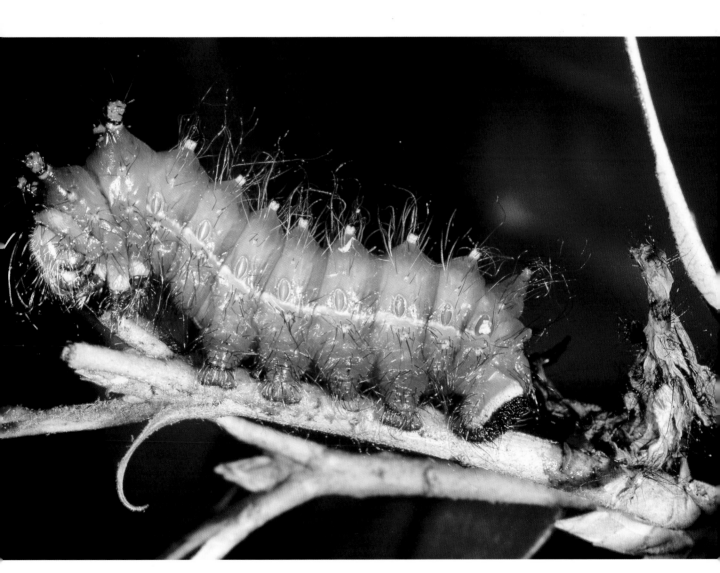

Forward Shuffle

THIS INDIAN MOON MOTH CATERPILLAR *(Actias selene)* clearly shows the five pairs of stump prolegs on the rear half of its body as well as the three pairs of true legs (brown) at the front. When walking, the caterpillar lifts the first one or two pairs of prolegs and moves them forward, takes a new grip, and then concertinas its body to bring the other prolegs forward. The prolegs grip firmly with the aid of minute hooks on the feet (see p. 36). The true legs may hold the twigs lightly, but often play no part in walking. This caterpillar has recently changed its skin and the shrivelled old skin can be seen on the right.

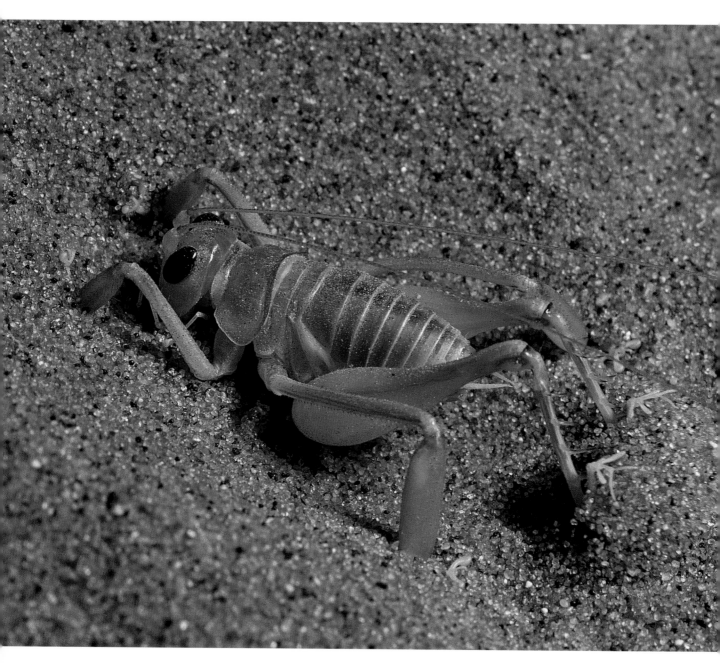

Sand-Shoe Shuffle

THE NAMIB DUNE CRICKET'S hind feet are equipped with wide, hair-fringed lobes that enable the insect to walk easily over loose sand. Its other feet have shorter lobes that can double as shovels when the insect needs to burrow into the sand to escape the scorching desert sun.

Looping Along

THE STRIPED INCHWORM is the caterpillar of a moth belonging to the family *Geometridae*. Caterpillars in this large family have only two pairs of fleshy legs on the rear half of the body, including the claspers right at the back. They are called inchworms or loopers because of the way they move. While gripping a leaf or a twig with its rear legs, the caterpillar stretches forward and takes a grip with its front legs, almost as if it is measuring the ground. It then brings its rear legs forward by throwing its body into a high loop or arch.

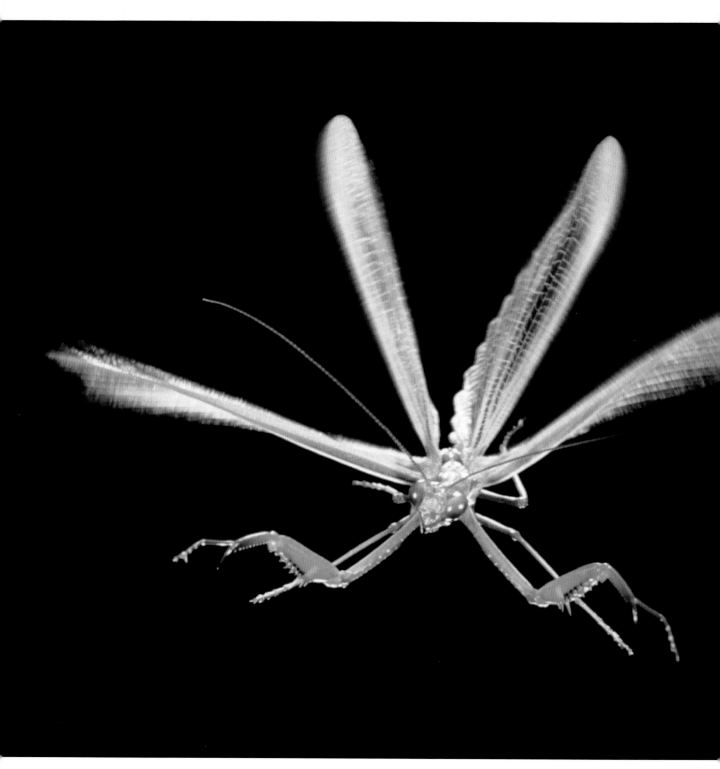

A Little Clumsy

THE PRAYING MANTIS (Mantis religiosa) is not the most elegant of aeronauts and certainly not the fastest. Its two pairs of wings beat independently of each other and at a rate of only about five beats per second. Flight is thus somewhat laboured, especially in the female, which is much stouter and heavier than the male.

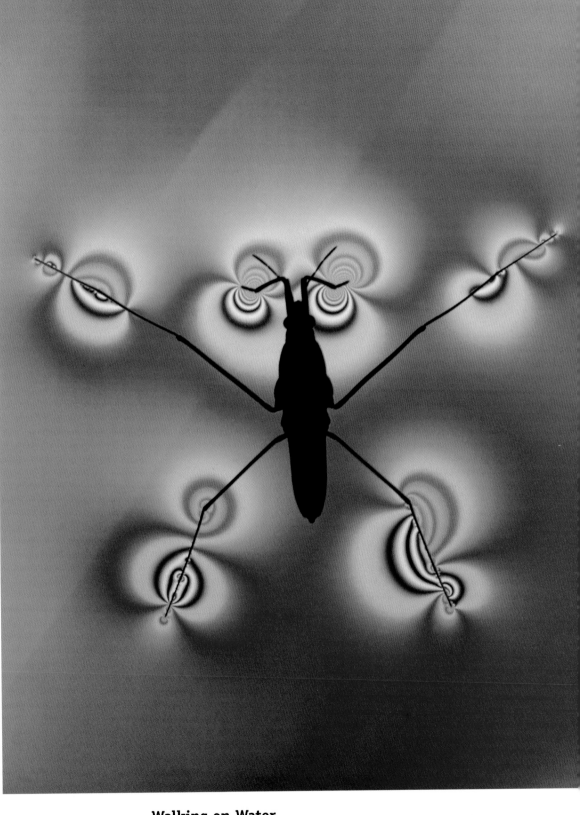

Walking on Water

POND SKATERS of the family *Gerridae* skim over the surface of still or slow-moving water. Surface tension forces holding the water molecules together cause the surface to act as if it were covered with a very thin skin, so it can support smalll objects as long as they do not pierce the 'skin'. Pads of water-repellent hairs a pond skater's feet prevent them from breaking through, but the insect's weight is still sufficient to make little dimples, seen easily from certain angles. The long middle legs push the insect around, while the hind legs are used mainly for steering. The front legs catch prey – usually other insects that fall onto the water, producing ripples that alert the skaters.

A Great Excavator

CICADA NYMPHS LIVE IN THE SOIL, piercing the roots of trees and shrubs to suck out the sap. They move readily from one plant to another with the aid of their powerful, toothed front legs, and if they are dug up they can bury themselves again remarkably quickly. Some American species, known as periodical cicadas, spend 17 years underground and adults appear only in certain years in a given area. The adults take sap from tree trunks and branches with their stout beaks, but they live for only a few weeks.

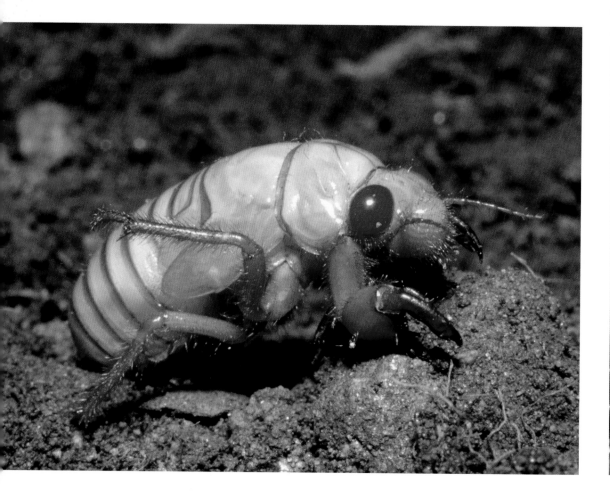

Expert Tunneller

THE MOLE CRICKET *(Gryllotalpa gryllotalpa)* spends most of its life underground, using its huge, shovel-like front legs to dig a network of tunnels through which it scuttles in its search for worms and a variety of insects. The tunnels may help to aerate the soil, but this good work may be off-set by the damage done to crop roots. In some areas the insects are serious pests of grape vines. Male mole crickets come to the surface on warm summer evenings and 'sing' from the mouths of their burrows. The 'song' is a soft churring sound and, as in all crickets, it is produced by rubbing the front wings together.

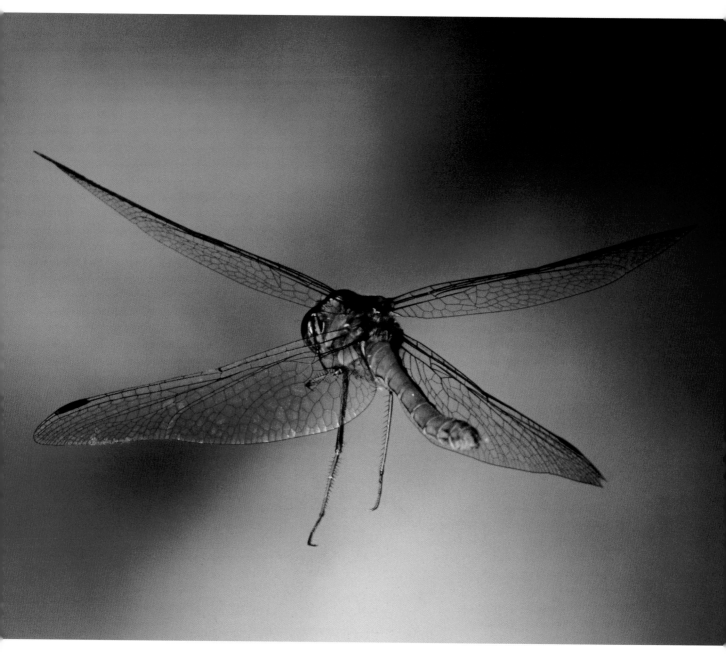

Accomplished Aeronauts

DRAGONFLIES ARE AMONG THE FASTEST AND MOST AGILE OF ALL INSECTS. They can reach speeds of about 70kph/45mph over short distances and they can also hover and fly backwards. Their four wings are all more or less alike and, as can be seen in the photograph, they move independently. Most other insects link their front and hind wings together in some way (see p. 48) so that they work as a single unit. Dragonflies use their great agility and amazing eye-sight to catch other insects in mid-air (see p. 24).

Coming Down

A GERMAN WASP *(Vespula germanica)* has its legs down ready to land on a flower. The insect looks as if it has only two wings, but the hind wings are very small and are securely linked to the front wings by a row of microscopic hooks (see p. 48) so that the two wings act as a single unit. The buzzing emitted by flying wasps is generated by the wings, which beat around 250 times every second.

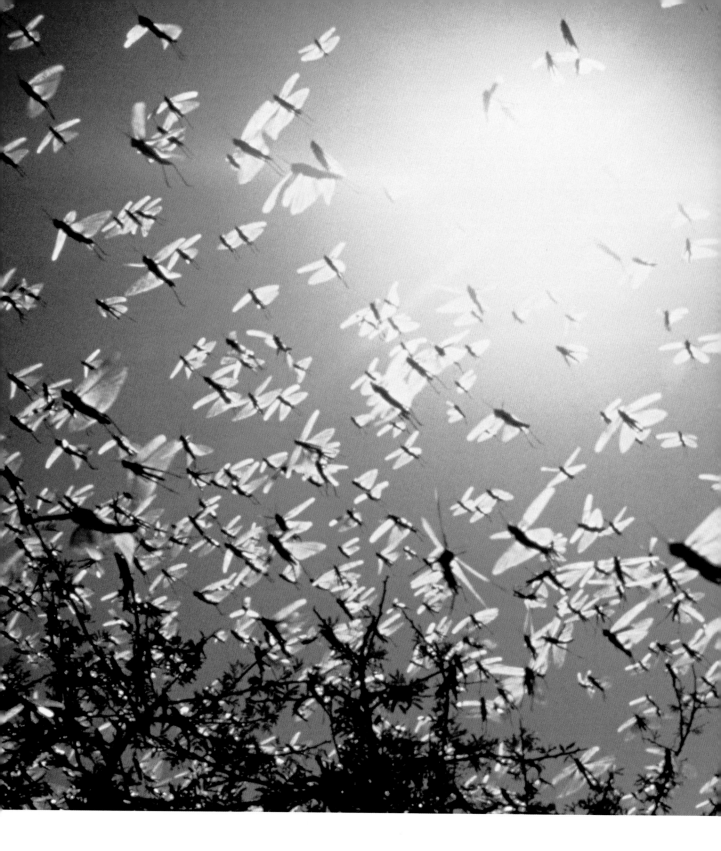

INSECTS

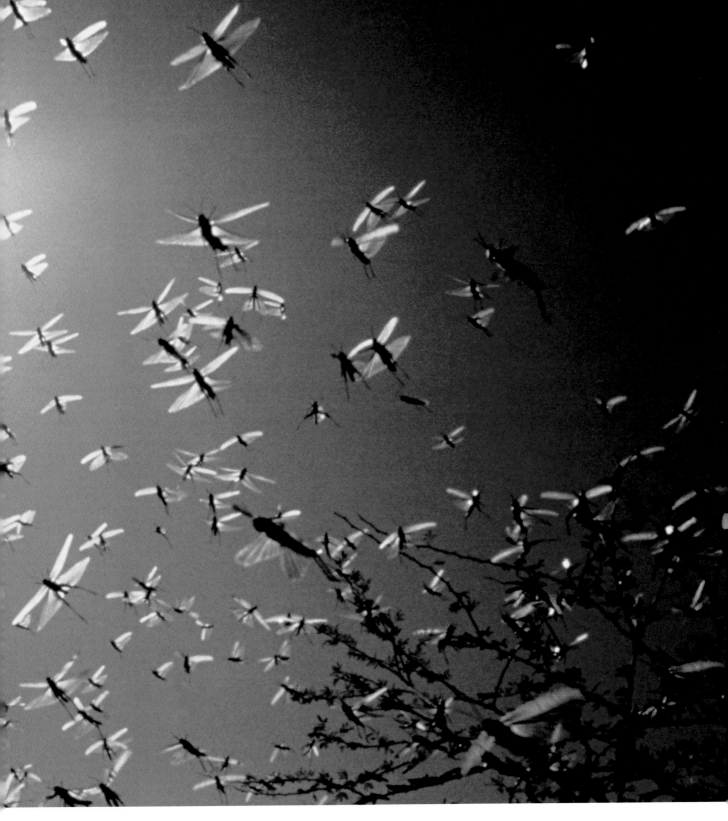

Destructive Locusts

LOCUSTS ARE LARGE GRASSHOPPERS that periodically build up immense populations and take to the air in dense swarms. Several billion locusts may be present in one swarm. They blot out the sun over large areas, and when they land they strip every trace of foliage from the vegetation. They can actually smell fresh vegetation from far away. Locusts live in most of the warmer parts of the world, the most damaging species being the desert locust *(Schistocerca gregaria)* of Africa and southern Asia.

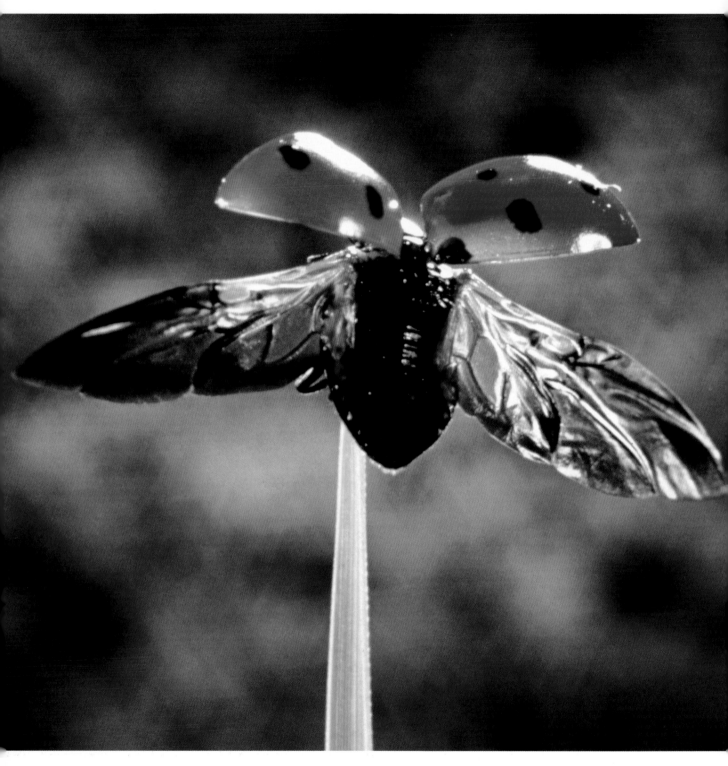

Take-off

A SEVEN-SPOT LADYBIRD *(Coccinella septempunctata)* raises its colourful front wings (elytra) and spreads its delicate hindwings in readiness for take-off from a blade of grass. The insect needs to have a bit of height before it can get launch itself into the air. As in all flying beetles, the elytra produce a certain amount of lift but may be more important in steering and in controlling stability. The hindwings clearly show the creases along which they are folded when they are tucked away under the elytra.

Windborne Aphid

THE APHID'S FLIMSY WINGS are plenty strong enough to carry it into the air but, unless the wind is very light, the insect has little control over where it goes. Huge clouds of aphids sometimes take off from the crops during the daytime and, after being lifted by rising air currents, they can be blown for hundred of miles, often across the sea. They usually come down again towards sunset, when rising air currents die out, and few aphids are found on the wing at night.

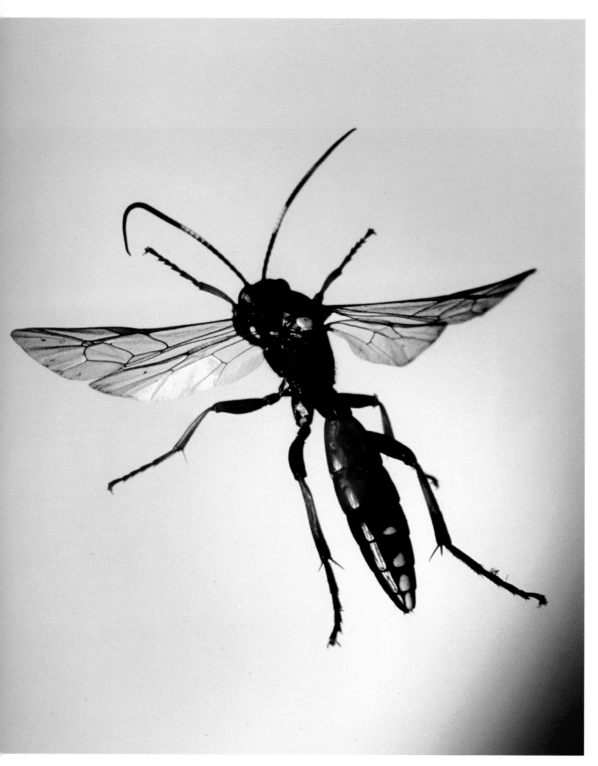

A Twist in the Wing

THIS ICHNEUMON, 'FROZEN' BY HIGH-SPEED PHOTOGRAPHY, shows how the wings are twisted in flight to produce both lift and forward motion (see p. 84). The insect also shows the narrow waist characteristic of most members of the *Hymenoptera*. Ichneumons are all parasites, using their long antennae to smell out suitable hosts. This one *(Ichneumon suspiciosus)* lays its eggs in various caterpillars

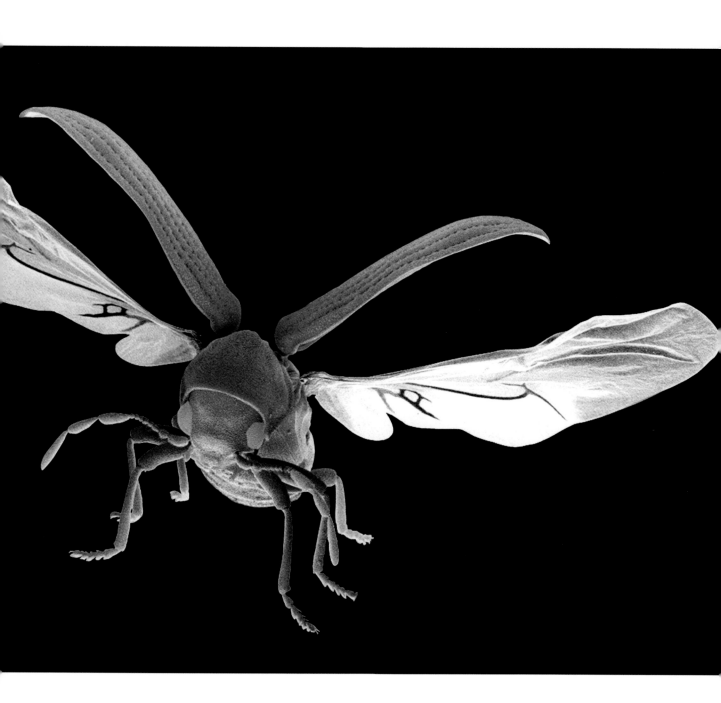

Delicate Propulsion

THE FURNITURE BEETLE *(Anobium punctatum)* in this computer-manipulated photograph shows how the front wings or elytra are held well away from the delicate hing wings that provide the propulsive power in flight. Furniture beetle grubs are the woodworms that do so much damage in our houses. The adults are most often seen in the summer, when they emerge from furniture and floor boards and try to get out of the windows.

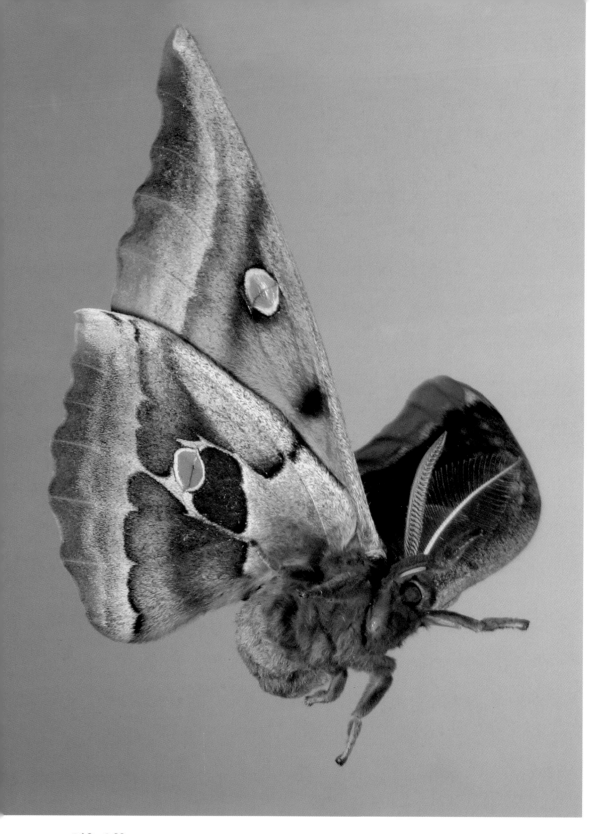

Lift-Off

THE WINGS OF THIS POLYPHEMUS MOTH *(Antheraea polyphemus)*, are linked together on each side by a fairly wide overlap. The two wings thus work as a single unit. Flight relies on very complex movements of the wings. As they flap up and down, the wings also swivel or twist, and in doing so they create the thrust and lift necessary to keep the insect aloft. The wings often meet above the body at the end of the up-stroke, and when they separate again there is a vacuum between them for a tiny fraction of a second. Lift is then produced by the air pressing up on the wings. This is why butterflies seem to be able to take off effortlessly just by opening their wings.

Flashing Colours

THE RED UNDERWING MOTH *(Catocala nupta)* is largely grey on the underside, so when it flies the red is visible only in flashes when the wings are open. This is thought to confuse birds that might have disturbed the resting moth. The birds are even more confused when the moth drops to the ground, covers its hind wings, and 'disappears'!

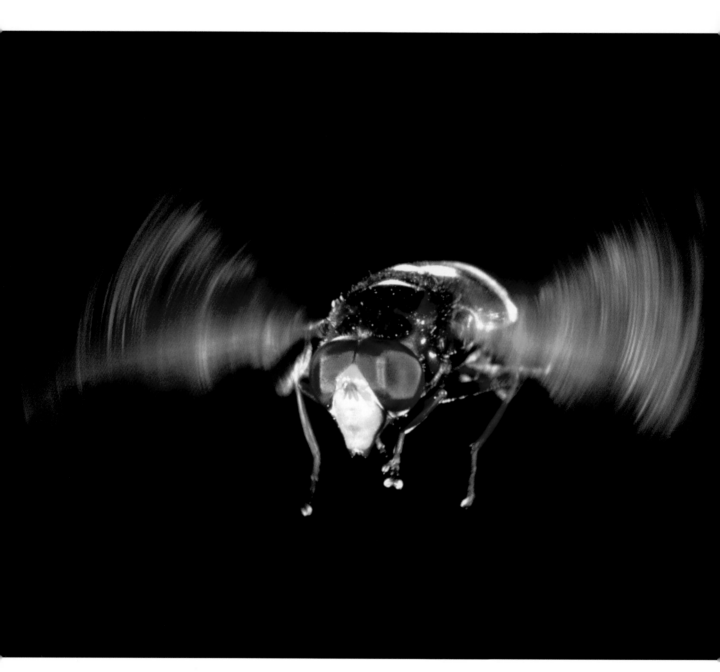

Basking on the Wing

HOVER-FLIES ARE WELL-NAMED, for these diurnal insects spend a lot of their time hovering at various heights above the ground, often in shafts of sunlight. Their wings usually beat between 100 and 150 times a second and give out a low-pitched hum. When the sun is not shining the insects usually settle on various flowers. They feed largely on nectar, which they soak up with spongy mops similar to that of the house-fly (see p. 115), but they can also tackle pollen grains by piercing and crushing them with spines inside the mops.

INSECTS

Feeding on the Wing

THE HUMMINGBIRD HAWK MOTH *(Macroglossum stellatarum)* really does look like a humming bird when hovering to take nectar from the flowers. Its rapidly-beating wings even sound like those of a hummingbird. Hovering uses up a lot of energy, so insects that feed on the wing usually confine themselves to flowers that produce large quantities of nectar, such as the buddleia being visited here.

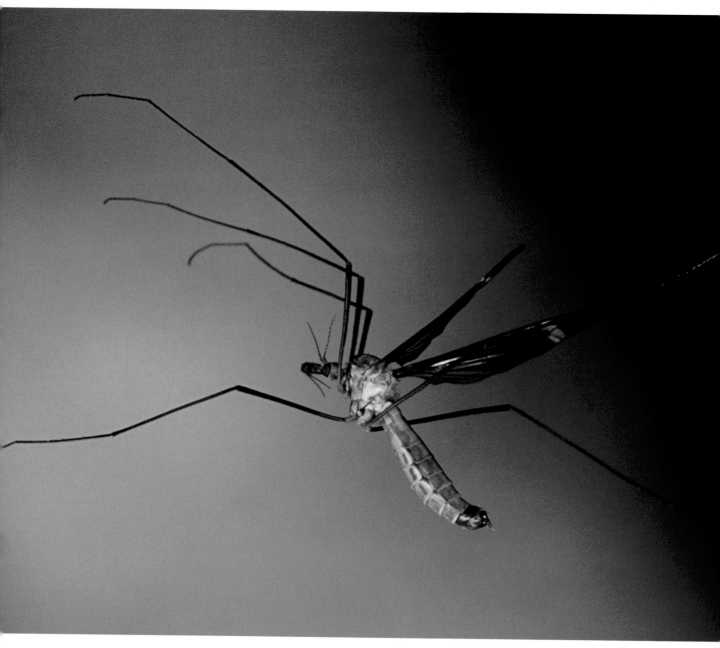

Expendable Legs

CRANE-FLIES, ALSO KNOWN AS DADDY-LONG-LEGS, are most ungainly creatures in flight, drifting about with their absurdly long spindly legs dangling in all directions. The legs often become entangled in vegetation or in spiders' webs, but this is not a major problem because the insects can simply snap off a trapped leg at the base – and as long as they don't lose more than three legs they don't seem to be inconvenienced. In common with all true flies, the crane-fly has just one pair of wings. Young crane-flies are called leatherjackets. They feed on plant roots and can be serious pests.

On Even Keel

THIS CRANE-FLY *(Tipula maxima)* shows two slender club-shaped organs sticking out from the rear of the humped thorax. Known as halteres, they are greatly modified hind wings and all true flies have them, although in house-flies and most other stout-bodied flies they are concealed under little flaps. They move up and down at the same rate as the wings, although not necessarily in phase with them, and are believed to act like gyroscopic stabilisers, helping the fly to maintain an even keel and control its balance while in flight. Any deviation from level flight is detected by the sense organs at the base of the halteres and the fly can then alter its position accordingly.

Elastic Power

SIZE FOR SIZE, FLEAS ARE THE WORLD'S BEST JUMPERS. The human flea has been known to cover 30 cm/12 in. in a single leap. Jumping is facilitated by the extra-long back legs, but muscular power is not the main driving force. The fleas depend largely on a rubber-like protein called resilin, which is the most elastic substance known – with an almost perfect recovery after distortion. All insects have some resilin in the thorax, but the fleas have it in large amounts. Before leaping, a flea draws its hind legs forward and compresses the pad of resilin, thus storing up potential energy. When the muscle tension is released, the resilin springs back to its former shape, straightening the legs in an instant and shooting the flea forward, as in this computer-generated picture.

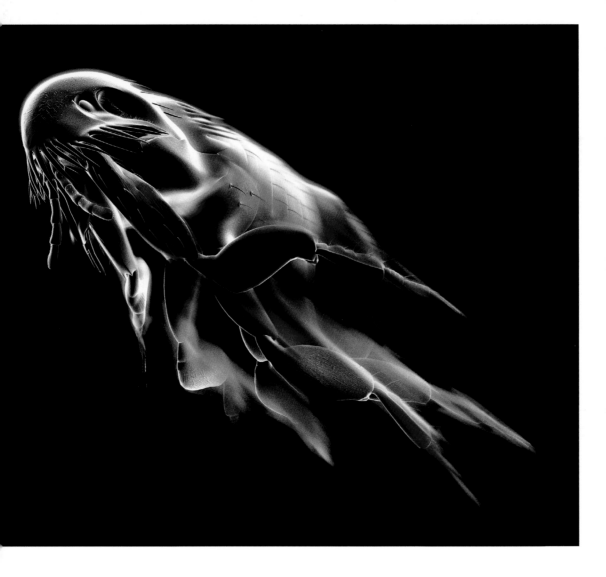

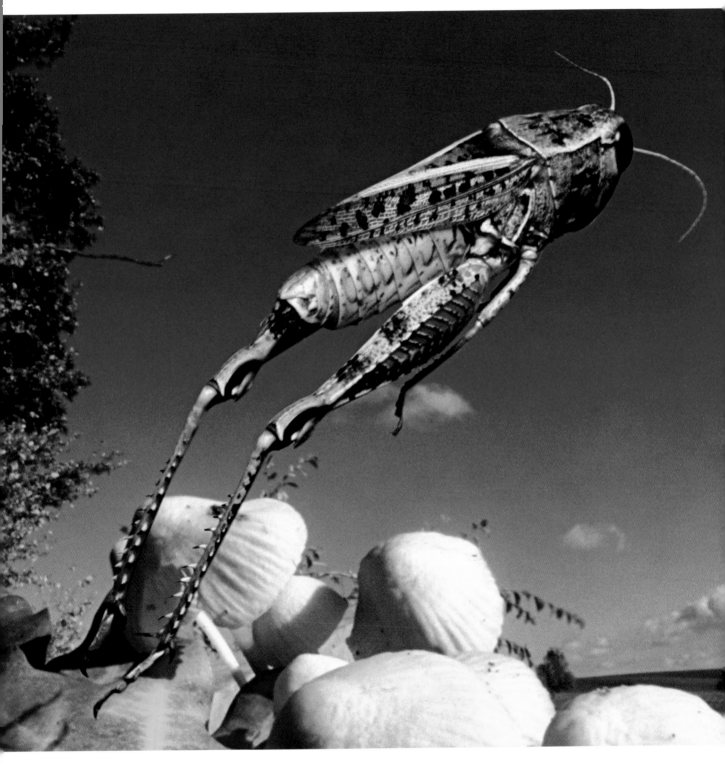

Muscle Power

GRASSHOPPERS HAVE VERY LONG BACK LEGS and the femur – the large section closest to the body – is packed with strong muscles. When these muscles contract, the legs straighten and shoot the insect into the air. Once airborne, the grasshopper may open its wings and fly or glide for a considerable distance. On the other hand, it may simply drop down again without opening its wings. Many grasshoppers lack hind wings and are unable to fly at all.

91

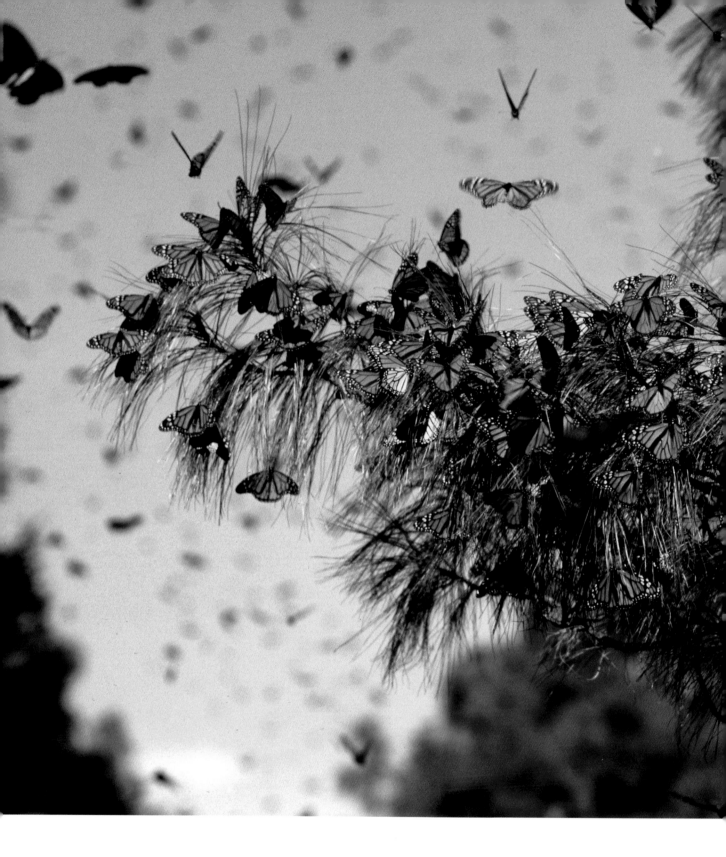

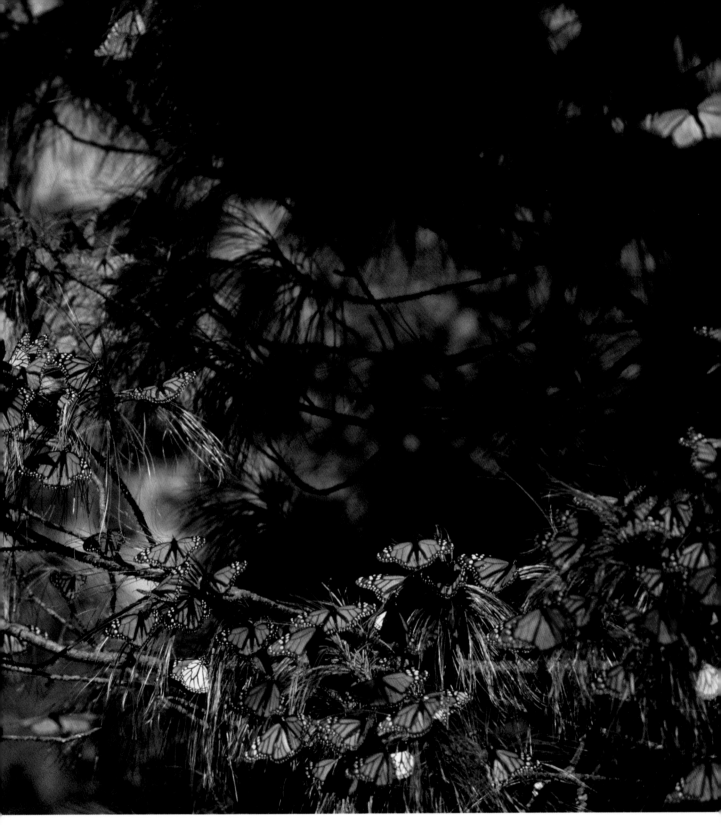

Long-distance Travellers

NORTH AMERICA'S MONARCH BUTTERFLIES *(Danaus plexippus)* make spectacular migrations in the autumn. Some fly thousands of miles from Canada to California and Mexico, where huge swarms spend their winter dozing in the trees. They fly north again in the spring, but these movements are less spectacular and the over-wintered insects do not get very far: it is their children or grand-children that get all the way back to Canada.

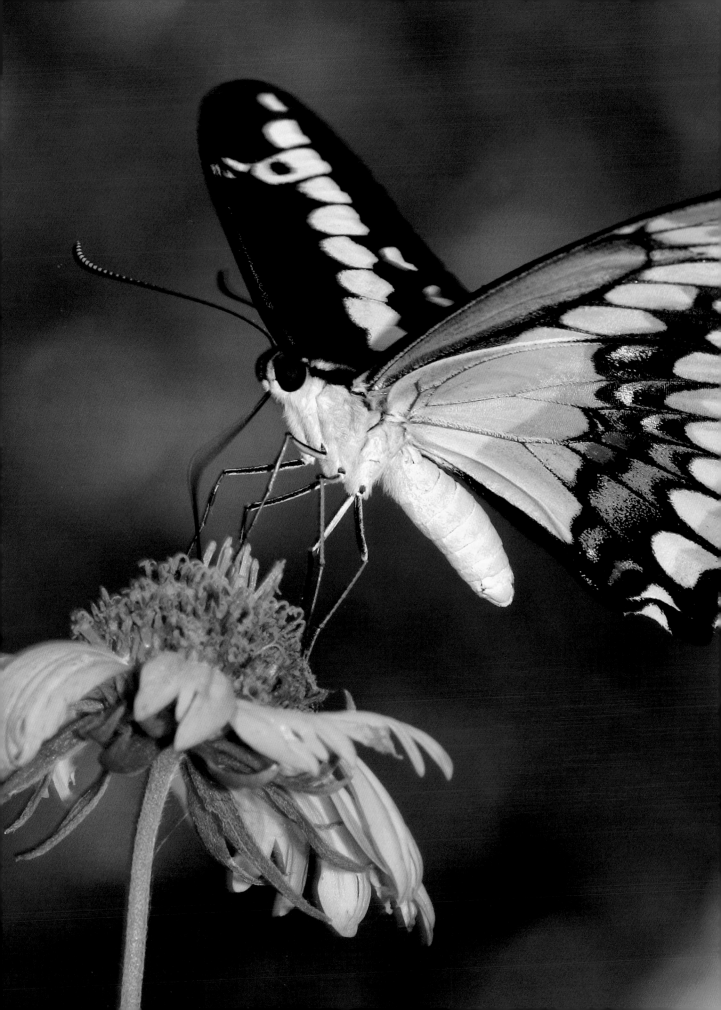

Food and Drink

Between them, the world's insects consume just about every kind of vegetable or animal material, living or dead. Acceptable foodstuffs range from sugary nectar to solid wood and from blood to dried bones. Their ability to deal with so many foodstuffs has played a major role in establishing insects as the most successful group of animals on earth.

The feeding apparatus varies according to an insect's diet, but it consists essentially of a cluster of highly modified limbs around the mouth. Insects that take solid food include dragonflies and grasshoppers, many adult and larval beetles, and the caterpillars of butterflies and moths. They all possess powerful jaws, equipped with sharp and often toothed edges, that slice through the food as well as picking it up. Unlike the jaws of vertebrates, an insect's jaws are outside the mouth, so the food has to be cut and chewed before it is swallowed. Bees and wasps also use their jaws for building (see p. 50), while some ants and termites use them for defence (see p. 120).

Insects with liquid diets include butterflies and moths, bugs, fleas, and flies. Their mouth-parts are generally in the form of slender tubes, although the detailed structure varies enormously. Butterflies and moths have tubular tongues, called probosci, which enable the insects to reach deep into flowers to suck out the nectar (see p. 126). Bugs, fleas, and many flies suck juices from plants or from various animals with the aid of piercing mouth-parts resembling minute hypodermic needles (see p. 23), while other flies merely suck up nectar or other free liquids with spongy 'mops'.

Herbivorous insects select their food largely by scent, although colour sometimes plays a part. Predators and blood-suckers also rely mainly on sight and smell to find their prey, with sound and body heat leading some insects to their victims. Some actually set traps for their prey, some lure their victims with lights or bright colours whilst others use their mouth-parts or legs to grab or impale their prey.

Parasitic insects live in or on other organisms, taking food from them but giving nothing in return. It has been estimated that more than 10 per cent of all insect species live in this way, including over 100,000 kinds of ichneumons and other hymenopterans (see p. 136), numerous flies, and all the fleas and lice. The fleas and lice are external parasites of birds and mammals, the lice spending their whole lives on their hosts while the fleas are parasitic only as adults. A few flies are parasitic as adults, but it is normally only the larval stages that are parasitic. The ichneumons and other parasitic hymenopterans also live as parasites only in their larval stages, most of them inside other young insects.

Nectar and Pollen Galore (Right)

A BUMBLE BEE BUSILY PROBES THE FLORETS OF A DANDELION HEAD. While sucking up the nectar with its long tongue its hairy coat becomes dusted with pollen grains. Both nectar and pollen are important foods for the bees. Nectar is carried back to the nest in the bee's stomach, while the pollen grains are periodically combed from its coat and packed into the pollen baskets on its back legs (see p. 99).

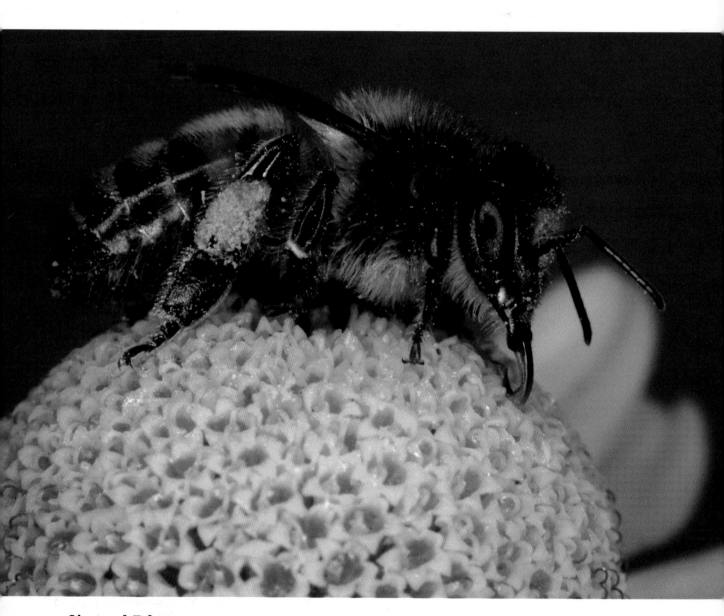

Give and Take

A HONEY BEE, SMALLER AND LESS HAIRY THAN THE BUMBLE BEE, feeds on a chamomile flower. Like the bumble bee, it collects both nectar and pollen, and in return for the food, it pollinates the flowers as it goes – by unknowingly brushing pollen from one flower on to the stigmas of another.

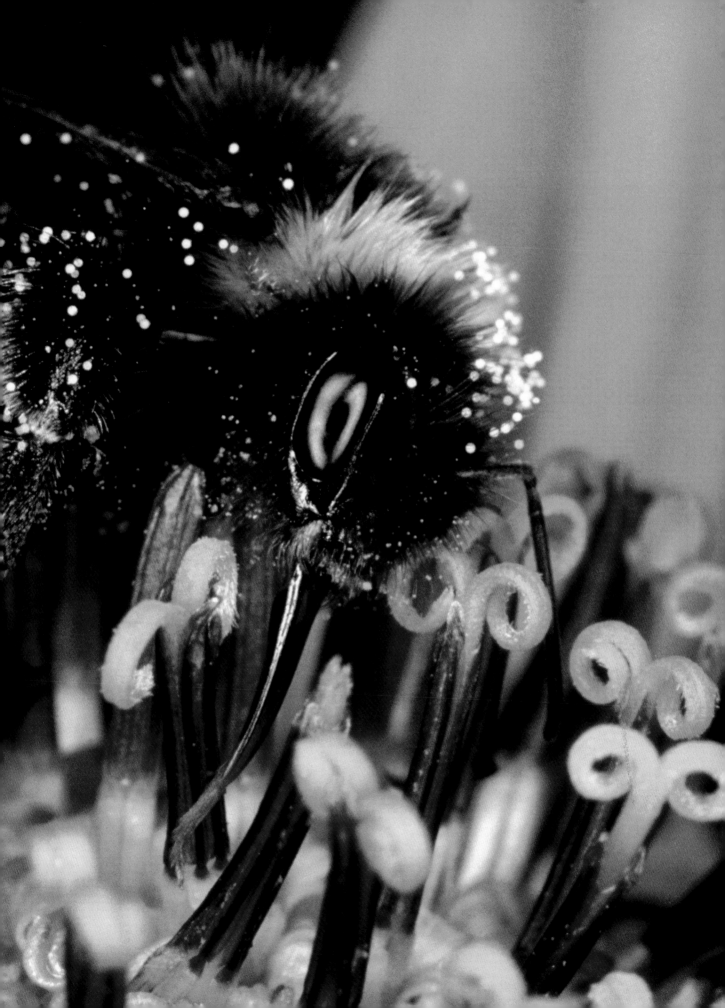

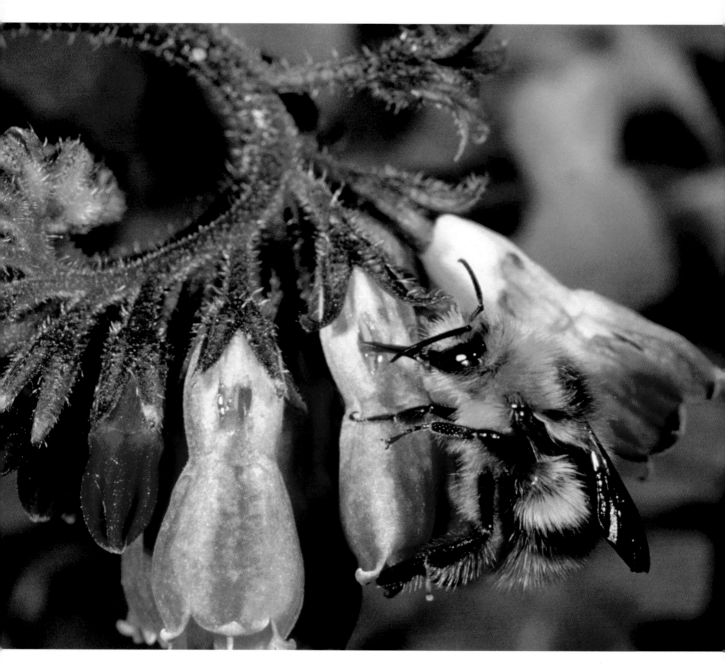

Nectar Thieves

TUBULAR FLOWERS are normally pollinated by moths and long-tongued bumble bees, which can reach the nectar deep inside the flowers. Some short-tongued bumble bees, however, 'steal' the nectar by biting holes in the bases of the petals. They don't come into contact with the stamens or stigmas, so they do not perform any pollination service in return for their nectar. Here, a short-tongued bumble bee is stealing nectar from comfrey flowers.

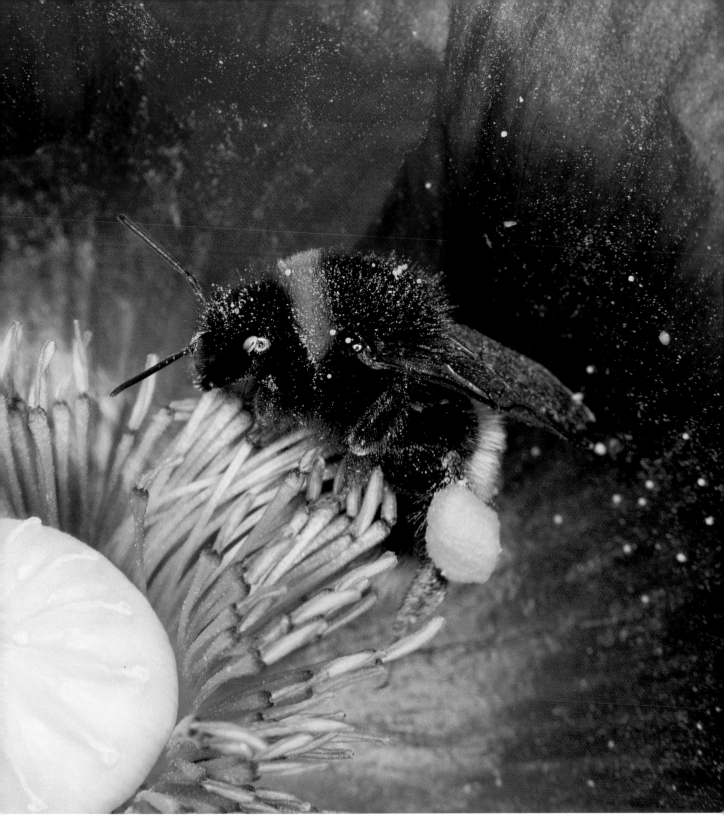

A Heavy Load

A BUMBLE BEE FORAGES FOR POLLEN in a poppy flower. Poppies do not produce nectar, but their numerous stamens release copious amounts of pollen. The bee's body is coated with it, and its pollen baskets, formed from stiff hairs on the back legs, are bulging with it. The bees can carry pollen loads weighing up to 50 per cent of their own body weight. Although they carry most of the pollen away, plenty remains on their bodies to pollinate the flowers.

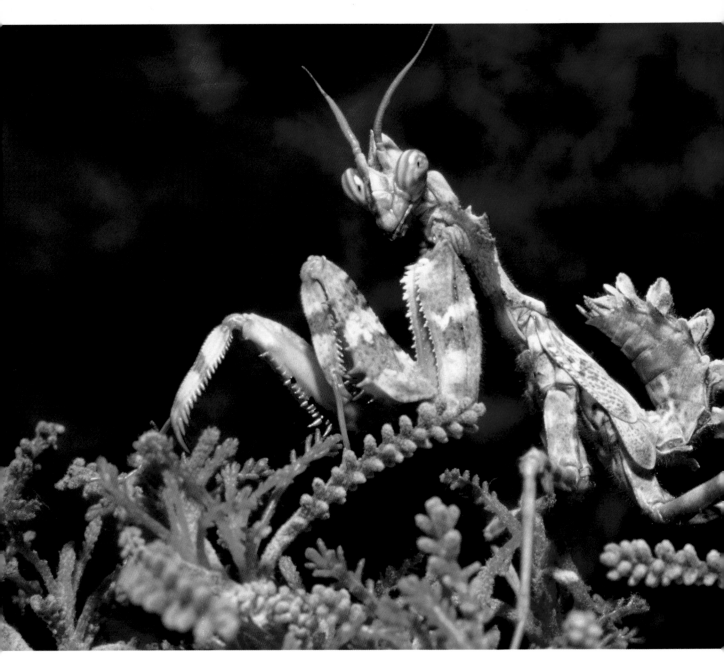

Aggressive Camouflage

BLENDING IN WITH THE SURROUNDING VEGETATION, this African mantis *(Blepharopsis mendica)* can hide from its prey as well as from its enemies. The flaps on its up-turned abdomen are a pretty good match for the leaflets of the surrounding plants on which it lies in wait for other insects. The mantis has a very flexible neck and can turn its head to look in nearly every direction. When prey is spotted, the mantis aligns its eyes and spiky front legs with its victim and then shoots out the front legs at high speed. The victim is trapped in a vicelike trap, from which there is no escape.

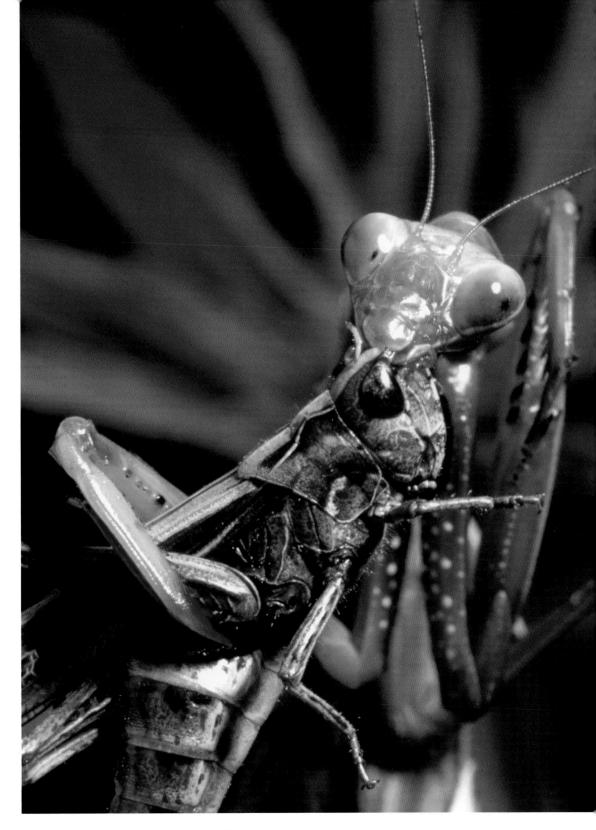

A Good Meal

THE EUROPEAN PRAYING MANTIS *(Mantis religiosa)* has a voracious appetite. Having captured a grasshopper, this mantis is wasting no time in settling down to eat. Its powerful jaws are a match for even the toughest insect, and very little of the meal is wasted, although the mantis does not always bother with the wings. This mantis got its name because while waiting for its prey it holds its legs in front of its head as if in prayer – a habit that it shares with most other mantids.

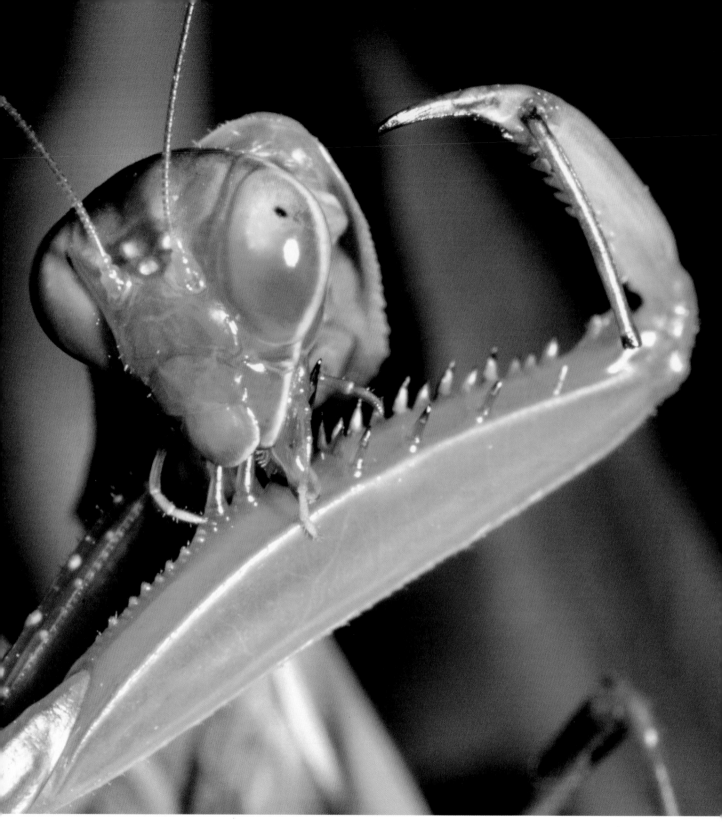

Washing Up

THE PRAYING MANTIS IS METICULOUS ABOUT CLEANING UP after eating, for any build-up of debris will harbour germs and could also reduce the efficiency of the 'gin-trap'. Here the insect is nibbling off every trace of its last meal.

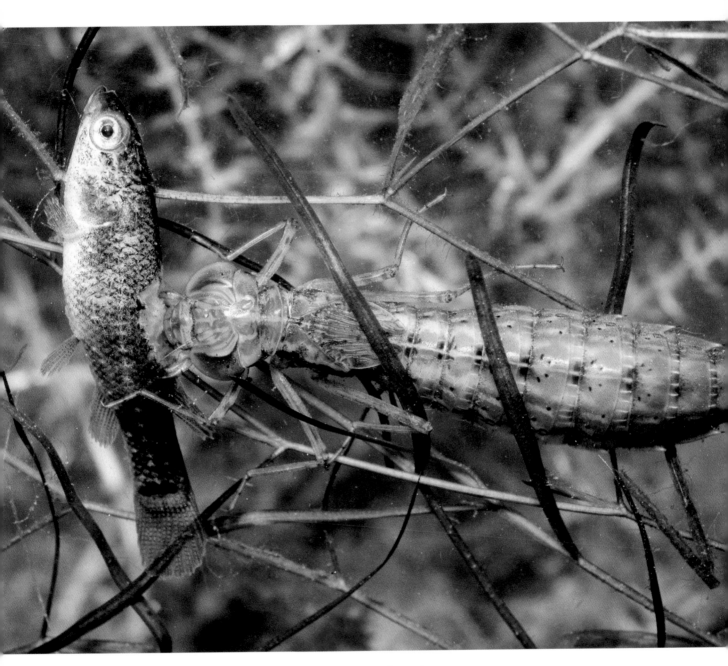

Ambush in the Water

DRAGONFLY NYMPHS ARE FIERCE PREDATORS, feeding on other insects, worms, tadpoles, and even small fishes, which they capture with a unique piece of apparatus known as the mask. When not in use, this is folded under the head, where it more or less conceals the jaws. The nymphs usually lie in wait amongst the water plants or partly buried in the mud or silt and then dart out to grab passing prey. The mask is shot out at high speed, impaling the victim on curved spines and bringing it back to the toothy jaws.

Ball-Rolling Beetles (Right)

DUNG BEETLES OF THE FAMILY *SCARABAEIDAE* play a major role in keeping the countryside clean by clearing up animal droppings. The most famous of these beetles are the dung-rollers or tumble-bugs. They form the dung into balls which they trundle along until they reach suitable burial spots. A ball may be as big as a tennis ball, and much heavier than the beetle, but it is moved with surprising speed. The beetle stands on its head and moves backwards while turning the ball with its hind legs. After burial, the dung may be eaten at a single sitting, but balls are also buried as larders for the larvae, in which case pairs of beetles may co-operate to roll and bury them.

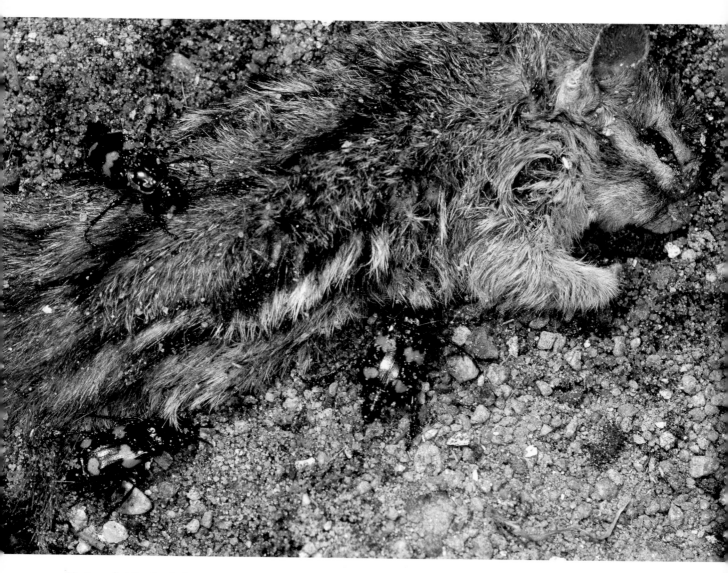

Nature's Undertakers

BURYING BEETLES OR SEXTON BEETLES *(Nicrophorus species)* quickly smell out dead birds and small mammals. They may eat some of the flesh, but their main aim in spring and summer is to bury the corpses to form larders for their offspring. The first individual to arrive at a carcass may nibble bits of flesh, but burial does not begin until a member of the opposite sex turns up. The beetles excavate a narrow shaft under the carcass and then use their powerful jaws to drag it down into the ground. The corpse ends up in a burial chamber a few inches below the surface. The female lays her eggs close to it and when the eggs hatch the larvae start to eat it.

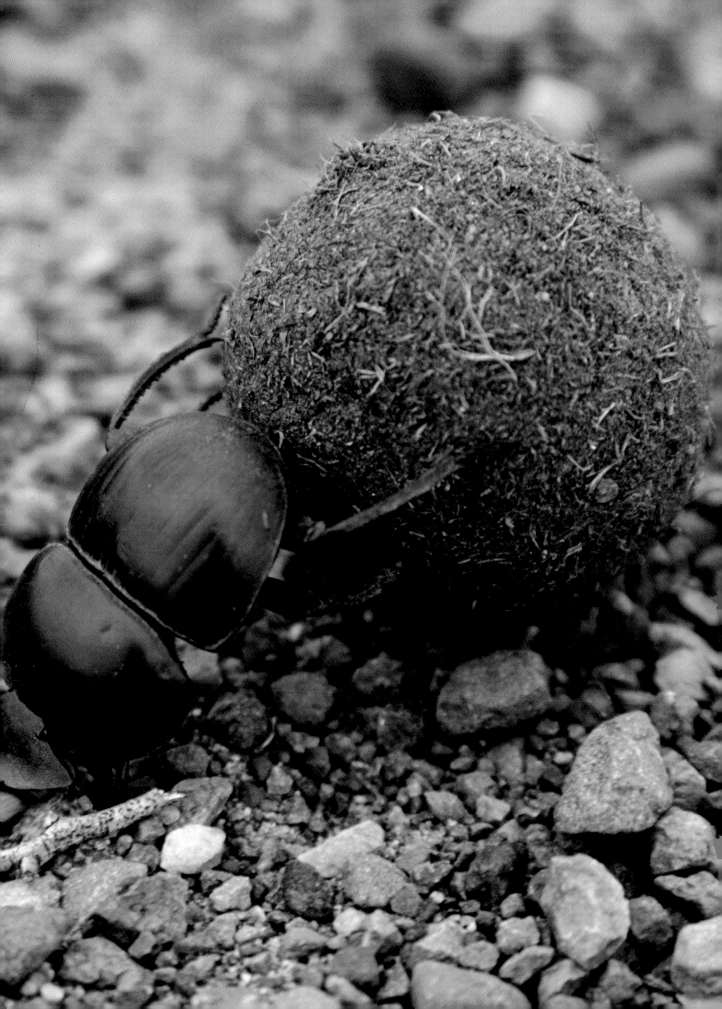

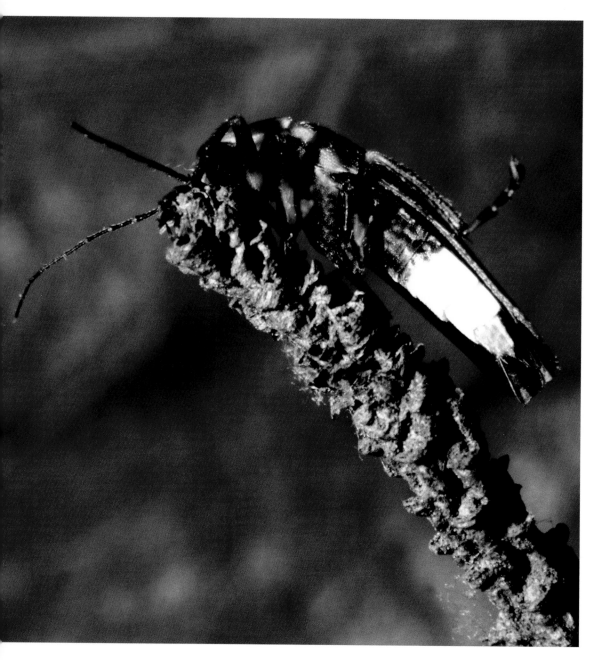

Dirty Tricks

THE FEMALE AMERICAN FIREFLY *(Photuris pennsylvanicus)* is a veritable siren, luring the males of other fireflies *(Photinus species)* to their deaths with false signals. When she detects *Photinus* males flashing overhead she replies by flashing in the manner of a *Photinus* female. The males then descend, not to an amorous embrace but to be eaten by the impostor.

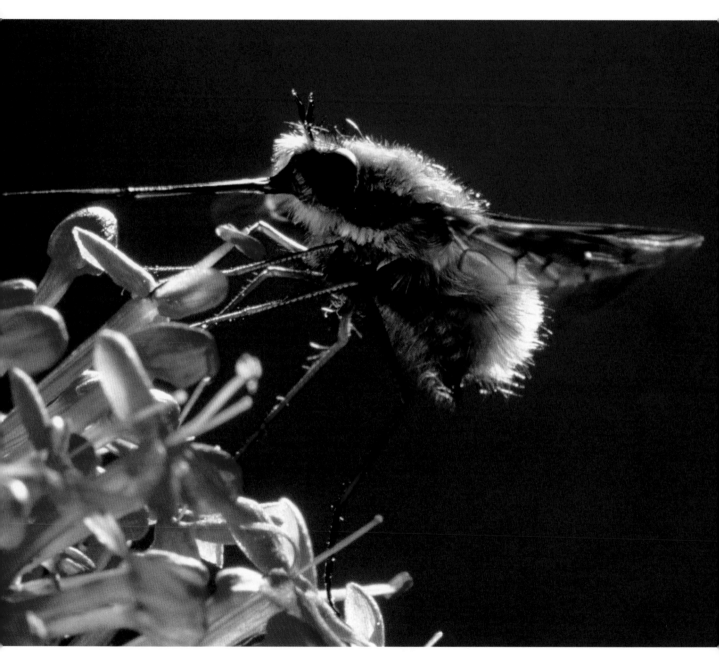

A Long Drink

THE LONG, RIGID PROBOSCIS OF THE BEE-FLY *(Bombylius major)* looks like some kind of weapon, but it is used only for drinking nectar from deep-throated flowers. The fly appears to hover while probing the flowers but, although its wings continue to beat, it usually clings to the flowers with its long, spindly legs. Bee-flies grow up as parasites in the nests of various solitary bees.

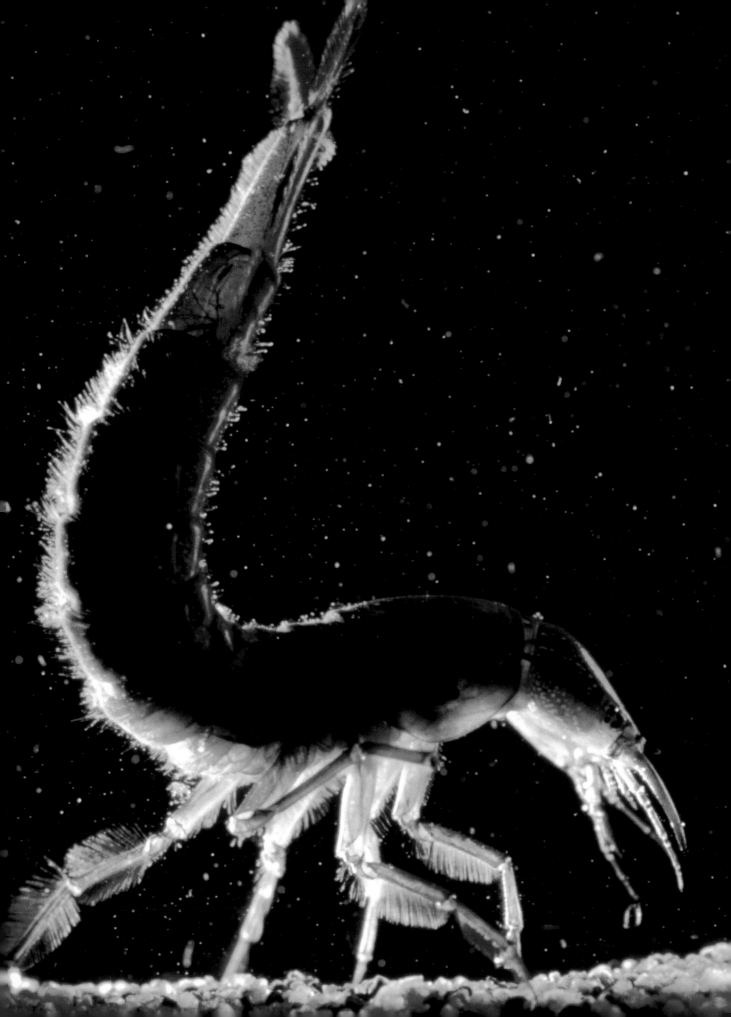

A Fearsome Predator with ... (Left)

THE LARVA OF THE GREAT DIVING BEETLE *(Dytiscus marginalis)* is a ferocious predator of other aquatic creatures and is often known as the water tiger. It will even attack newts and other creatures larger than itself. It swims well with the aid of its feathery legs, which act like paddles. Although living in the water, the larva breathes air by coming to the surface and pushing the hairy tip of its abdomen into the air above. Two spiracles at the end of the abdomen allow air into the breathing tubes (see p. 62).

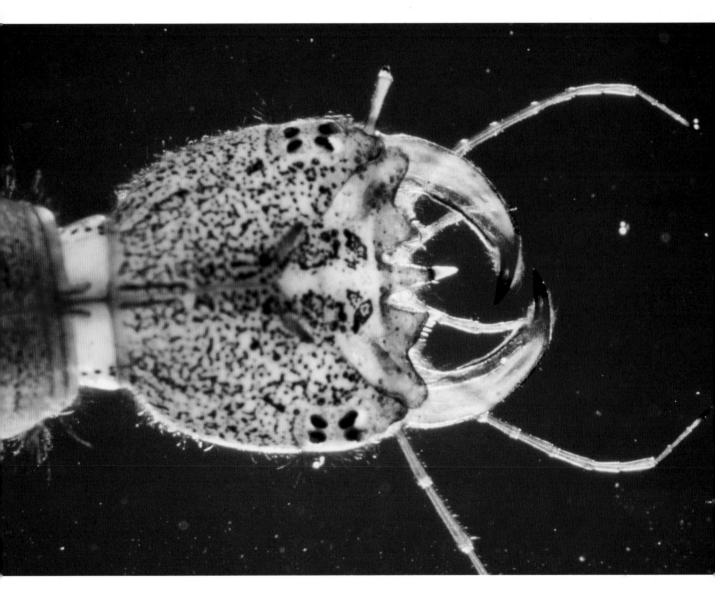

... Hollow Jaws

THE DIVING BEETLE LARVA grabs passing prey with its formidable curved jaws, which are plunged deep into the flesh. Each jaw contains a narrow canal, through which the larva pumps digestive juices into its victim. These juices slowly convert the flesh into a 'soup' which the larva then sucks back up into its mouth. Just the skin and assorted hard parts are left when the beetle has finished.

109

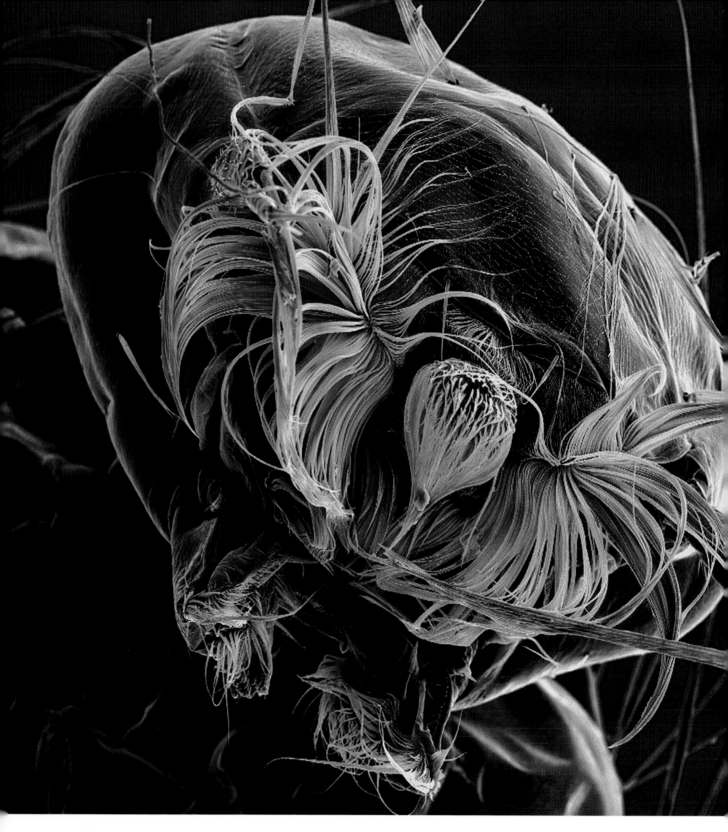

Filter Feeding Larva ...

THE HEAD OF A MOSQUITO LARVA, very highly magnified, shows the feeding brushes – the light brown bunches of hairs – that it combs through the water to filter out algae, bacteria, and other micro-organisms. Mosquitoes breed in all kinds of still water, including garden ponds and water butts, and the larvae are usually seen just below the surface – either hanging upside down or lying horizontally. They breathe by breaking the surface with a tiny tube bearing a spiracle (see p. 62) at the tip.

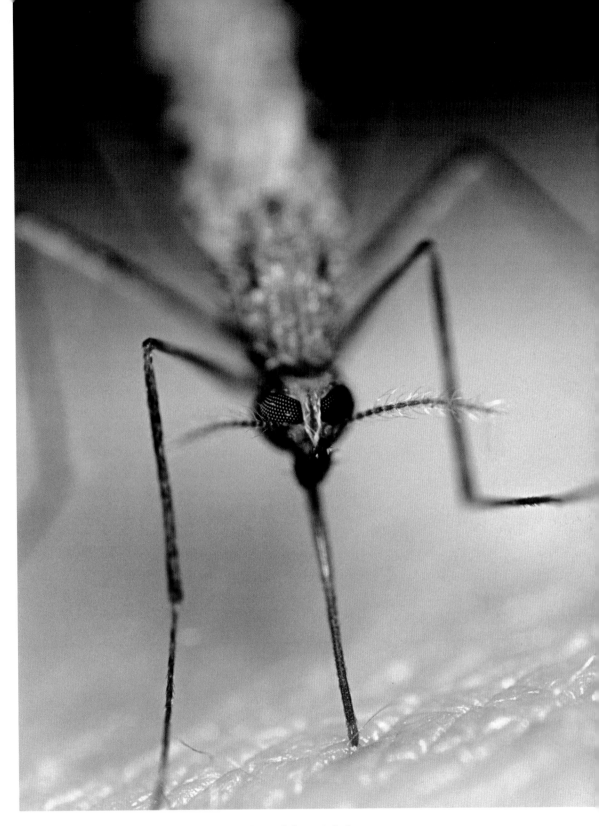

...and Blood-Sucking Adult

FEMALE MOSQUITOES need a meal of blood, from birds or mammals, before they lay their eggs. They usually find their victims by detecting their body warmth and also the higher concentration of carbon dioxide around them, and then in goes the needle-like beak with its two canals – one to inject anti-coagulating saliva and one to suck up the blood. If the mosquito happens to be carrying the malaria parasite or other disease-causing germs when it bites someone the germs can be passed on in the saliva, and this is why mosquitoes are among the world's most dangerous insects. Male mosquitoes are unable to penetrate skin and they all feed on nectar.

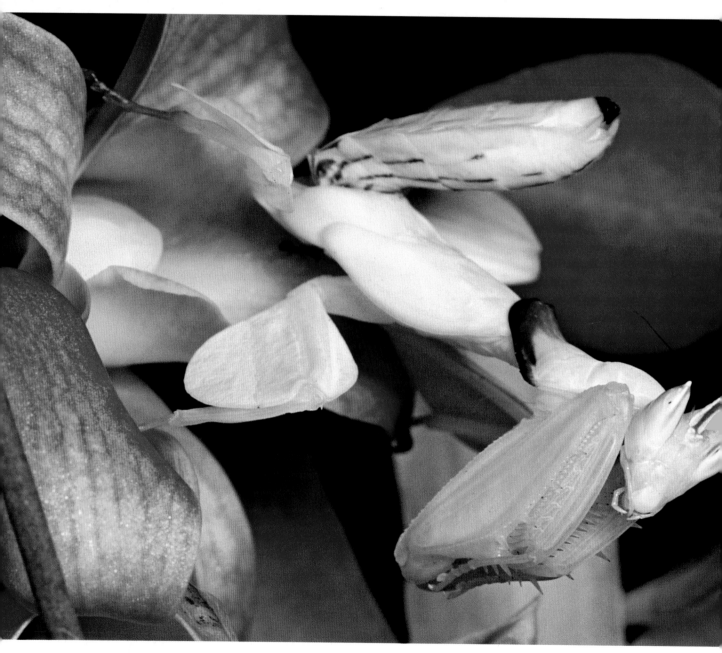

A Deadly 'Flower'

THE MALAYSIAN FLOWER MANTIS *(Hymenopus coronatus)* uses its incredibly flower-like appearance to deceive its prey. It normally sits unnoticed on pink or white flowers and when other insects visit the flowers to feed they are quickly grabbed in a fatal embrace. The up-raised abdomen and the outgrowths on its legs are so like petals that other insects mistake the mantis for a flower, even when it is sitting on the leaves.

Cave Lighting

LARVAE OF THE NEW ZEALAND GLOW-WORM *(Arachnocampa luminosa)* cling to the ceilings of water-filled caves in their thousands and dangle sticky threads from their bodies. Each larva produces light in the same way as the true glow-worm (see p. 223), although from a different part of its body, and the glow, reflected from the sticky globules coating the threads, can light up the whole cave. It attracts small flies, which become trapped on the threads and are then hauled up to be eaten by the larvae. The spectacle also attracts boat-loads of tourists, as seen here. *Arachnocampa* is a small midge and not related to the true glow-worms, which are beetles.

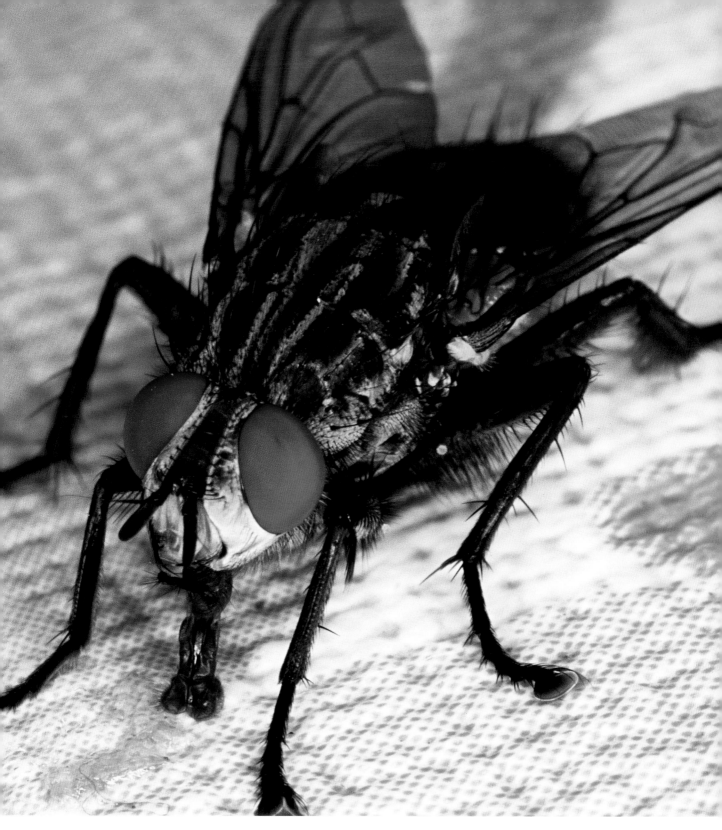

Mopping Up

THIS FLESH-FLY *(Sarcophaga carnaria)* is using the sponge-like tip of its proboscis to mop up some spilled juice on the tea table. House-flies and bluebottles all feed in the same way and, because they are just as likely to feed on dung and carrion as on our food, they are major carriers of disease, especially in warmer climates.

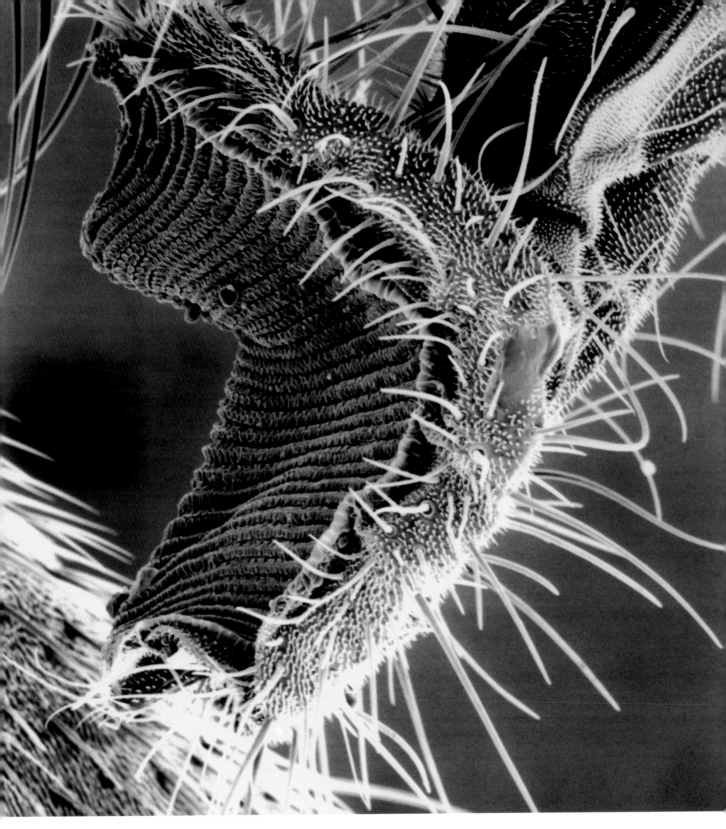

The Mop

THIS HIGHLY MAGNIFIED VIEW OF THE TIP of a fly's proboscis shows its spongy nature, with numerous fine channels through which its liquid food is sucked up and then pumped into the mouth. Saliva can also be dribbled out through these channels to dissolve solid food. (See also p. 35.)

115

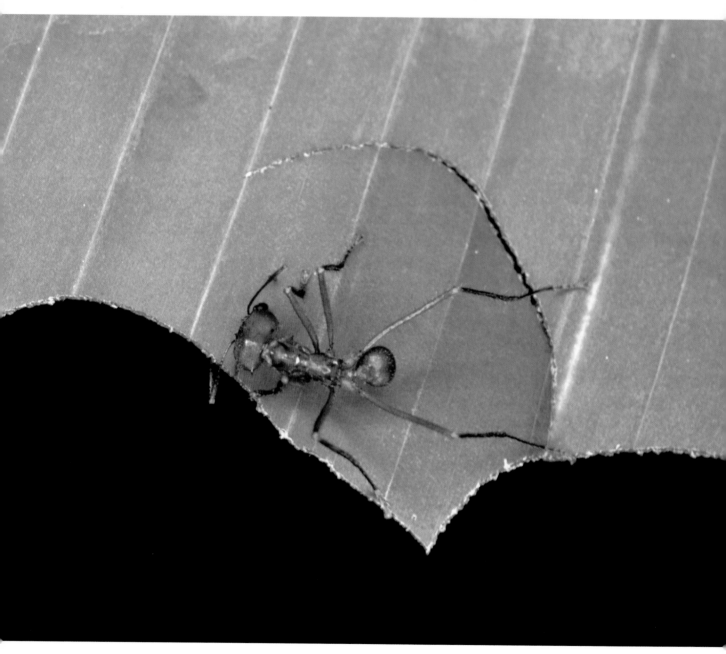

Crop-growing Ants

LEAF-CUTTER ANTS OF THE GENUS *ATTA* live in tropical America and stream out of their huge underground nests at sunset to attack the surrounding trees and shrubs. Using powerful, scissor-like jaws, they carve pieces from the leaves and then carry them back to the nest. But the ants are not about to eat the leaves. Smaller workers take the fragments and chew them to pulp, which they then heap up in special areas of the nest. Tiny mushrooms soon grow on the pulp, and these are what the ants rely on for food.

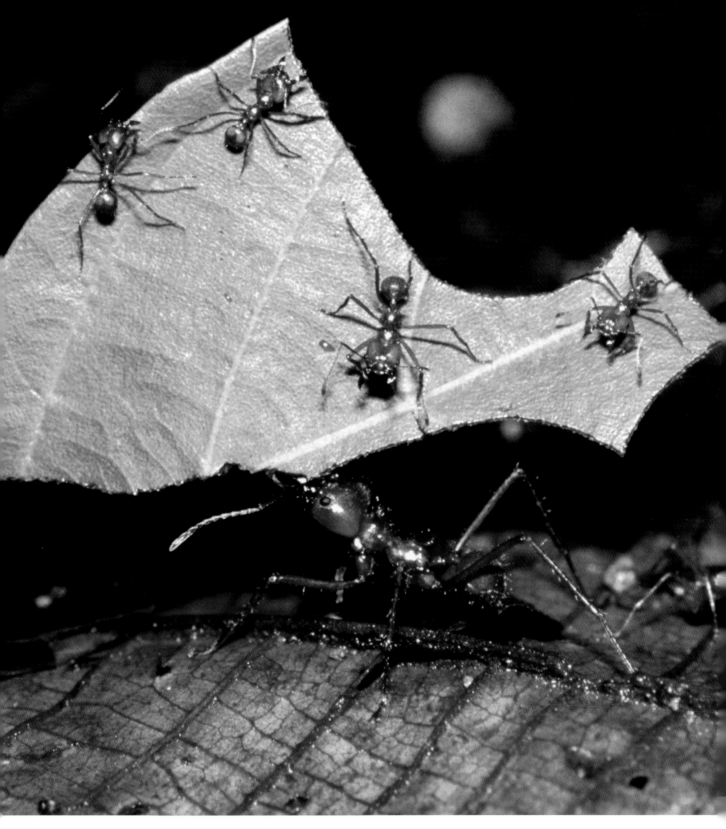

Riding Shotgun

CARRYING LEAF FRAGMENTS in their jaws, the leaf-cutter workers are unable to defend themselves against a deadly enemy – a tiny fly called *Apocephalus*, whose larvae eat out the ants' brains if they get the chance. But protection is afforded by small workers who ride on the leaf fragments and attack any flies that might try to lay their eggs on the leaf-carriers.

Living Larders

HONEY ANTS LIVE IN DESERT REGIONS, where nectar and other sweet foods such as honeydew are in short supply in the dry season. A certain proportion of the workers, known as repletes, do nothing but store up food in times of plenty. The other workers continually pour food into them and their bodies swell up so much that they cannot move. They simply hang from the ceilings of their subterranean chambers, and during dry periods they regurgitate the nectar when the other workers ask for it by stroking them. There may be over 1,500 repletes in a nest and desert-living people commonly take advantage of them.

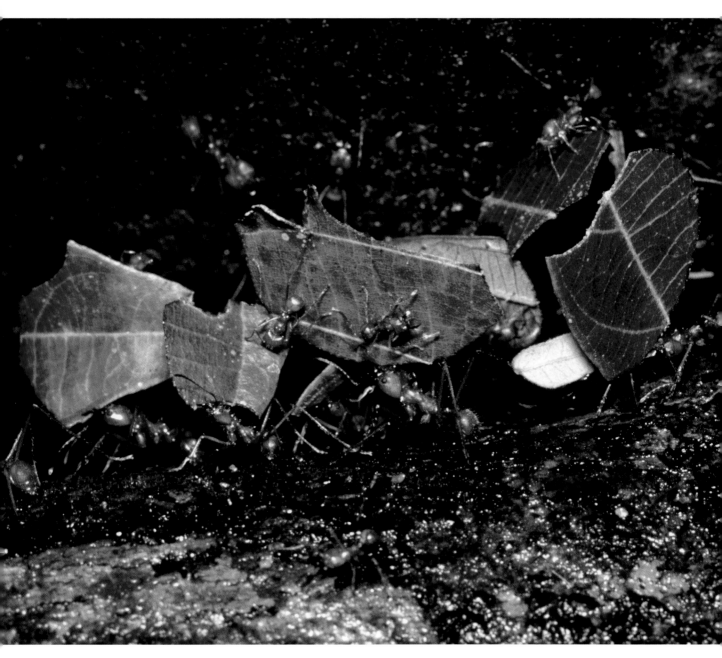

Long-distance Transport

LEAF-CUTTER ANTS commonly travel over 100 m/ 330 ft. from their nests to collect leaves, and with over 5 million ants in a single nest, large areas can be completely defoliated in a short time. Long lines of workers can be seen carrying leaf fragments in their jaws as they stream back to their nests. Because the ants carry the fragments over their heads, they are often known as parasol ants.

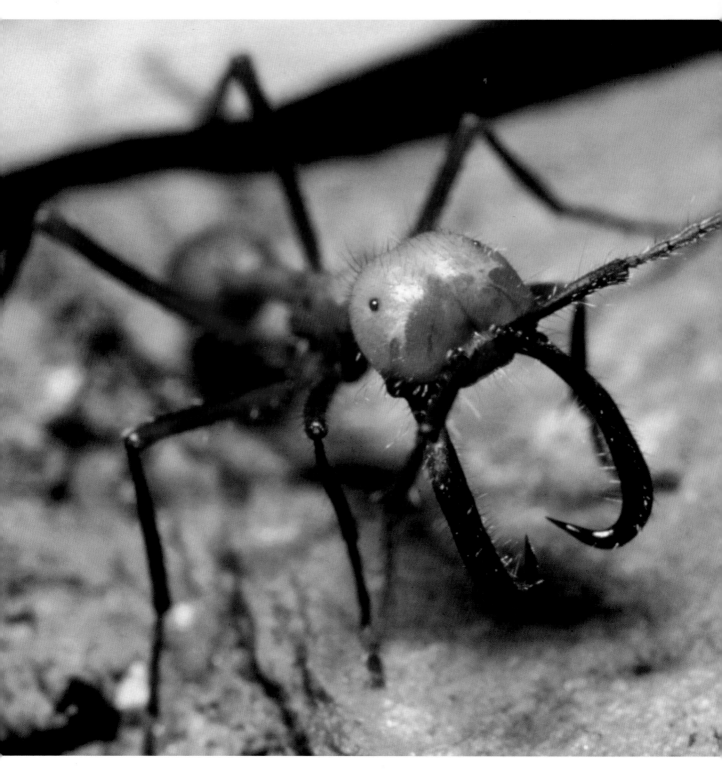

Surgical Jaws

THE IMMENSE JAWS OF AN ARMY ANT SOLDIER *(Eciton species)* are used primarily to defend the other ants when they are foraging. The soldiers march along the edges of the foraging columns, attacking potential predators and also ensuring that the smaller workers do not stray and expose themselves to danger. The jaws can deliver a painful bite and some South American people actually use them to sew up wounds: they encourage the ants to bite across cuts, and when the jaws close the heads are cut off, leaving the jaws in place like stitches.

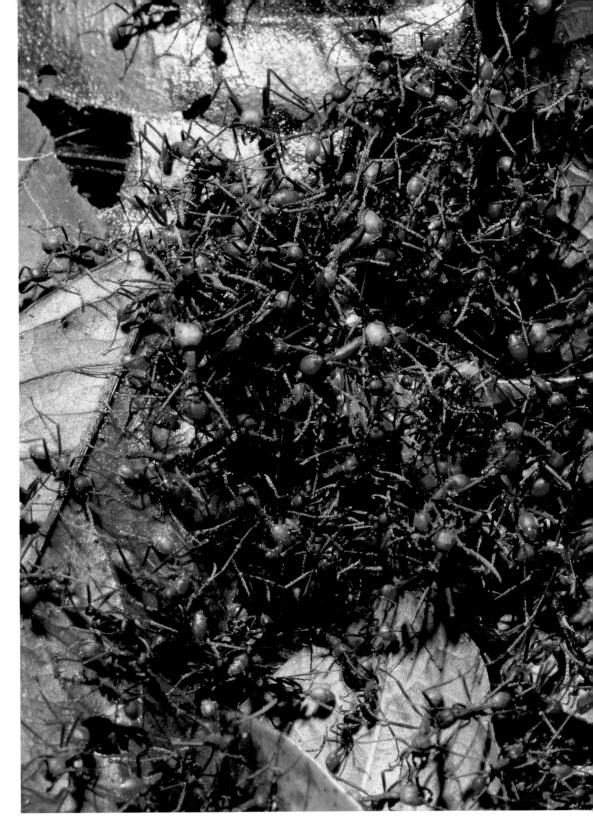

Sweeping the Floor

THE ARMY ANTS OF TROPICAL AMERICA live in immense colonies, each of which may contain several million individuals. Columns of ants fan out over the forest floor and overpower any animal that cannot escape. Even large snakes can be killed, although other insects make up the bulk of the army ants' food. Here a group of workers are dismembering a large grasshopper.

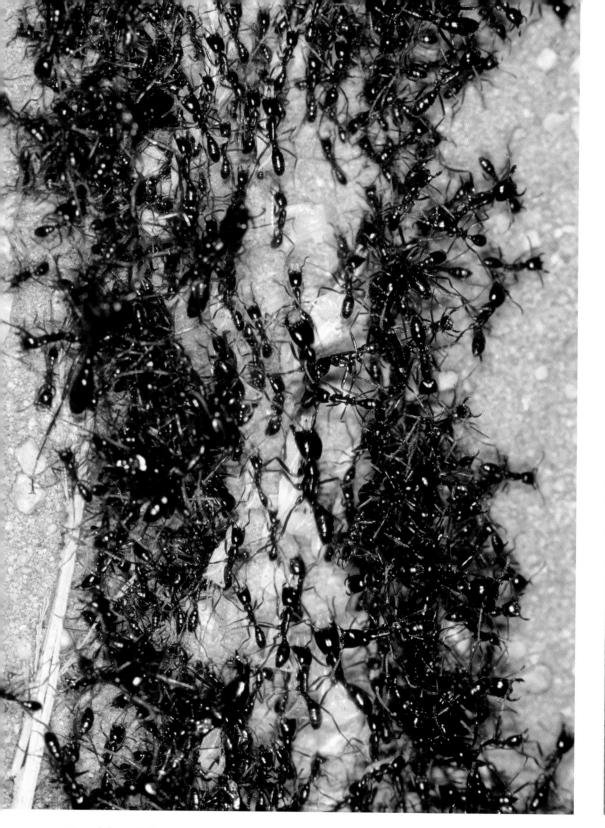

Marching Columns ...

AFRICA'S DRIVER ANTS LIVE IN IMMENSE COLONIES, some with well over a million individuals. Like the army ants of America (see p. 121), they have no permanent homes. They periodically move to new 'camps' and fresh feeding grounds. Here, the larger workers are carrying the larvae in the centre of the column. The largest larvae will develop into winged male ants, which are very much larger than the workers and are known as sausage flies.

... Up to 500 m Long

DRIVER ANTS HUNT ALL DAY LONG. Lengthy columns of workers stream out from the camp and fan out to collect their prey, and then re-join the column to march back to camp with their booty – mainly dismembered insects and other arthropods. Large soldier ants march on the outside of the column to protect it, as seen here, and they even form themselves into living bridges when the column needs to cross small gullies.

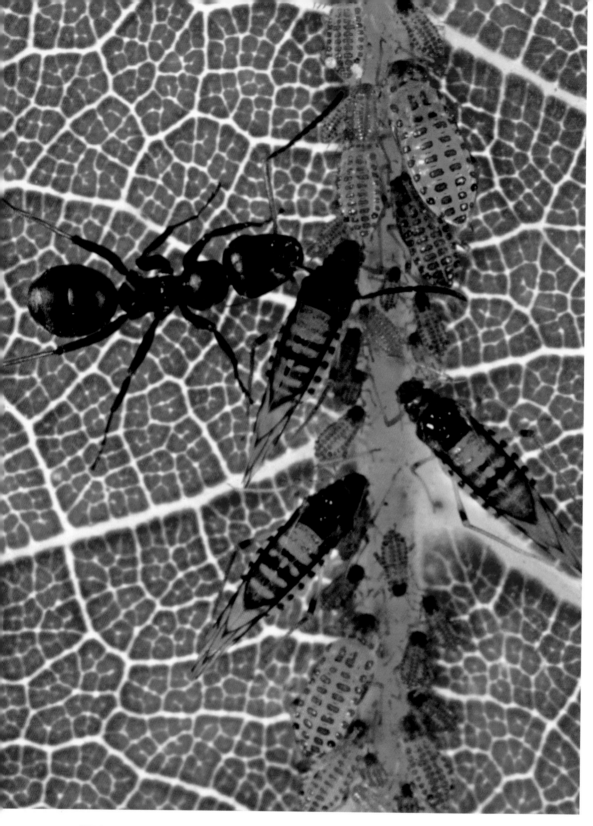

Milking Aphids

ANTS LOVE SWEET THINGS and one of their favourite foods is the honeydew exuded by aphids. Here, an ant is stroking aphids to encourage them to give out the sugary liquid. This is known as milking, and the aphids are frequently referred to as 'ant cows'. In return, the ants protect the aphids from enemies and sometimes tend the aphids in their nests (see p. 125). Aphids feed entirely on plant sap, which is rich in sugar but relatively poor in protein so to obtain enough body-building proteins, they have to take in far more sugar than they need. Most of it goes straight through and emerges at the other end as the sticky droplets of honeydew that the ants love.

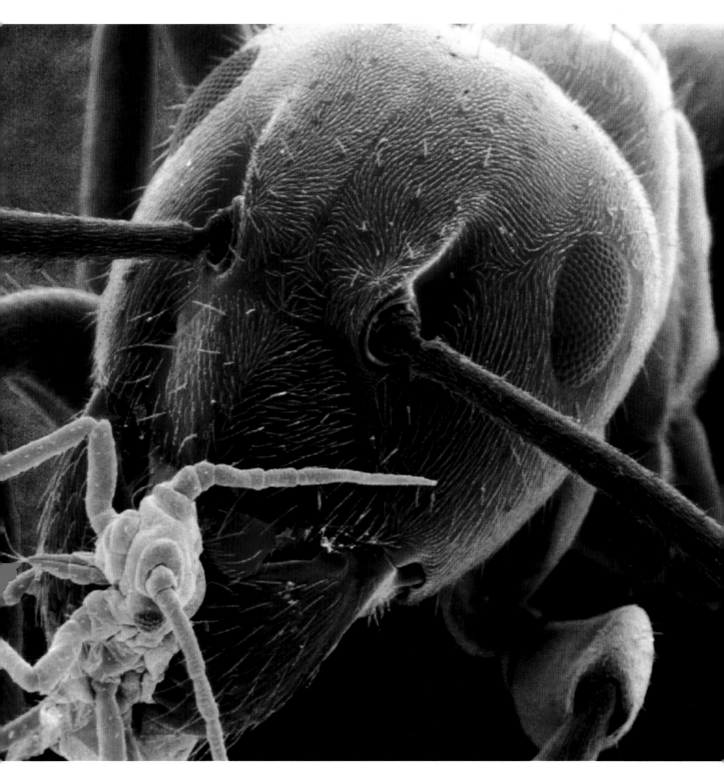

Pastures New

ANTS ARE SO KEEN ON THE HONEYDEW that they get from aphids that they often carry them to fresh pastures. Here, the common black ant *(Lasius niger)* is gently carrying a young aphid in its jaws. It will deposit the aphid on a fresh plant where it will find good quality food. Some ants even build 'cowsheds' around their aphid herds by piling soil particles around the bases of the plants, and aphids are also herded in many ants' nests, where they feed on roots and underground stems.

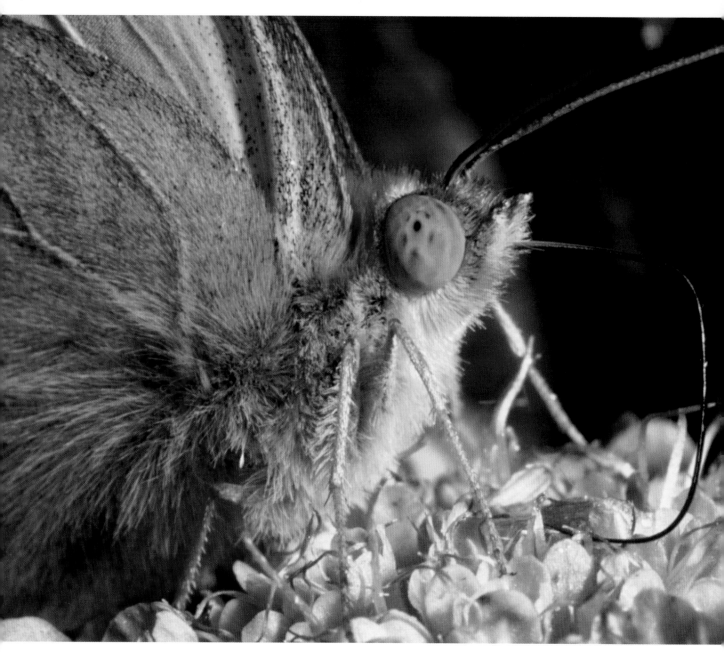

Probing Proboscis

THE BUTTERFLY'S PROBOSCIS HAS A FLEXIBLE KNEE-LIKE JOINT near the middle. This allows the insect to probe for nectar in several neighbouring flowers or florets without moving its whole body, thus using up valuable energy and possibly drawing attention to itself. Most butterflies go for nectar containing 20-35 per cent of sugar. If the nectar is weaker than this the insects may expend more energy than they acquire, and if it is much stronger it becomes sticky and more difficult to suck up.

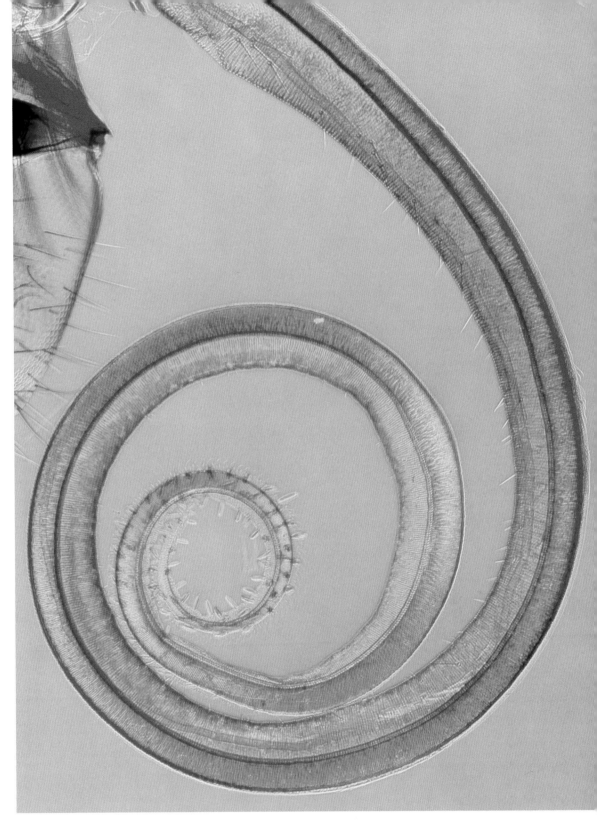

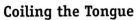

Coiling the Tongue

A BUTTERFLY'S PROBOSCIS may be several centimetres long. It consists of two concave strips, like miniature lengths of guttering, which the butterfly has to zip together to form a tube as soon as it leaves its chrysalis. Each strip contains muscles and nerves, as well as tracheae supplying them with oxygen. Muscles and blood pressure combine to uncoil the proboscis for feeding, and when the muscles relax the elasticity of the walls coils it up again (see also p. 32).

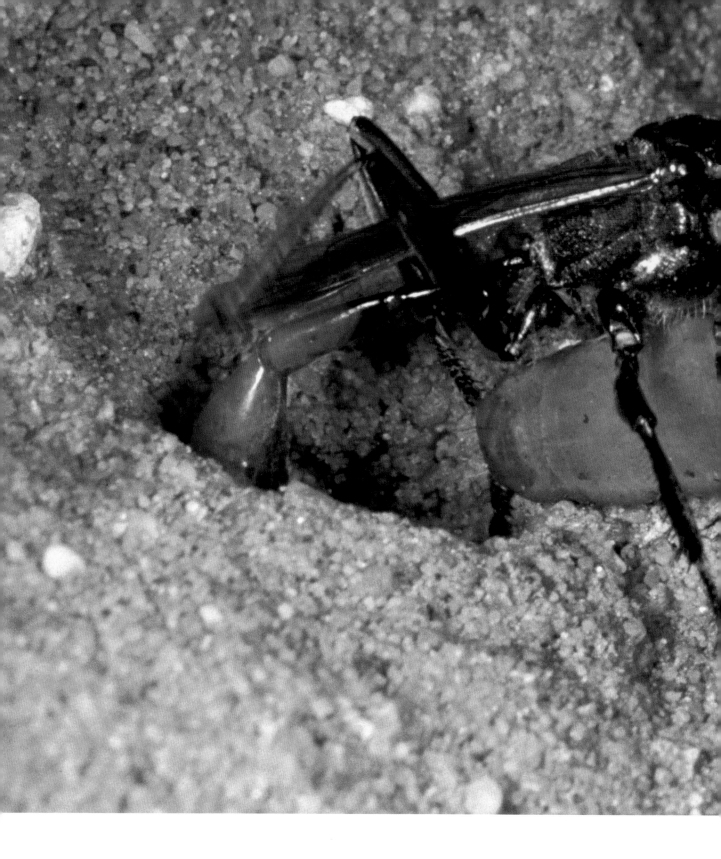

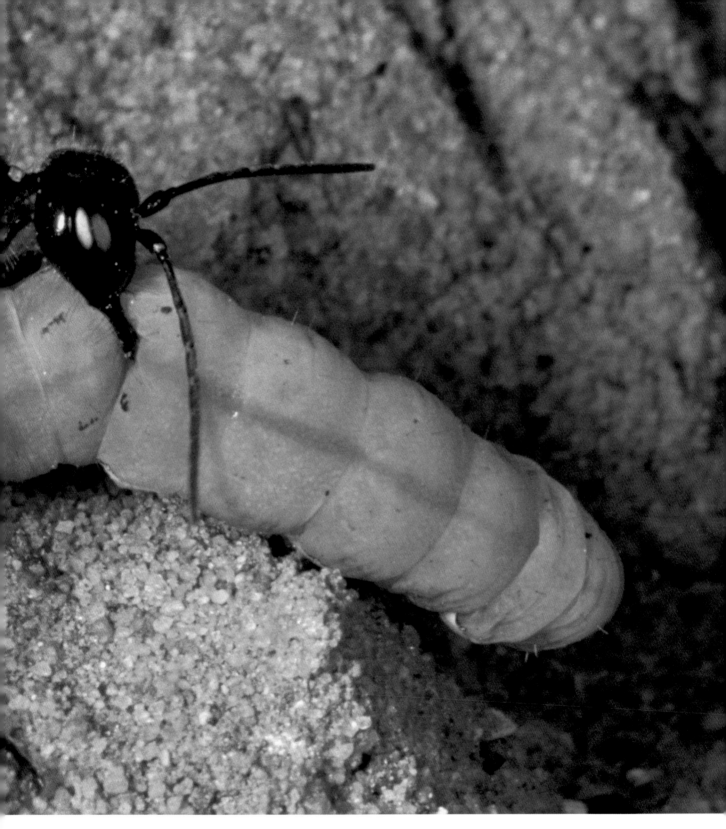

Bringing Home the Grub

THIS SAND WASP, *AMMOPHILA SABULOSA*, has made it back to its burrow with a plump caterpillar, which it has paralysed by stinging it. The caterpillar will feed the wasp's grub and, because it is paralysed and not dead, it will remain in good condition until the wasp grub has finished with it. Small caterpillars may be carried in flight, but larger ones are dragged over the ground, sometimes over distances of 50 m/164 ft. or more, showing that the wasp has an amazing sense of direction.

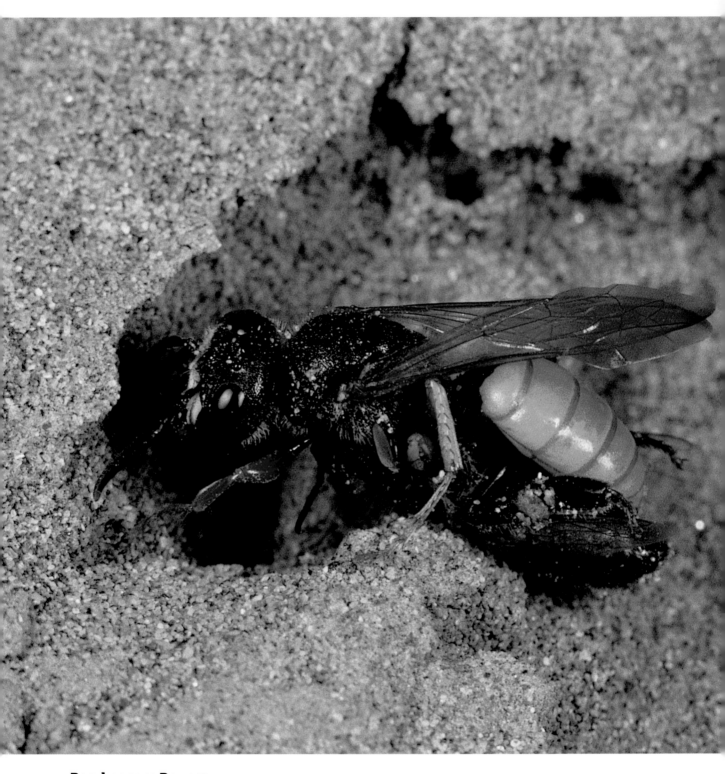

Bee-keepers Beware

THE BEE-KILLER WASP OR BEE-WOLF *(Philanthus triangulum)* specialises on honey-bees, which it normally catches and stings on flowers. The bee is quickly paralysed and, slung below the wasp's body, it is carried back to the nest – usually in a sandy bank. Each bee-killer may stockpile 10 or 12 bees as food for its larvae, so a large population can spell trouble for bee-keepers. Wasps returning to their nests may be accompanied by tiny flies. Known as satellite flies, they wait to nip in and lay their eggs or deposit their grubs on the bee. The fly grubs grow quickly and mature before the wasp larva can eat much of the bee.

130

INSECTS

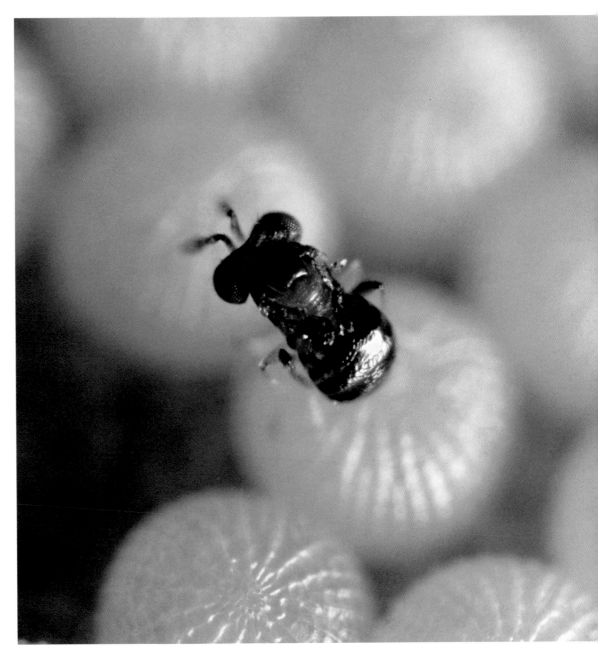

The Smallest Insects

EGG PARASITES INCLUDE SOME OF THE SMALLEST OF ALL INSECTS. They grow up inside the eggs of other insects. Many of them belong to a group of *hymenopterans* called chalcids. Here, one of the larger chalcids is laying an egg in an egg of the cabbage moth. The resulting grub will feed on the contents of the egg and then pupate inside it before emerging as a new adult chalcid. Some chalcids, known as fairy flies, have feathery wings spanning no more than a millimetre.

131

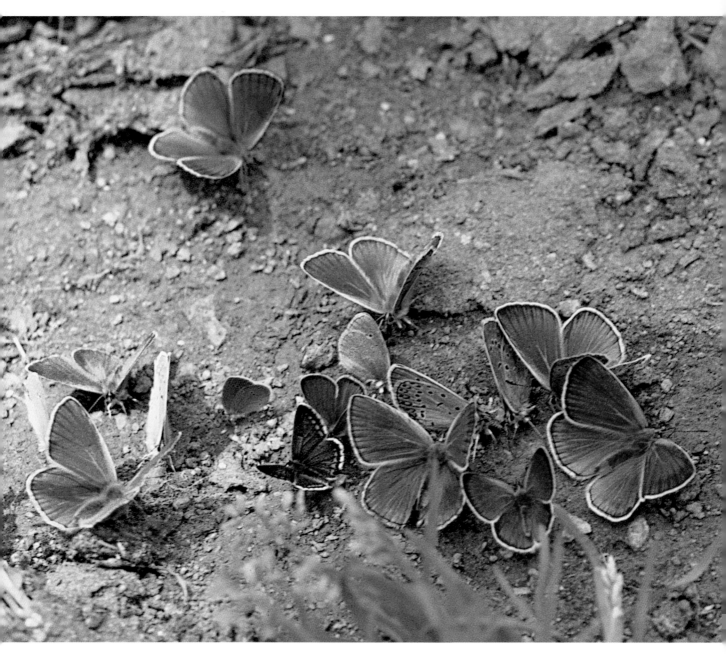

Mud, Mud, Nourishing Mud

BUTTERFLIES OFTEN GATHER TO PROBE DAMP PATCHES of ground with their tongues. This habit is known as mud-puddling and almost all of the insects in such gatherings are males. They are seeking sodium salts, which are necessary for the formation of the packets of sperm that they pass to the females when they mate. Mud-puddling is particularly obvious in dry regions, where patches of damp ground are usually confined to the edges of streams and seepages from hillsides and large numbers of butterflies may gather for a communal drink. Many species indulge in this habit but it is particularly prevalent amongst blue butterflies, as seen here.

Drinking in the Fog

ONYMACRIS UNGUICULARIS is one of a number of beetles living on the coastal dunes of south-west Africa. Rain is rare here, but the fog that regularly drifts in from the Atlantic early in the mornings provides the beetles with life-giving water. The insects sit head-down on the dunes and raise their bodies to face the on-shore breeze. Fog then condenses on the body and runs down to the head, where it is lapped up by the jaws. The beetles can take in nearly half of their body weight in this way.

Stealing from Spiders

SCORPION FLIES OF THE GENUS *PANORPA* are omnivorous scavengers and commonly steal dead insects from spider webs. This one is feasting on a damselfly. The insects are in no danger of becoming trapped in the web because they can dissolve the silk simply by spitting on it, and the spiders rarely attack them because the fluid that dissolves the silk also repels most spiders! Small spiders that get too close have even been known to get a clout from a scorpion fly's abdomen. The scorpion flies are commonly found in pairs in the webs, because a male usually attracts a female when he has found food.

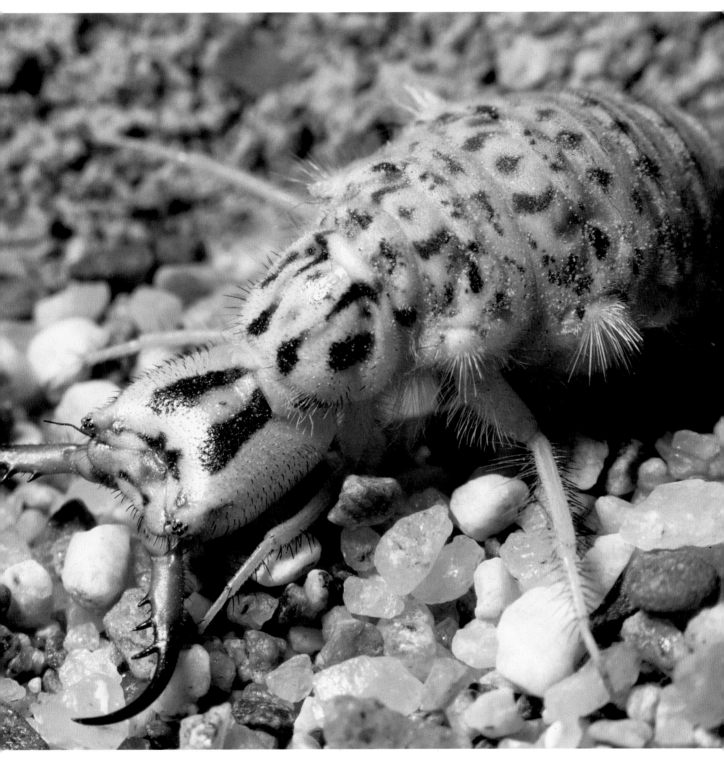

Death in the Sand

THIS ANT-LION LARVA *(Palpares libelluloides)* lurks in sandy ground with its powerful, toothy jaws at or just below the surface. Its bristly skin is sensitive to any vibration, and when another insect comes within range the ant-lion strikes. Its hollow jaws pierce the victim and quickly suck it dry. Some ant-lions dig conical pits in loose soil and lurk at the bottom, waiting for ants and other insects to tumble in. Adult ant-lions, also known as doodle-bugs, resemble dragonflies, but have a much slower and weaker flight and also have sturdy, clubbed antennae.

135

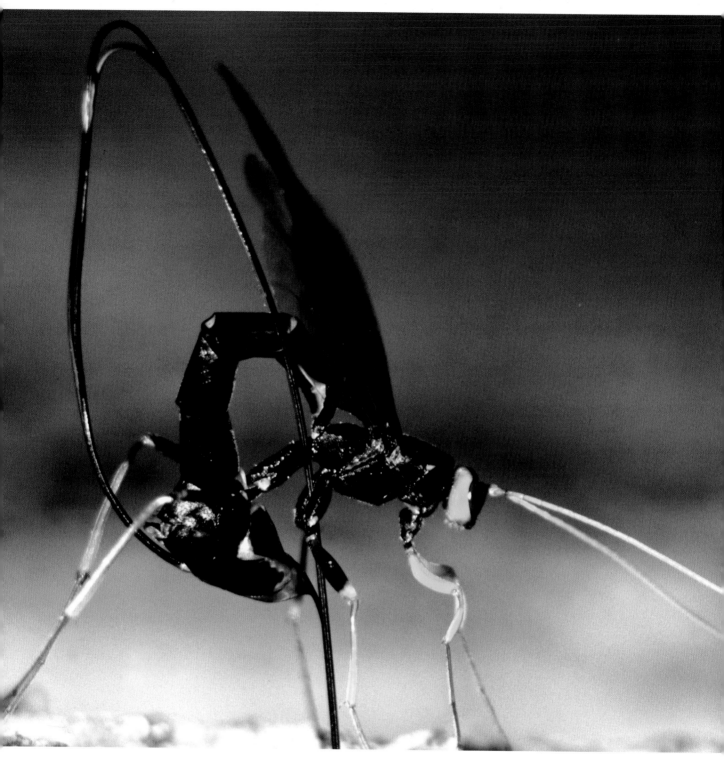

A Metal-tipped Drill

AN ICHNEUMON OF THE GENUS *MEGARHYSSA* uses an ovipositor longer than its own body to drill into a tree trunk and lay an egg on the grub of a wood wasp deep in the timber. The ichneumon detects the grub initially by the scent of its droppings and possibly by sound as well. The ovipositor sheath guides the ovipositor into position and is then pulled out of the way and arched over the body to let the ovipositor get to work. Although not much thicker than a human hair, the ovipositor twists this way and that and, aided by metallic compounds in its tip, it easily penetrates the timber. The egg is deformed as it passes down the tube, but regains its shape once it is free.

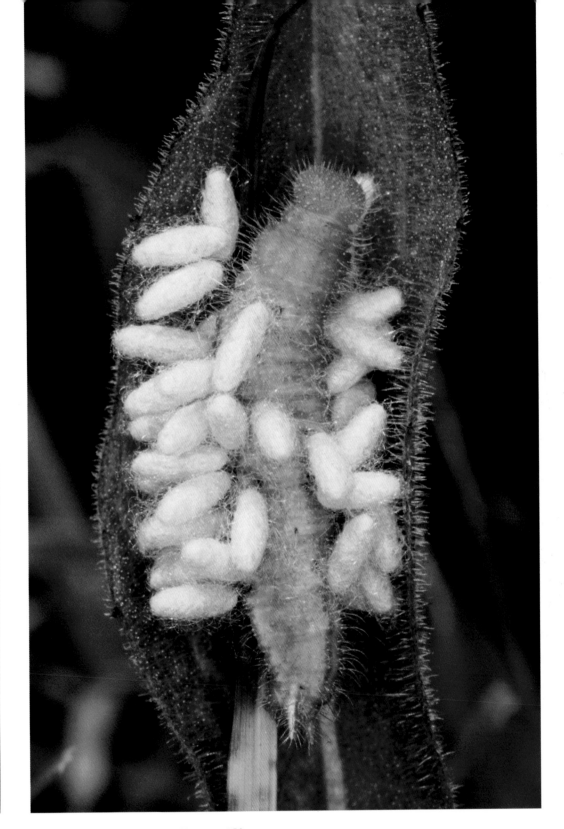

Eaten Alive

COCOONS OF TINY PARASITIC WASPS of the family *Braconidae* surround the corpse of their erstwhile host – the caterpillar of a large heath butterfly *(Coenonympha tullia)*. The parent wasp laid her eggs in the caterpillar and the resulting grubs gradually ate their way through it, avoiding the vital organs until the end. When fully grown the grubs tunnelled out of the host and spun their silken cocoons around the shrivelled skin. Nearly all butterfly and moth species are parasitised by some kind of braconid.

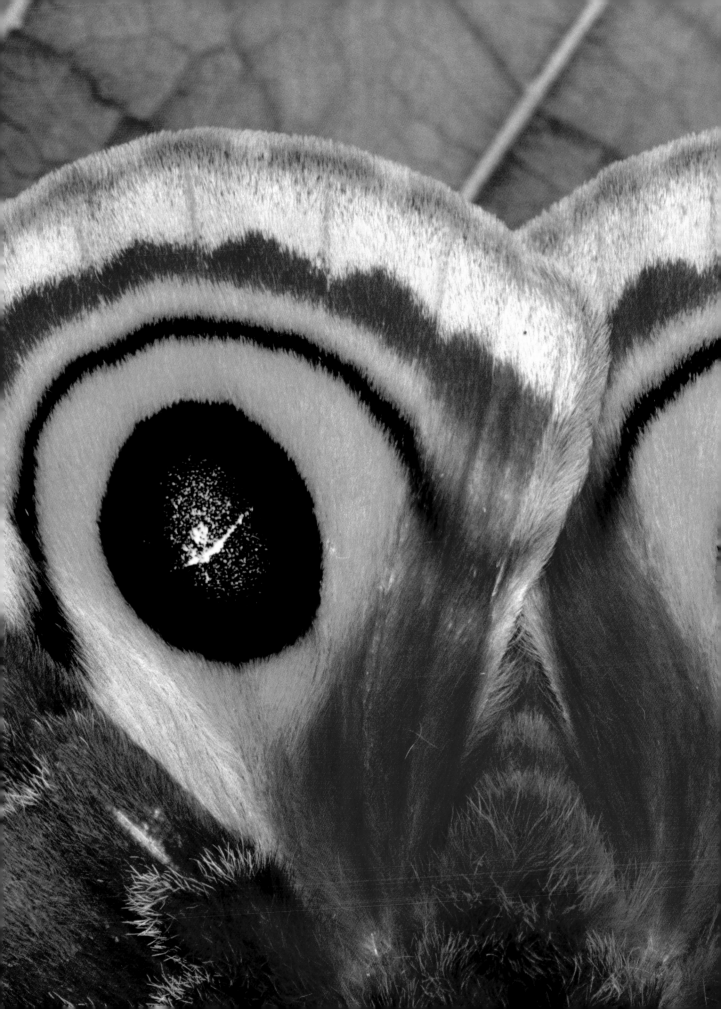

Camouflage and Defence

No matter how well an insect manages to feed itself, if it is to stay alive long enough to reproduce – the fundamental 'purpose' of all living things – it must also have some way of defending itself against the multitude of enemies waiting to attack it. Birds, lizards, amphibians, fishes, small mammals, spiders, and other insects are all major predators, and these are joined by a wide range of parasites. Many of the latter are themselves insects, especially flies and various wasp relatives, whose insidious behaviour has already been described.

Insects defend themselves with a fascinating array of physical and chemical weapons. Tough coats are enough to protect many insects, notably the beetles, and if these coats are augmented by spiny outgrowths the insects are even harder to bite or to swallow. Some armoured insects simply sit still and wait for their enemies to go away, but others defend themselves more energetically. Many grasshoppers and crickets, for example, have spiky legs and lash out with them if they are attacked. The large jaws of some ants and termites do a similar job. Even aphids can fight, kicking out with their legs and gumming up the jaws of their enemies with waxy secretions. At the same time, they secrete alarm pheromones – volatile chemicals that warn other aphids of the danger and ensure that they keep away.

Chemical defences include foul tastes, deterrent smells, and repellent or even blistering sprays. Many bees, wasps, and ants possess stings, with which they defend not just themselves but their whole colonies. At the same time they may emit alarm pheromones that summon more colony members to the battle. The spines and hairs of various caterpillars and other insects may be connected to poison-secreting glands and they can inflict a lot of pain and discomfort on any creature that tries to sample them.

Producing poisons or venoms uses a lot of energy and resources, and the insects usually discharge them only when actually molested. It is better to warn enemies of the possible consequences before they attack, and most poisonous insects do this by displaying bright colours or bold patterns – often a combination of red and black or yellow and black. Young predators may try the insects once or twice, but they soon learn to associate the warning colours with an unpleasant experience and leave the insects alone. But a brightly or boldly coloured insect is not necessarily poisonous: many harmless species have evolved colours similar to those of the poisonous species and thus gain protection. This phenomenon is called mimicry and it is particularly well developed in tropical butterflies and many hover-flies (see p. 193).

The safest means of defence is probably to evade detection altogether, and most insects rely on some form of camouflage to avoid being eaten. In the widest sense of the word, camouflage means deception or trickery, but the word is

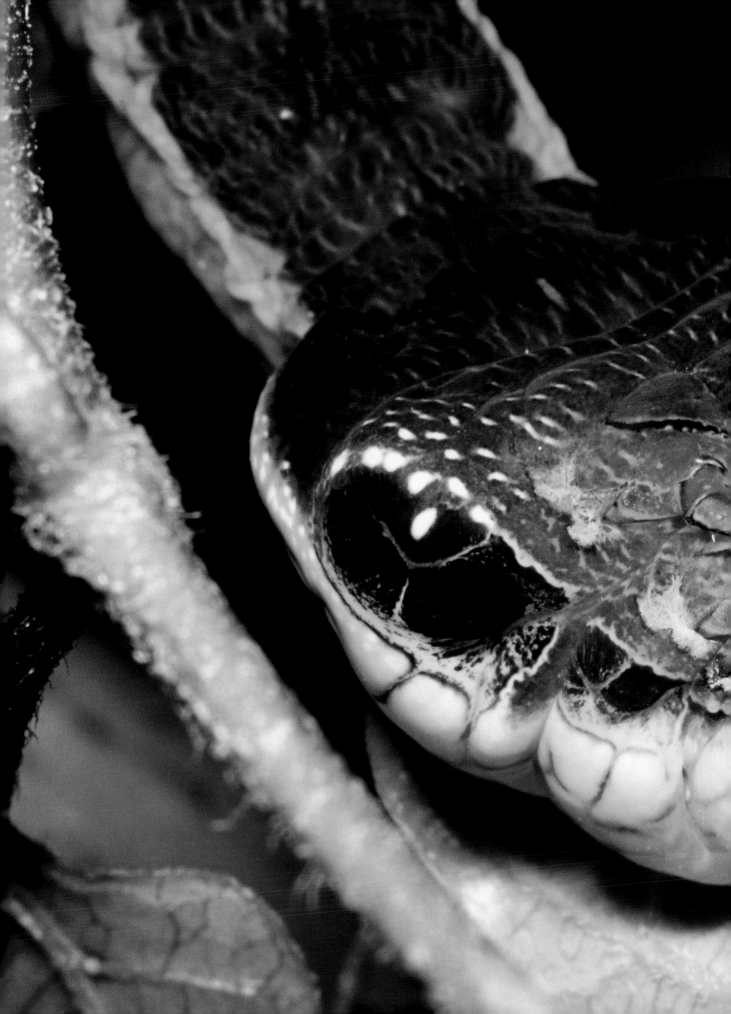

most commonly used to describe concealment from enemies. Mantids and some other predatory insects also use camouflage to hide from their prey. In its simplest form, known as crypsis, camouflage relies on colours that blend in with the surroundings and make the insects hard to spot. Grasshoppers that merge with grasses or with stony ground, and caterpillars that melt into their leafy backgrounds are good examples. Some moths that spend the daylight hours resting on tree trunks match their backgrounds so well that even experienced entomologists have difficulty in spotting them. Many of these moths exhibit contrasting stripes or blotches that break up the outlines of their wings and make them even more difficult to spot.

Many insects take things a bit further and actually resemble their surroundings – twigs or leaves, or even bird droppings! This form of camouflage is called protective resemblance. The insects may be quite obvious, but they are relatively safe because they resemble things that are of no interest to their predators. But there is no hard and fast division between crypsis and protective resemblance and the two grade into each other, with many intermediate examples. Protective resemblance is often called mimicry, but it is better to restrict the term to those instances in which the animals gain protection by resembling harmful species (see above). Mimics draw attention to themselves by means of bold colours, whereas protective resemblance is a way of avoiding attention.

Eye-spots of various kinds are used by numerous insects to deceive their enemies. Large eye-spots, resembling the eyes of cats or other mammals, are found on the hindwings of many moths and bush-crickets. The spots are normally concealed, but if the insects are disturbed they open their wings and reveal the 'eyes'. It is only bluff, but it works – birds draw back in alarm and few are brave enough to attack. Smaller eye-spots around the edges of the wings of many butterflies draw a predator's attention away from the head and towards the expendable wing-tips, while some insects have complete head-like patterns at the rear (see p. 154). Predators attacking these 'back-to-front' insects are totally confused when their quarry moves off in the 'wrong' direction.

The above examples can all be explained in terms of natural selection and the survival of the fittest. In each generation there is inevitably some variation: the insects might differ slightly in colour or pattern, or there may be minor differences in resting posture. Any variation making the insects more obvious is weeded out by predators, but anything that provides the slightest benefit is likely to result in longer life and a better chance of mating, with the consequence that the useful variations are passed to the next generation. Again, there will be variation, natural selection, and survival of the fittest. And so the process goes on, producing gradual improvements from generation to generation, resulting in the amazing examples that we see – or perhaps do not see – in the world today.

Snakes on the Mind

NOT A SNAKE, BUT A HARMLESS CATERPILLAR belonging to a species of *Hemeroplanes* from Costa Rica. The caterpillar normally rests upside-down and when alarmed it pulls in its head and legs and bends back to reveal its incredibly snake-like underside, complete with a scale-like pattern and large shiny 'eyes'. Many other caterpillars make similar use of eye-spots, often rearing up and thrashing about to enhance the snake-like appearance.

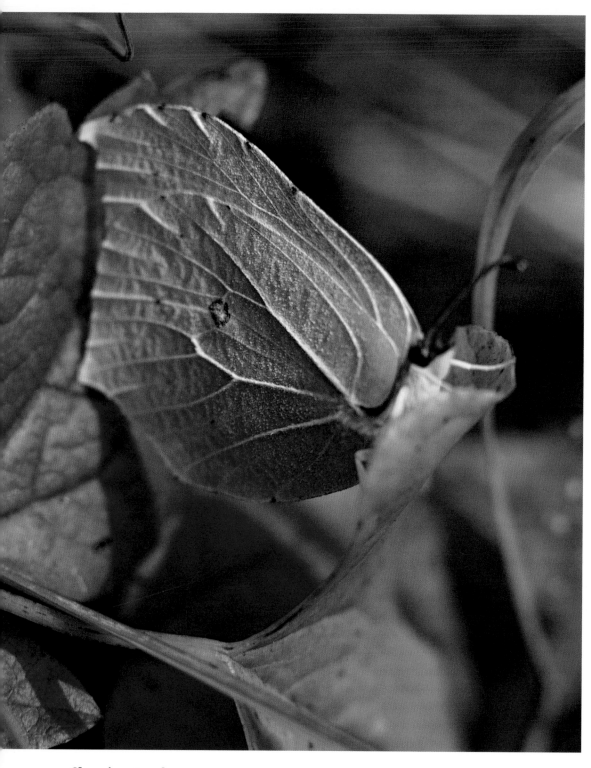

Sleeping Leaf

THE EUROPEAN BRIMSTONE BUTTERFLY *(Gonepteryx rhamni)* never opens its wings when resting and relies on its strongly-veined, leaf-like underside to camouflage it amongst the foliage. The female's upperside is greenish white, but the male has a brilliant yellow upperside and he would be very conspicuous with his wings open. The adult butterfly can live for up to a year, but it spends the winter months asleep, usually in evergreen trees or shrubs where its camouflage serves it well.

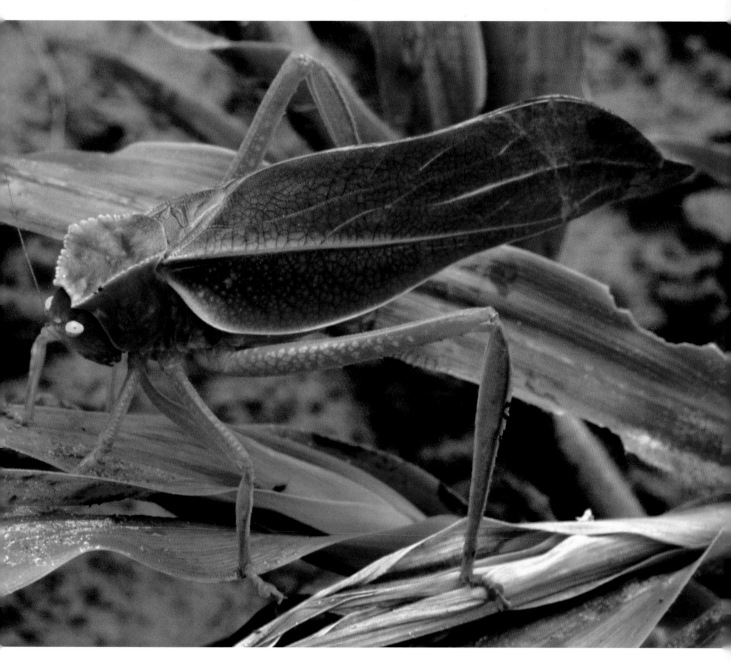

Disappearing Trick

SO GRASS-LIKE IS THIS BUSH CRICKET OR KATYDID from the Amazonian rain forest that it is almost impossible to spot it from even a short distance. Its whole body, including the legs, are grass green and its wing veins are easily mistaken for the veins of the leaves. Only its eyes give the insect away. The resemblance of animals to plants in this way is sometimes called phytomimesis.

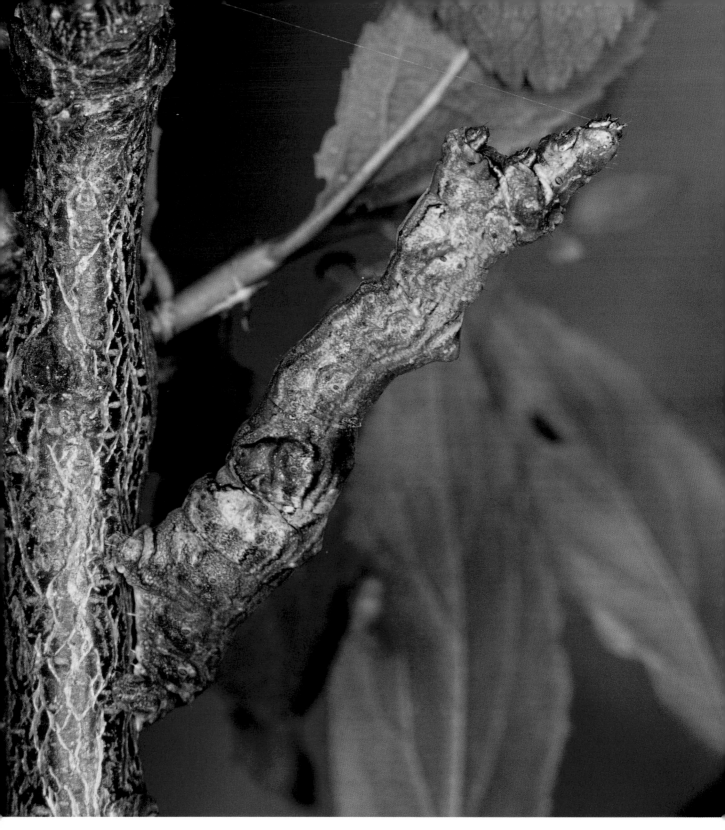

Sticking Up for Itself

THE CATERPILLAR OF THE EARLY THORN MOTH *(Selenia dentaria)* is easily mistaken for a twig, but only if it adopts the right posture: at rest, it clings to a twig with its back legs and holds its body at just the right angle to match the surrounding twigs. But it does not rely entirely on muscle power to hold itself in position – a silken thread running from its mouth to the twig gives it extra support. Wart-like outgrowths on its body resemble buds and complete the illusion.

INSECTS

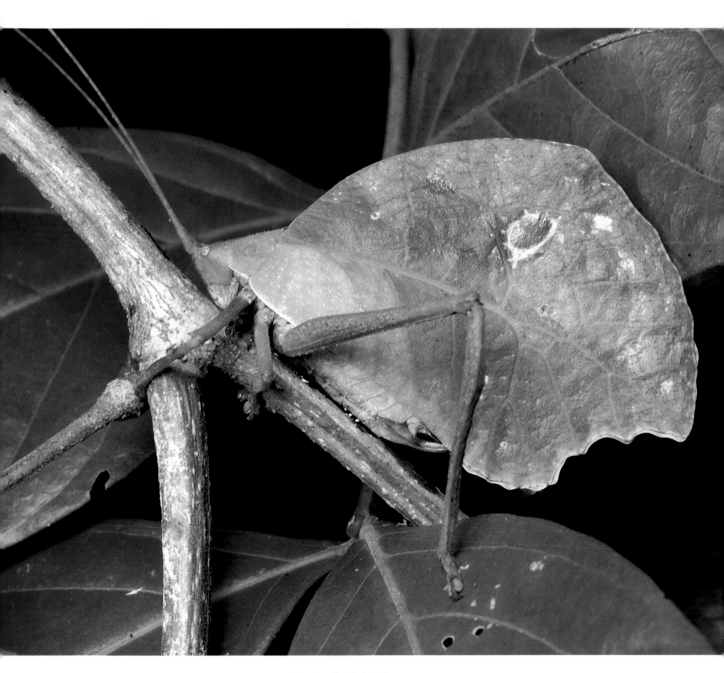

Not what it Seems

THE BUSH CRICKET *TYPOPHYLLUM LUNATUM* from Amazonia is so incredibly leaf-like that it can
spend all day fully exposed on the vegetation without fear of attack. Its colour and the veins on
its wings match the surrounding leaves perfectly, and the indented rear margin looks just as if it
has been nibbled. Pale patches on the wings look like blemishes and the insect may even sway
gently on its long legs to imitate the movement of the leaves in the breeze.

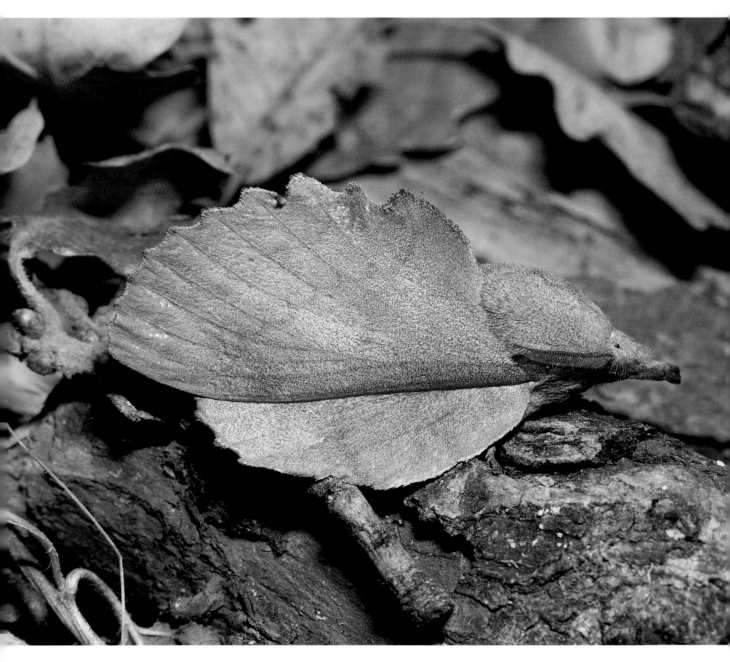

Dead Leaf or Living Moth?

THE EUROPEAN LAPPET MOTH *(Gastropacha quercifolia)* adopts an unusual resting position, with its hind wings more or less flat and the forewings held tent-like above them. Whether the insect is resting on the ground or on the vegetation, the scalloped wing margins and the strong veins create an astonishing likeness to a dead leaf. The front edge of the forewing could be mistaken for the mid-rib of a leaf, and the resemblance is completed by the palps, which project forward from the head and resemble a leaf stalk.

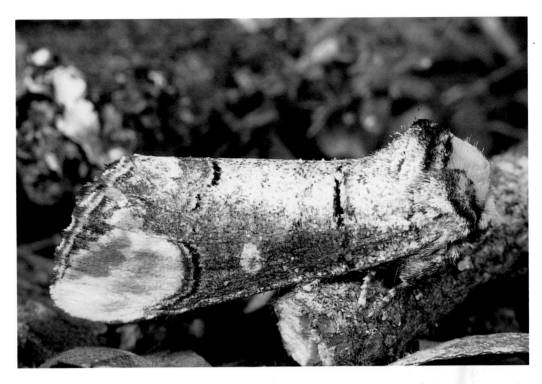

A Double Defence

THE BUFF TIP MOTH *(Phalera bucephala)* normally rests on the ground, with its silvery grey wings wrapped tightly around its body. The pale brown hairs on its thorax and the pale wing-tips give it a strong resemblance to a broken twig and few predators give it a second glance. If it is molested it can fire a stream of excrement at the enemy. Its caterpillar feeds on a wide variety of trees and has an unpleasant taste, which it advertises with its bold black and yellow coloration.

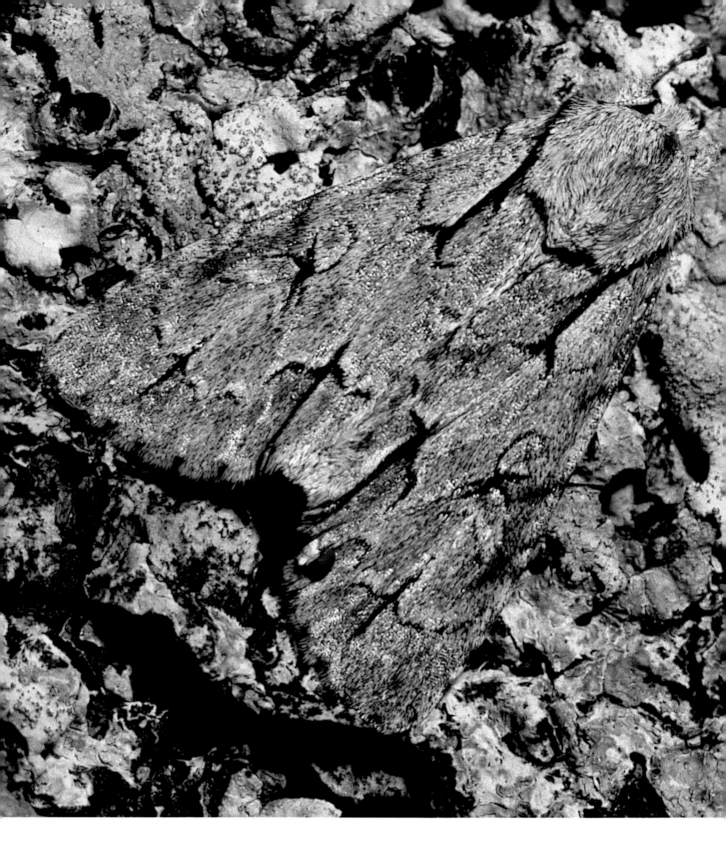

148

The Right Choice

THE GREY DAGGER MOTH *(Acronicta psi)* is hard to see because it blends so well with the lichen-covered bark on on which it is resting. Experimental work suggests that moths and other insects instinctively choose backgrounds that match their own colours, so they rarely settle down to rest on unsuitable surfaces.

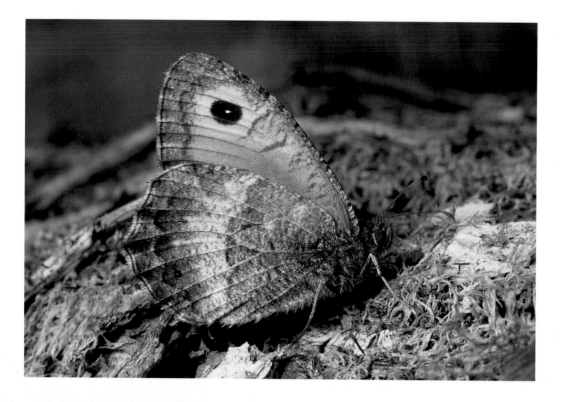

Now you See Me, Now you Don't

THE FALSE GRAYLING *(Arethusana arethusa)*, in common with many of its relatives, exposes the prominent eye-spot near its wing-tip when it first lands. If nothing attacks it within a few seconds the butterfly feels safe and lowers its front wings to cover the eye-spot. It then blends beautifully with the dry grass and other vegetation and it is very hard to detect. It may even lean towards the sun to reduce any shadow cast by its wings.

See-through Wings

GLASS-WING BUTTERFLIES, such as this species of *Greta*, live in the forests of tropical America
and are very easily overlooked because their transparent wings, with very few scales, render them
almost invisible against the flowers and other vegetation.

Safety in Numbers

THE EUROPEAN FIREBUG *(Pyrrhocoris apterus)* has no need to hide. It relies on its bold warning colours to keep most predators away, and the warning is intensified by the fact that the bugs usually feed and mate in dense clusters, either on the ground or on the vegetation. Chemical attractants emitted by the bugs cause them to congregate. But not all predators take notice of the warning: toads and some birds ignore the signals entirely and tuck in to the bugs with impunity. When this happens, the bugs emit another chemical signal that causes them to disperse, so they don't all get eaten.

A Thorny Problem

THORN BUGS *(Umbonica crassicornus)* have sharp spines on their backs and bear a remarkable similarity to natural thorns when clustered on a twig. Most predators are probably fooled by this camouflage, but even if they are not deceived they are unlikely to bother with these spiky creatures.

153

Back-to-Front Deception

THIS AFRICAN BUTTERFLY *(Hypolycaena lebona)*, belonging to the 'blue' family *(Lycaenidae)*, is one of numerous species known as back-to-front butterflies because of the head-like pattern on the hindwings. This species even has ribbon-like extensions resembling antennae. The butterflies draw attention to their false heads by moving their hindwings up and down. Any bird spotting such a butterfly will inevitably go for the conspicuous eye-spot at the 'wrong' end, and will get no more than a expendable fragment of the wing when the insect disappears in an unexpected direction. Quite a number of bugs and beetles have also evolved back-to-front designs.

INSECTS

A Scary 'Face'

THE EUROPEAN EMPEROR MOTH *(Saturnia pavonia)* is a harmless insect, but to a small bird flying over the vegetation and seeing the moth head-on, it may appear quite scary. The dark thorax and large eye-spots bear a striking resemblance to the head of a cat or some other predatory mammal.

Flashing False Eyes

THE EUROPEAN EYED HAWKMOTH *(Smerinthus ocellata)* is quite well concealed when resting on the rough bark of a tree trunk (top), but if it is disturbed it bluffs its way out of trouble by lifting its forewings and exposing the very realistic eye-spots on the hindwings (bottom). It may fall to the ground, but it continues to display, and it commonly enhances the effect by heaving its body up and down. Confronted with what could be the eyes of a cat or an owl, small birds back off in alarm.

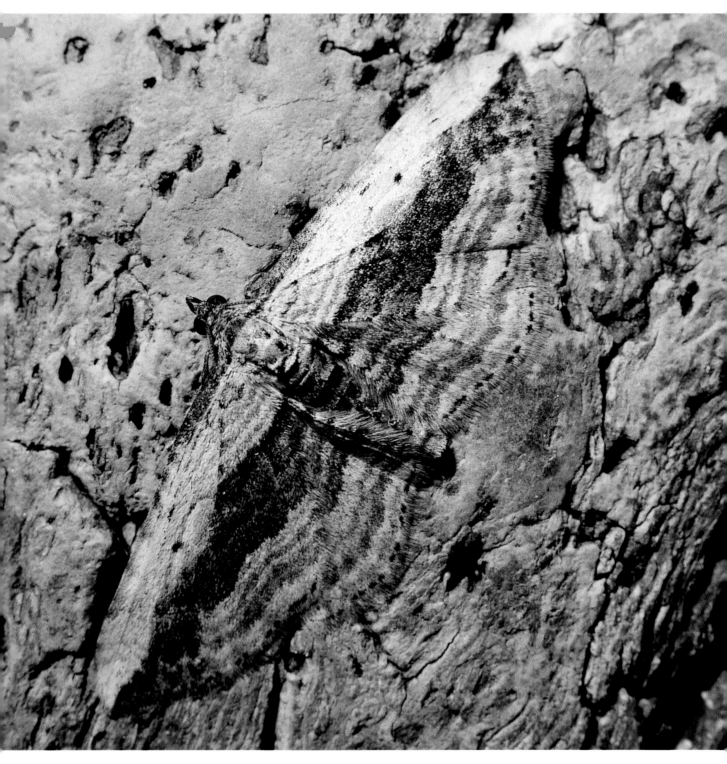

Hiding the Shape

THE SMALL WAVED UMBER MOTH *(Horisme vitalbata)* is difficult to see when at rest on a tree trunk because the contrasting stripes on its wings draw the eye away from the outline and break up the shape. But this disruptive coloration works only if the moth sits in the right position. It habitually rests with its body horizontal, so the wing pattern is automatically lined up with the bark crevices. If the moth came to rest in an upright position it would stick out like the proverbial sore thumb.

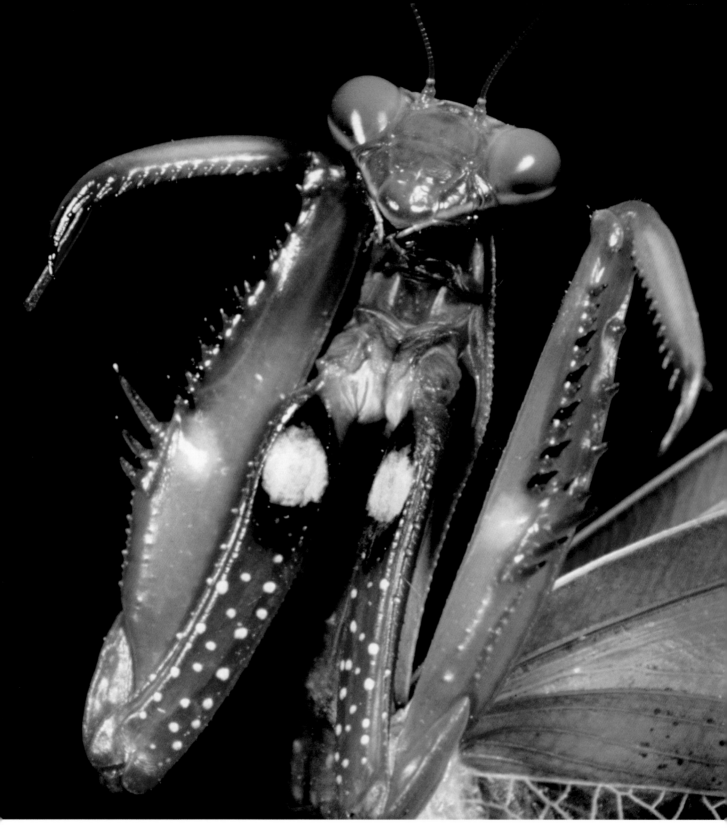

A Menacing Display

THE PRAYING MANTIS *(Mantis religiosa)* is not easy to see when resting or stalking prey on the vegetation, but if a predator does spot it the mantis immediately adopts a threatening posture. Up go the spiky front legs to reveal the false eyes and the wings are raised to make the whole insect look much larger than it really is. At the same time the insect makes a loud hissing sound by rubbing its abdomen against its rather stiff wings. Although it is all bluff, this display is likely to put off all but the most determined adversary.

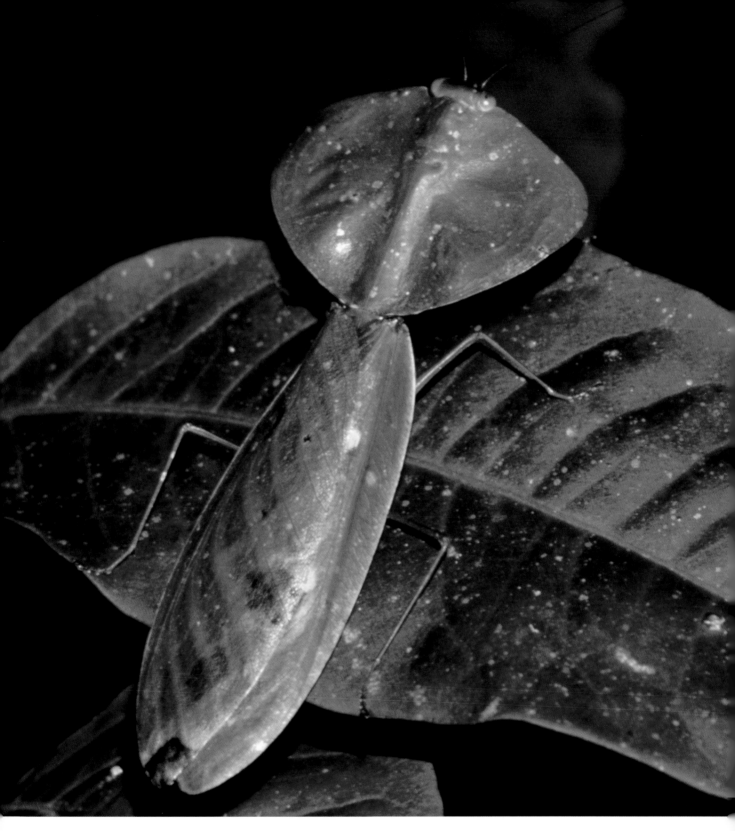

A Remarkable Resemblance

THIS MANTIS FROM CENTRAL AMERICA fools both predators and prey with its leaf-like appearance. The broad flanges extending from its neck and the smoothly rounded wings give the insect an amazing similarity to a chewed leaf. Delicate veins on the wings resemble those of the surrounding leaves, and if the insect had taken up a position along the leaf instead of lying across it the deception would have been complete.

Eyes Up (Right)

THE PEACOCK KATYDID *(Pterochroza ocellata),* a South American bush cricket, looks like a dead leaf when at rest, but frightens its predators by lifting its wings and exposing the large eye-spots on the hind wings. Experiments have shown that most birds, and many other small animals, are inherently scared of sudden flashes of colour, especially of rounded patches, and the more eye-like they are the more frightening they appear, so natural selection has tended to produce incredibly good imitation eyes on a variety of insects.

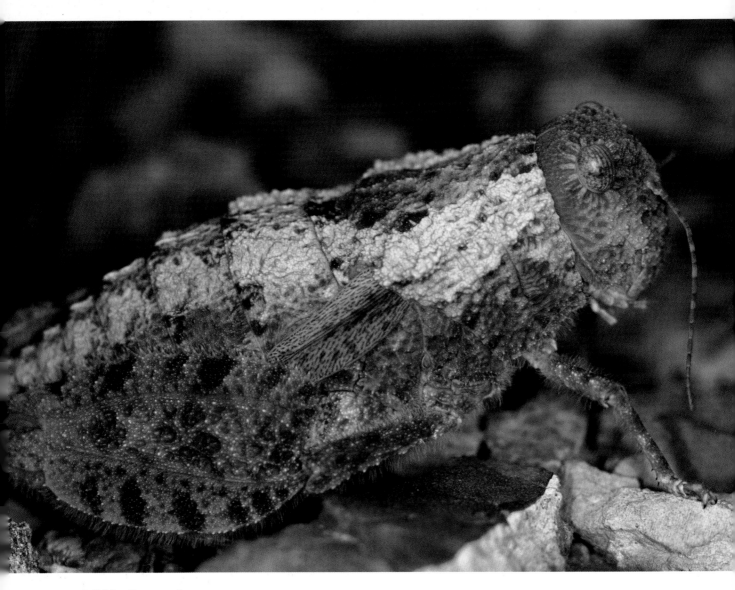

Pebble Protection

160 A CHUNKY GRASSHOPPER from Namibia is perfectly camouflaged to resemble the pebbles on the floor of its desert home. Many grasshoppers and other desert-living insects have evolved this form of protective resemblance.

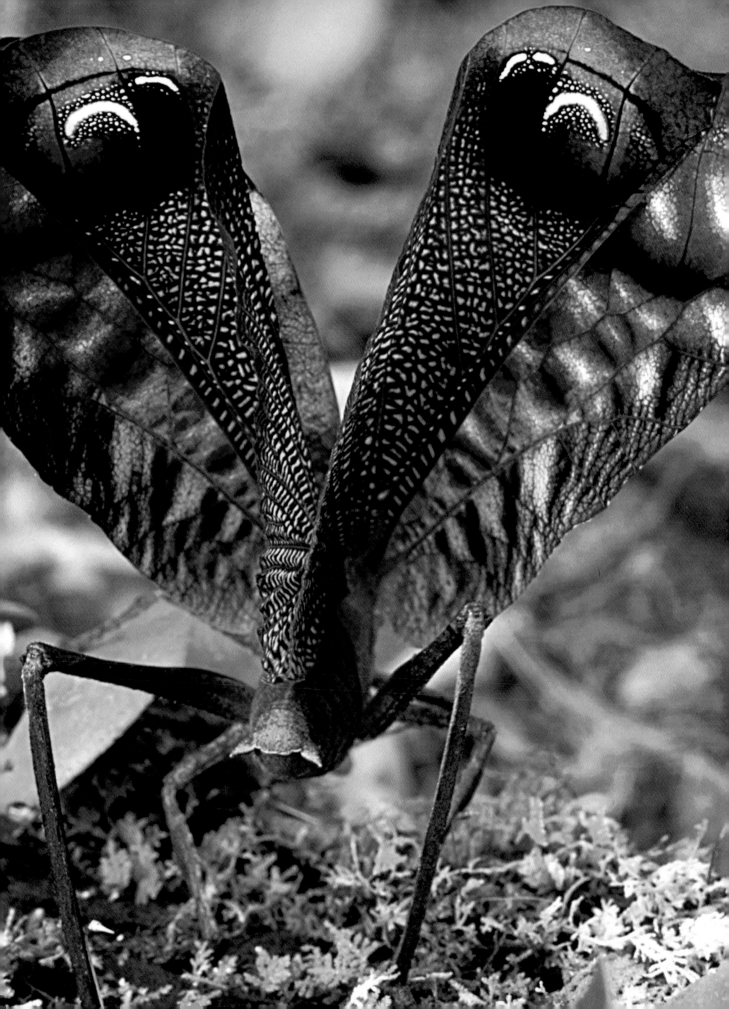

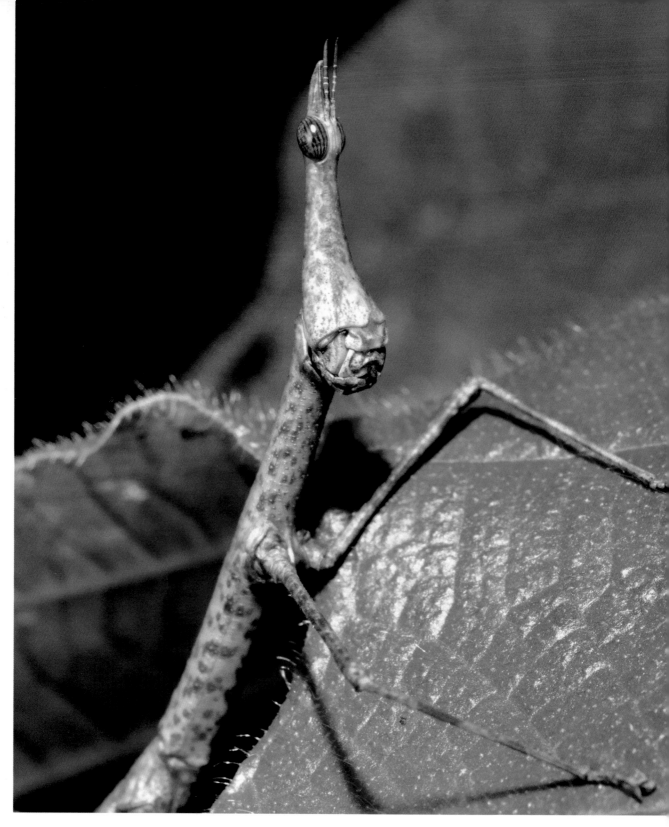

Jumping Stick

NOT A TWIG OR EVEN A STICK INSECT, this strange creature is a wingless grasshopper, much modified for life in the rain forest. It belongs to a small family called the *Proscopiidae*, which occurs only in South America. The long, pointed head, with the eyes near the top, is typical of the family.

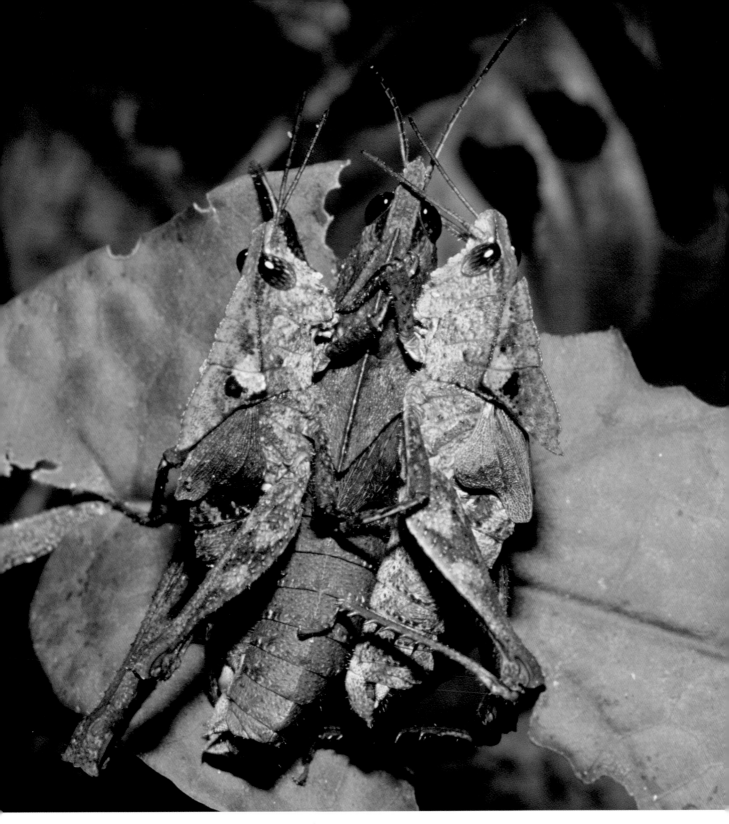

Adaptable Grasshoppers

LOOKING LIKE A BUNCH OF DEAD LEAVES, two male grasshoppers are attempting to mate with the central female. Grasshoppers are very variable insects, having evolved a wide range of form and behaviour that enables them to live in a wide variety of habitats, from rain forests to deserts and mountain tops. The insects in this photograph live on the ground in the South American rain forest, where the leaf litter affords them both protection and food.

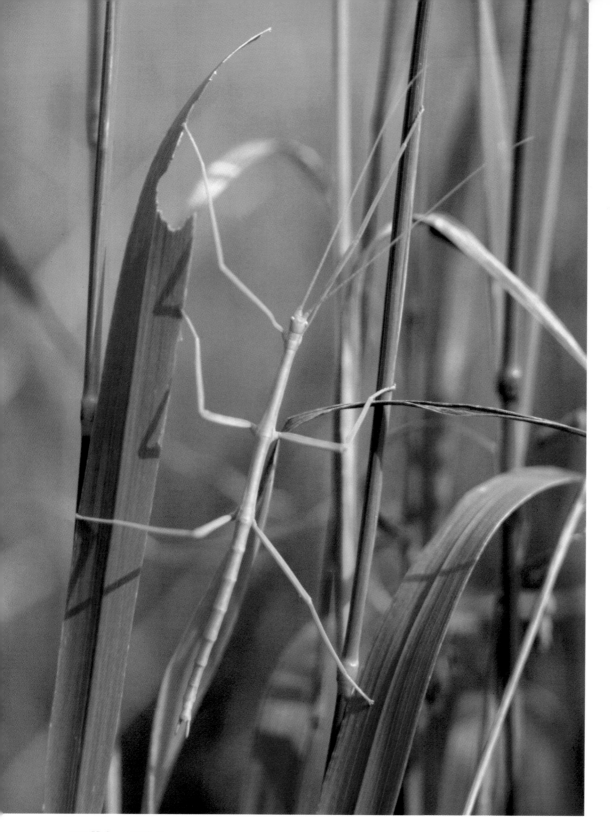

Walking Sticks

STICK INSECTS, ALSO KNOWN AS WALKING STICKS, are mostly long and slender creatures showing remarkable similarities to twigs and other plant stems. All are vegetarians. Some are winged and some, like this species of *Diapheromera* from North America, are completely wingless. Many species imitate the action of leaves and stems by swaying gently from time to time, as if disturbed by the breeze, and if they are disturbed they may become rigid, pulling their legs in line with the body and falling to the ground like broken twigs.

Leafy Imitation

LEAF INSECTS live in south-east Asia and are closely related to the stick insects. The broad, flat abdomen and the strongly-veined front wings are very leaf like and the flanges on the legs look very much like chewed leaves. The camouflage may be enhanced by swaying gently, as if rocked by the breeze, but otherwise the insects sit very still. They usually rest by day and feed by night, when most birds are asleep. They are all vegetarians.

165

Colourful Warning

THE COLOURFUL COATS OF LADYBIRDS warn of the insects' disagreeable taste – well known to anyone who has handled the insects and been daubed with their pungent yellow secretions. The fluid is actually blood, which contains several very bitter alkaloids and oozes out through pores in the leg joints. The warning is particularly effective when the insects cluster together to bask in the sunshine before and after hibernation. They usually hibernate in clusters as well and use the same sites year after year. These sites inevitably pick up some of the insects' smell and this is probably what attracts the next winter's hibernators.

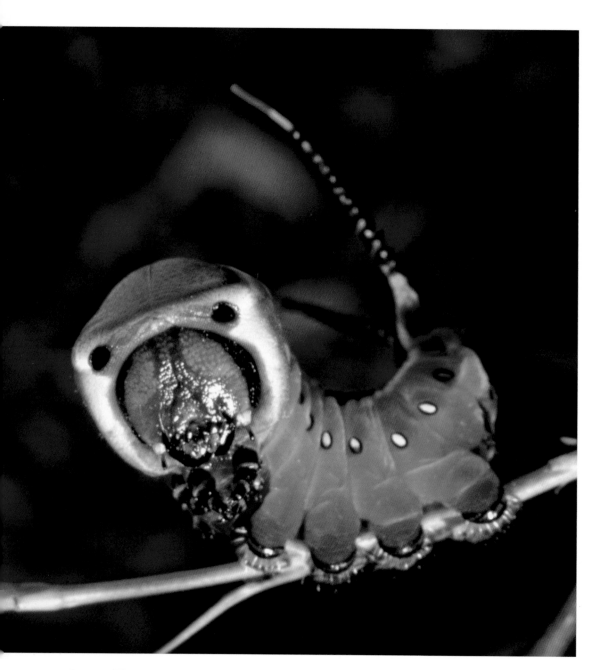

Caterpillar Weapons

THE PUSS MOTH CATERPILLAR *(Cerura vinula)* has a dark saddle-shaped patch on its back (not obvious in the photograph) and this effectively breaks up its outline and makes it difficult to see among the foliage. But it has other defences in case it is spotted by a predator. It pulls its head back into its thorax, as seen here, and the red and white mask, complete with false eyes, gives it a rather fearsome appearance. An acrid odour is released by the red filaments extruded from the much-modified back legs, and the caterpillar can also squirt pungent formic acid from a gland just behind the head.

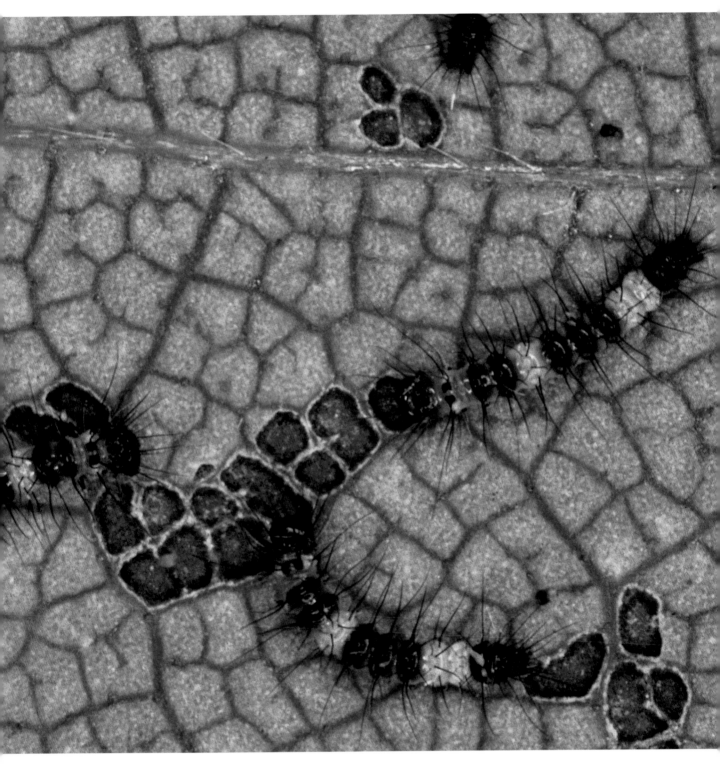

Caterpillar Camouflage

YOUNG CATERPILLARS OF THE MILLER MOTH *(Acronicta leporina)* feed by scraping the surface cells from the leaves, creating twisting channels of dark, empty cells. The caterpillars themselves, of which there are three in the photograph, look like tiny bird droppings and are very hard to see when lying along these grazed areas. Older caterpillars are clothed with long silvery hairs and are easily mistaken for small feathers.

Cryptic Colours (Right)

BLENDING IN WITH THE BACKGROUND is a very effective way of hiding from one's enemies. These two moths from Panama do not necessarily look like leaves, but their coloration is a perfect match for the dead leaves on the forest floor. Irregular wing margins enable the insects to blend in even more effectively.

Helpful Wrinkles

THE LILAC BEAUTY MOTH (Apeira syringaria) has a characteristic resting attitude, with wrinkled front wings that make it easily mistaken for a dead leaf. It is extremely difficult to pick out among the fallen leaves when resting on the ground. The moth gets its name not from its colour but from the fact that its caterpillar often feeds on lilac.

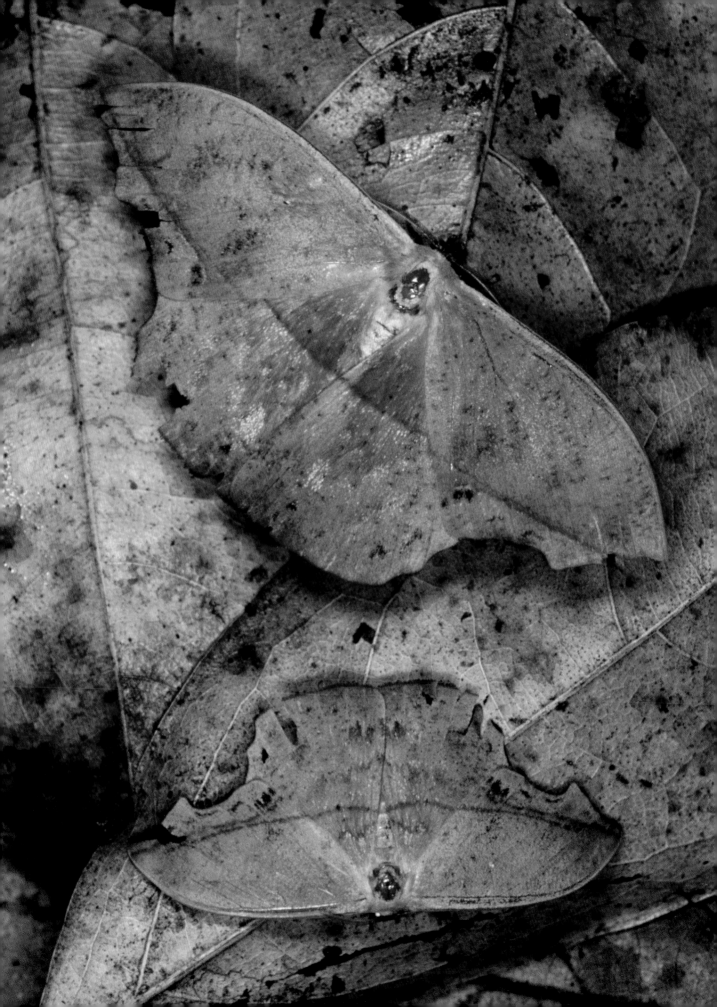

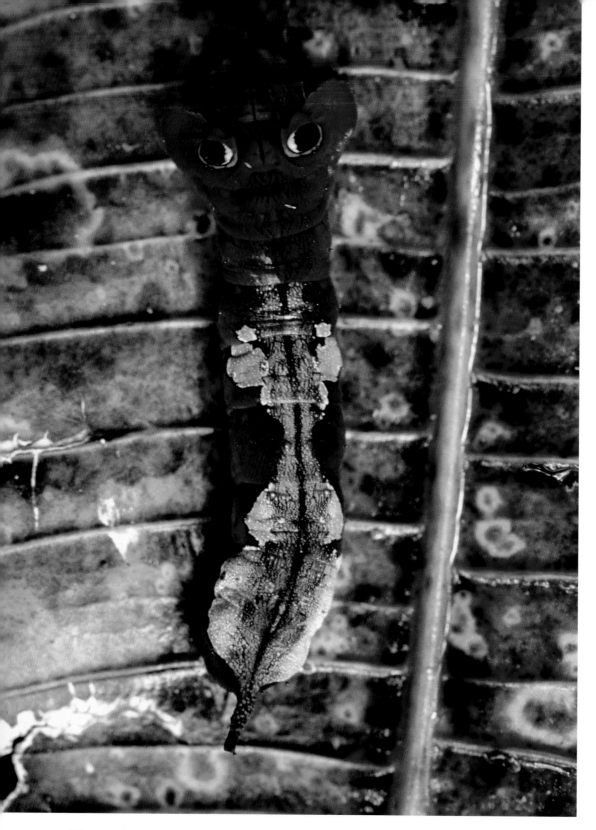

Disruptive Pattern

PALE PATCHES ON THE REAR HALF EFFECTIVELY BRAKE UP THE OUTLINE of this unidentified caterpillar from Amazonia and make it hard to detect. If a predator does get close, the caterpillar can bluff its way out of trouble by enlarging its eye spots.

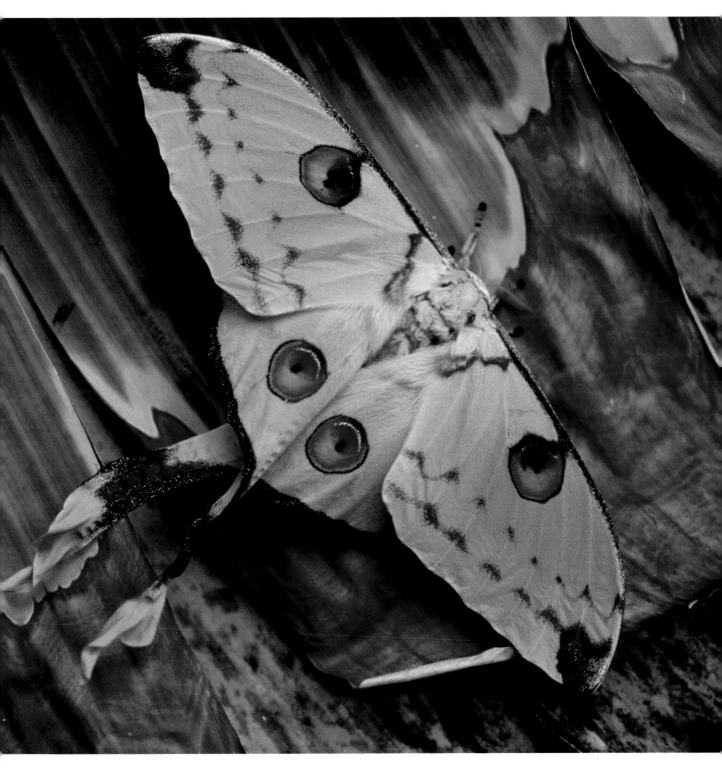

Multiple Defence

THE COMET MOTH FROM MADAGASCAR *(Argema mittrei)* has several strings to its defensive bow. The large eye-spots could frighten predators, but could also help to camouflage the moth by disrupting its outline or by resembling blemishes on the surrounding leaves. The twisted tails on the hind wings certainly resemble shrivelled leaves. The moth's wingspan is about 20 cm/8 in.

173

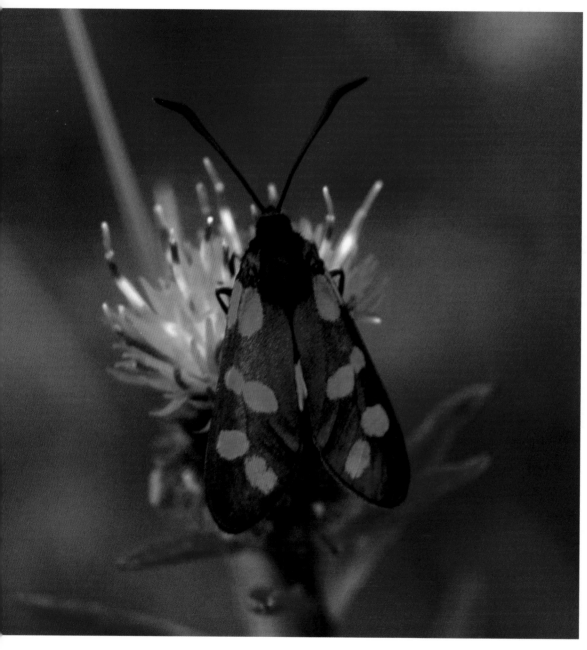

A Poisonous Package

THE SIX-SPOT BURNET MOTH *(Zygaena filipendulae)* is a rather sluggish insect and very easy to approach, but it has little to fear from birds or other predators because its body is full of poison. Most birds leave it well alone. If they do molest it, the moth exudes pungent fluids from glands around its mouth and this is sufficient to repel most predators. If the attack continues, the moth exudes cyanide-containing fluids from joints on its legs and thorax. Most predators then back off immediately. The moth's outer coat is quite leathery and pliable, and if it does suffer minor damage in an attack it heals very quickly.

Short Exposure

THE PEACOCK BUTTERFLY *(Inachis io)* normally rests with its wings closed, showing only its sombre underside, but it opens its wings when disturbed and waves them up and down, often rubbing their edges together to produce a faint hissing sound. Birds usually back off when faced with such a display, but experiments have shown that they may ignore eye-spots if they meet them too often, so the peacock butterfly and most insects with large eye-spots keep them hidden until they are needed. Insects with permanently-exposed eyespots tend to be rare or conceal themselves in other ways.

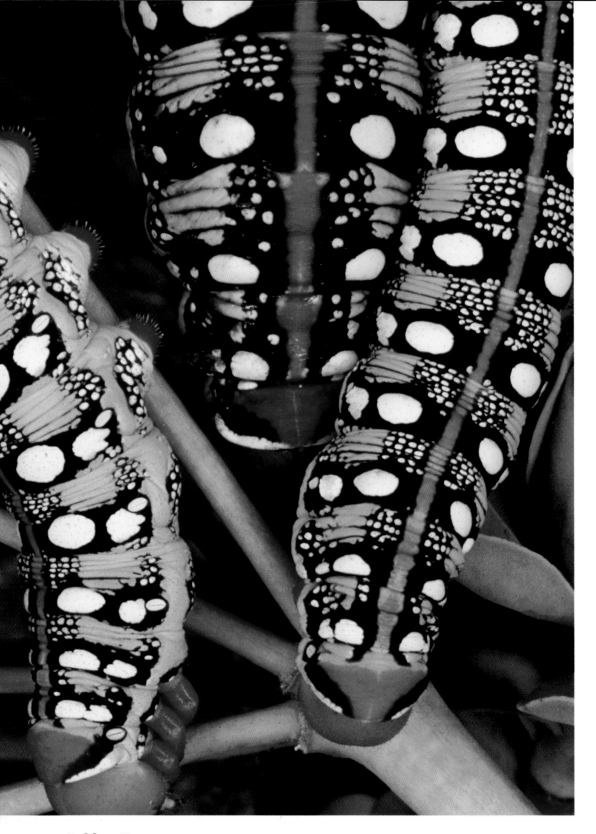

Bold as Brass

CATERPILLARS OF THE SPURGE HAWKMOTH *(Hyles euphorbiae)* combine four of the strongest colours to exhibit some of the most striking warning coloration in the insect world. The caterpillars feed on various spurge plants, from which they obtain and store their powerful poisons.

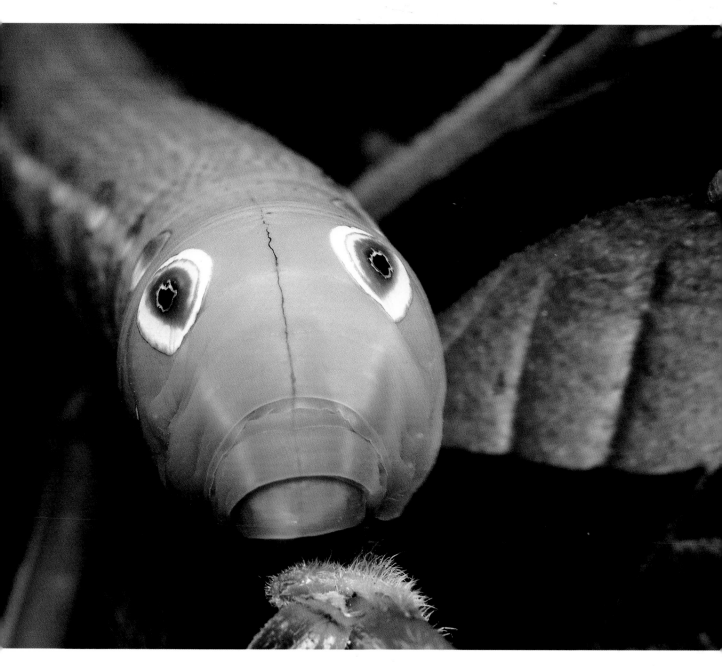

Snakes Alive!

THE TERSA HAWKMOTH CATERPILLAR *(Xylophanes tersa)* of North America makes good use of the false eyes on its thorax to frighten its predators. When threatened, it pulls its head into the thorax, which automatically swells up and enlarges the eye-spots, as in this photograph. The resemblance to a small snake is more than enough to scare off inquisitive birds.

Decoy Eyes (Right)

THE BLUE MORPHO BUTTERFLY *(Morpho peleides)* of tropical America has brilliant blue uppersides, but when at rest with its wings closed it looks totally different. Small eye-spots around the edges of its wings are quite conspicuous and draw the attention of birds away from the body. Many butterflies bear triangular beak marks around the eye-spots, or even have sections torn out, showing that these false eyes really do divert a predator's attack to these non-essential areas. The irregularly-arranged eye-spots can also be regarded as disruptive patterns, making the butterfly more difficult to see in certain situations (see p. 141).

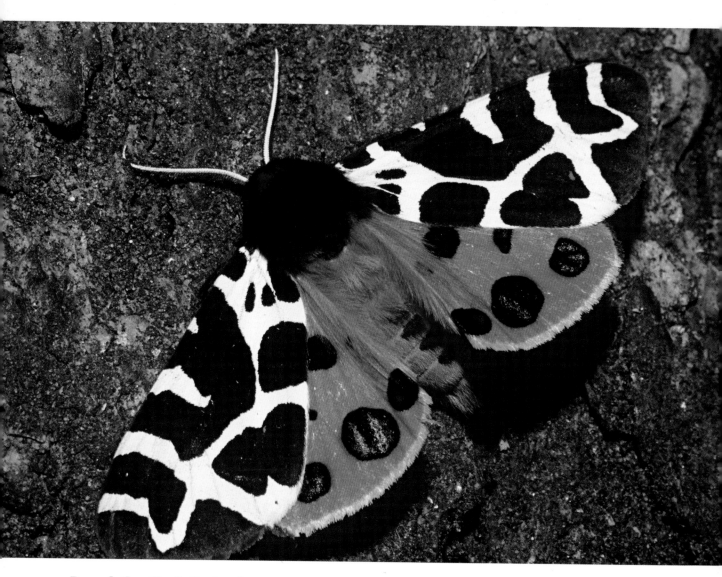

Round-the-Clock Protection

THE EUROPEAN TIGER MOTH *(Arctic caja)* is loaded with poisons and also protected by a thick hairy coat. It is quite well camouflaged when at rest with its hindwings concealed, but if it is disturbed in the day time it advertises its distasteful nature by revealing its brightly coloured forewings. At the same time, it exposes the red glands just behind its head that pump out repellent fluids. At night, the moth warns bats of its unpalatable nature by emitting a series of squeaks or clicks, which can be regarded as an audio version of warning coloration.

178

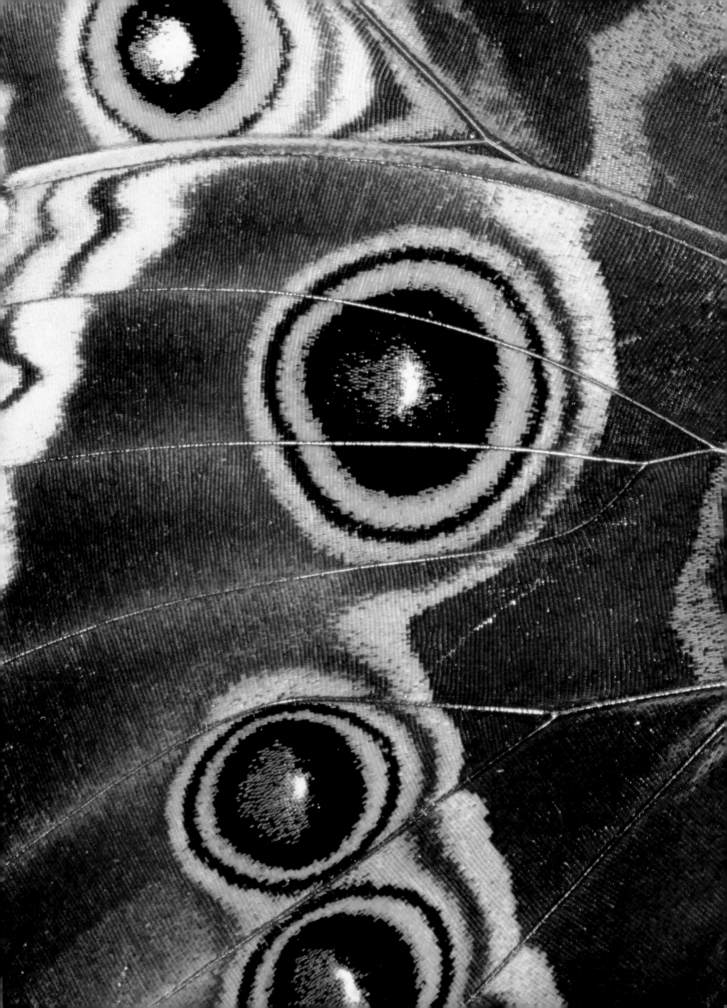

One-Eyed Threat (Right)

THE OWL BUTTERFLY *(Caligo illionis)* is one of South America's largest butterflies. It flies at dusk and rests by day. Although it normally rests with its wings closed and only one large eye-spot visible on each side, the owl-like effect is more than enough to keep most predators away.

A Piece of Bark?

THE CATERPILLAR OF THE WIDOW UNDERWING MOTH. *(Catocala vidiu)* from North America feeds mainly on hickory and walnut. Blending beautifully with the twigs, it is an excellent example of crypsis (see p. 141), but it could also be regarded as an example of protective resemblance because it looks just like a piece of loose bark.

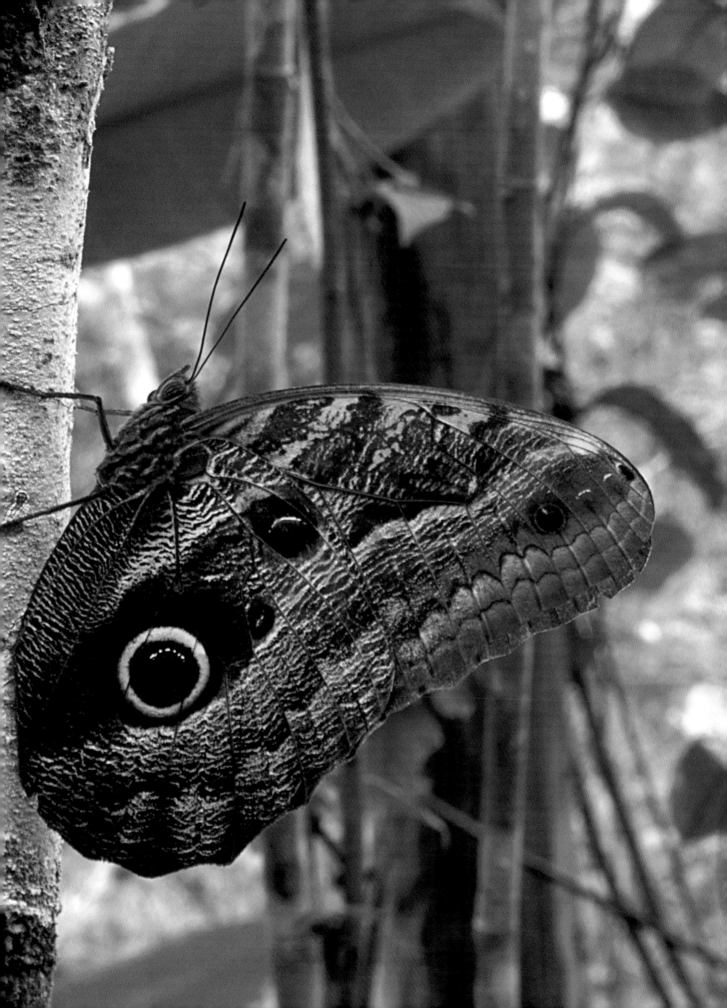

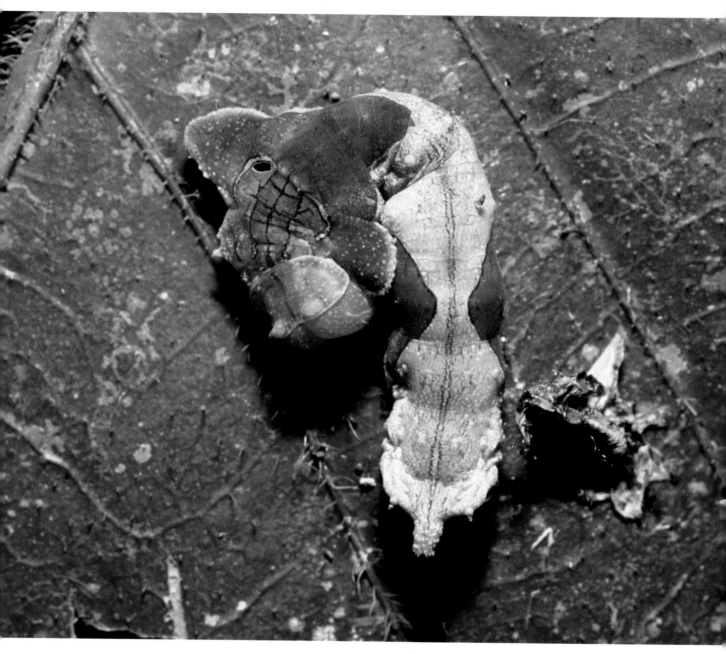

Deceptive Dropping

LOOKING LIKE A BIRD DROPPING is an excellent way of avoiding the attention of birds, and many insects have adopted this policy. They are largely white or cream, with black or brown markings that are often shiny. This caterpillar from the Amazonian rain forest habitually rests with its body strongly curved: lying in a straight line, it would look much less like a bird dropping and lose much of its advantage.

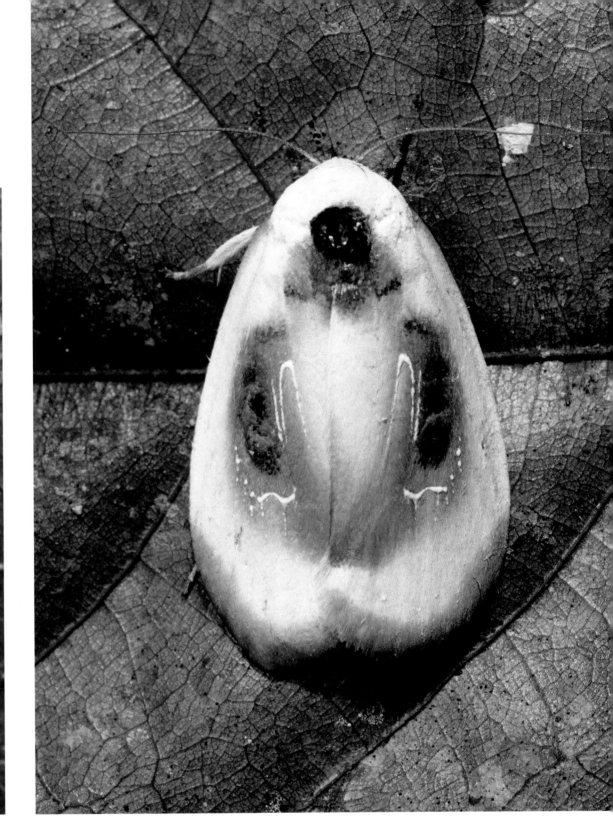

Black Marks

THE DARK MARKINGS AND SHINY SQUIGGLES on the Amazonian moth give it a strong resemblance to a bird-dropping – something in which no birds are likely to take an interest. Moths that go in for this form of protection often acquire a realistic, three-dimensional appearance by resting with their wings slightly raised.

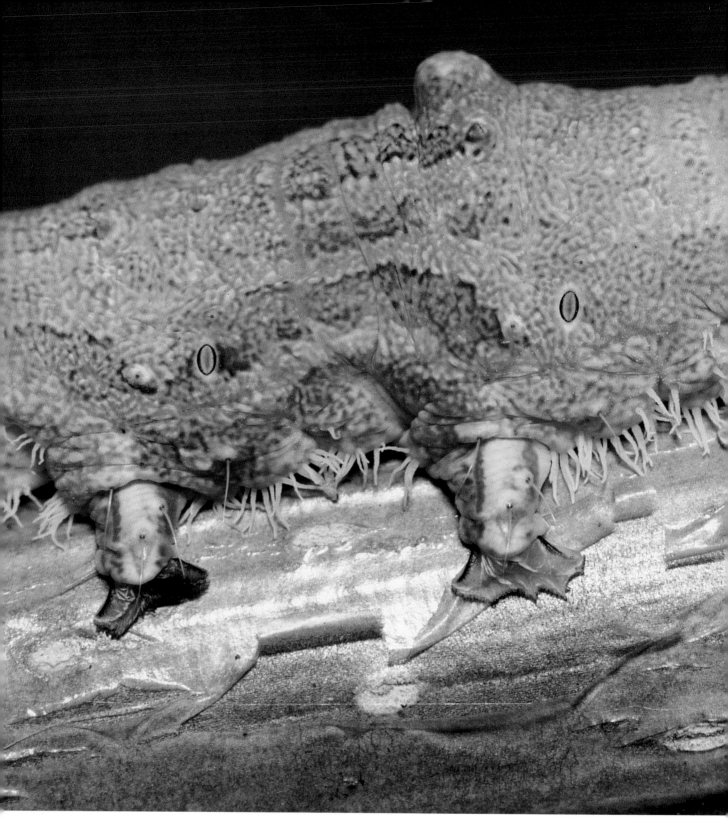

Getting rid of the Shadows

SHADOWS CAN BE A BIG GIVE-AWAY for anything trying to hide. The caterpillar of the red underwing moth *(Catocala nupta)* habitually rests on twigs and one might expect to see a shadow or dark hollow between its body and the twig. But evolution has ensured that this does not happen: a curtain of fleshy 'fingers' extending from the caterpillar's lower surface covers the gap and merges the caterpillar with its perch. Wart-like outgrowths on the body make it look even more like the surrounding twigs. Only part of the body is shown here, with three prolegs and two spiracles (see p. 62) clearly visible.

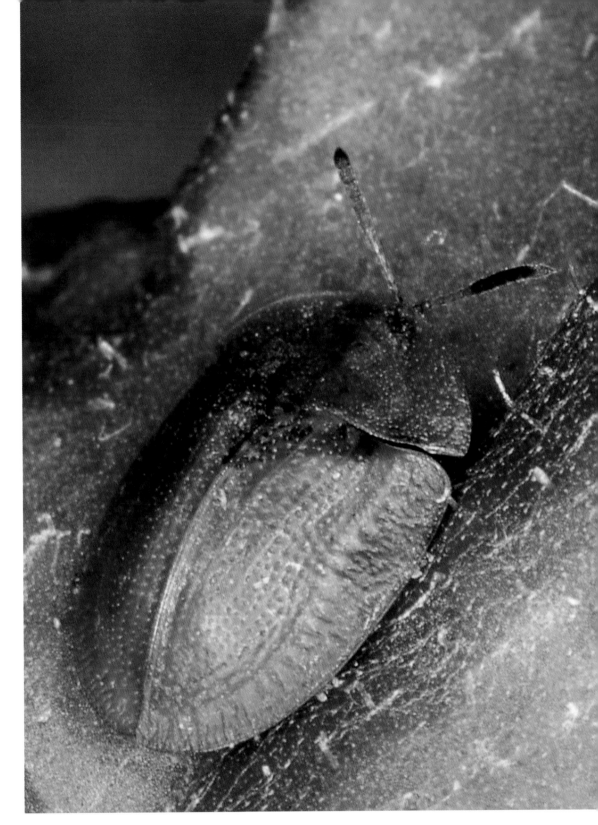

No Shadows Here

THIS GREEN TORTOISE BEETLE is very hard to spot when resting on a leaf. Its thoracic shield and its forewings (elytra) extend well beyond the sides of the body and can be pulled down to touch the leaf surface, thereby eliminating any tell-tale shadows. What is more, the beetle seems able to detect the contours of the leaf and, by shuffling itself around on its legs, it even aligns the junction of its elytra with the mid-rib of the leaf. When it is satisfied with its position, it will pull in its antennae and 'melt away'.

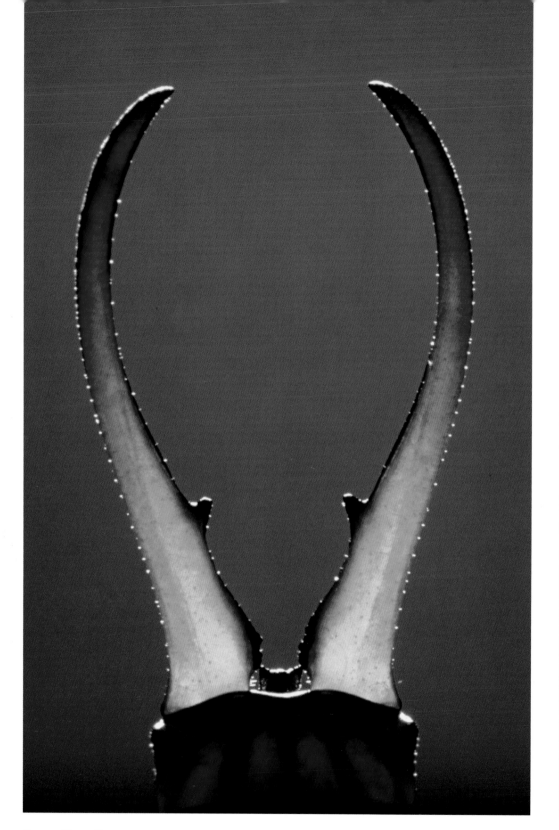

Grappling Irons

THE PINCERS OF AN EARWIG have several functions. Male pincers, pictured here, are usually strongly curved and used mainly for intra-specific fighting, especially when the males are arguing over food or competing for a female. Female pincers are more slender and more or less straight. Both sexes use them for defence: they cannot normally pierce human skin, but can inflict pain on the nose of an inquisitive shrew. Pincers are also used to fold up the delicate hind wings after a flight – although not all earwigs can fly. Some earwigs exude a fluid from their jaws when attacked. This secretion is not sticky, but its pungent nature certainly deters ants and other small predators.

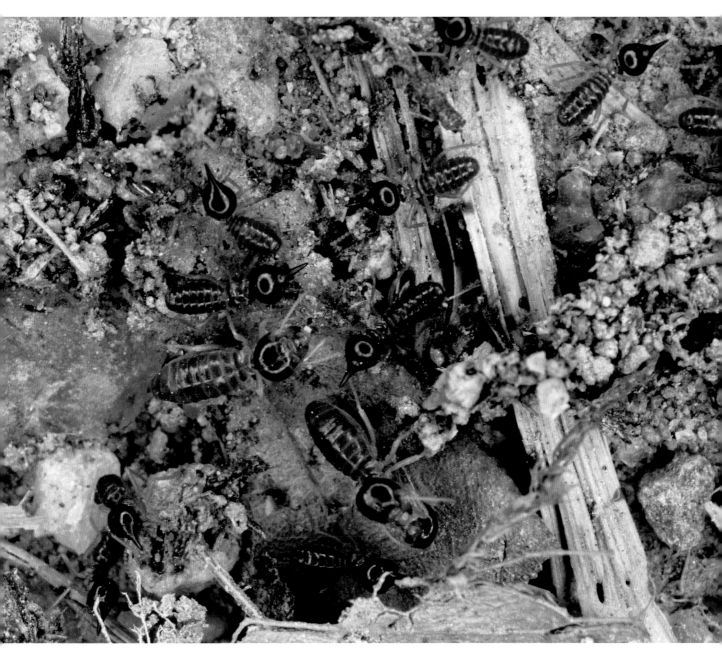

Living Glue Guns

MANY TERMITE SPECIES, living in various parts of the world, have specialised soldiers called nasutes, whose heads are little more than reservoirs of glue. The front of the head is drawn out into a pointed nozzle and if the colony is attacked the nasutes defend it by squirting their glue at the aggressors. Ants and other small predators are quickly incapacitated and may be completely trussed up in a web of sticky threads. Nasute workers also accompany columns of workers along their foraging trails.

187



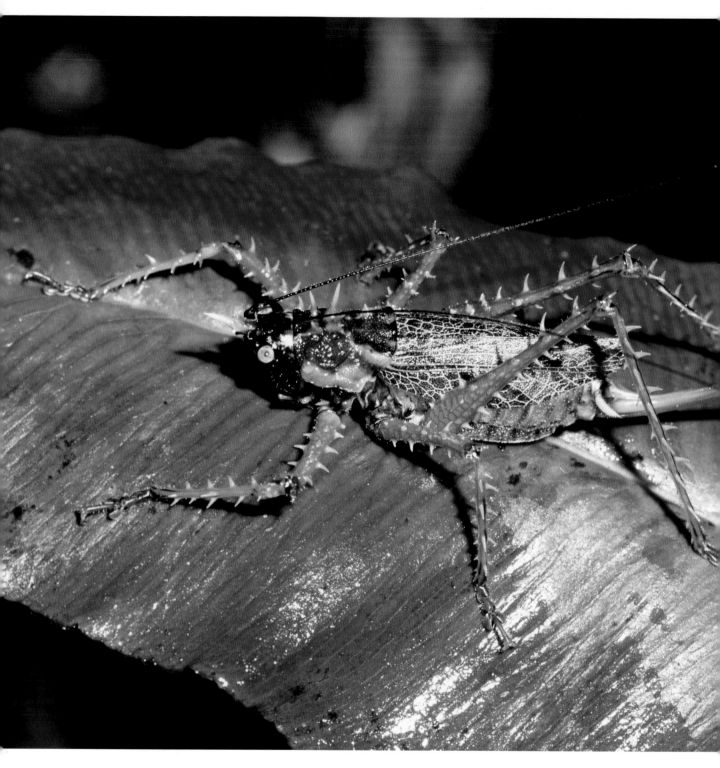

Spiny Defence

THIS FEMALE BUSH CRICKET HAS LITTLE TO FEAR. Any predator attempting to capture it is likely to receive a well-aimed blow from one or more of the insects' spiny legs, and the spines are more than capable of piercing the flesh of a bird or mammal. The long 'spear' arising from the rear of the insect is the ovipositor, used for laying eggs deep in the soil or in rotting timber.

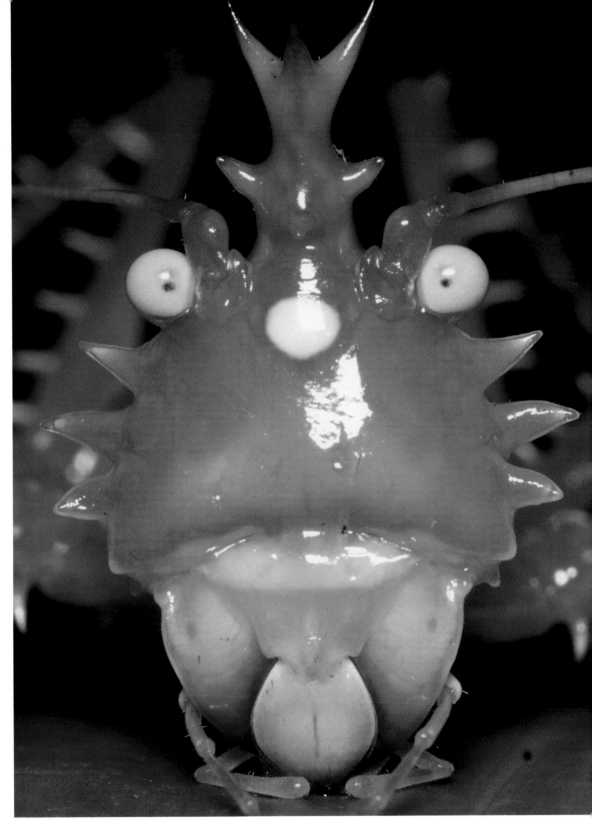

Crown of Thorns

A SPINY 'HELMET' GIVES THIS BUSH CRICKET NYMPH all the protection it is likely to need. Few predators are likely to press home an attack in the face of this formidable armour. Living in the Amazonian rain forest, this species *(Panacanthus cuspidatus)* is also well endowed with spines on its legs.

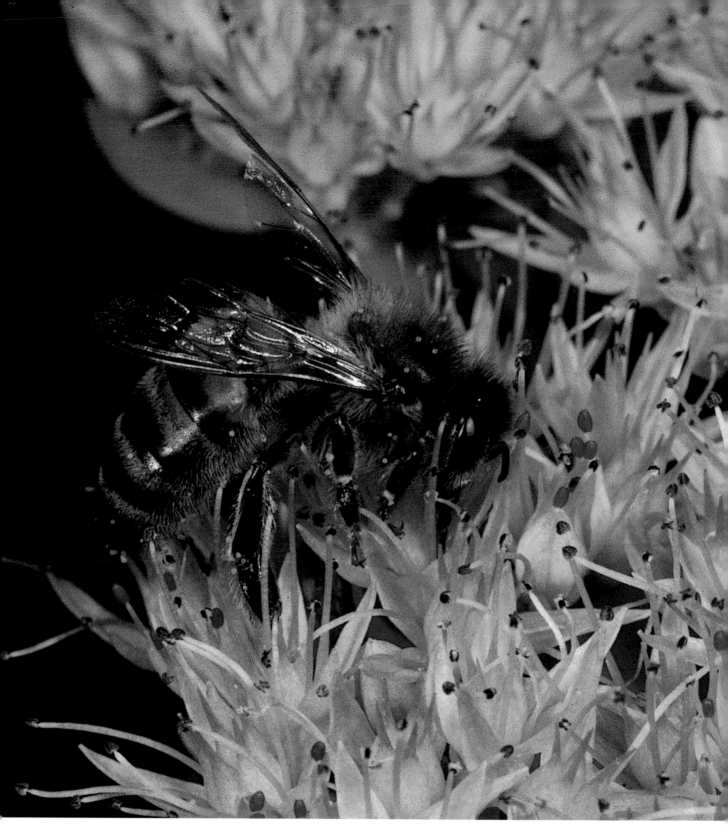

A Model Insect....

THE HONEY BEE *(Apis mellifera)*, seen here feeding on a garden Sedum, is protected by a powerful sting, although bee-eaters and some other birds know how to remove the sting and enjoy the bee and its load of sweet nectar. Many harmless insects, including numerous hover-flies, gain protection by mimicking the honey bee's colours and behaviour.

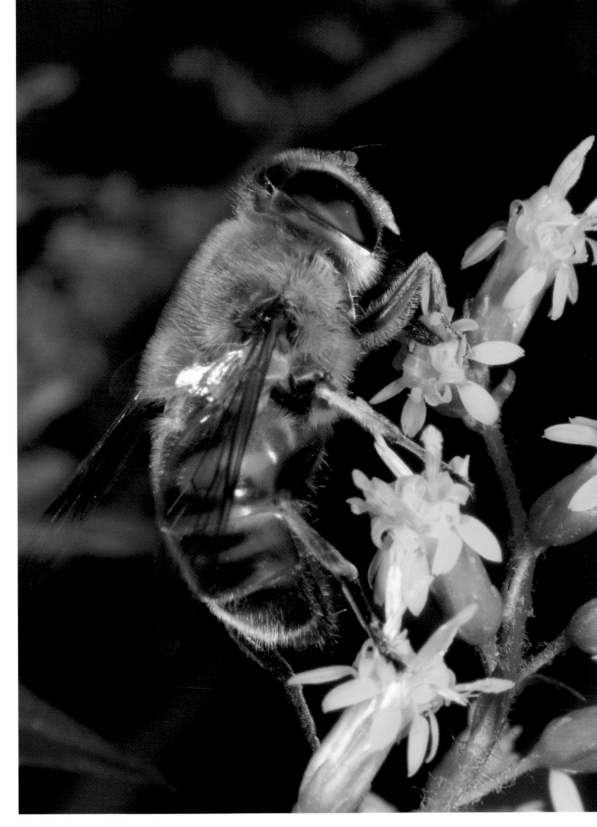

....and one of its Mimics

THE DRONE-FLY *(Eristalis tenax)* is one of the hover-flies and it is an excellent honey bee mimic. In flight it looks very much like the bee, although when seen at close quarters the drone-fly is easily recognised by its short antennae and its single pair of wings. And there are, of course, no pollen baskets (see p. 99).

(see p. 99).

191

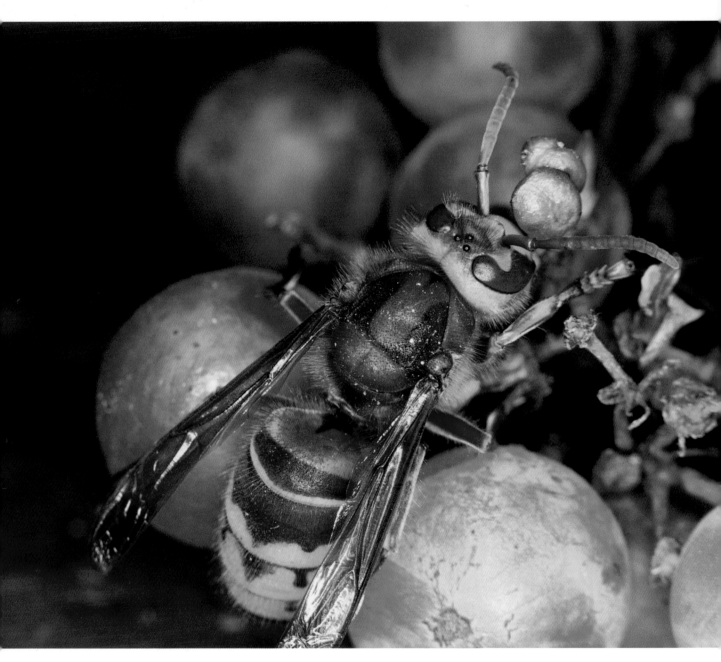

A Conspicuous Model...

THE HORNET *(VESPA CRABRO)* IS A LARGE WASP advertising its nasty taste and stinging capabilities with bold warning colours. Many harmless and palatable insects gain protection by mimicking the hornet's colour and pattern, because once a predator has had an unpleasant experience with a hornet it is likely to avoid everything else with similar colours. These mimics include numerous hover-flies and several moths.

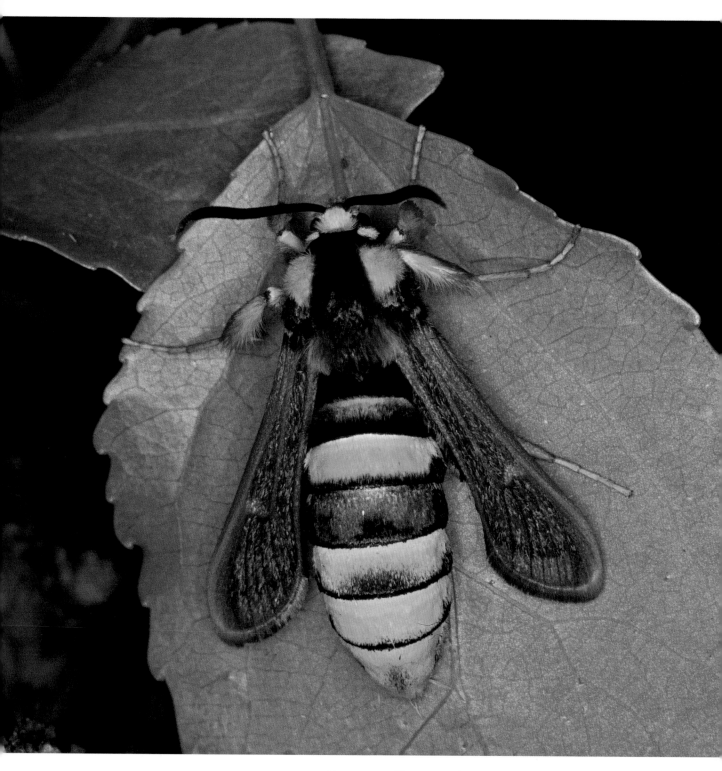

... and an Equally Conspicuous Mimic

THE HORNET MOTH *(Sesia ariformis)* is an excellent hornet mimic despite being rather more brightly coloured than a typical hornet. At rest, with its clear wings folded along the sides of its body to expose the boldly marked abdomen, it is sufficiently hornet-like to deter most predators, and when disturbed it makes remarkably wasp-like jerky movements. In flight, it even buzzes like the hornet. Hornet moths are much less common than hornets and other wasps, so birds and other predators are likely to meet the models and learn their lessons before coming into contact with the palatable mimics.

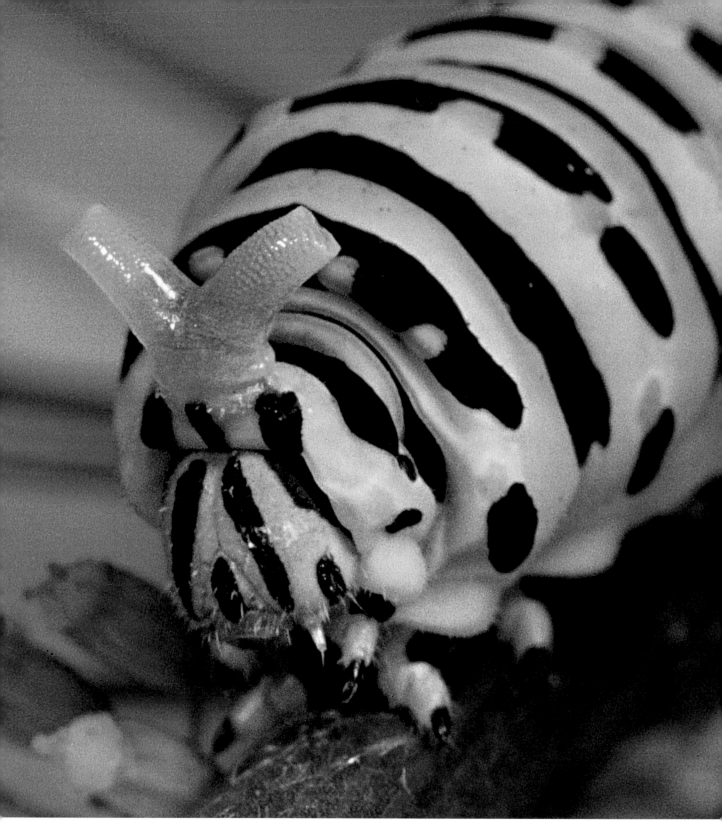

Chemical Deterrent

CATERPILLARS OF SWALLOWTAIL BUTTERFLIES thrust out a forked 'sausage' from behind the head and wave it about when they are alarmed. The sudden appearance of this brightly coloured organ, known as an osmeterium, may put off some birds, but it also secretes pungent fluids which deter enemies by irritating their eyes. The odour, which varies with the species, may also deter parasites, although it is not always unpleasant to humans' noses – the European swallowtail *(Papilio machaon)* pictured here smells of lanolin. Young swallowtail larvae are largely black and white and escape attention because they look like bird droppings.

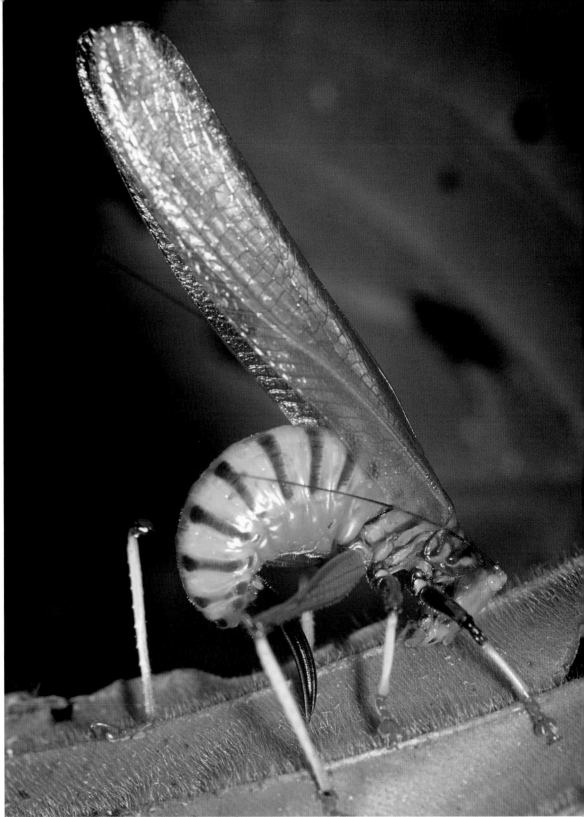

Wasp-like Warning

THIS POISONOUS BUSH CRICKET, A SPECIES OF *VESTRIA* from the Amazonian rain forest, is raising its wings to display the warning colours on its inflated abdomen. Its largely white legs add to the deterrent effect. The blade-like ovipositor is used to lay eggs in plant tissues.

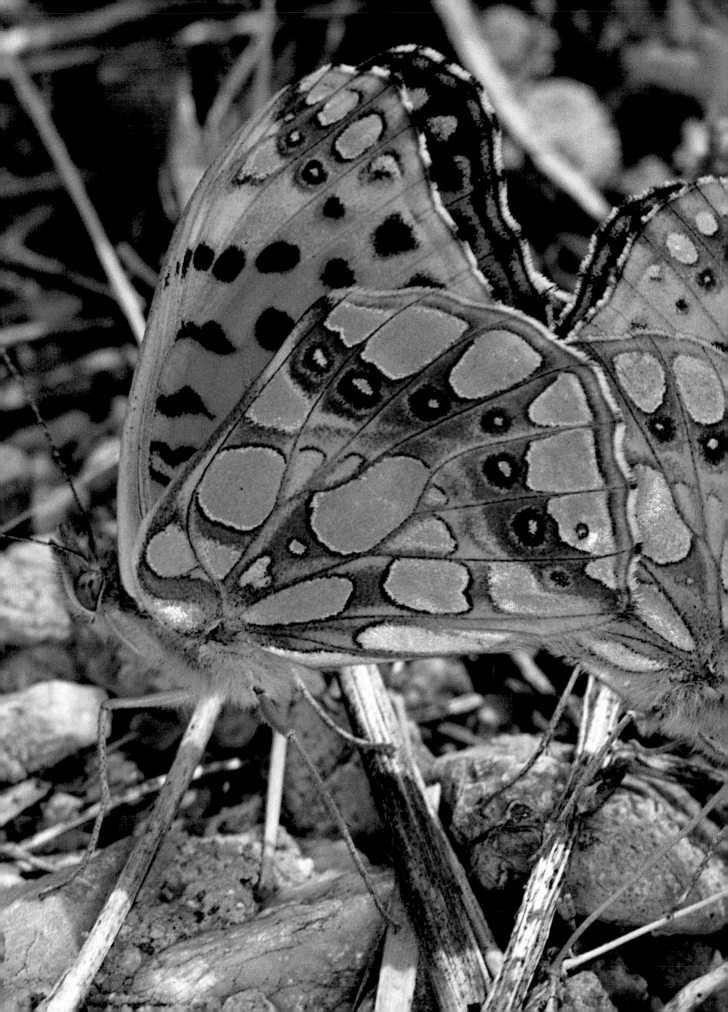

Life Cycles

Although some insects, including the summer generations of aphids, give birth to active young, the majority reproduce by laying eggs. The latter differ a great deal in shape and many are exquisitely sculptured on the outside (see p. 198). The young of some wingless insects, such as silverfish and lice, look just like small adults, but most young insects bear little or no resemblance to the adults when they emerge from their eggs. One major difference is that the young insects never have functional wings. As they grow up, they have to undergo a series of changes, collectively known as metamorphosis. All insects have tough and often hard outer skins that have only a limited ability to stretch, so an insect has to change its skin periodically to keep pace with its growth. This skin-changing process is called moulting or ecdysis (see p. 215) and most insects moult between four and 10 times as they grow up. The stages between moults are called instars.

Metamorphosis can be achieved in two different ways. Dragonflies, grasshoppers, earwigs, true bugs and several other insect orders undergo partial or incomplete metamorphosis. The young stages, known as nymphs, usually resemble the adults in shape, although they have no functional wings, and they often inhabit the same environment and feed on the same foods as the adults. After the first or second moult, tiny wing-buds appear on the back and these get larger at each later moult. The nymph gradually comes to look more like the adult, and when it is fully grown it changes its skin for the last time and reveals the adult insect with fully-developed wings.

Lacewings, scorpion flies, caddis flies, beetles, butterflies and moths, true flies, and the bees, wasps and ants grow up in a different way. The young stages, known as larvae, bear no resemblance at all to the adult insects and often feed on totally different foods. Most caterpillars, for example, feed on leaves, whereas the butterflies and moths which they eventually become feed on nectar. When a larva moults, it becomes bigger and may change colour, but it does not exhibit wing buds at any stage. When fully grown, it sheds its skin again, but instead of turning into the adult insect it reveals a pupa or chrysalis. Although the outlines of wings and legs and other adult features may be visible, most pupae are unable to move about and this is often referred to as a resting stage. Internally, however, there is fervent activity as the larval body is broken down and rebuilt into that of the adult insect. Eventually the pupal skin splits and the adult struggles out (see p. 212).

Once their new skins and wings have hardened, the adult insects set about finding mates. Sounds, colours, lights, and scents may all be involved in their courtship and mating rituals, and then the females can lay their eggs and start the cycle again. Although some insects, notably queen ants and termites, can live for several years (see p. 203), the majority of insects have short adult lives, often no more than a few days, but this is usually sufficient for them to start off a new generation and ensure the future of their species.

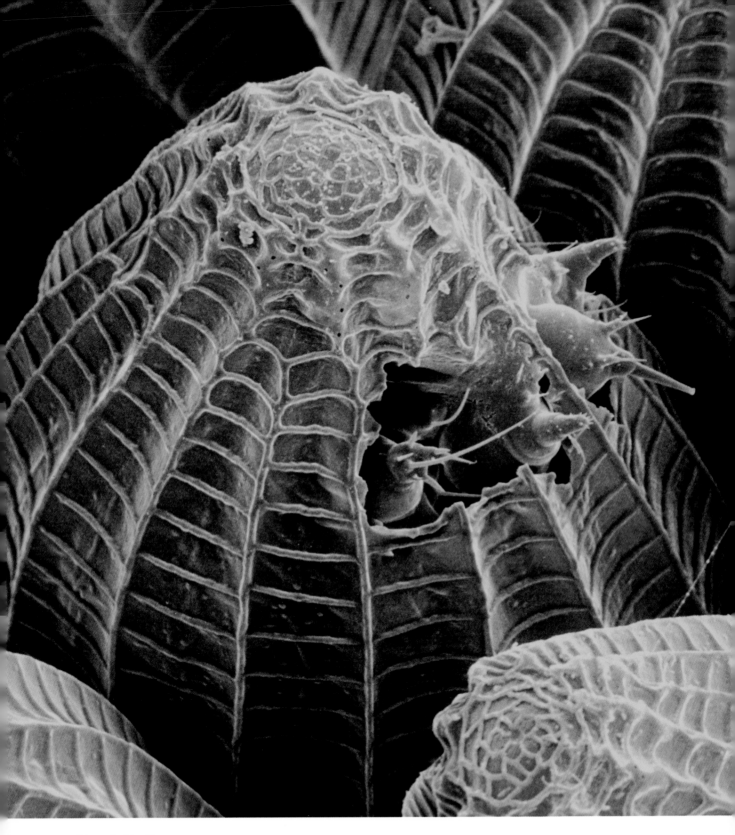

Exquisite Eggs

THE EGGS OF THE LARGE WHITE BUTTERFLY *(Pieris brassicae)*, in common with most other butterfly eggs, reveal an exquisitely sculptured surface when highly magnified. Back in the 19th century, these intricate patterns were described as 'a thousand times more delicate and fine than any human hand could execute' and the electron microscope has now revealed even finer details. On and between the ridges there are thousands of minute pores through which oxygen enters the eggs. Here, a caterpillar has nibbled a hole in its egg shells and is taking its first look at the outside world.

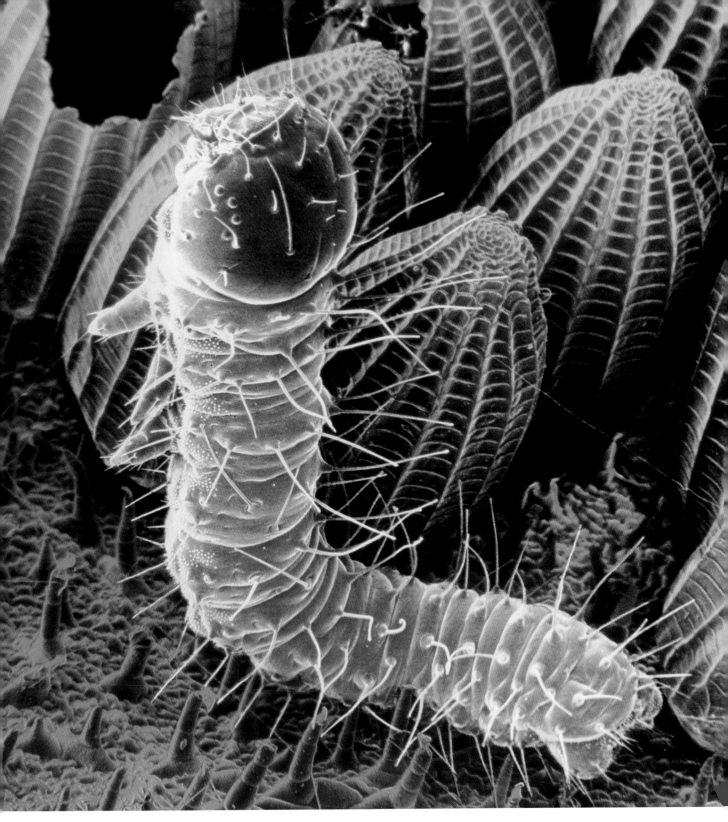

Designed for Eating

NEWLY HATCHED CATERPILLARS are nearly all alike, usually pale green or cream with a few long hairs. The first meal for most caterpillars is their own egg-shell, and then they turn their attention to the food-plant, which the parent butterfly carefully selected before laying her eggs. By continuous munching, a little caterpillar can increase its original weight by as much as 10,000 times within a few days, and it is soon ready for its first moult (see p. 197). After that, each caterpillar begins to take on the characteristics of its own species and this little creature will assume a black and yellow colour of the large white.

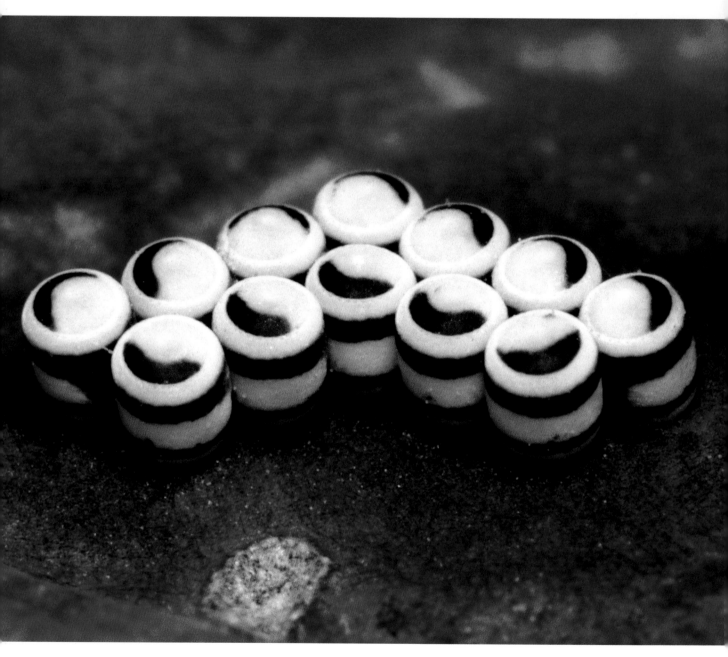

Neatly Does It

THE HARLEQUIN BUG *(Murgantia histronica)*, in common with most other shield bugs, lays neat clusters of barrel-shaped eggs. The size of the cluster is often related to the size of the adult bug, because the females of many species sit on the eggs until they hatch. Some species lay lots of small eggs, while others, including the harlequin bug, lay a few large eggs. Harlequin bugs are serious pests of cabbages in America.

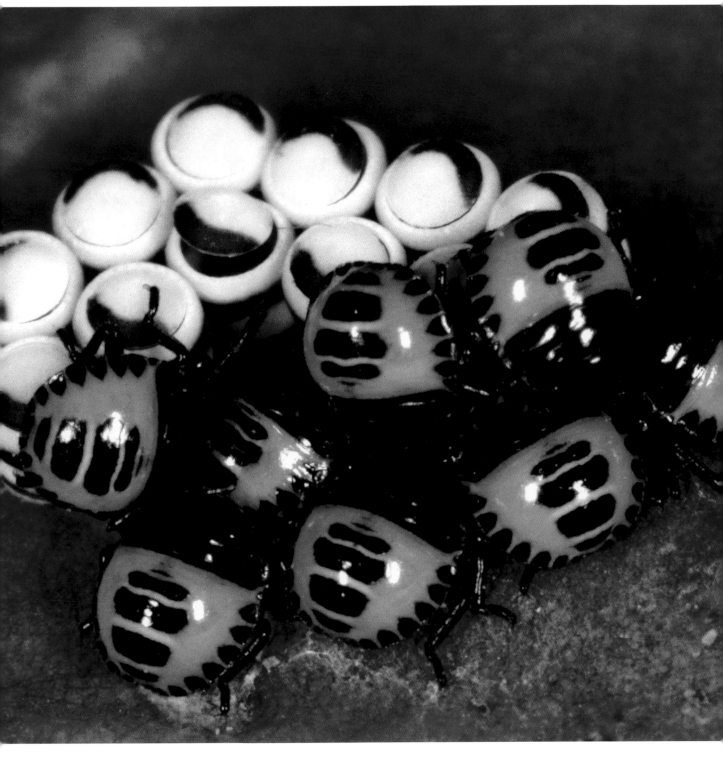

The First Meal

NEWLY HATCHED HARLEQUIN BUG NYMPHS cluster around their empty egg shells. Unlike most caterpillars, they do not eat the egg shells because bugs have sucking mouths and feed only on liquids. They soon plug their beaks into the food-plant and begin to suck out the sap. Wings develop later and the nymphs gradually turn into adults without any chrysalis stage.

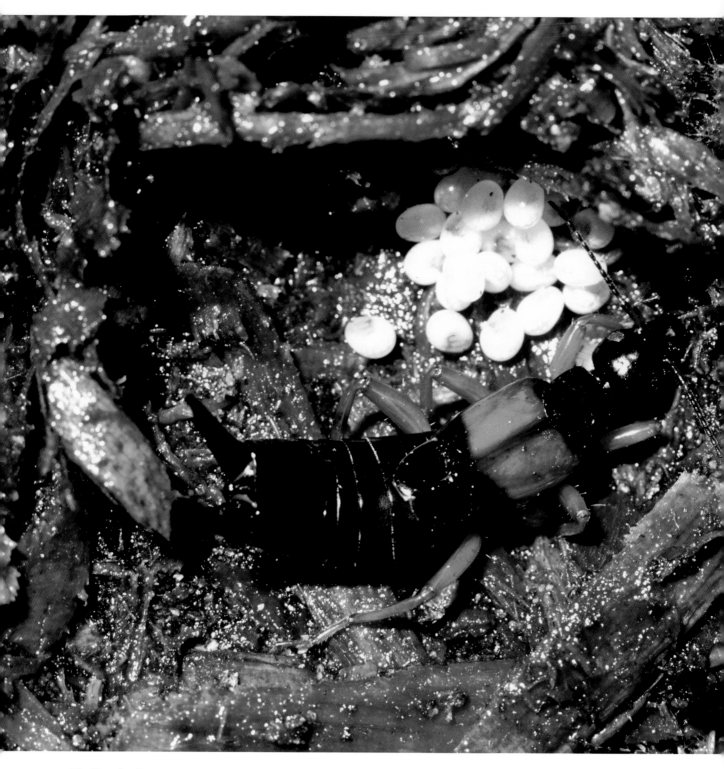

Motherly Love

FEMALE EARWIGS ARE GOOD MOTHERS and may look after their eggs and nymphs for several months. Eggs are usually laid in the soil, often close to a large stone that absorbs warmth from the sun and acts as a radiator for the nursery. The female guards the eggs and licks them regularly to prevent mould growth. When the eggs hatch she feeds the nymphs with regurgitated food, and she regularly washes them. The nymphs emerge from their nurseries after their first moult, but the female continues to feed them and to shepherd them carefully into secure places for several more weeks.

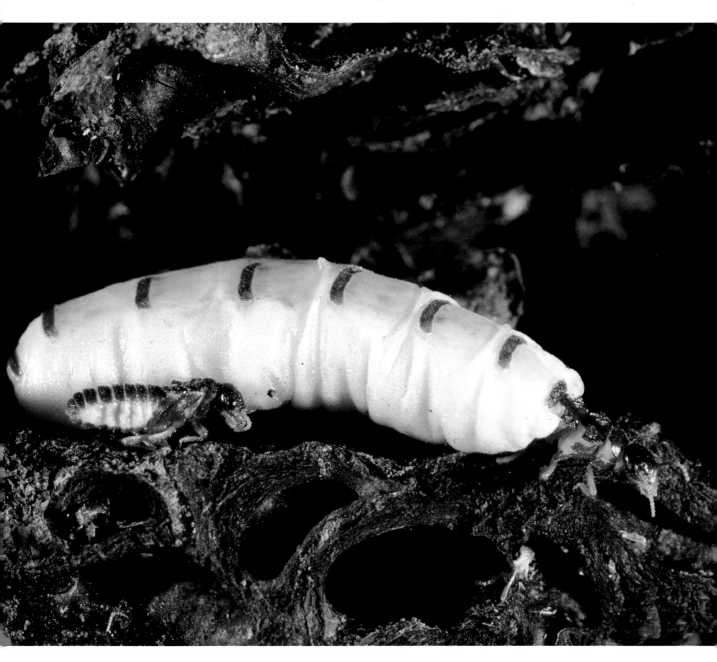

A Royal Giant

THE QUEEN TERMITE DWARFS HER MATE and all her sons and daughters. Up to 15 cm/6 in. long in some species, she is little more than an egg factory and she can hardly move. Lying in her royal chamber, she mates periodically with the king and churns out several thousand eggs every day. Both king and queen are fed and groomed by the workers.

Time to Get Out (Right)

AFTER PERHAPS SEVERAL MONTHS, THE MANTIS EGGS HATCH. Looking like tiny white sausages, the nymphs force their way through tiny trap-doors in the ootheca until they are about half way out. Then, by pumping blood into the head end, each one splits open its enclosing the membrane surrounding it, and out pops the leggy nymph. The nymphs may congregate on the ootheca for a while, as seen in this photograph of a *Stagmomantis carolina* ootheca, but then disperse and begin to look for tiny insects to eat.

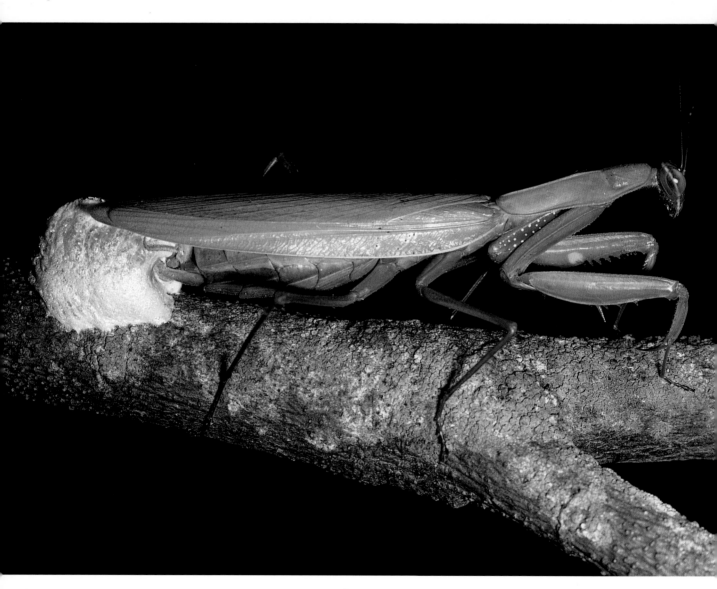

Egg Packing

THIS FEMALE PRAYING MANTIS *(Mantis religiosa)* is laying her eggs in a sort of soufflé, exuded by glands in her abdomen and whipped into a frothy mass with air blown into it from her rear end. Up to 300 eggs are laid in the froth, which quickly hardens into a tough, horny case called an ootheca. The eggs, each in their own little chamber, are safe from most enemies, but some sneaky little wasp-like insects hitch lifts on the mother mantis and nip into the froth to lay their own eggs in it before it hardens. The resulting grubs then feed on the developing mantis eggs.

204

Chains of Eggs

THE EUROPEAN MAP BUTTERFLY *(Araschnia levana)* lays its eggs in little chains under stinging nettle leaves. Each chain normally contains 6-15 eggs and there may be several chains close together. The chains resemble the nettle catkins, so the eggs are quite well camouflaged.

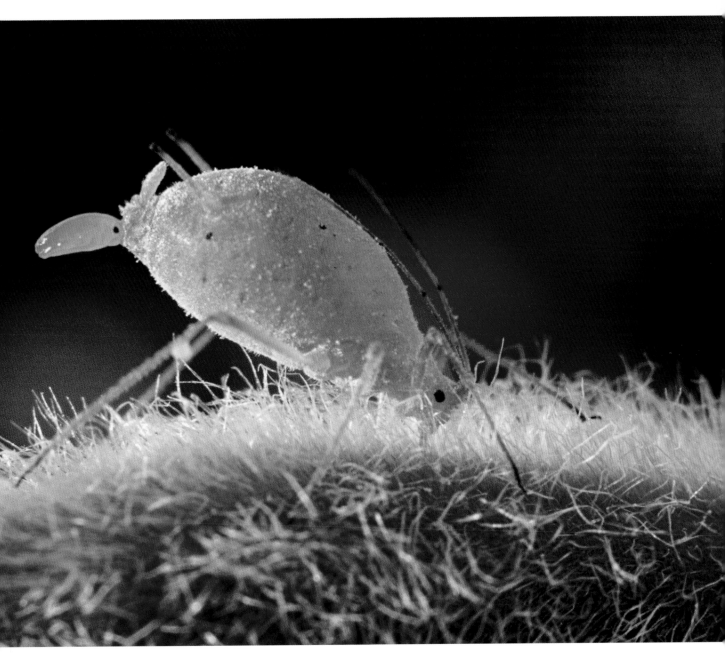

Virgin Birth

APHIDS ARE PROLIFIC BREEDERS. For much of the summer, the greenfly and blackfly that infest our gardens exist only as females and give birth without mating. The babies pop out backwards, as seen here. They are perfectly developed and their own babies are already growing inside them. They can mature and give birth themselves within two weeks. Some youngsters develop wings and fly to fresh plants, but others stay put and continue to breed, so it is no wonder that our plants become covered so quickly. At the end of summer, males and egg-laying females are produced. Eggs are laid after mating and many aphid species pass the winter in the egg stage.

The Magic of Metamorphosis – Out of the Water...

THIS EMPEROR DRAGONFLY NYMPH may have spent three or more years in the water, but now it is time to change into an adult and take to the air. The nymph climbs a reed and splits open the now fragile skin on its back. Using its legs, it pushes its head and thorax out of the old skin (left). The insect then bends back and, with a few vigorous wriggles, works most of its abdomen out of the old skin. Little wings are visible on the thorax, but otherwise the dragonfly still has the shape of the nymph. This kind of development is called partial metamorphosis.

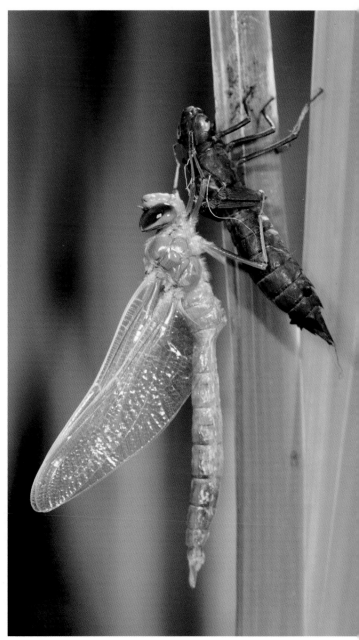

..and into the Air

WITH MOST OF ITS ABDOMEN FREE, the dragonfly heaves itself upright again and, clinging to the old nymphal skin (left), it frees the rest of its abdomen. It then begins to inflate its wings by pumping blood into them. The wings and skin dry and harden within an hour or so and the adult dragonfly is ready to fly away, although it will be some days before its full colours appear. The adult dragonflies rarely live for more than a few weeks.

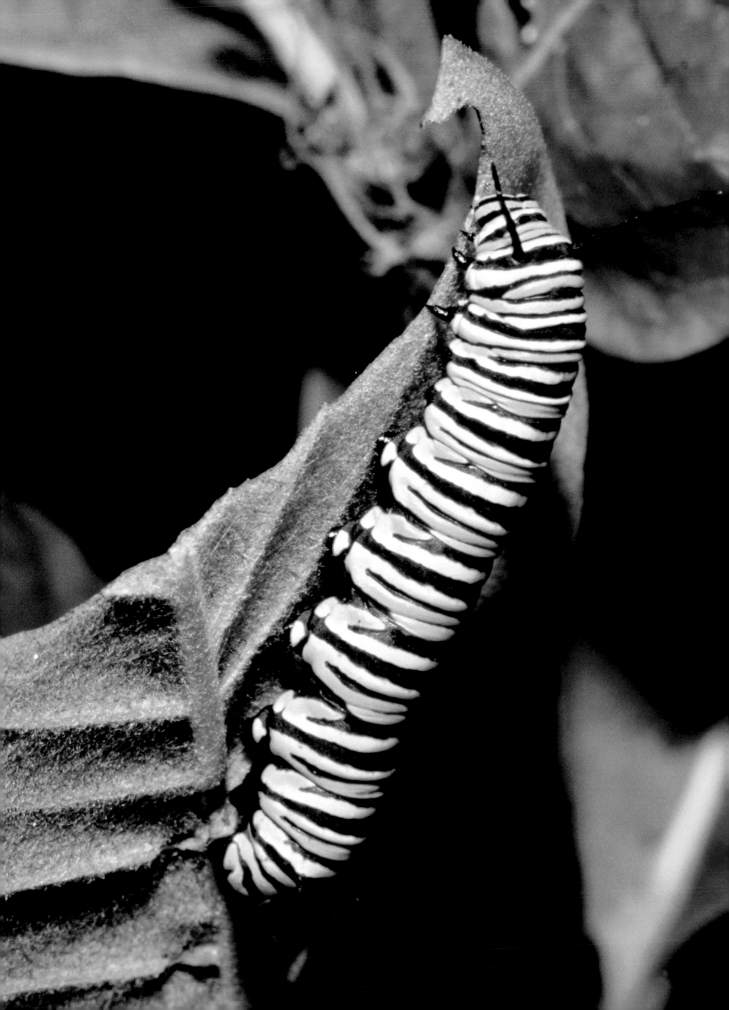

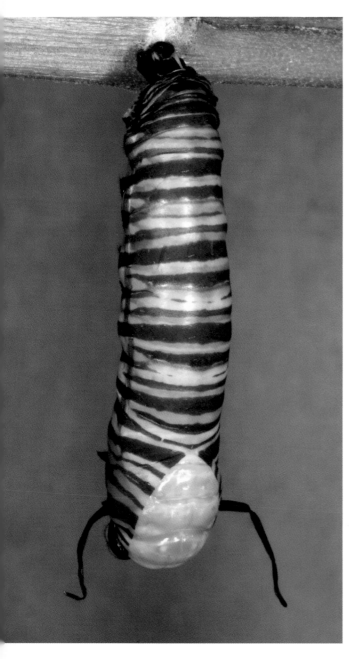
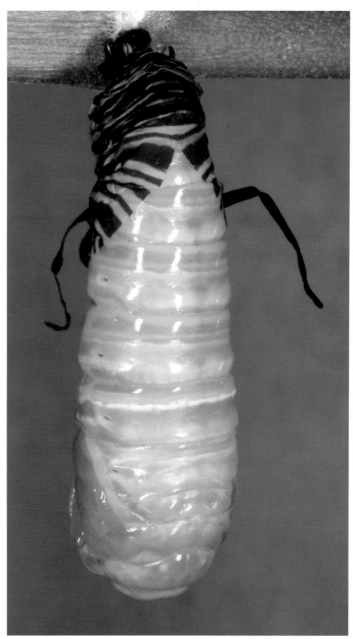

From Caterpillar to Chrysalis

THE MONARCH BUTTERFLY CATERPILLAR *(Danaus plexippus)* on the left is fully-grown after spending several weeks munching on milkweed leaves. It then spins a little pad of silk on a convenient support and hangs upside-down from it. Its skin splits, and after a good deal of wriggling, it is pushed off to reveal the chrysalis or pupa (above).

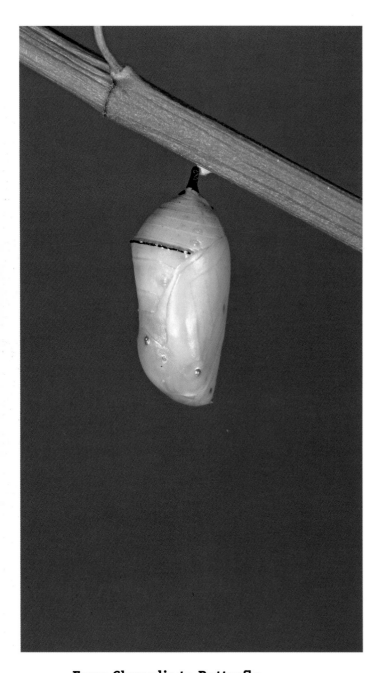
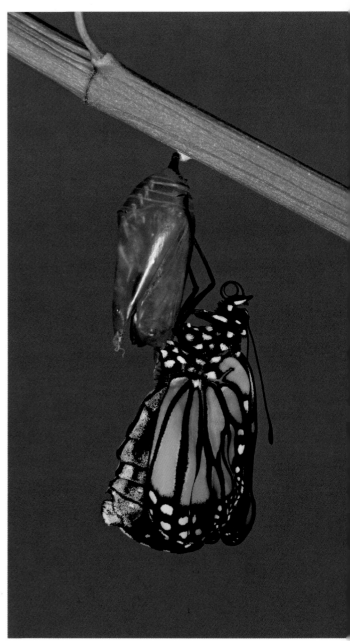

From Chrysalis to Butterfly

THE CHRYSALIS is soft at first, but its skin gradually hardens and the whole thing becomes shorter as it assumes the typical chrysalis shape of the monarch (left). After as little as 10 days in warm weather, the chrysalis skin splits and the adult butterfly struggles out. Clinging to the chrysalis skin, it gradually expands its wings by pumping blood into their veins (right). As soon as its wings have dried and hardened, the butterfly can take to the air.

Metamorphosis is Complete

THE ADULT MONARCH BUTTERFLY displays its richly coloured wings as a warning to birds and
other predators that the butterfly is poisonous (see p. 139). The poison comes from the milkweed
plants on which the caterpillar fed. Predators that do try to eat the butterfly usually discover that
it is distasteful before they can do it much harm. In common with many poisonous insects, the
monarch has a rather rubbery skin that soon heals after minor damage.

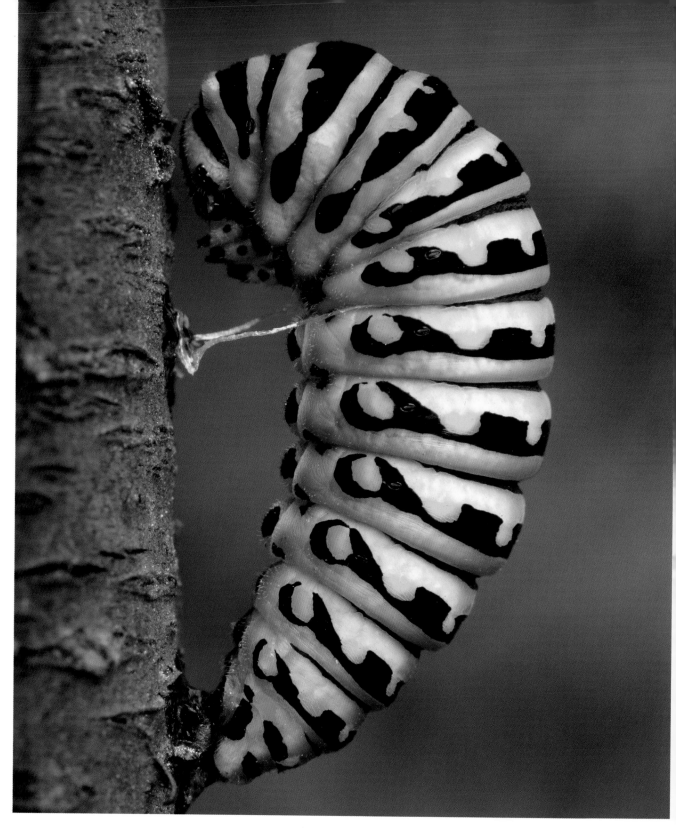

Fasten Your Safety Belt

THE CATERPILLAR OF THE SWALLOWTAIL BUTTERFLY pupates in an upright position, unlike that of the monarch butterfly (see p. 211). Spinning a silken pad on a stem and gripping this tightly with its back legs, the caterpillar then spins a silken girdle around its middle. Firmly secured in this way, it is ready to turn into a pupa. Great changes take place in its body at this time and the pupa is revealed after a day or two when the caterpillar's skin splits and is pushed off.

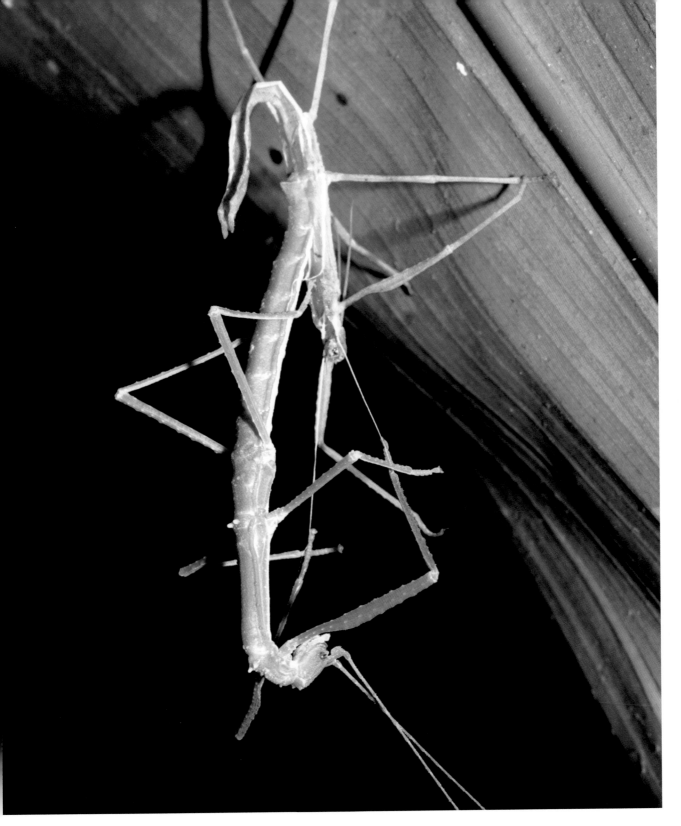

A Tricky Business

THIS STICK INSECT HAS JUST COMPLETED A MOULT. Moulting is a hazardous process, especially for a leggy stick insect. Stick insects normally moult upside-down and the first part to emerge from the old skin is the head, with the tip of the abdomen being last to escape. In between, the insect must withdraw all six legs and even its delicate antennae from the brittle old skin. The new skin is very soft and the insect stretches it by pumping itself full of air. It takes a few hours to dry and harden and then, by getting rid of the ingested air, the insect makes room for more growth. Moulting insects are completely defenceless and usually seek secluded spots before embarking on the process.

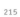

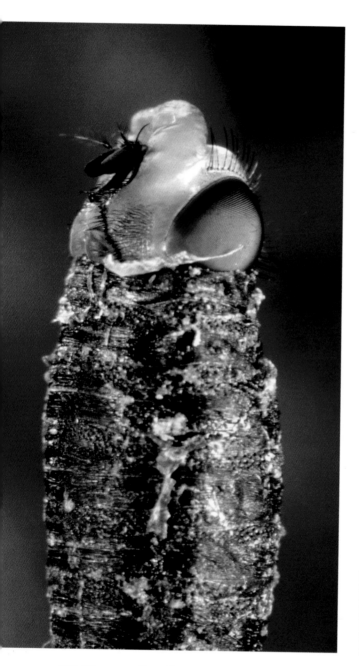
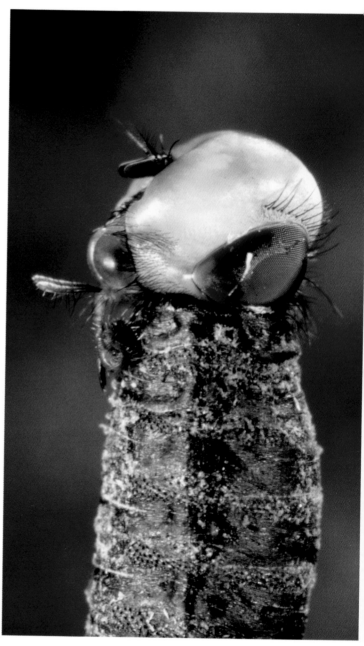

All Change for the House-fly

THE HOUSE-FLY *(Musca domestica)* undergoes a complete metamorphosis. It spends its early life as a legless maggot feeding on dung and other decaying matter. Fully grown, it burrows out of sight, often into surrounding soil, and its skin hardens to form a barrel-shaped puparium. Inside this tough case, the maggot's body is rapidly converted, first into a pupa and then into an adult fly, which is soon ready to break out. The new fly pumps fluid into an inflatable balloon, known as the ptilinum, which erupts from a groove in the head and forces a lid off the puparium. The ptilinum is clearly seen here, swelling up between the antennae at top left and the brown eye on the right.

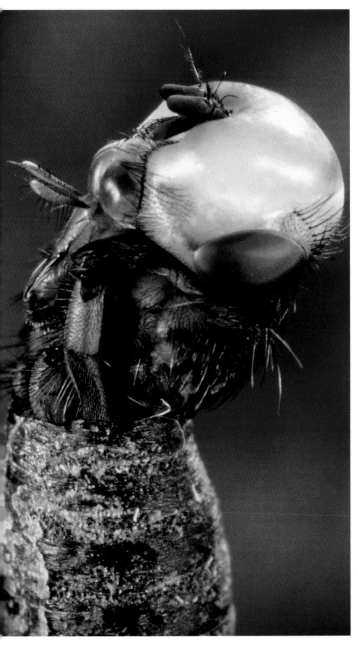
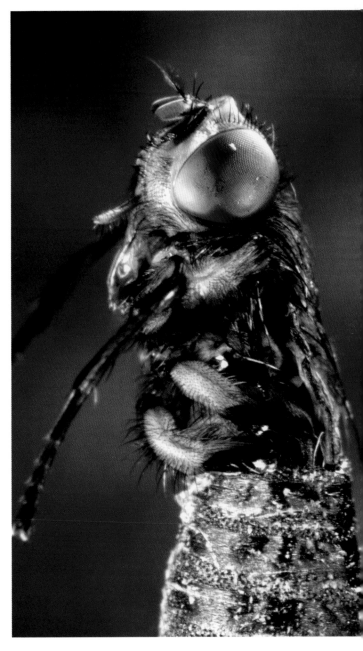

Nearly Out

Having forced the lid from the puparium, the fly begins to heave its body out. On the left, most of the thorax is already free and the front legs are about to be withdrawn. Once free, they help draw out the rest of the body. On the right, the middle and hind legs are more or less out and the abdomen will soon be free. Its function fulfilled, the ptilinum has already deflated and withdrawn into the head, which is restored to its normal shape. The wings are very crumpled when it leaves the puparium, but they soon inflate and harden and the fly is ready to take off in about half an hour. The whole cycle, from egg to adult may be completed in under two weeks in warm weather.

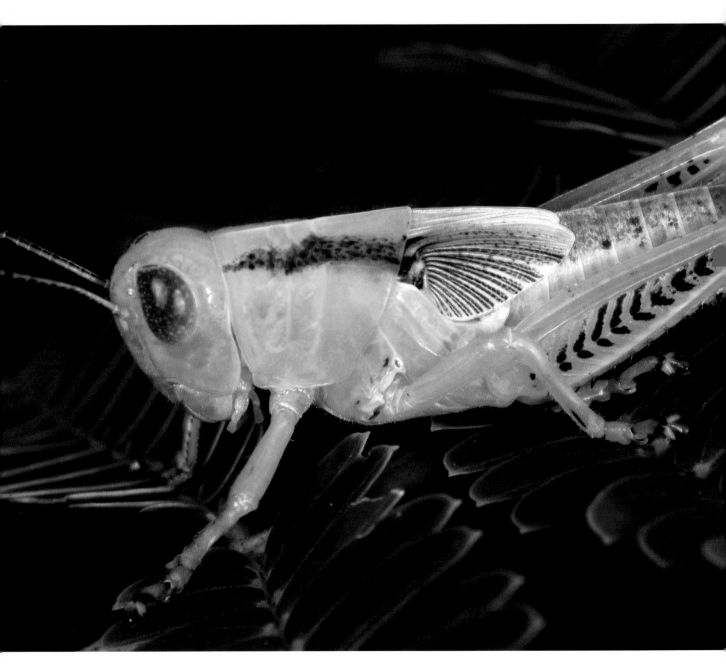

Incomplete Metamorphosis

GRASSHOPPERS, REPRESENTED HERE BY THE DIFFERENTIAL GRASSHOPPER *(Melanoplus differentialis)*, grow up without any pupal or chrysalis stage. The young stage (above) is known as a nymph and it looks quite similar to the adult (right), but it lacks functional wings and, of course, reproductive organs. The wing buds of the nymph pictured here are turned upside-down, so that the front edge is at the top and the hind wings cover the front wings. This is normal for grasshopper nymphs approaching maturity…

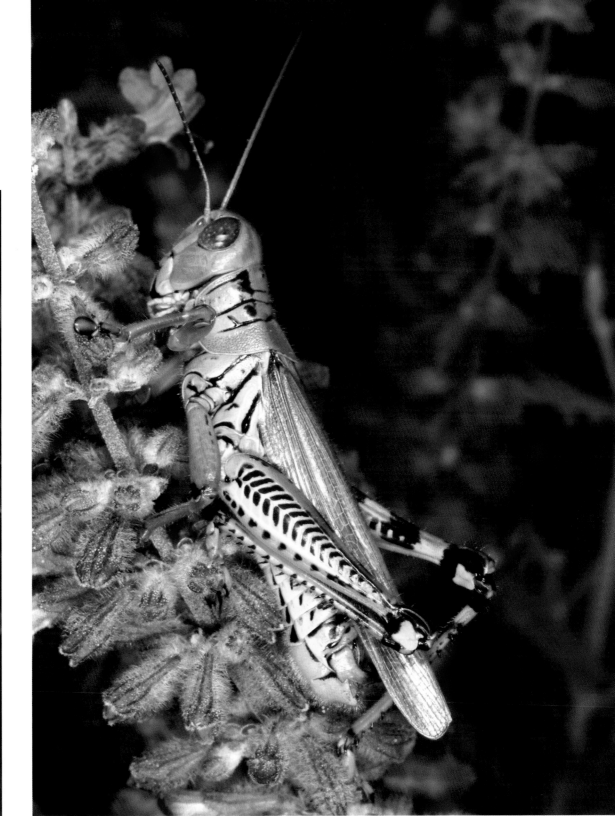

... When it is fully grown, the nymph shrugs off its skin to reveal the adult body and its wings turn again so that the front edge is at the bottom and the front wings conceal the hind wings. Metamorphosis in the grasshopper is said to be partial or incomplete. This large grasshopper can be destructive to crops, although it does not form huge swarms like the locusts.

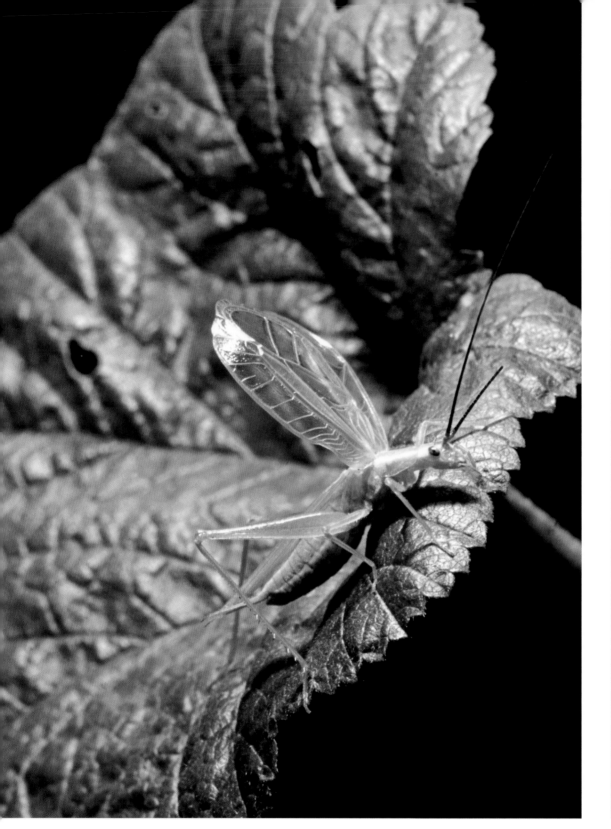

Voice-throwing Crickets

TREE CRICKETS OF THE GENUS *OECANTHUS* stridulate or 'sing' by raising their delicate front wings and rubbing their bases together, producing a soft and very pleasant warbling sound. If disturbed, they continue calling, but lower their wings somewhat, thereby reducing the volume so that the sound appears to come from further away. This makes it very difficult to track the insects down when they are singing on the vegetation at night. Tree crickets live in many of the warmer parts of the world.

A Natural Amplifier

TREE CRICKETS generally produce soft, warbling calls, but several species have discovered a simple way to amplify them. The cricket bites a pear-shaped hole in a leaf of just the right size to take its raised front wings. The insect then sits at the edge of the hole, with its wings raised to fill the space, and when it starts to stridulate the vibration of its wings is transmitted to the leaf. The leaf then starts to vibrate and it can treble the volume of the original sound.

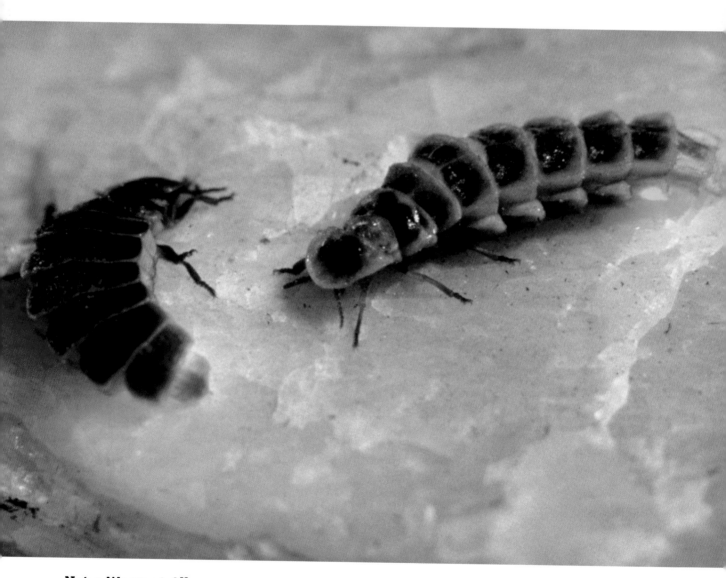

Not a Worm at All

THE EUROPEAN GLOW-WORM *(Lampyris noctiluca)* is not very well named: it is actually a small
beetle. The males are fully-winged and can fly, but the females, pictured here, are wingless and
often mistaken for woodlice, although they have only six legs. Woodlice have 14 legs.

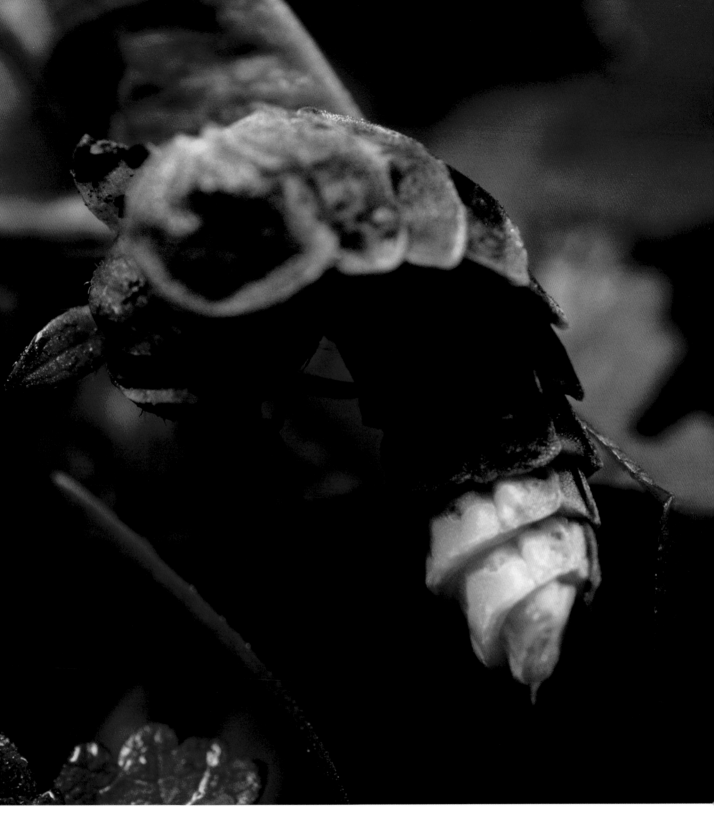

The Lure of the Lamp

The last three segments of the female glow-worm's abdomen are packed with luciferin, which produces a yellowish green light by means of a chemical reaction like that used by the fireflies (see p. 224). A layer of tiny crystals behind the luciferin acts like a mirror and beams the light out through the translucent underside of the body. Switching on soon after dusk, the female glow-worm clings to a plant and turns her body so that the underside of her abdomen faces upwards. Male glow-worms flying overhead detect the steady glow and drop down to mate. The female turns her lamp on and off by controlling the oxygen supply to the luciferin.

Light without Heat

THIS GHOSTLY PATTERN was made when a flashing firefly crawled across photographic film. Firefly light is produced by a chemical reaction in which luciferin is combined with oxygen in the presence of an enzyme called luciferase. Almost all of the energy emitted by the reaction is in the form of light. The insect probably sends a nerve impulse to trigger the release of a small amount of luciferase, which reacts with the luciferin to produce a flash of light. The luciferase is chemically bound up almost as soon as it is released and the light goes out until the next nerve impulse releases more and switches on the lamp again. Each species has its own flashing frequency.

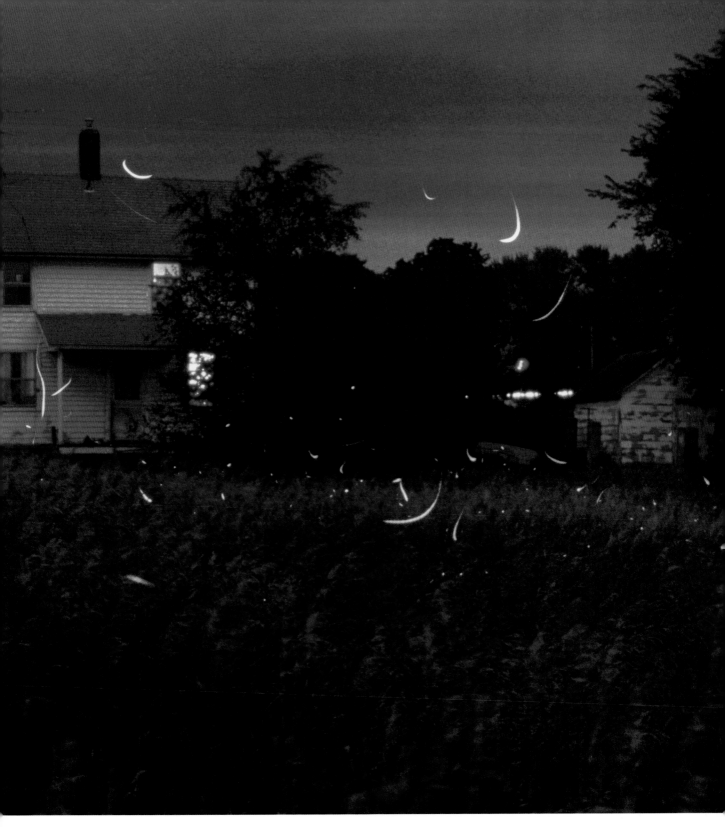

Flashing Fireflies

SEVERAL FIREFLY SPECIES fly together in the Americas and each one has its own display signal. The males often light up for a second or more at a time, and while glowing they often trace a particular path through the air. The light thus forms streaks of various lengths and shapes and the females respond only to the males of their own species.

Well-timed

THE EUROPEAN FIREFLY *(Luciola lusitanica)* is a small beetle related to the glow-worm, but both sexes give out short flashes of light. The male takes to the wing at dusk and flashes his silvery green light almost exactly once every second, with each flash lasting for between one fifth and one quarter of a second. The female has wings, but does not fly. When she sees a male flashing overhead she responds with her own flash, which she emits after a very precise time interval – one fifth of a second at 23°C, although the delay is longer at lower temperatures. The males respond only to flashes coming at the right intervals, and a male picking up a correct signal flies more or less straight down to mate with the female.

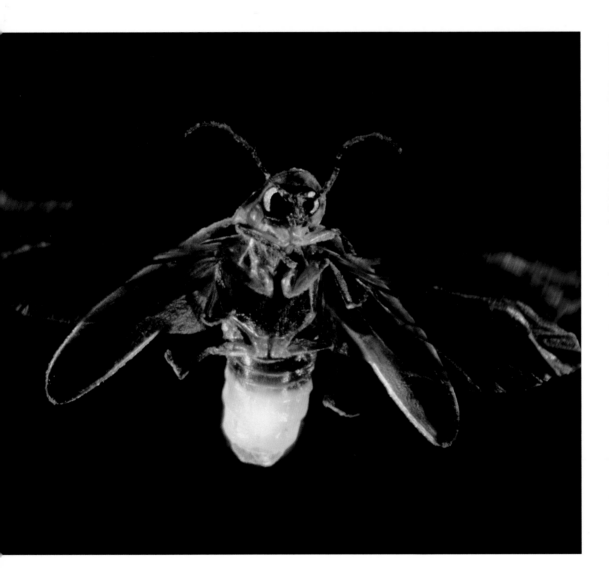

Lighting up Time

FIREFLY TREES in the mangrove swamps of south-east Asia are truly astonishing sights. Male fireflies *(Pteroptyx tener)* gather there in their thousands, lighting up at dusk and flashing in unison, just like the lights outside a theatre or on an advertising hoarding. Females attracted to the trees have no trouble in finding mates.

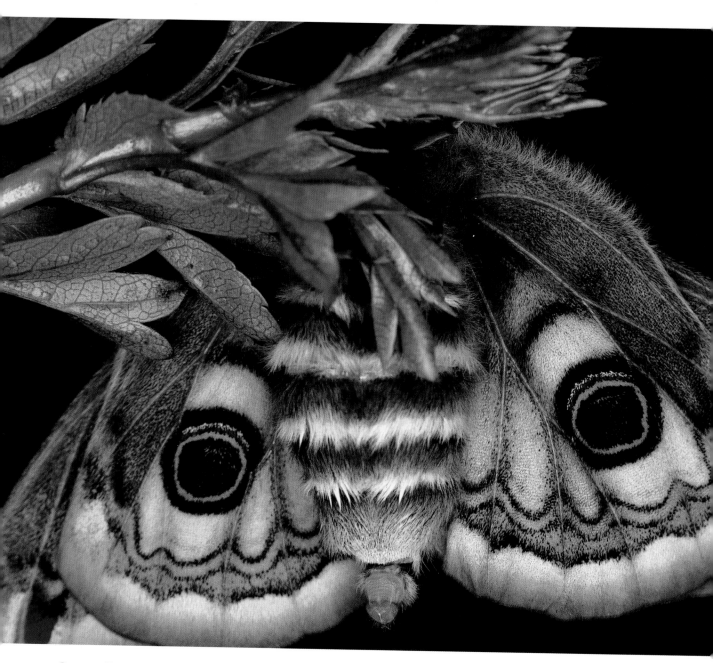

Scented Female

THIS FEMALE EMPEROR MOTH *(Saturnia pavonia)* is 'calling' for a mate by exposing the scent gland at the tip of her abdomen. The gland releases a scent or pheromone that the male emperor moths just cannot resist (see p. 65). It is quite common for several males to home in on a freshly-emerged female and try to mate with her. The males will even swarm to a cloth from which a calling female has long since been removed.

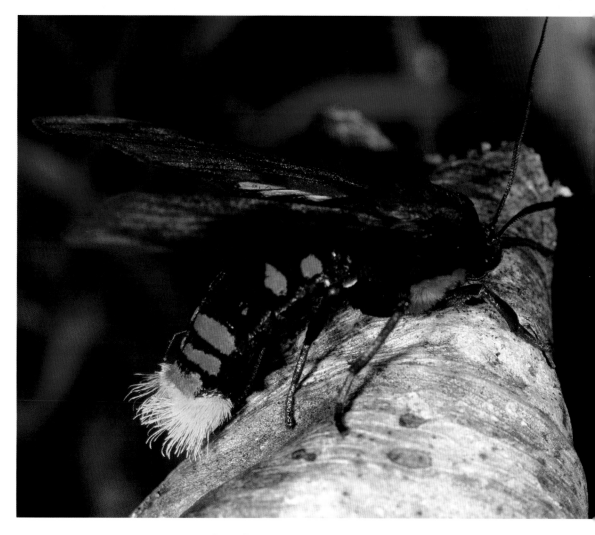

Scented Male

THIS TIGER MOTH (*Thysanoprynna cepiana*) from South America is one of many moths in which the males give out scent to attract the females. Here, the scent, produced in abdominal glands, is being disseminated by bright yellow brushes known as hair-pencils on the insect's rear end. These brushes are normally hidden inside the abdomen, and are everted when required. As well as simply attracting the females, the scents given out by these hair-pencils may induce the females to settle and accept the males.

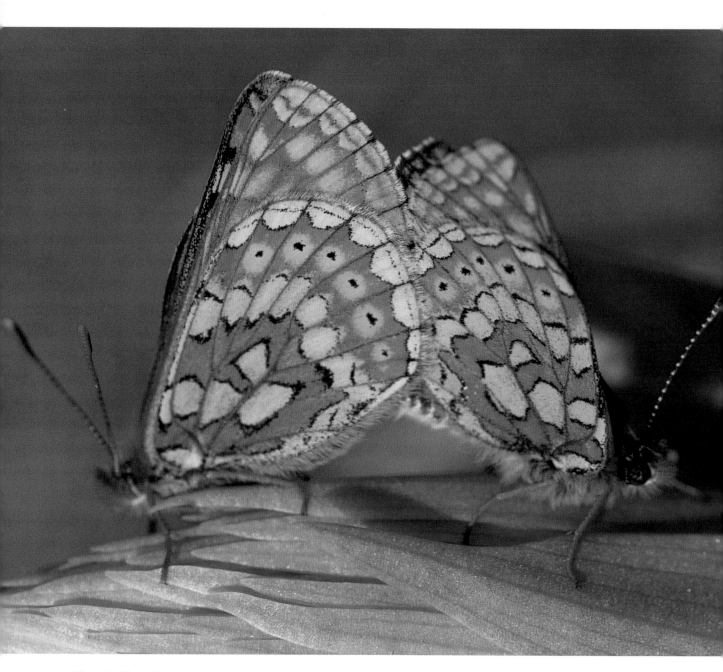

The Mating Game

BUTTERFLY COURTSHIP USUALLY BEGINS WITH VISUAL SIGNALS, but scent soon takes over and if the two insects receive all the right signals from each other, they move on to the final stage of the process – copulation. This usually takes place on the ground or vegetation, with the two insects coupled tail-to-tail and facing in opposite directions as illustrated by these marsh fritillaries. They may stay coupled for hours and normally remain at rest, but can fly if necessary. Either sex can take the lead and fly in a forward direction. The leader often basks with its wings open while mating, absorbing the sun's rays ensuring that its muscles are warm enough for a quick take-off.

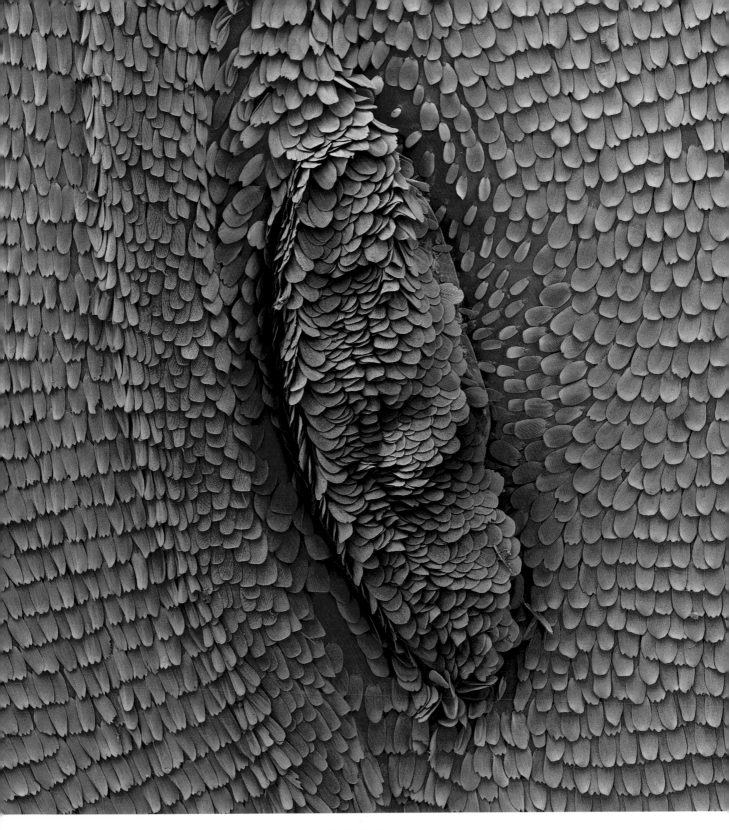

Scented Scales

MOST MALE BUTTERFLIES HAVE SPECIAL SCENT-PRODUCING SCALES known as androconia. The
scales often have tips that help to disseminate the scent. They may be scattered all over the
wing, but are more concentrated in certain areas, known as sex brands, as shown here on the
wing of a monarch butterfly. The females commonly rub their antennae against the sex brands
during courtship and this stimulates them to mate.

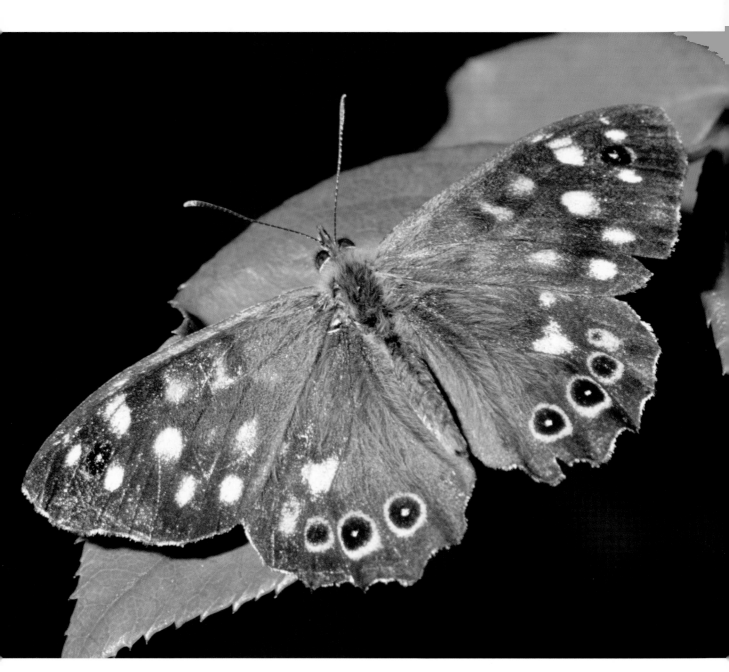

Warming Up for the Chase

THE MALE SPECKLED WOOD BUTTERFLY *(Pararge aegeria)* normally defends a patch of sunlight on the woodland floor or on low-growing herbage. Sunny spots are attractive to both sexes, and therefore ideal meeting places. Anything flying in the vicinity of the territory causes the male to fly up to investigate, and if it is another male of the same species there is a short scuffle before the intruder retreats. The resident almost always wins and it seems likely that basking in the sunshine warms him up sufficiently to give him extra speed and agility. When the female arrives, the male begins a courtship dance and if the female is sufficiently impressed she settles beside him.

INSECTS

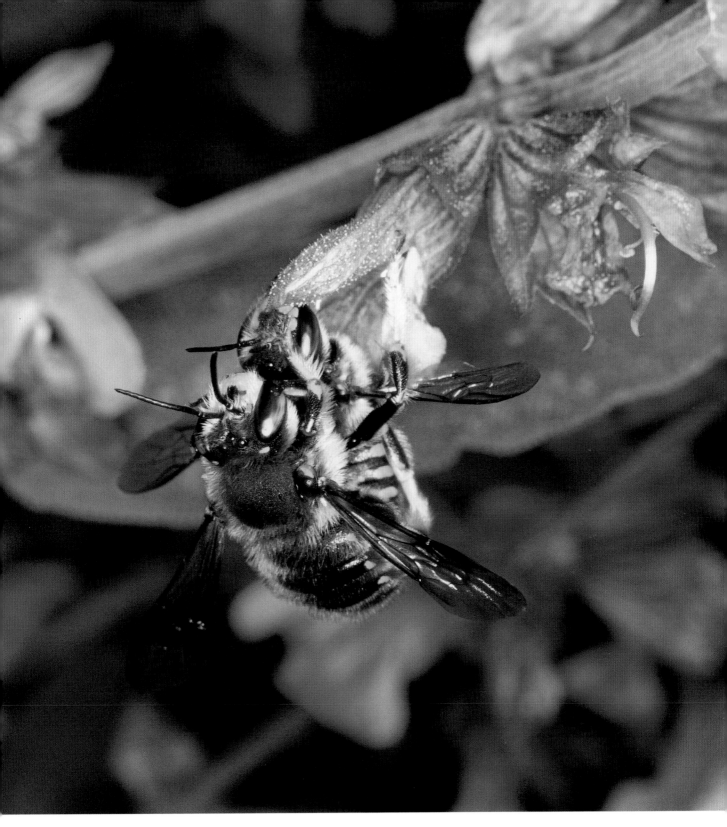

Get off my Patch

THE MALE WOOL CARDER BEE *(Anthidium manicatum)* is usually much larger than the female and he puts his size to good use in the defence of a patch of flowers. He shows little interest in the flowers themselves, but vigorously attacks other bee species attempting to feed from them. Even big bumble bees turn away in the face of such an attack. The territory-holding male is not guarding the nectar and pollen for himself, but ensuring there is a plentiful supply to attract female wool carders into his territory. He mates with the females while they are feeding, as pictured here.

234

Wrestling Giants

THE MALE HERCULES BEETLE *(Dynastes hercules)* is one of the world's largest beetles, with a total length, including the horns, of about 15 cm/6 in. The upper horn springs from the thorax and the lower one springs from the head. In common with many other horned beetles, rival males wrestle with their horns as each tries to overturn the other and impress any watching female! The females are much smaller and lack the horns. Also called the rhinoceros beetle, the species lives in the rain forests of tropical America, where it breeds in rotting timber.

A Complete Change

THE GREAT DIVING BEETLE *(Dytiscis marginalis)*, in common with all beetles, undergoes complete metamorphosis as it grows up. The larva (above) has no trace of wings and shows no anatomical similarity at all with the adult beetle (right), although both are fierce predators (see p. 108)…

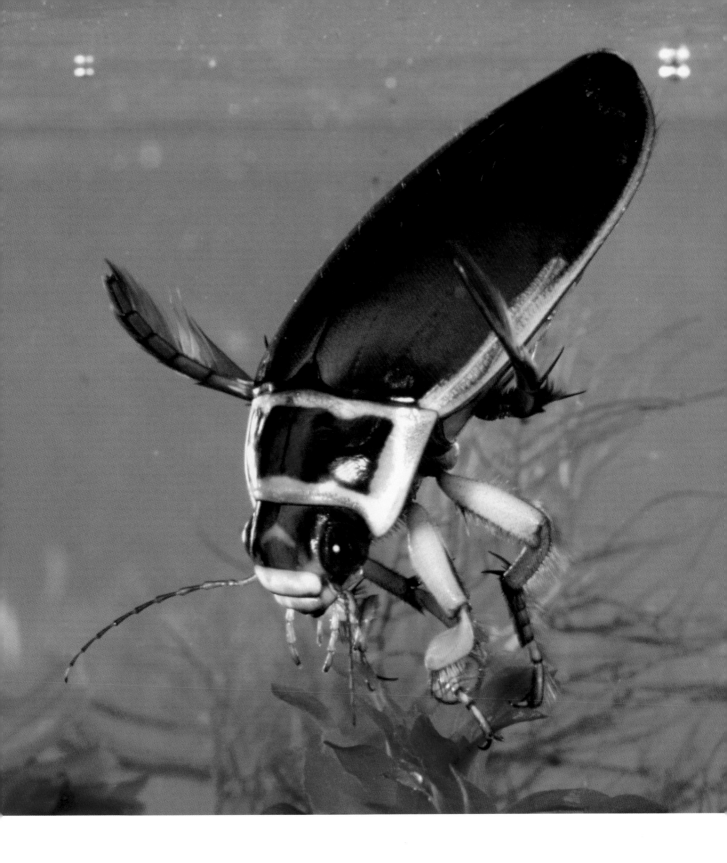

...When fully grown, the nymph leaves the water and turns into a pupa in the surrounding soil, from which the adult beetle emerges a few weeks later. The adult is a powerful swimmer, propelling itself through the water with its broad, hair-fringed legs. It also flies well, so it can colonise new ponds very easily.

Sucker Power (Right)

THE SWOLLEN PAD on the diving beetle's front leg is clothed with two large suction cups and numerous much smaller ones, seen here at high magnification. Adhesion is enhanced by a sticky secretion and the male can keep hold of the female in this way for many hours.

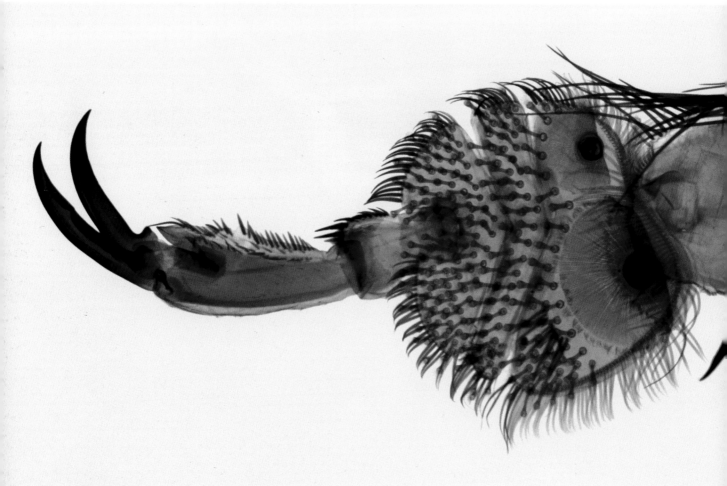

Hold Tight

EACH FRONT LEG OF A MALE GREAT DIVING BEETLE (*Dytiscus marginalis*) bears a large adhesive pad that enables him to take a firm hold of the female during mating. The claws at the tip of the leg are used primarily to grab the beetle's prey – a variety of other animals, including worms, small fish, and even frogs.

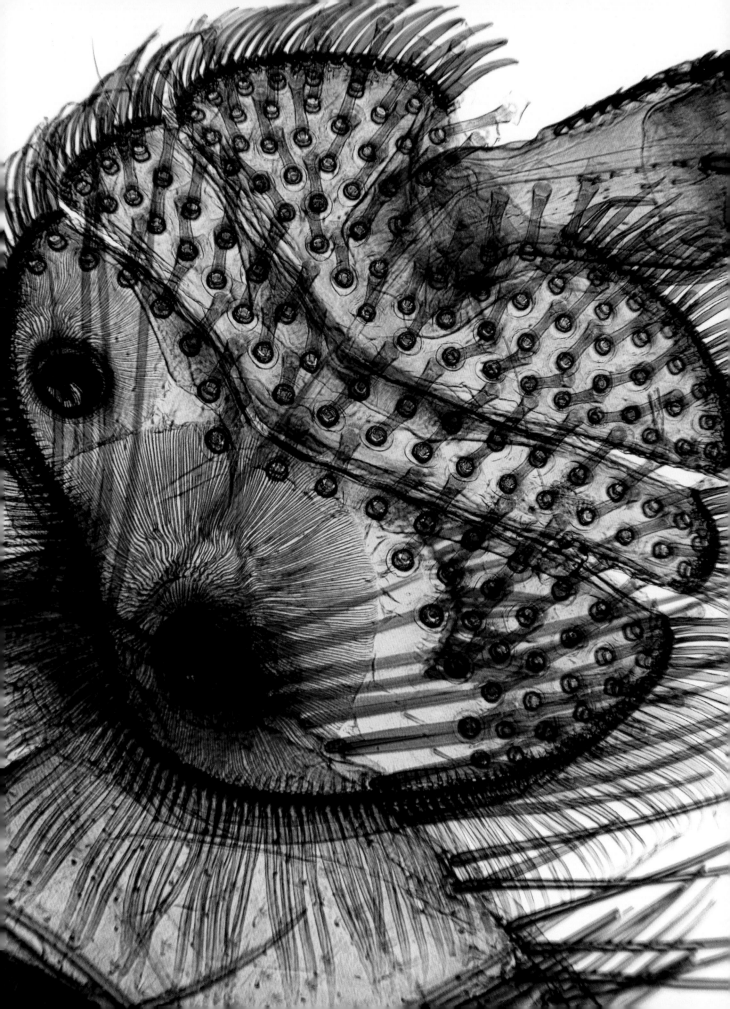

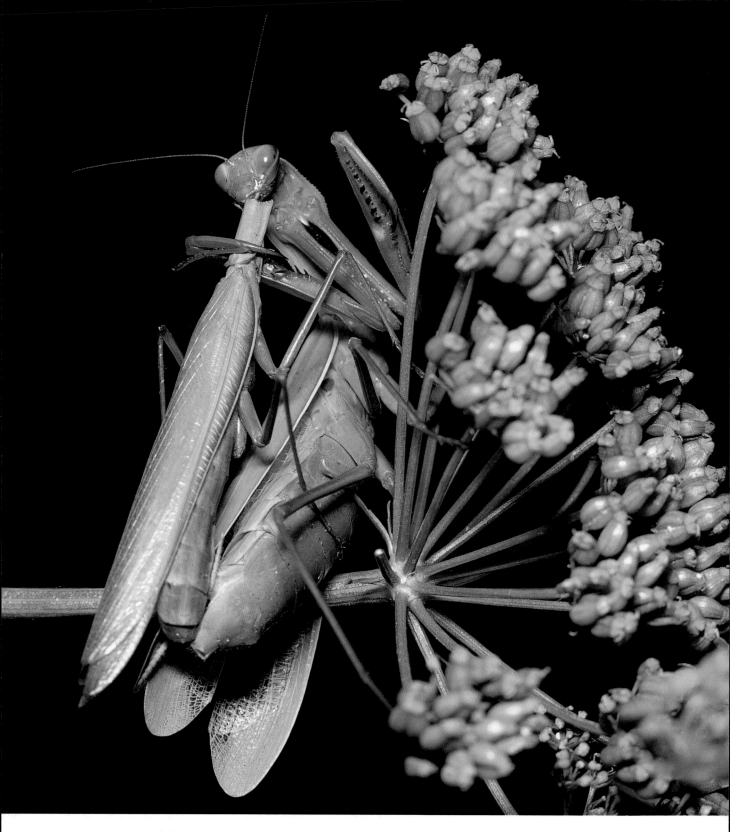

Dangerous Liaison

THE MALE PRAYING MANTIS *(Mantis religiosa)* is much smaller than the female and mating is a dangerous game. In fact, the female usually eats the male and often starts tucking in to him even before they have finished mating. Here, the hapless male has already lost his head, but his body continues to pump sperm into the plump, egg-filled female until there is nothing left of him. It's the supreme sacrifice: his body helps to nourish the eggs that he has fertilised.

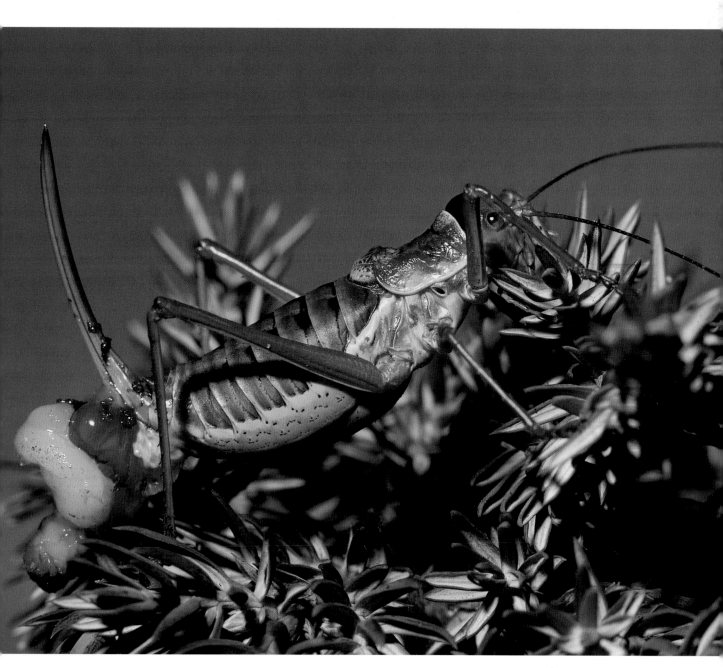

Wedding Breakfast

THIS FEMALE BUSH CRICKET *(Ephippiger ephippiger)* looks as if she has met with a nasty accident but the jelly-like mass attached to her rear has actually been donated by a male during copulation. Known as a spermatophore, this package represents up to a third of the male's body weight and contains both a supply of sperm and a nutritious meal for the female. Only the part nearer to the female's body actually contains sperm. The rest is for eating, and as soon as the male has left the female tucks in. It keeps her occupied while the sperm makes its way into her body to fertilise her eggs, and also prevents her from mating with another male.

241

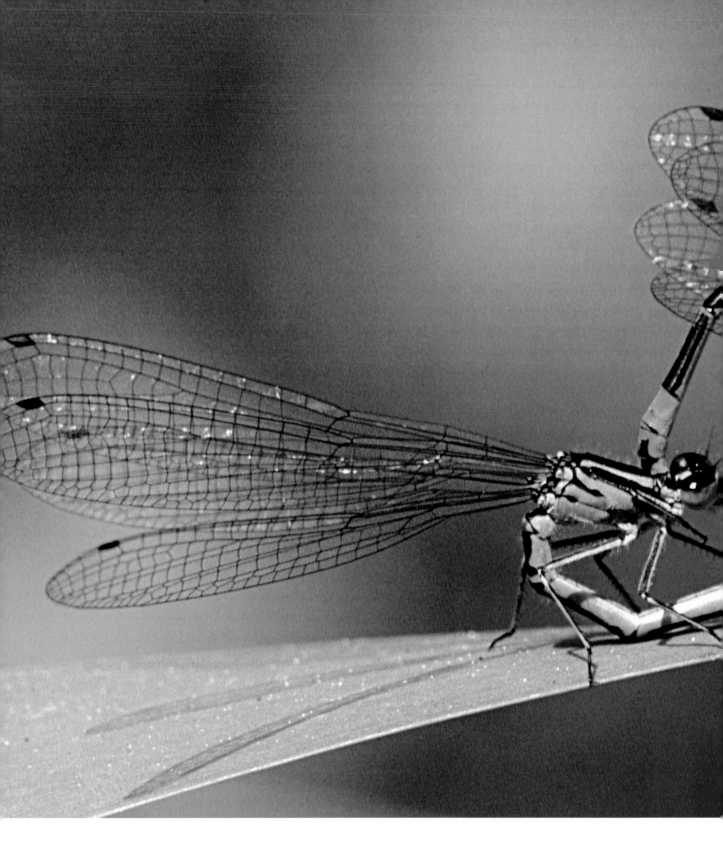

242

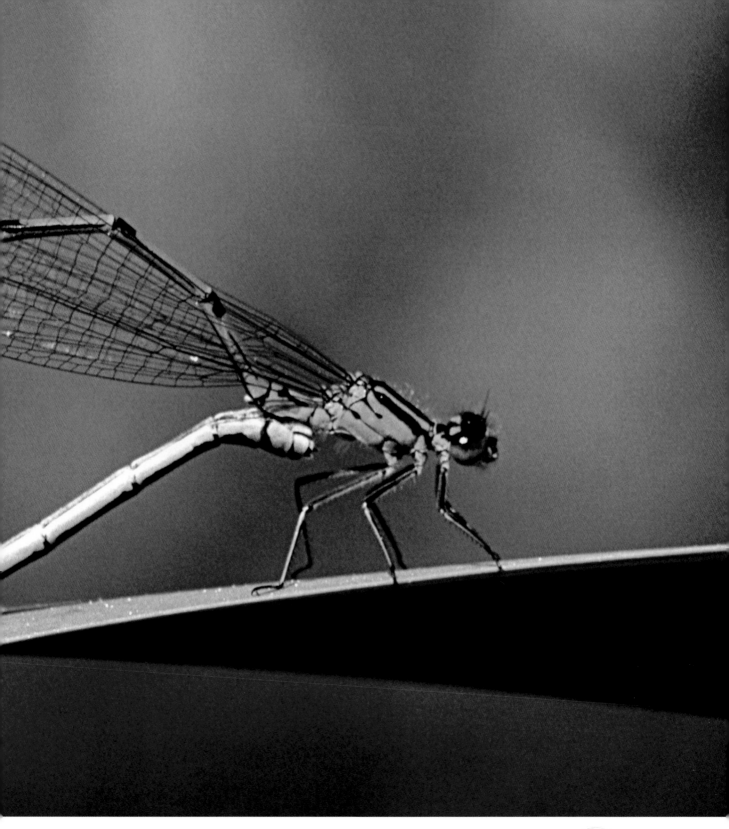

A Unique Union

THESE AZURE DAMSELFLIES *(Coenagrion puella)* are exhibiting the mating technique of the
dragonflies and damselflies. Although the male's genital opening is near the end of the abdomen,
his copulatory organs are at the front. Before mating he transfers sperm to them by bringing his
rear end forward so that the tip of his abdomen makes contact with the copulatory organs. This
normally happens while he is holding a female by the neck (see p. 246). Transfer completed, the
male straightens his abdomen and the female bends hers forward to collect the sperm. This is
called the copulation wheel. The pair can fly, although they usually rest on vegetation.

(see p. 246)

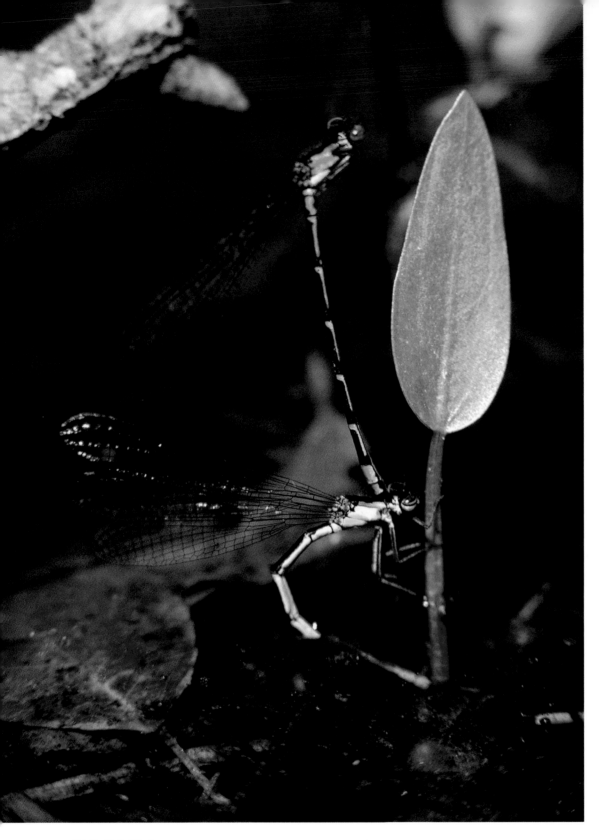

Helpful Males...

AFTER MATING, MANY DAMSELFLIES REMAIN IN TANDEM, with the male holding the female's neck, while the female lays her eggs. Here, a male *Enallagma civile* is gently lowering his mate into the water so that she can lay her eggs in a submerged plant. Guarding the females in this way clearly discourages further mating by the females and ensures that their eggs are fertilised by the guardian males.

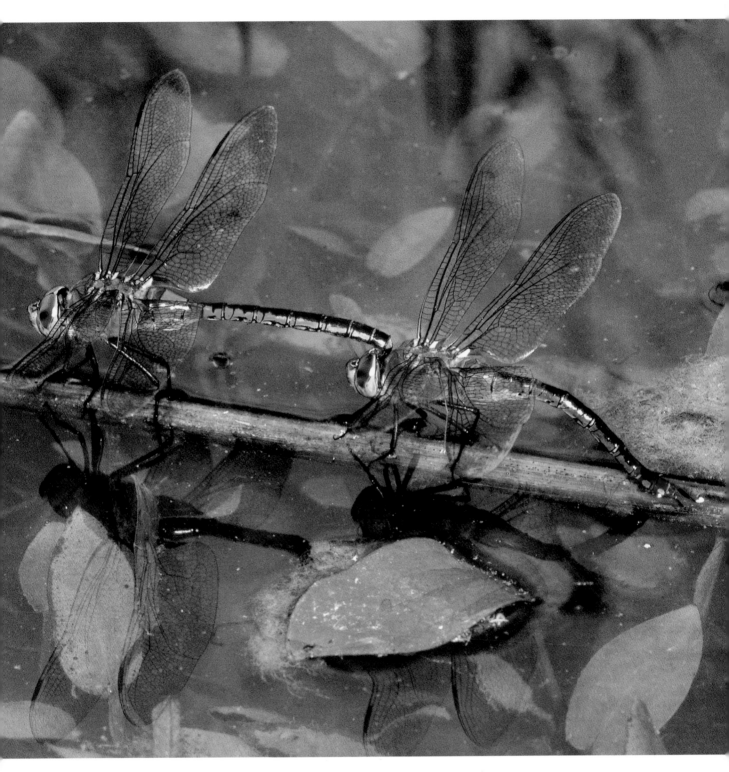

...Stand Guard

A PAIR OF GREEN DARNER DRAGONFLIES *(Anax junius)* remain in tandem, with the male keeping watch for rivals, while the female, on the right, deposits her eggs in the floating vegetation. Not all dragonflies behave in this way: the females of many species lay their eggs alone, often skimming over the surface and dipping their rear ends periodically into the water to scatter the eggs.

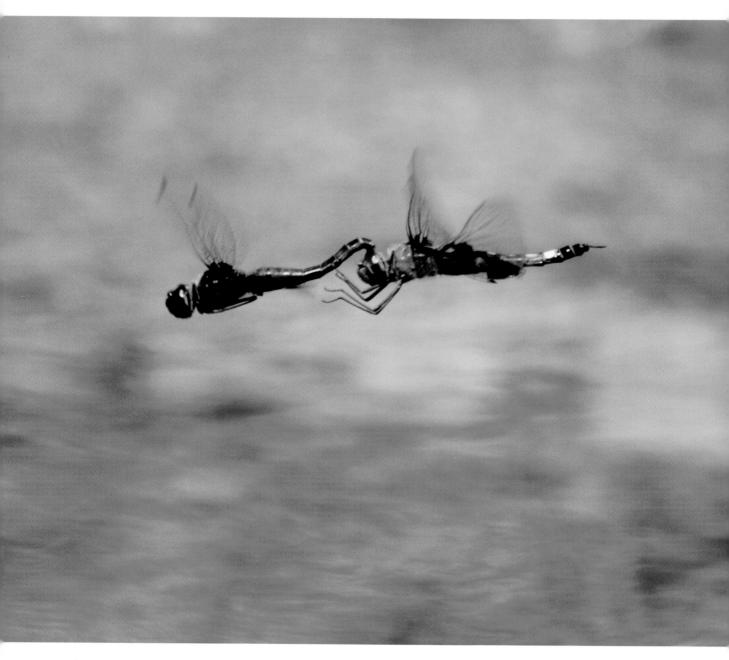

Gentlemen First

MALE DRAGONFLIES GRAB THEIR PARTNER BY THE SCRUFF OF THE NECK. Claspers at the tip of the male's abdomen are just the right shape to hold females of the same species. The insects fly together in tandem as shown here before settling down to mate (see p.242-243) and may continue to fly like this after mating, with the male guiding his mate to suitable egg-laying sites (see p. 244).

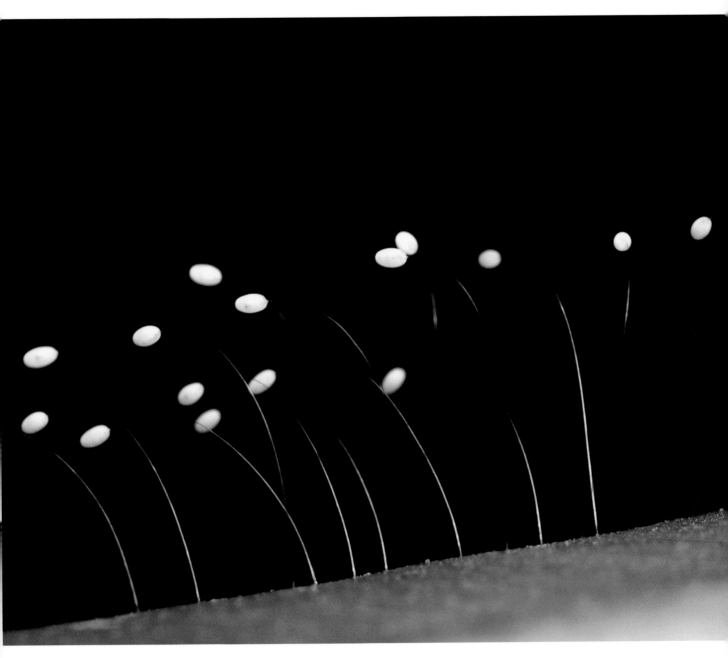

Eggs on Stalks

GREEN LACEWINGS OF THE FAMILY *CHRYSOPIDAE* lay their eggs at the ends of slender threads, formed from quick-drying mucus. When laying her eggs, the female lacewing first dabs a spot of the mucus on to the substrate and then draws it out by raising her abdomen. The mucus immediately hardens and an egg is glued to the free end. Some species lay their eggs separately, but others lay them close together and their threads coalesce. Suspended from their delicate threads, the eggs are safe from at least some of their enemies.

247

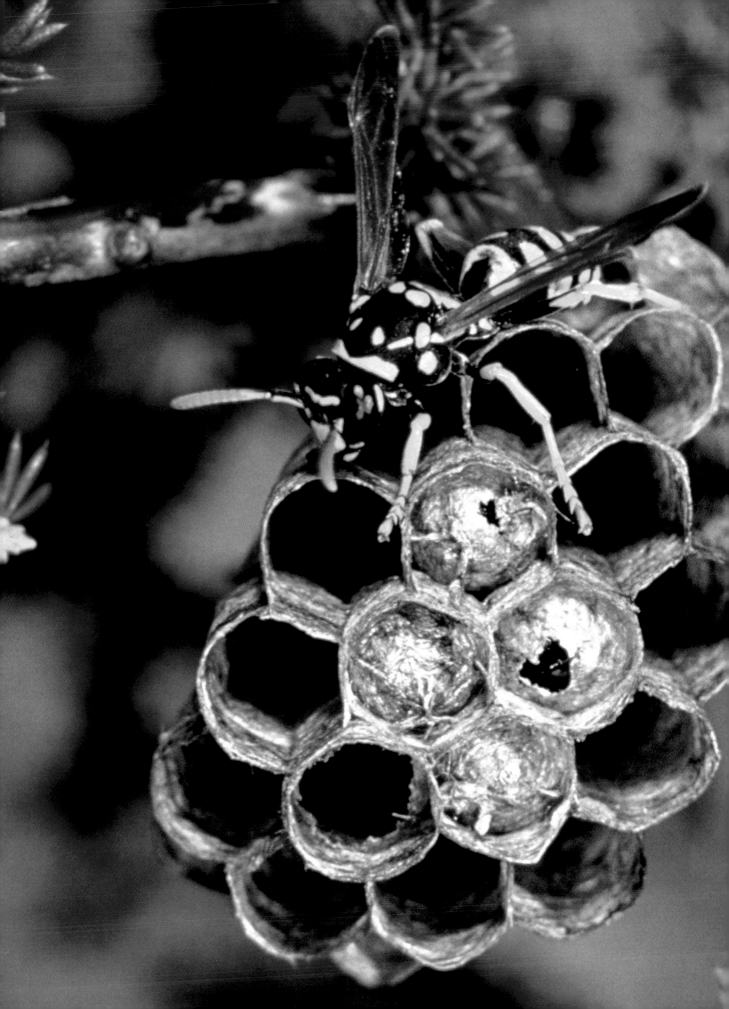

Homes and Habitats

Insects have colonised just about every available habitat, from snowy mountain tops to scorching deserts and steamy rain-forests. Some confine themselves to distinct territories, but most insects roam freely through their habitats and rest in any convenient spot. Few species have permanent homes. Leaf-miners feed between the upper and lower surfaces of leaves when they are young (see p. 252) and live in the galleries that they create, but the adult insects are free-living. Bark-beetle galleries (see p. 253) are also home only to the young stages. Young gall-causing insects live and feed in swellings on their host-plants, but these growths are formed entirely by the host-plants (see p. 255). We cannot credit any of the above insects with any building ability. Dung beetles exhibit something of an advance in that they excavate underground cells which they stock with dung as larders for their young. The caterpillars of various butterflies and moths, notably those of the processionary moths (see p. 250), make silken nests in which they rest when not feeding, although these shelters are abandoned when the caterpillars grow up.

Mason wasps, potter wasps, leaf-cutter bees, and many other solitary species are true builders, using a variety of materials to construct and furnish their nests. They are the plasterers and tailors of the insect world, but here again the nests are occupied only by the young stages, and the same is true of the elegant portable homes built by many larval caddis flies. Permanent homes, in which adults and young live side by side, are built only by the social insects – termites, ants, and some of the bees and wasps. The largest nests are those of various tropical termites, some of which may contain as many as 10 million insects! Built with earth and saliva, liberally mixed with the insects' droppings, these nests may be as hard as concrete and many have efficient air-conditioning systems. It is truly remarkable that such nests are built entirely by instinct, without any plans or building instruction, and that the builders are only a centimetre or so long and virtually blind!

Many ants also build with chewed wood and soil and some use leaves (see p. 260), but the internal nest structure is fairly simple – usually just a few cavities hollowed out to accommodate the ants and their offspring. There is never any of the intricate cellular construction seen in the nests of the social wasps and the honey bees. The hexagonal cells of these nests (see p. 268 and 279) are fitted together with amazing precision, again entirely by instinct and nearly always in the dark.

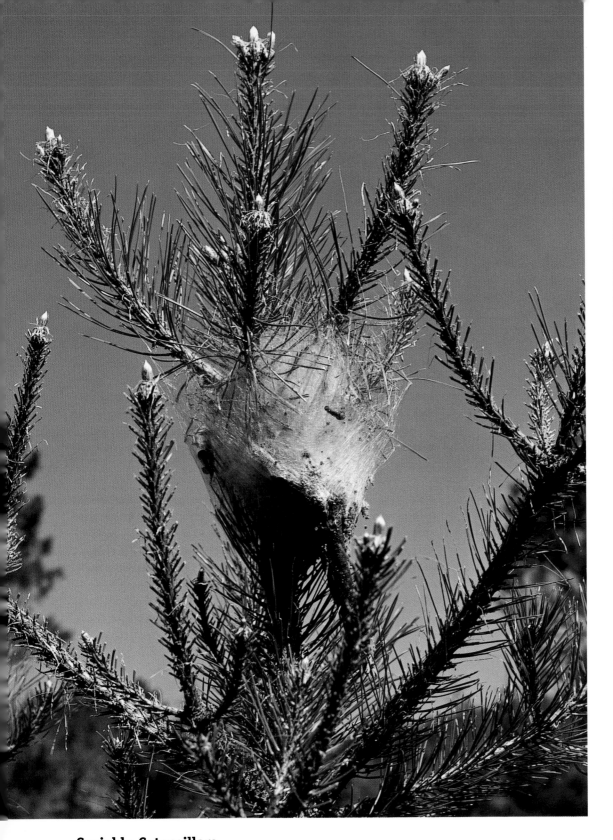

Sociable Caterpillars

CATERPILLARS OF THE PINE PROCESSIONARY MOTH *(Thaumetopoea pityocampa)* live in silken tents spun among the pine needles. The tents may be as big as rugby balls and the caterpillars often bask communally on the outside in warm weather. They also hibernate in the tents.

Keep Going

PINE PROCESSIONARY MOTH CATERPILLARS (*Thaumetopoea pityocampa*) leave their tents to feed on the pine needles at night. They walk nose to tail along the branches as they search for fresh leaves. This is an instinctive action, as the French naturalist Henri Fabre demonstrated when he persuaded a procession to start walking around the rim of a tub. When the circle of caterpillars was complete, Fabre deflected the rest of the column and those on the rim continued to walk around it for eight days! The caterpillars lay down silk strands as they go, and they use these pathways to find their way home after feeding – still walking in processions.

251

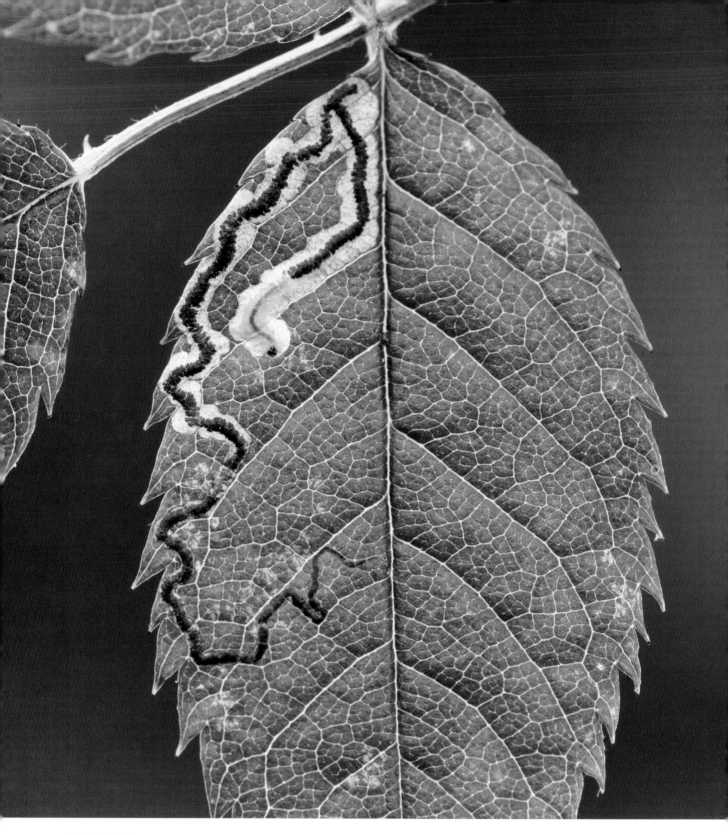

A Tight Squeeze

There is not much space between the upper and lower surfaces of a leaf, but the tissues there are very nutritious and many moths, grubs, beetles, and flies live and feed there. Known as leaf-miners, they excavate twisting tunnels or broader chambers as they nibble away at the tissues, and these excavations or mines are usually clearly visible through the skin of the leaf. Here is a serpentine mine in a rose leaf. It is very narrow at first, but gradually gets wider as the insect grows. The black dot at the end of the mine shows where the adult insect finally escaped.

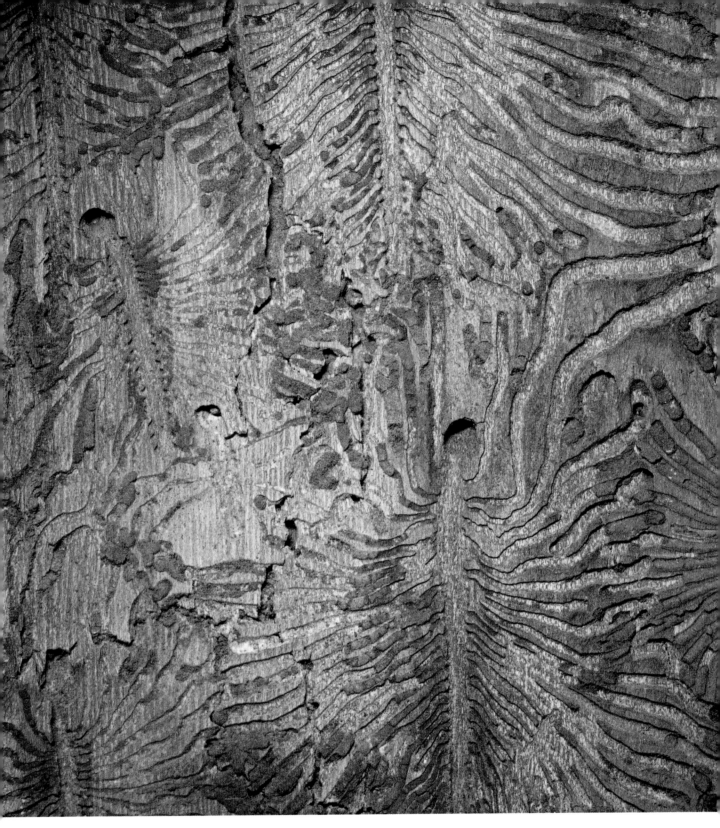

Bark Patterns

RADIATING PATTERNS ON A PIECE OF ELM BARK are the work of the notorious elm bark beetle *(Scolytus scolytus)* – the carrier of Dutch elm disease. The vertical channels are excavated by a mated female, working just under the bark of the tree. She lays her eggs at intervals on each side, and the resulting larvae tunnel away from the main gallery in a more or less horizontal direction, producing the characteristic patterns seen here. The larval tunnels get wider as they get further from the main gallery. When abundant the insects may completely detach the bark from the underlying timber and the tunnels can then be seen on the fallen bark and on the denuded trunks.

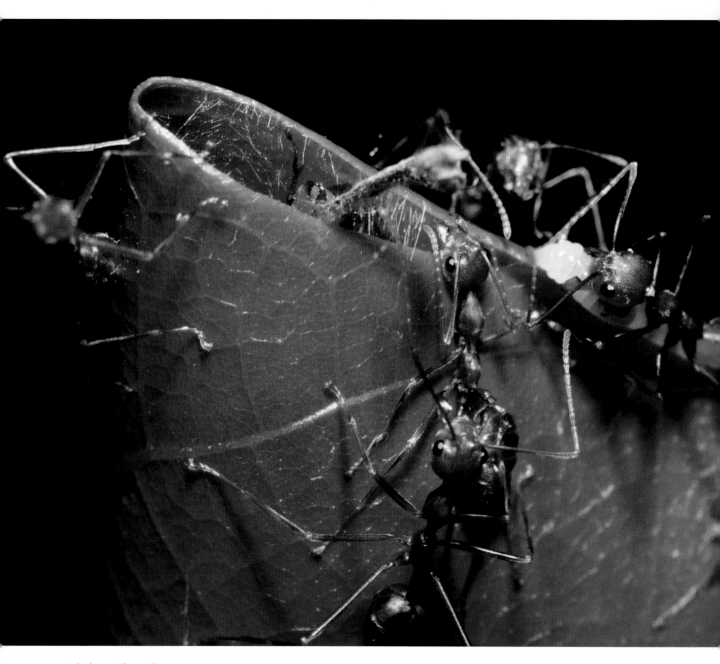

Living Shuttles

WEAVER ANTS make their homes by fixing living leaves together to form pouches, each of which may contain several hundred ants. The insects pull the edges of the leaves together with their jaws and legs, and then the other ants zig-zag along the joins carrying grubs in their jaws, as can be seen in the centre of the picture. The grubs exude sticky strands of silk that glue the edges together. Some nests are as large as footballs, but they are not easy to see because the leaves remain alive and the nests blend in with the rest of the foliage.

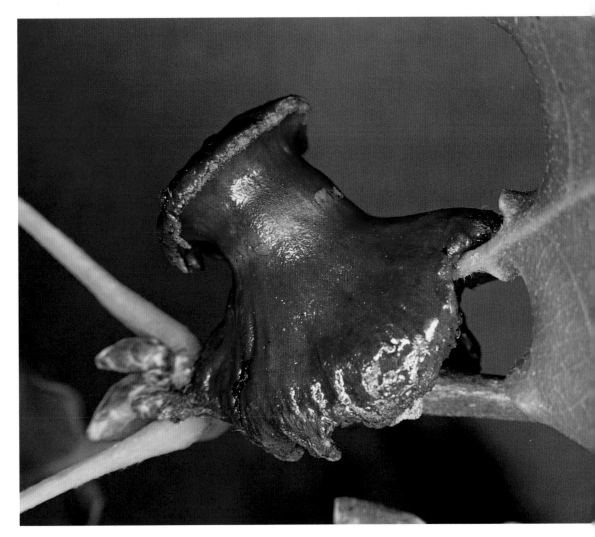

Food and Shelter

THE GALL OF *ANDRICUS VISCOSUS* is one of the more complex plant galls. It grows on acorns and, in common with all galls, it provides both food and shelter for the gall-causer – in this instance a gall wasp of the family *Cynipidae*. The insect grows up in a chamber right inside the gall and the sticky coating deters parasites from laying their eggs in the gall. Plant galls develop when an insect or other organism gets inside a plant and causes its cells to grow and multiply abnormally. They are formed entirely from plant tissue but the structure of the gall depends on the gall-causer. Closely related insects can induce galls of very different shapes.

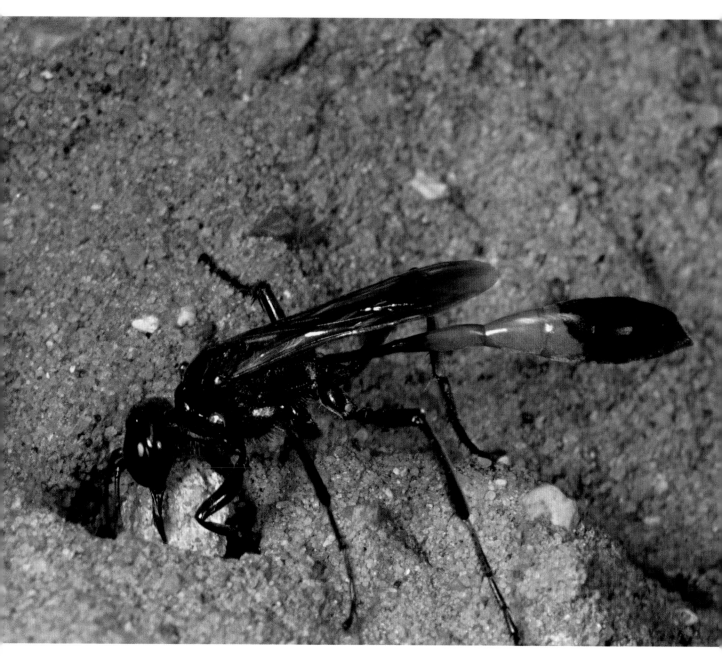

Shut the Door

THE SAND WASP *AMMOPHILA SABULOSA* is a clever tool-user. The female excavates a burrow with her jaws and the comb-like hairs on her front legs. The burrow can be completed within an hour or two. After assessing the width of the burrow with her jaws, she searches for a pebble to fit and wedges it in the mouth of the burrow. She is then ready to look for a caterpillar. Having carried or dragged the prize back to the burrow, she removes the pebble and drags the caterpillar inside (see p. 128-129). An egg is laid in the chamber and the nest is sealed, often by forcing the pebble further into the shaft and back-filling it with sand.

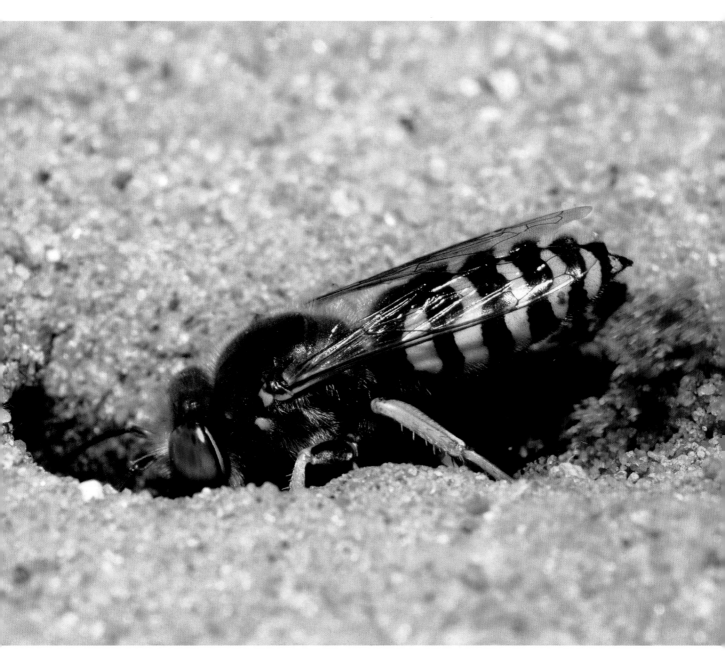

Going Down

A FEMALE SAND WASP *(Bembix americana)* vigorously excavates a nest burrow in sandy ground. Her front legs are furnished with stiff bristles that make excellent brushes for sweeping out the sand. The completed burrow, usually with a single chamber, is stocked with paralysed flies that will serve as a larder for her developing offspring. Although each burrow normally contains just one wasp larva, the female usually excavates several burrows in close proximity.

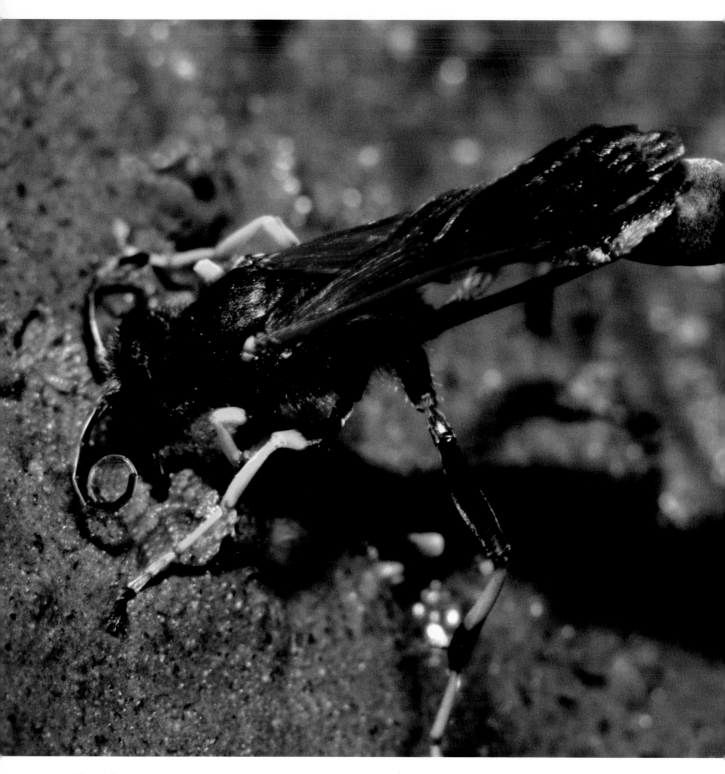

The Plasterer ...

THIS BLUE MUD DAUBER *(Chalybion californicum)* is collecting mud for its nest and rolling it into a ball before carrying it home in its jaws. The nests are built on rocks and walls, and even on ceilings. Each contains a number of tubular cells which are stocked with paralysed spiders. When all the cells have been stocked, the whole nest is plastered over and it looks just like a lump of mud thrown at a wall.

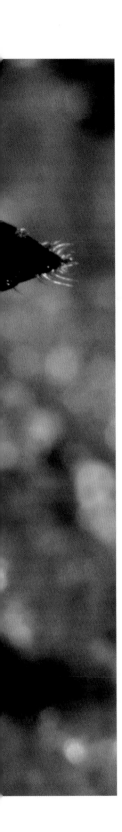

... and The Potter

THE EUROPEAN HEATH POTTER WASP *(Eumenes coarctatus)* is a true artisan, building these neat little vases by moulding mud and fine sand with its jaws and front legs. If the material is too dry the wasp collects water to mix with it. When the nest is complete the wasp pushes her abdomen into it and lays an egg on the ceiling, just inside the entrance. She then stocks the vase with paralysed caterpillars. When the vase is more or less full, she seals it with another pellet of clay and then begins another building cycle. Several vases may be built close together or even touching, and they can be found on rocks and tree trunks as well as on low-growing plants.

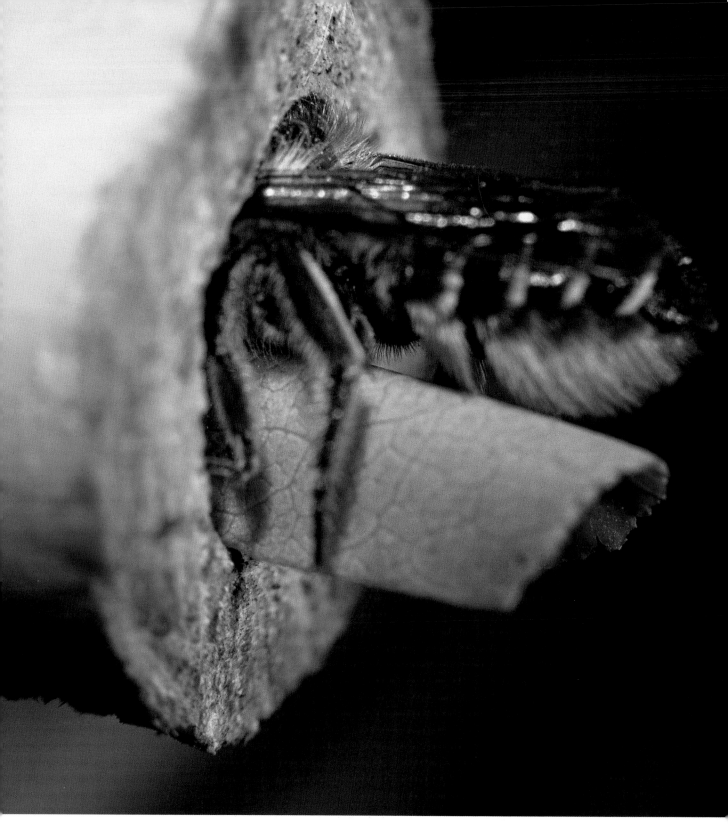

Working with Leaves

LEAF-CUTTER BEES of the genus *Megachile* nest in narrow cavities, in which they construct several sausage-shaped cells with oval and circular leaf fragments. The bees use their sturdy, sharp-edged jaws like scissors to carve out the pieces, and can remove a perfect oval 10-15 mm/0.4-0.5 in. long in less than five seconds. The excised pieces are rolled up and carried back to the nest cavity slung under the bee's body as shown by this bee entering her nest in a hollow cane. Leaf-cutter bees commonly damage lilac and roses in the garden...

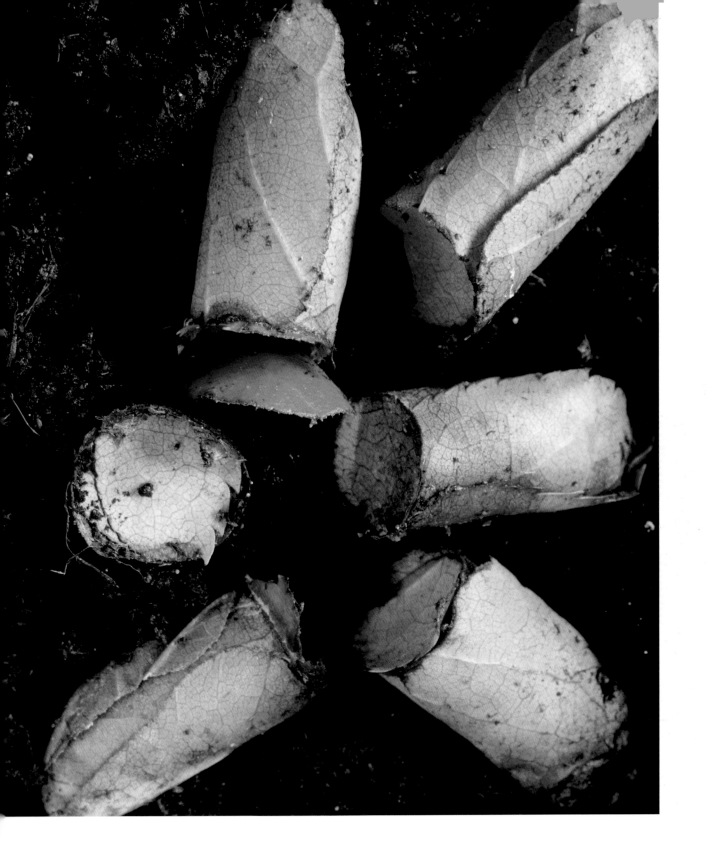

...Back at the nest, the leaf sections are neatly fitted together to form the cells. The edges are crushed and squeezed together in the bee's jaws and the sap sticks them lightly together. As each cell is completed, the bee stocks it with pollen and nectar and lays an egg on the moistened pollen. Several circular leaf fragments are then used to form a plug to close each cell. A completed nest has up to 10 cells, each of which may be composed of about 30 leaf fragments. The completed cells, seen here after removal from the nest cavity, resemble squat cigars.

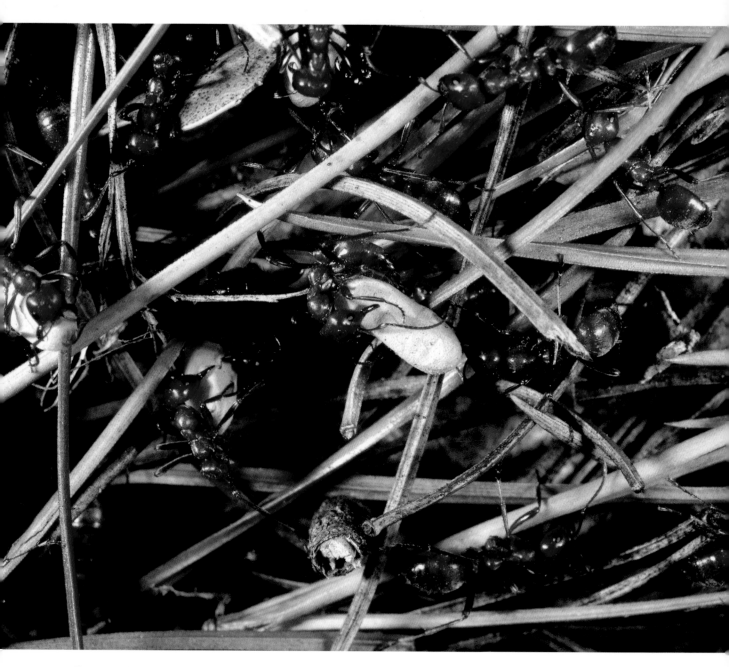

Slave Labour

THESE ANTS HAVE RAIDED THE NEST OF ANOTHER SPECIES and are carrying pupae back to their own nest. Adult ants emerging from these stolen pupae work as household 'slaves' in their new colony. Although commonly referred to as slaves, these workers do not really have a bad life. Apart from the fact that they do not seem to forage outside the nests, they live and behave in just the same way that they would in their own homes. They are merely working for different mistresses. Ants on a slave raid may spray the target nest with scents that alarm the resident ants and cause them to scatter, thus allowing the raiders to plunder the nest.

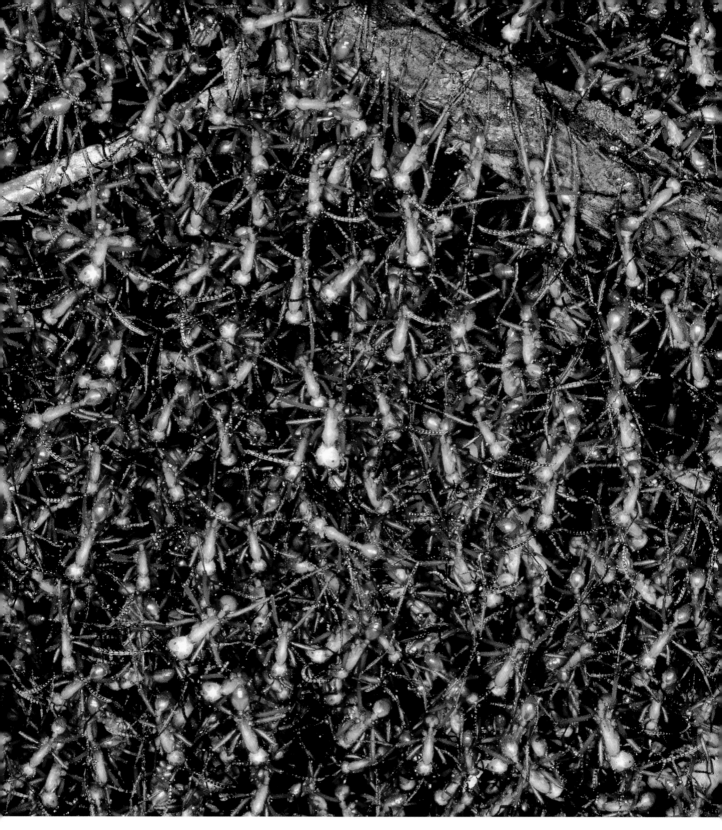

Living Walls

WHEN SOUTH AMERICA'S ARMY ANTS ARE REARING YOUNG, they cannot possibly find enough food day after day in one area, so they move camp every night. They obviously cannot construct a proper nest every night, so thousands of workers merely link legs and form a thick wall around the rest of the colony, including the queen and the larvae. This temporary nest is commonly known as a bivouac. (see p. 121).

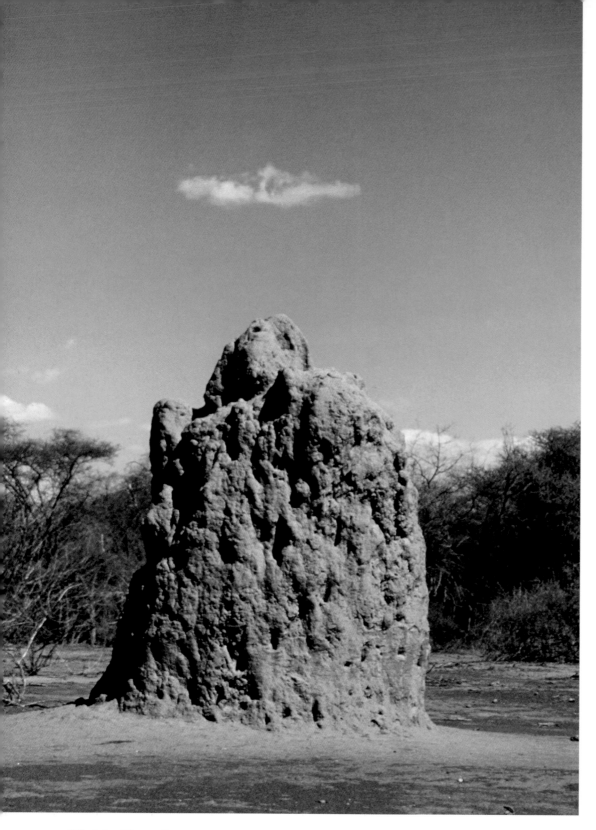

Mighty Mounds

THIS TERMITE NEST IN TANZANIA towering several metres into the air, weighs many tons. Thousands, or even millions of insects live inside it, and also in the ground beneath it. The mound is built with excavated soil, bound together with the insects' saliva and droppings, and the outer wall is rock-hard. Inside the nest there is a labyrinth of tunnels and chambers where the termites rear the young and store their food. Some species even grow fungi in their nests like the leaf-cutter ants.

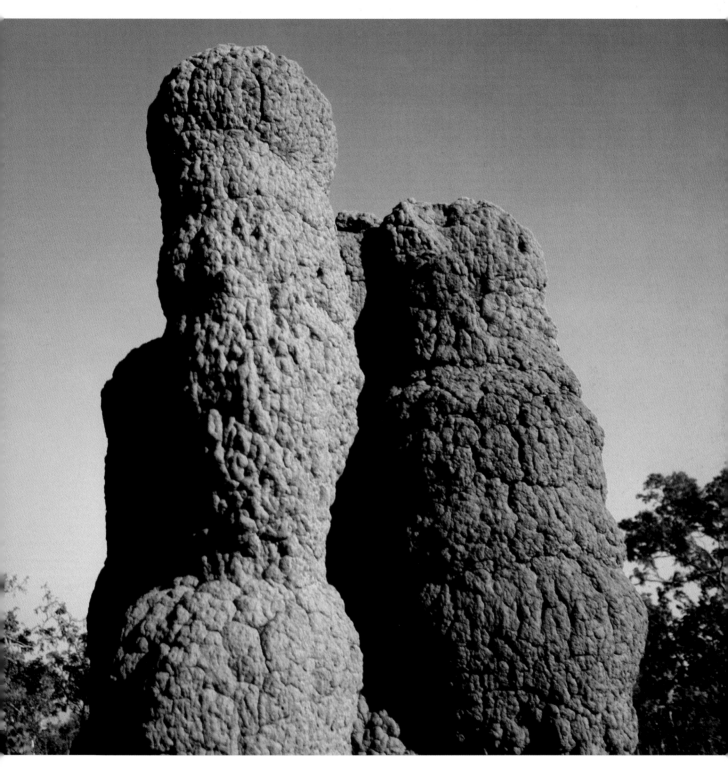

Air-Conditioning

THE AIR INSIDE A TERMITE MOUND CAN GET VERY HOT and also very stale with millions of termites breathing away, and perhaps growing crops of fungi. But the insects have solved this problem with efficient ventilation systems. Hot air rising from the breeding and growing areas travels through ducts that carry it close to the walls. The latter are porous, despite their hardness, allowing carbon dioxide to diffuse out and oxygen to diffuse in. The air is also cooled in the ducts, and then it returns to the base of the nest in another system of ducts.

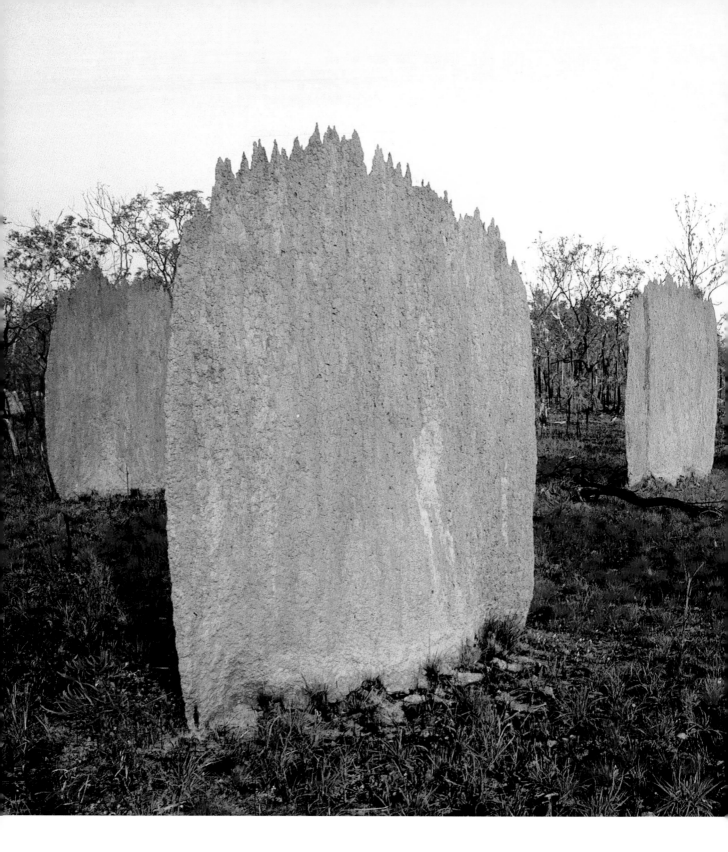

266

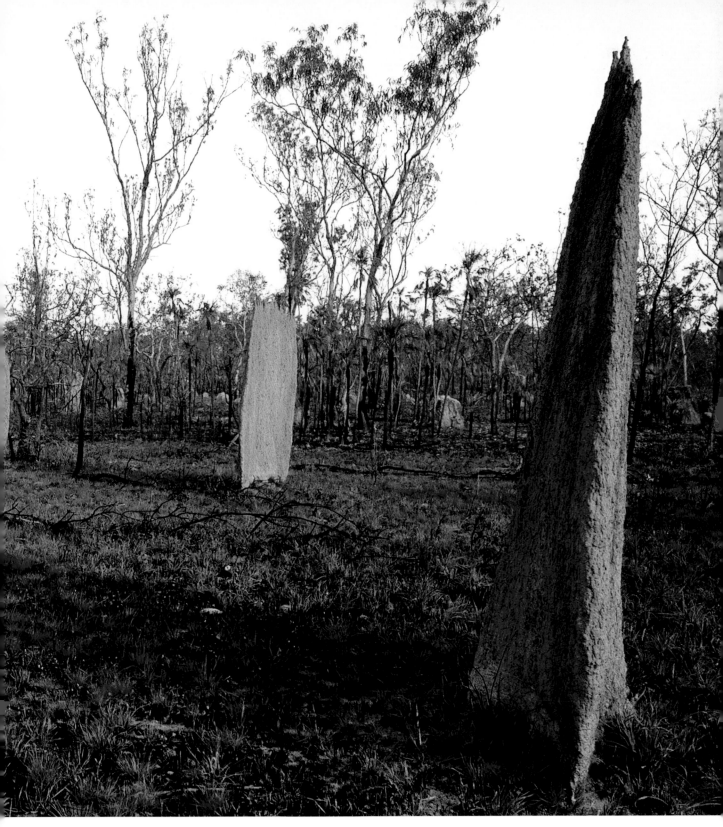

Magnetic Masonry

THE COMPASS TERMITES OF NORTHERN AUSTRALIA *(Amitermes meridionalis)* build mounds that resemble giant tombstones, and they align them very precisely in a north-south direction, like compass needles. Placing magnets around the mounds shows that the insects really do detect the earth's magnetic field and build accordingly. The early morning sun strikes the east face of the nest and warms it up nicely, but the midday sun strikes only the narrow north face and the ridge, so the nest does not over-heat. The mounds may be over 4 m/13 ft. high and 3 m/10 ft. long, but their internal structures are much less complex than that of many other termite mounds.

Paper Insulation (Right)

THE OUTER COVERING (ENVELOPE) OF THE NEST OF A COMMON WASP *(Vespula vulgaris)* is made of shell-like layers of paper, which trap layers of air around the nest and help to insulate it from external temperature changes. Nests built in exposed situations usually have thicker envelopes than those built in more sheltered places. Each coloured band on the shells represents a single load of wood pulp, put in place by a single wasp.

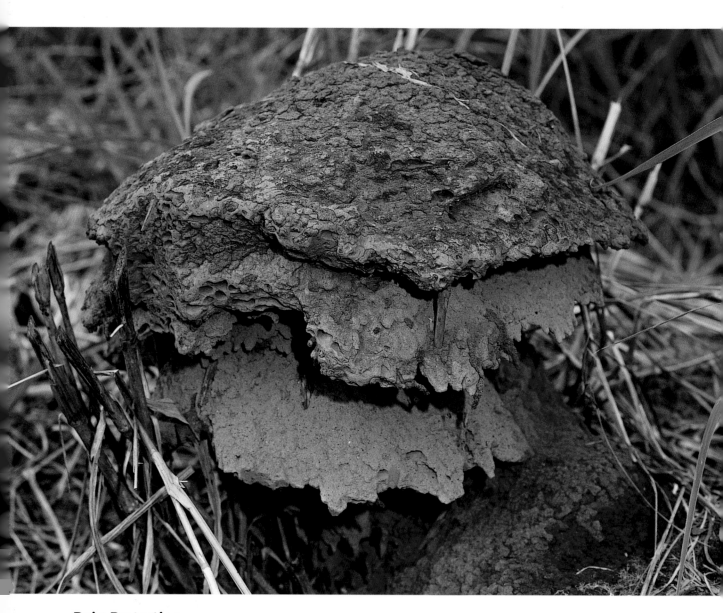

Rain Protection

THESE PAGODA-LIKE MOUNDS belong to termites of the genus *Cubitermes* living in the African rain forests. The tiers of over-lapping roofs shoot the heavy rain away from the main structure, but they do not last very long and have to be repaired at regular intervals. Related termite species build mushroom-shaped mounds with just a single roof. Such structures are not found in drier habitats.

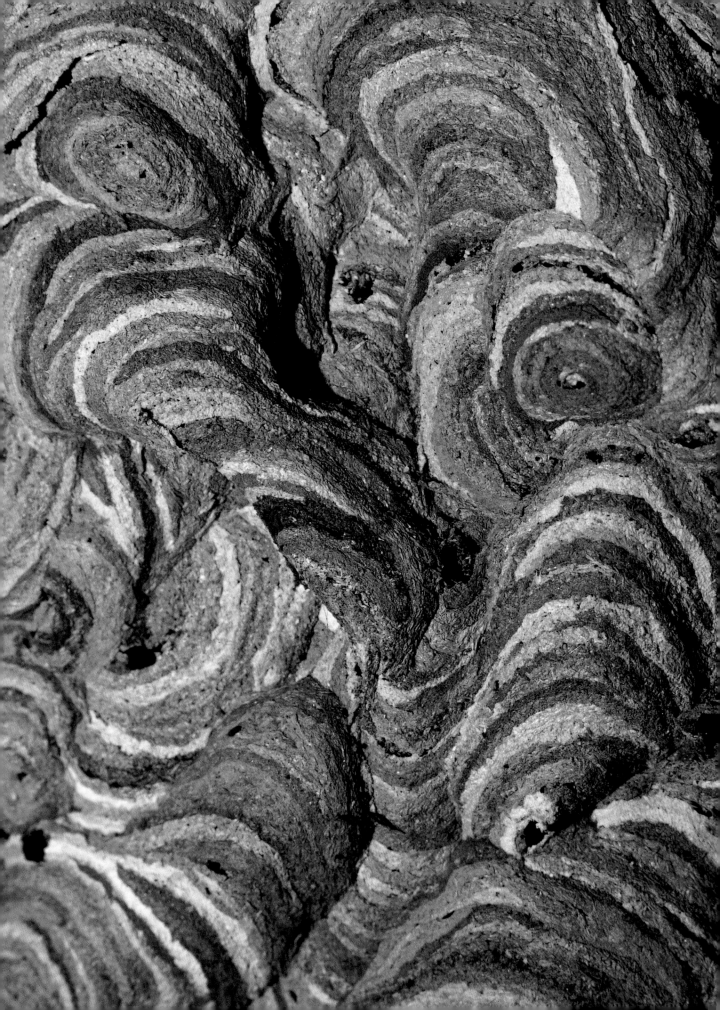

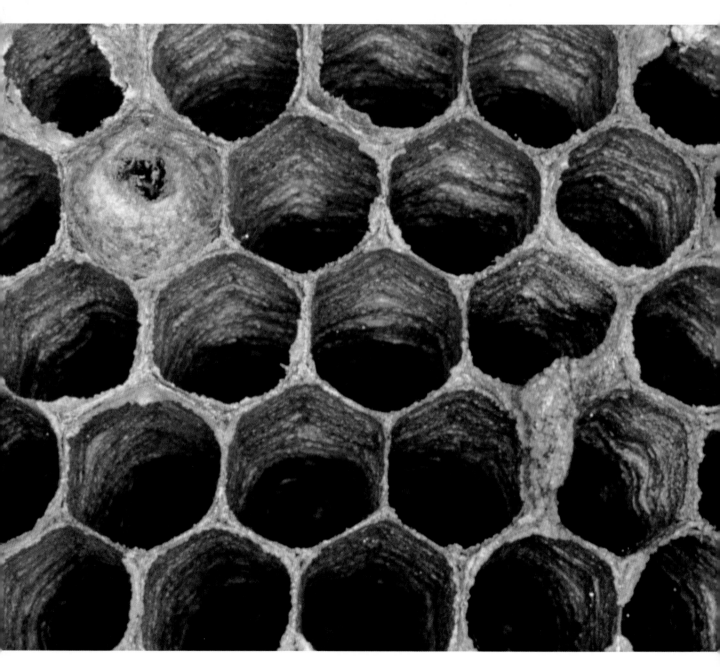

Hexagonal Economy

THE SOCIAL WASPS OR YELLOWJACKETS CONSTRUCT THEIR NESTS WITH PAPER, which they make themselves by chewing up dead wood and mixing it with saliva. Inside the nest, the worker wasps form the paper into hexagonal cells in which they rear the young. The hexagonal shape is the most efficient in terms of economy of space and material, for the cells all share walls with their neighbours and there is no wasted space between them. The wasps use their antennae to ensure that each cell is the right size and shape.

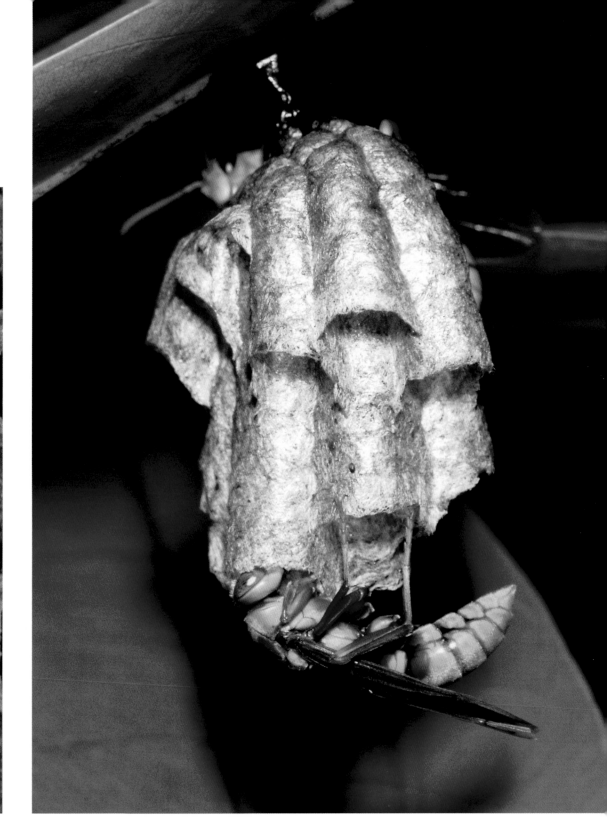

Ant Protection

MANY TROPICAL WASPS, INCLUDING THIS SOUTH AMERICAN SPECIES, make small stalked nests that hang from twigs and leaves. The stalks give the nests some protection against marauding ants, and some of the wasps reduce the risk even further by smearing ant-repellent secretions on the stalks.

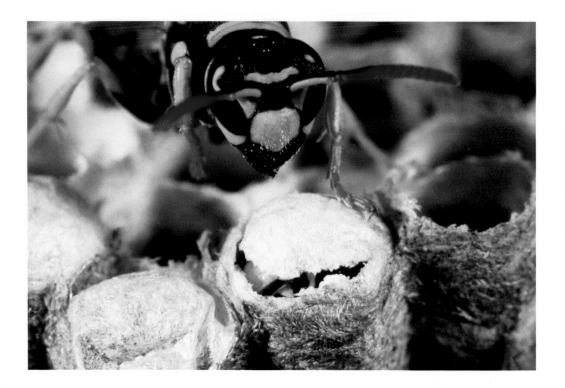

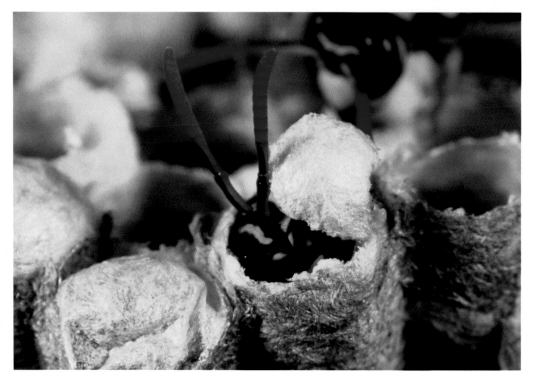

A Wasp Grows Up

WASPS OF THE GENUS *POLISTES* make simple nests with just one tier of cells and no envelope. The queen wasp builds the first few cells and lays an egg in each one. In common with the other social wasps, she rears the first few grubs herself, feeding them on crushed insects and other animal matter. When the grubs are ready to pupate, each closes its cell with a silken cap.....

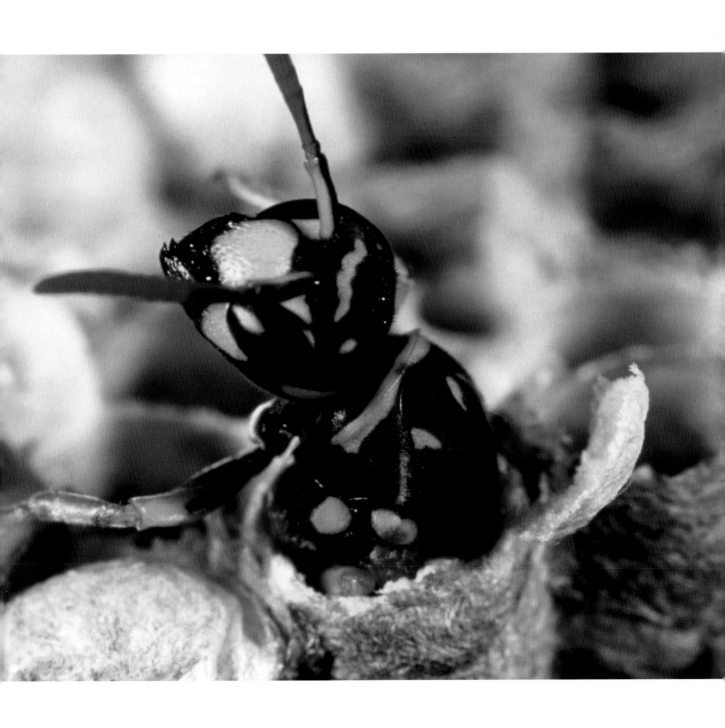

… Four to six weeks after the eggs were laid, the new adult wasps are ready to emerge from their cells. Each one bites through the silk cap and slowly struggles out of its cell, as can be seen in the pictures. Most of the new wasps are workers and one of their first jobs is to clean out their cells so that the queen can lay more eggs in them. The workers also enlarge the nest and collect food for the next brood of grubs. Although these wasps are shown in a head-up position, the cells all open downwards – otherwise they would fill with rainwater!

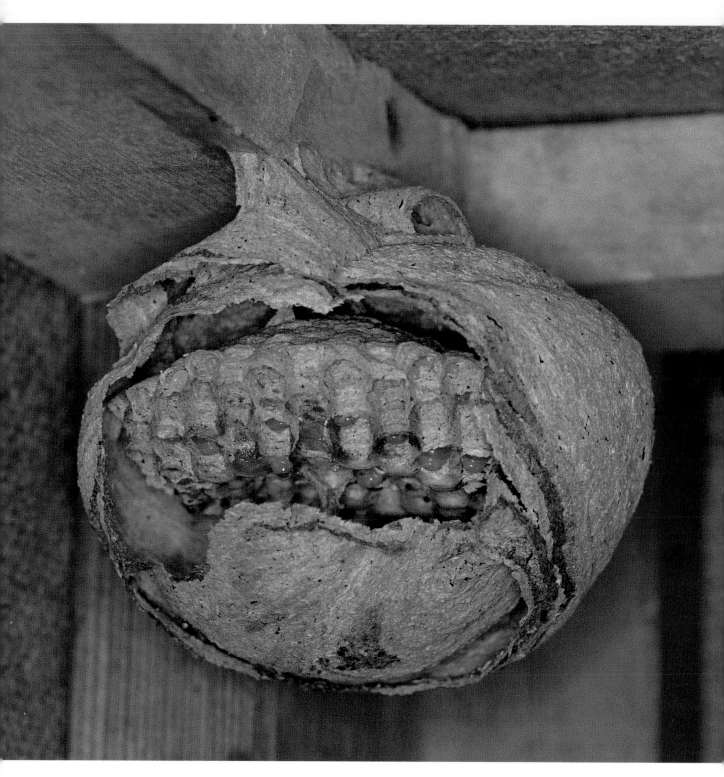

Complex Architecture

THE INTERNAL STRUCTURE OF A WASP NEST, revealed by removing part of the envelope, shows
one horizontal comb or tier of cells. Larvae can be seen in some of the cells, while others have
already been capped with silk and contain pupae. The nest is firmly anchored to the roof of a
garden shed by tough paper stalks. This is a fairly young nest and, had it not been damaged, the
wasps would have added several more tiers. A mature, football-sized nest of the common wasp
may contain up to 10,000 cells in eight or more tiers. Up to 25,000 wasps could be reared in one
of these nests during the summer, although not all of them would be alive at any one time.

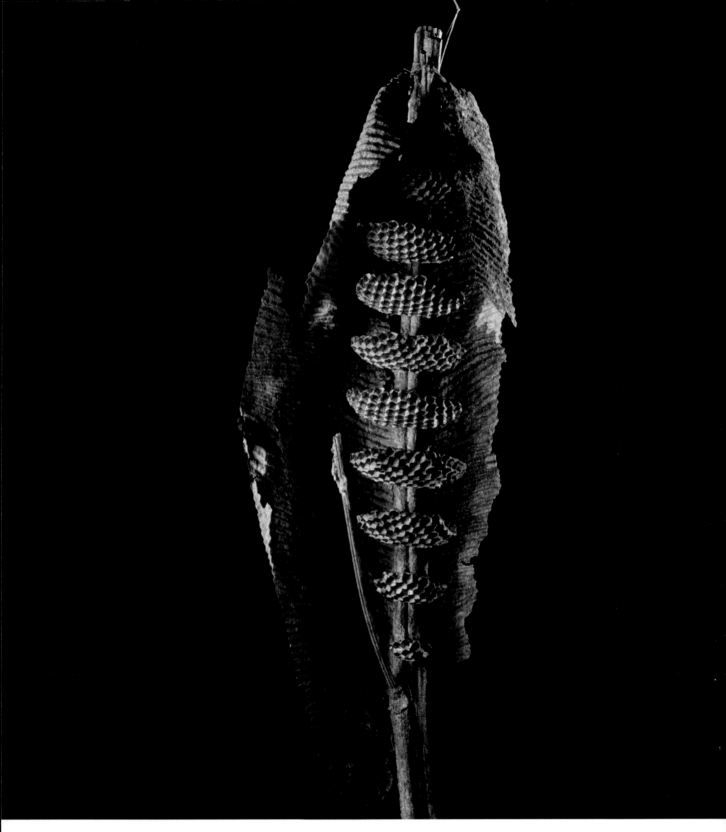

Multi-storey Nests

THIS NEST OF A SOUTH AMERICAN WASP of the genus *Parachartergus* consists of several delicate paper combs built around a slender twig. The paper envelope, which has been partly removed in this photograph, is attached to the twig above and below the combs, but not to the combs themselves – so the wasps can move freely from comb to comb. The envelope provides some protection from ants and other potential enemies. The entrance to the nest is at the bottom.

275

Sweet Store

WILD HONEY BEES and those that escape from captivity usually nest in hollow trees or similar cavities, but they occasionally build in the open, especially in warm climates. The nest pictured here has six large vertical combs, firmly attached to a support, and the bees are huddled in the lower part of the nest to keep warm. Each comb is covered with hundreds of six-sided cells, arranged back-to-back and containing stores of pollen and honey as well as young bees. The German biologist Karl von Frisch found that a comb measuring 37 cm/14 in. by 22.5 cm/9 in. could hold more than 4 lb/2 kg of honey, yet the wax comb itself weighs only about 40 g/1 oz.

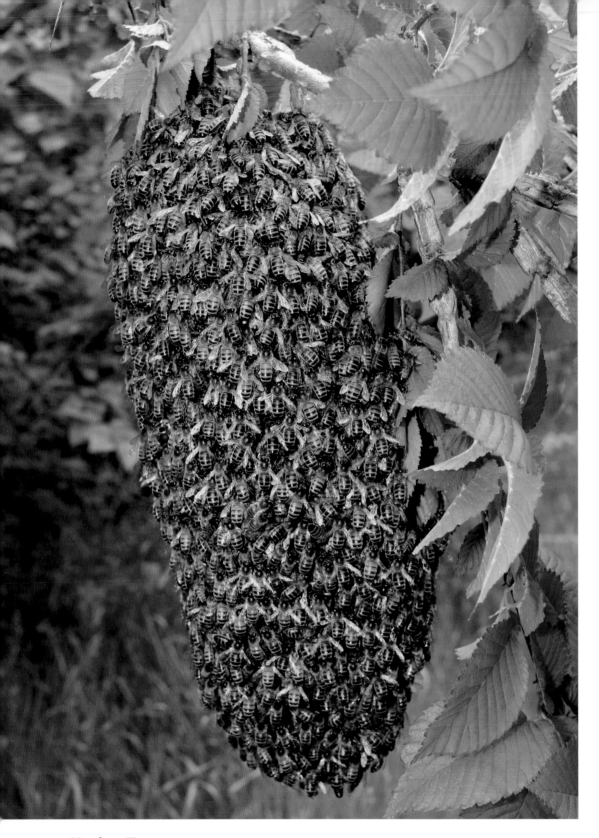

Moving House

IF A HONEY BEE COLONY BECOMES OVERCROWDED it usually sends out a swarm, consisting of the old queen and a few thousand workers – usually about half of the original population. The swarm usually settles on a tree or a bush, as pictured, and may stay for several days while scout bees look for a permanent home. If they find something promising, they return to the swarm and 'dance' on its surface. The dance indicates the direction and also the distance of the site, and it encourages other workers to go and have a look. If enough workers come back and indicate a particular site, the whole swarm moves to it and the workers start building new combs.

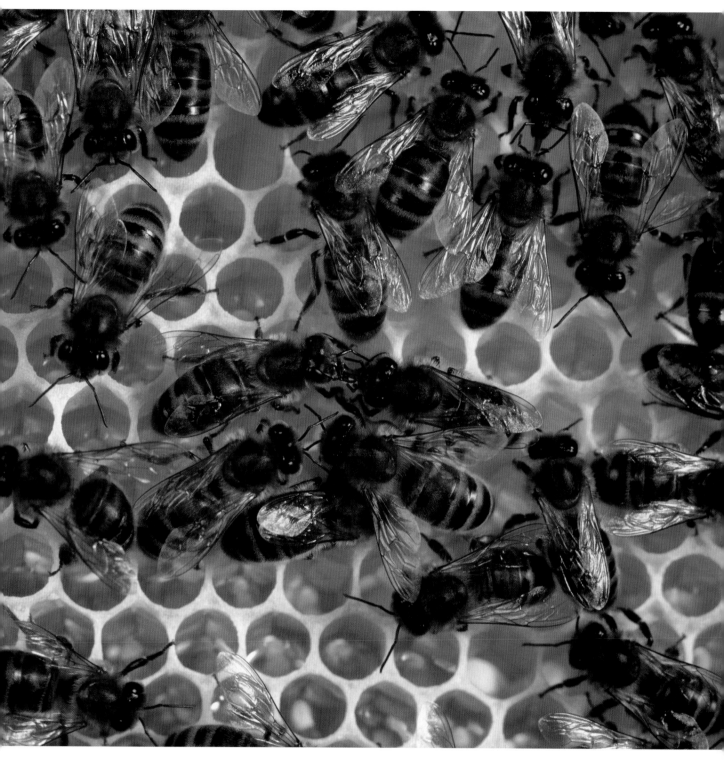

Hive of Activity

THESE WORKER HONEY BEES are busy on one of the combs, filling the hexagonal cells with honey before capping them with wax. The combs are made completely from wax, which is secreted by glands in the bees' bodies. The honey is a food store for the bees to use in cold or wet weather when they cannot go out to forage.

INDEX

Page number in *italic* type refer to illustrations.

285

PICTURE CREDITS

Cassell Illustrated would like to acknowledge and thank all the following for permission to reproduce images in this book, with special thanks going to the Science Photo Library (SPL).

Key: a above, b top centre, c bottom centre, d below, l left, r right.
Jacket, front, SPL/Scott Camazine; back l-r, SPL/Scott Camazine, USDA, NHPA/Anthony Bannister.

2-3 SPL/Kenneth H Thomas; 4-5 Michael Chinery; 6-7 SPL/Sinclair Stammers; 8-9 SPL/John Mitchell; 10 NHPA/George Bernard; 11, 12 all Michael Chinery; 13a & b Alamy/blickwinkel; 13c NHPA/Stephen Dalton; 13d, 14a Michael Chinery; 14b NHPA/Anthony Bannister; 14c & d NHPA/Stephen Dalton; 15a NHPA/Guy Edwardes; 15b, c & d Michael Chinery; 16a NHPA/Image Quest 3-D; 16b, c & d, 17 all Michael Chinery; 18-19 SPL/Eye of Science; 20 SPL/David Scharf; 21 SPL/Eye of Science; 22 SPL/Steve Gschmeissner; 23 SPL; 24 SPL/Claude Nuridsany and Marie Perennou; 25 SPL/John Walsh; 26 SPL/Claude Nuridsany and Marie Perennou 27 SPL/Andrew Syred; 28, 29 SPL/Steve Gschmeissner; 30 SPL/Edward Kinsman; 31 Michael Chinery; 32-33 SPL/Andrew Syred; 34 SPL/Darwin Dale; 35 SPL/Claude Nuridsany and Marie Perennou; 36, 37 SPL/Steve Gschmeissner; 38, 39 SPL/Andrew Syred; 40 SPL/Eye of Science; 41 SPL/Susumu Nishinaga; 42 SPL/Steve Gschmeissner; 43 SPL/Dr Jeremy Burgess; 44 SPL/Eye of Science; 45 SPL/Susumu Nishinaga; 46, 47 SPL/Steve Gschmeissner; 48 SPL/Andrew Syred; 49 SPL/Eye of Science; 50, 51 Michael Chinery; 52 SPL/Eye of Science; 53 SPL/Andrew Syred; 54 SPL/Dr Jeremy Burgess; 55 SPL/Andrew Syred; 56, 57 SPL/Susumu Nishinaga; 58 SPL/Alfred Pasieka; 59 SPL/Eye of Science; 60 SPL/Susumu Nishinaga; 61 SPL/Manfred Kage; 62 SPL/Microfield Scientific Ltd; 63 SPL/Claude Nuridsany and Marie Perennou; 64 SPL/E R Degginger; 65 Michael Chinery; 66-67 SPL/Dr John Brackenbury; 68 SPL/David Aubrey; 69 SPL/Thomas R Taylor; 70 Michael & Patricia Fogden; 71 SPL/Valerie Giles; 72, 73, 74, 75 SPL/Claude Nuridsany and Marie Perennou; 76, 77 SPL/Dr John Brackenbury; 78-79 SPL/Kazuyoshi Nomachi; 80 SPL/Claude Nuridsany and Marie Perennou; 81 SPL/Andrew Syred; 82 SPL/Dr John Brackenbury; 83 SPL/Andrew Syred; 84 SPL/Edward Kinsman; 85 SPL/Dr John Brackenbury; 86 SPL/Claude Nuridsany and Marie Perennou; 87 Michael Chinery; 88 SPL/Dr John Brackenbury; 89 SPL/Andrew Syred; 90 SPL/Ian Cuming; 91 SPL/Dr John Brackenbury; 92-93 NHPA/James Carmichael Jr; 94-95 SPL/Gregory Dimijian; 96, 97 SPL/Dr Jeremy Burgess; 98 SPL/Claude Nuridsany and Marie Perennou; 99 Michael Chinery; 100, 101, 102 SPL/Claude Nuridsany and Marie Perennou; 103 SPL/Gary Meszaros; 104 SPL/Scott Camazine; 105 SPL/Peter Chadwick; 106 SPL/Kenneth H Thomas; 107 SPL/Claude Nuridsany and Marie Perennou; 108 SPL/J C Revy; 109 SPL/Claude Nuridsany and Marie Perennou; 110 SPL/Steve Gschmeissner; 111 SPL/Sinclair Stammers; 112 Michael & Patricia Fogden; 113 SPL/Brian Brake; 114 Michael Chinery; 115 SPL/Biomedical Imaging Unit, Southampton General Hospital; 116 SPL/Dr Morley Read; 117 SPL/William Ervin; 118 SPL/Jacana/Jean-Philippe Varin; 119 SPL/Gregory Dimijian; 120 SPL/Dr Morley Read; 121 SPL/George Bernard; 122, 123 SPL/Sinclair Stammers; 124 SPL/Claude Nuridsany and Marie Perennou; 125 SPL/Andrew Syred; 126 SPL/Claude Nuridsany and Marie Perennou; 127 SPL/Alfred Pasieka; 128-9 Roger Key; 130 Michael Chinery; 131 SPL/Sinclair Stammers; 132 Michael Chinery; 133 Michael & Patricia Fogden; 134, 135 Michael Chinery; 136 SPL/Kenneth H Thomas; 137 SPL/Vaughan Fleming; 138-9 SPL/Jeff Lepore; 140-1 SPL/Dr George Beccaloni; 142 Michael Chinery; 143 SPL/David M Schleser/Nature's Images; 144 Michael Chinery; 145 SPL/Nature's Images; 146, 147, 148-9, 150 Michael Chinery; 151 Michael & Patricia Fogden; 152 SPL/Bob Gibbons; 153 NHPA/Stephen Dalton; 154, 155, 156, 157 Michael Chinery; 158 SPL/ Claude Nuridsany and Marie Perennou; 159 SPL/William Ervin; 160 SPL/Sinclair Stammers; 161 SPL/Nature's Images/David Schleser; 162 SPL/Stuart Wilson; 163 SPL/Dr Morley Read; 164 SPL /Kinsman Physics Productions/Ted Kinsman; 165 SPL/Richard R. Hansen; 166-7 SPL/Agstock/Ed Young; 168 SPL/Claude Nuridsany and Marie Perennou; 169, 170 Michael Chinery; 171 SPL/Scott Camazine; 172, 173 SPL/Art Wolfe; 174 SPL/Leslie J Borg; 175 SPL/Sinclair Stammers; 176 SPL/Dr John Brackenbury; 177 SPL/Gregory Dimijian; 178 SPL/Tony Wood; 179 SPL/Valerie Giles; 180 SPL/Scott Camazine; 181 SPL/Nature's Images/David Schleser; 182 SPL/Dr Morley Read; 183 SPL/Stuart Wilson; 184, 185 Michael Chinery; 186 SPL/Claude Nuridsany and Marie Perennou; 187, 188 SPL/Dr Morley Read; 189 SPL/Dr George Beccaloni; 190 Michael Chinery; 191 SPL/Scott Camazine; 192, 193, 194 Michael Chinery; 195 SPL/Dr George Beccaloni; 196-7 Michael Chinery; 198, 199 SPL/Dr Jeremy Burgess; 200, 201 SPL/Harry Rogers; 202 SPL/Dr Morley Read; 203 SPL/Gregory Dimijian; 204 Michael Chinery; 205 SPL/Ray Coleman; 206 Michael Chinery; 207 SPL/George Bernard; 208, 209 all SPL/Andy Harmer; 210 SPL/Michael P Gadomski; 211 l & r SPL/Scott Camazine; 212 l & r SPL/Jim Zipp; 213 SPL/John Mitchell; 214 SPL/Edward Kinsman; 215 SPL/Dr Morley Read;